Praise for *Information for Sustainable Development*

'*Information for Sustainable Development* addresses timely topics associated with achieving the targets of the Sustainable Development Goals (SDGs) in a global information society. The authors are knowledgeable in the SDGs as well as the data generated and collected by information systems, information-seeking behaviour, digital information literacy, and education for information professionals. They provide an overview of how the SDGs can be integrated into an information society and identify the opportunities and challenges related to this. Centering the discussion of the SDGs on people and highlighting the importance of measuring the success of the integration of the SDGs into the global information society differentiates this book from others.'
Lynn Silipigni Connaway, Executive Director, Research, OCLC

'In *Information for Sustainable Development* Gobinda and Sudatta Chowdhury build on their extensive careers and expertise to support librarians, information scientists and many others who confront sustainable development goals (SDGs). They cover the full spectrum of what should be considered, ranging from core concepts such as information and data to information activities such as information seeking, information literacy, metadata, digital skills, the digital divide and the link between information and the SDGs. *Information for Sustainable Development* succeeds in widening the perspectives of how we address sustainable development and search for solutions. The content touches every facet of life: everyday, education, research and professional development. This is certainly an exciting, well-structured and thought-provoking book that would stimulate the training of librarians and information scientists, and that can guide policymakers to recognise the importance of information and its intersection with people and technology in addressing sustainable development.'
Professor Ina Fourie, Department of Information Science (iSchool), University of Pretoria, South Africa

'*Information for Sustainable Development* is a comprehensive volume which addresses the key challenges of achieving the UN's Sustainable Development Goals (SDGs) through the lens of information science, demonstrating the importance of information, people and society in achieving the SDGs. It underscores the significance of data, metadata, and information in evaluating achievements, tackling problems, and enabling collaboration. Written in an accessible and engaging style, this book will support students, academics and professionals in the field of information, as wel'

in other fields, fostering cross-disciplinary synergies in addressing the complex societal challenges.'
Professor Koraljka Golub, Head of iInstitute, Linnaeus University, Sweden

'This book is highly recommended to scholars and students who wish to gain a solid understanding of the relationship between sustainable development and information science. The book offers a lucid and in-depth analysis of the information dimensions that directly impact the United Nations' Sustainable Development Goals associated with poverty, hunger, health, education, climate, and justice. Clear descriptions of the foundational principles of information science provided in the initial chapters are particularly helpful, making the monograph accessible to a wider audience. The coverage of critical data standards, robust information management systems, and information literacy skills and how they help in addressing public sector organizational capacity and competency demands is timely and deserves our attention.'
Professor Javed Mostafa, Dean, Faculty of Information (iSchool), University of Toronto, Canada

'Gobinda and Sudatta Chowdhury bring their wealth of knowledge and expertise to *Information for Sustainable Development.* With the Sustainable Development Goals of the United Nations becoming ever more important, this volume presents a timely and valuable exploration of information science's role in the measurement of those objectives. In our increasingly data-driven world, an evaluation of the part played by data, metadata, and information is crucial for developing an understanding of the extent to which these global challenges are being addressed. This book provides an excellent exploration of the subject and makes a strong contribution to wider discourse on global sustainability.'
Professor Peter Reid, School of Creative and Cultural Business, Robert Gordon University, Scotland

'Gobinda and Sudatta Chowdhury's book *Information for Sustainable Development* addresses a critical contemporary issue that has implications for the planet. The authors discuss both the kind of information needed to make sustainable development possible, and how to determine the degree of progress using both direct and indirect measures. Data collection is a key issue, and another is the use of metadata to match the indicator data to criteria for success. The authors look internationally at both the European Union and the G20 countries, including the UK, when talking about the digital divide and the factors that cause it. They emphasize the importance of both digital

and information literacy for employment, health, education, and environmental literacy and the role of these factors in understanding and combating climate change. This is a book that everyone who cares about the state of the planet should read.'
Professor Michael Seadle, Humboldt-Universität zu Berlin (iSchool), Germany and Executive Director, iSchools.org

'If you are an information professional and wonder how today's craze of data analytics and artificial intelligence can support the development of a sustainable world, this is a book that you absolutely cannot miss. The book serves not only a critical teaching need, because it provides clear definitions, ideas and knowledge for information students, but it will also become an essential reference for future academic studies, because it constantly challenges existing knowledge and presumptions about how information leverages social development.'
Professor Lihong Zhou, School of Information Management (iSchool), Wuhan University, China

Information for Sustainable Development

Information for Sustainable Development

Technology, People and Society

G. G. Chowdhury and
Sudatta Chowdhury

facet
publishing

Published by Facet Publishing
c/o British Library, 96 Euston Road, London NW1 2DB
www.facetpublishing.co.uk

Facet Publishing is wholly owned by CILIP:
the Library and Information Association.

British Library Cataloguing in Publication Data
A catalogue record for this book is available from the British Library.

ISBN 978-1-78330-666-4 (paperback)
ISBN 978-1-78330-667-1 (hardback)
ISBN 978-1-78330-668-8 (PDF)
ISBN 978-1-78330-669-5 (EPUB)

First published 2024

Typeset from authors' files by Flagholme Publishing Services in
10/13 pt Palatino Linotype and Open Sans.
Printed and made in Great Britain by CPI Group (UK) Ltd, Croydon, CR0 4YY.

To Avirup, Caitlin and Anubhav,
who continue to inspire us. . .

Contents

Figures

Tables

About the Authors

G. G. Chowdhury, BSc (Hons), MSc, PhD, FCLIP, SFHEA, is a Professor of Information Science in the Department of Computer & Information Sciences at the University of Strathclyde in Glasgow, UK. Previously, he had held several senior academic positions: as a Professor and Head of Mathematics and Information Sciences, and as the Head of iSchool at Northumbria University in Newcastle, UK; and as a Professor and Director of Information and Knowledge Management at the University of Technology Sydney in Australia. Professor Chowdhury's research focuses on connecting people with information through technology. He is a world-leading expert in digital libraries, cultural information management and sustainable information systems and services. He has published 16 books and over 160 research papers. Professor Chowdhury has been the European and Global Chair of the iSchools organisation (www.ischools.org).

Sudatta Chowdhury, BSc, MSc, MPhil, PhD, is a Research Associate in the Department of Computer & Information Sciences at the University of Strathclyde in Glasgow, UK. Previously, she had held several academic and research positions at universities in the UK, Singapore and Australia. Her research focuses on information-seeking behaviour and human-centred challenges for access to information, including digital divide and digital and information skills. She has co-authored five books and several journal and conference papers and book chapters.

Both authors are currently involved in externally funded research projects on libraries for a sustainable future. They are regularly invited to deliver talks on libraries, SDGs and climate change on national and international platforms.

Introduction

The Sustainable Development Goals (SDGs) that were proposed by the United Nations (UN) and adopted as UN Resolution A/RES/66/288 in 2015 are a set of 17 universal Goals and 169 associated Targets that have implications for everyone in every country and society, at present and in the future. Consequently, countries around the world signed up to the UN Resolution, accepting and agreeing to work towards achieving the Targets of the SDGs by 2030. Numerous reports, research papers, books and web resources have since appeared, discussing the benefits, progress, challenges and needs for co-operation and collaboration for achieving the SDGs that touch upon almost everything in each country, each society and each individual in the world.

This book offers an information science perspective on measuring the performance and assessing progress in achieving the SDGs. The primary focus is on the role and use of data, metadata and information in measuring the achievements and progress in different SDGs, and the standards and tools developed by international and national agencies to support this work. The book introduces the concepts and principles of information science and data management to people without a specialist background in those areas and similarly promises an introduction to the concepts and principles of sustainable development and sustainable information, before moving on to consider the current state of collection, management and use of different kinds of data for the SDGs at global and national levels, followed by chapters dealing with particular issues and specific Goals and Targets.

Overall, the book discusses the role and importance of data, information, people and society in achieving the Targets of the SDGs. It discusses the different types of metadata required for capturing data and information related to the Targets of different SDGs and various associated challenges, such as data availability and completeness, and even challenges associated with metadata and data collection, such as qualitative versus quantitative data for some Targets and Indicators. Appropriate data, charts and tables have been used from different reports and statistics from the various UN agencies,

OECD and EU, as well as national agencies such as the ONS (Office for National Statistics) in the UK.

The book argues that in addition to data and technology, different human and social issues, and their associated challenges, are also very important for achieving success in different SDGs and the associated Targets. For example, it critically analyses some datasets around SDG16.10, focusing on the access-to-information legislations and the digital and information skills that are required to access the relevant data and information – arguing and demonstrating that unless people's skills are improved and the digital divide in society and communities is reduced, legislation alone cannot guarantee the intended goal of access to information for all in every country and society.

The book is composed of four distinct but related sections that aim to discuss the background, the metadata, the Targets and Indicators of the 17 SDGs and progress in the SDGs at international and various country levels; then it moves on to discuss some specific data and information-related challenges that need to be addressed in order to achieve the intended Goals and Targets of the SDGs.

In the first section, Chapters 1 and 2 provide the basics of data, information, metadata and the SDGs to set the background. In the second section of the book, Chapters 3, 4 and 5 discuss the SDGs, specific Targets, Indicators and metadata required for measuring achievements and success. Specific examples and challenges associated with some metadata, and complexities associated with the methods of calculation/interpretation of data, are also discussed. Some data related challenges, such as, data completion, disaggregation of data, currency of data, missing data, and data gaps are discussed. The discussions are supported with data, tables, charts and critical comments around metadata and data related challenges for measuring the progress and achievements in various SDGs.

The book provides comparisons amongst different countries and regions, e.g. global achievements in SDGs in different regions and countries in Europe, Africa, the OECD countries, to demonstrate the current levels of progress and various challenges associated with the data and progress in achieving the Targets of different Goals. These are made in several chapters using tables, charts, and notes/comments around specific Goals, as well as some specific Targets and Indicators, especially those that are related to data and information, e.g. SDG16.10, SDG17, and data-related challenges, such as lack of disaggregated data on gender divide, and the overall availability, currency and completeness of data. Needs for, and the current levels of, national and international co-operation and collaboration for resources and data sharing for the SDGs are also discussed, with specific examples.

In the third section, Chapters 6, 7 and 8 discuss specific human and social challenges associated with the SDGs in general. Chapter 6 focuses on the digital divide in different regions and countries and their implications for the SDGs, especially in the context of access to information, SDG16.10, and access to technology: Target 9.c and Indicators 17.6.1 and 17.8.1 (all related to access to the internet). The discussions show how the existing digital divide in different regions, countries and communities hinders progress in the SDGs.

In Chapter 7 the digital skills of people in different countries and regions are compared and discussed in the context of the SDGs, supported by the latest data tables, charts and critical comments. Chapter 8 discusses information skills and how these are critical for everyone in achieving success in the SDGs; for instance, we look at the latest UK and international datasets on information skills at workplaces, in everyday life and at the foundation level and the related strategies/policies, arguing that these are the prerequisites for achieving the intended Targets of several SDGs. Relevant information literacy policies and frameworks, e.g. Unesco's MIL framework and the information literacy framework of CILIP, the Library and Information Association, have been discussed in the context of the SDGs, especially SDG16.10 (public access to information), SDG9c, 17.6.1 and 17.8.1 (access to the internet and digital divide), SDG3 (health and health information literacy), and SDG4 (education and information literacy), SDG8 (work and employment) and SDG13 (environmental literacy). Some works and initiatives of the LIS (library and information science) sector around green libraries, resources/activities to support health literacy, environmental literacy/awareness, and so on, are also mentioned in Chapter 8.

The fourth section of the book consists of three chapters, 9, 10 and 11. Chapter 9 focuses on education and the SDGs, highlighting how education for sustainable development and information and environmental literacy play an important part in achieving the SDGs. Examples of various activities and initiatives around education for sustainable development in different countries are also provided in Chapter 9. Chapter 10 discusses the trends of research on different aspects of the SDGs. Adopting the approach of a metareview, this chapter shows the levels of discussions and progress in research on the SDGs, especially around data and information, and highlights some challenges. Chapter 11 discusses the research and development activities undertaken by library and information science researchers, and library and information services professionals and the sector in general, around sustainability, green libraries and climate change agenda, and the SDGs in general. This chapter also proposes a research and training framework for the current and future generations of information professionals and researchers, pointing out how the SDGs and sustainability

issues should be embedded in the information science education curricula and research agenda for the future generations of information professionals, researchers and scholars.

The intended target audience of the book comprises the students, academics, researchers and professionals in the information sciences discipline, and especially library and information science and information and knowledge management, and in the cognate disciplines such as computer science, data science and environmental science. The book will be useful for practising professionals, researchers and senior management in the broader library and information services sector to help them understand how the LIS sector can contribute to the SDGs and thus engage in various activities and discussions that may result in developing policies and action plans for the sector. The book will also be useful for students, academics and researchers in other disciplines – education, social and political sciences, business and management science programmes, and so on – who are working with SDGs. It is hoped that the book will create new research and discussions in the study of data, information, people and the SDGs, generating discussion and debate on how the data, information, human and social elements of SDGs should be considered holistically, and how these elements should be embedded in the formal and informal information education and training, and research and professional activities, of the library and information science, knowledge and information management, records management, cultural heritage information management, and the allied disciplines.

Data, Information, People and Society

Introduction

In its meeting on 25 September 2015, the United Nations General Assembly adopted the *Resolution A/RES/70/1* that proposed 17 Sustainable Development Goals (SDGs) and the associated Targets (UN General Assembly, 2015a) (see Figure 1.1). Although they were adopted as a UN Resolution in 2015, SDGs are successors of the UN Millennium Development Goals (MDGs) adopted in 2000 (United Nations, 2013a). The SDGs are 'universal goals and targets which involve the entire world, developed and developing countries alike' (UN General Assembly, 2015a, 3). Alongside the continuing development priorities, such as poverty eradication, health and wellbeing, education for all and food security and nutrition, SDGs set out a wide range of economic, social and environmental objectives; promise more peaceful and inclusive societies; and define means of implementation of the Goals and Targets (UN General Assembly, 2015a).

Figure 1.1 *The 17 Sustainable Development Goals*
(© UN; https://unstats-undesa.opendata.arcgis.com)

More details of the 17 SDGs and the associated Targets are discussed in Chapter 3. Although countries around the world agreed to accept them, right from the beginning there was a debate on how the SDGs and their success could be measured. While the thematic areas covered by the SDGs are well connected with one another, and overall the SDGs as a whole are a more integrated system than the MDGs were (Le Blanc, 2015), the information systems, tools, standards and policies required to measure the achievements in each SDG needed to be developed and adopted by countries around the world.

The importance of, and need for, appropriate management, access, use and sharing of data and information for achieving sustainability in different sectors have been mentioned in several places within the UN, and also other international, policy documents (see for example, UN General Assembly, 2012; OECD, 2010) and information science literature (see for example, Nolin, 2010; Nathan, 2012; Chowdhury, 2013; 2014b; Chowdhury and Koya, 2017). Several international and national policy documents have recognised the importance of management, access, use and sharing of data and information for sustainable development. For example, the canonical text on sustainable development, *Our Common Future* (United Nations, 1987), has clearly highlighted the need for improved access to information in a number of places. Chowdhury and Koya (2017) have shown some examples of such references to data and information in *Our Common Future*, as follows:

- Free access to relevant information and the availability of alternative sources of technical expertise can provide an informed basis for public discussion (United Nations, 1987, 57).
- The real challenge is to ensure that the new technologies reach all those who need them, overcoming such problems as the lack of information (p. 77).
- Many developing countries need information on the nature of industry-based resource and environmental problems, on risks associated with certain processes and products and on standards and other measures to protect health and ensure environmental sustainability. They also need trained people to apply such information to local circumstances (p. 192).
- The primary frustration about this wealth of data is that the information is dispersed among governments and institutions, rather than being pooled (p. 227).
- New technologies and potentially unlimited access to information offer great promise (p. 257).
- Augmented by digital communications and advanced information analysis, photos, mapping, and other techniques, these data can provide

up-to-date information on a wide variety of resource, climatic, pollution, and other variables (p. 267).

The need for access to, and sharing of, information has also been mentioned in many other policy documents created by the UN (such as UN General Assembly, 2012; 2015a; 2015b), the European Commission (EC, 2010), the OECD (2010), and studies commissioned by national governments, for example, the Department for Environment, Food and Rural Affairs in the UK (DEFRA, 2013); as well as by researchers in information science (see for example Nolin, 2010; Nathan, 2012; Chowdhury, 2014a; 2014b; Chowdhury and Koya, 2017).

So, information and data form the foundations of all activities related to sustainable development. But the questions are why and how? This book aims to address these two key questions: why data and information form the bases of all the activities, Targets and Indicators of the 17 Sustainable Development Goals; and how data and information can and should be gathered, processed, shared, accessed and used for measuring the Targets of each SDG. The following sections in this chapter provide an overview of some relevant concepts – such as information, data, information seeking and information behaviour – in order to provide the context for further discussions in this book.

Information

Information is 'a fairly old English word' (Case and Given, 2016, 56), and some researchers have even traced its origins back to Latin and Greek terms of the pre-Christian era (Case and Given, 2016, 56). Information has for long been treated as an asset and in today's world information is perhaps the richest commodity of all (Stanford Encyclopedia of Philosophy, 2022). However, although numerous scholarly books and research papers have been written on the topic, there is no single agreed definition of the term. Different people have defined the word 'information' in different disciplinary or application contexts over time, and some such definitions are often highly contested. Hence Floridi (2011) comments that 'Information is still an elusive concept'. Adriaans (2020) points out that 'the term "information" in colloquial speech is currently predominantly used as an abstract mass-noun used to denote any amount of data, code or text that is stored, sent, received or manipulated in any medium.'

Tracing the history of the term, Buckland points out:

> In the middle of the twentieth century, the word information was adopted as a technical term (notably as information theory) in engineers' calculations of reliability in telephony and similar signalling systems. This use related the word information to a series of developments in logic, probability, and computation that proved very fertile in some important fields.
>
> (Buckland, 2017, 4)

Buckland further points out that:

> these important technical developments and assumptions about the truth value of information have little overlap with everyday human experience, so it is important to recognize that there are two fields of study, both of which have used the name information science, but they have little in common beyond using the same name. Each seems to have limited interest in, or relevance to, the other.

Floridi (2011) suggests that the term 'information' can be viewed from three perspectives: 'information *as* reality (e.g. as patterns of physical signals, which are neither true nor false), also known as *environmental* information; information *about* reality (semantic information, alethically qualifiable); and information *for* reality (instructions, like genetic information, algorithms, orders, or recipes).' In mathematical or computational terms, information, 'rendered as bits', is treated to have a fixed meaning and connotations which are used for performing specific decision making or operations, usually machine-level: mechanical or digital. Such bits or signals should carry some semantics that can be used to carry out specific instructions, algorithms, functions, etc., and these semantics are set on the basis of some operational and functional needs, business context, regulations and policies, etc.

However, information communicated as recorded bits or in other forms, such as sound, lights, gestures, etc., is also used by humans for different purposes as part of everyday living, learning, work, entertainment, etc. When we consider it, in the context of everyday human experience, and society as a whole, information is associated with:

- the complex, and often multiple, meanings embedded in messages, records, documents and perceptions in our lives; as well as
- the difficulties associated with finding the most relevant information and making sense of it in a specific context, and various associated factors such as efforts and resources required to find the right information; and reliability, trust and confidence on the sources of information.

Buckland (2017, 6) argues that 'information is used in an ordinary, everyday sense with two related meanings: (1) what we infer from gestures, language,

texts, and other objects; and (2) material forms of communication – bits, books, and other kinds of physical messages and records'. Case and Given prefer the definition of information as 'any difference you perceive, in your environment or within yourself', further stating that it is any aspect or pattern that you notice in your reality, and it is 'something that brings about a change in your take on the world' (Case and Given, 2016, 6).

Buckland (1991; 2012; 2017) points out that the term 'information' has three different connotations:

1 'Information-as-process', which relates to the act of informing or the process of being informed
2 'Information-as-knowledge', which is intangible but can be regarded as the result of being informed; and
3 'Information-as-thing', where the term information is used attributively for objects such as data and documents.

So, in order to achieve the intangible, 'Information-as-knowledge', one needs tangibles – data organised in a specific form and format resulting in documents ('Information-as-thing') to communicate that results in the recipients – humans or machines, being informed ('Information-as-process').

Although the definitions vary, there is a common agreement that information comprises data associated with meaning. There is a general agreement to the notion that information is well-formed data which is also meaningful to a recipient. The terms 'well-formed' and 'meaningful' are two important attributes of data that are essential for it to be used as information. Furthermore, the recipient and the specific context are important determinants of whether data, however well-formed it is, can or cannot be information. Two key points to note here are: information is (1) what is communicated in some way – gestures, recorded bits, messages, texts, words, images, etc.; and (2) what we 'infer' from that. So, whether it is meant for machine or human consumption, a meaning has to be inferred from data in order for it to be useful. Obviously, the meaning and inference drawn from data depends on specific contexts which depend on people, institutions and society that create and/or use data for making decisions or performing specific activities in a given context. This book focuses on 'Information-as-thing' i.e. data recorded in documents used to infer meaning in specific contexts of the SDGs.

Data

Like information, the term 'data' is also used differently by different people, and often the meaning of the term depends on the context. Data can be text,

sound, still images, moving images, models, games, simulations, etc., as well as:

> data and databases that generally require the assistance of computational machinery and software in order to be useful, such as various types of laboratory data including spectrographic, genomic sequencing, and electron microscopy data; observational data, such as remote sensing, geospatial, and socioeconomic data, numerical data and other forms of data either generated or compiled by humans or machines.
>
> (Borgman, Wallis and Mayernik, 2012, 488)

Data means different things to different people. For example:

- For a computer programmer or an application developer, data is what enables the creation of a digital system or a service, or what is generated as part of specific digital activities or transactions.
- For a researcher, data is what is collected or generated as part of research activities such as experiments, surveys, analyses, etc.
- For a legal practitioner or a data protection person, data may be the records of people or institutions that are kept or captured as part of various activities or transactions.
- For a health professional or a fitness trainer, data is what is generated by machines through specific clinical tests or physical activities measured through different machines or devices.
- For the general public, data is something that needs to be provided to accomplish online tasks such as performing a bank transaction, making an online hotel or flight booking, applying or renewing a passport, etc.

Data about people can include personal data, such as contact details, age or date of birth, health conditions, etc.; or myriad data generated through various web and social media transactions and activities. It can also extend to population-level data, such as those collected through various data-capturing mechanisms like census or national surveys, such as the Office for National Statistics (ONS) in the UK. Data can also be about institutions, systems and infrastructure, such as administrative records about institutions, governments and businesses, or details of computers, lights and other equipment in the laboratories at a university. Data is increasingly used to describe location and the environment we live in – geospatial references, often gathered through different devices, and a variety of data constantly generated through social media, various sensors, IoT (internet of things), etc.

Like information, data is considered to be an extremely valuable asset. It is often said that we live in a data-driven world. An article in *The Economist* (Economist, 2017) points out: 'Data are to this century what oil was the last one: a driver of growth and change. Flows of data have created new infrastructures, new businesses, new monopolies, new politics and – crucially – new economics'.

Data can be classified into different categories, such as:

- *Primary data*, the kind of data that is created/gathered and stored in a database, for example a simple array of numbers, text strings, images, etc., and forms the basis of an information-management system. Examples of such data include data that is stored and processed in a database: records of students, faculty or research activities at a university; records of sales of items in a business or a supermarket; records of energy consumptions in an industry, business, or a household; records of people's communications on mobile device or social media; and so on.
- *Secondary data*. This is the data that may be directly or indirectly generated from primary data, e.g. data on purchase patterns of customers from the daily transaction data of a supermarket, or data generated from the online transactions in a bank. Sometimes secondary data may also be the absence of data of a particular kind, e.g. absence of a number in a sequence, or a gap in a series of number or musical notes, etc., that generates a new kind of data that may provide a different form of meaning or inform about something.
- *Operational data*. This is data regarding the operations of the whole data system and the system's performance. Examples include the operational data stored in a credit or a debit card or in the chip of a digital passport.
- *Derivative data*. This is data that can be extracted from some primary data whenever the latter is used as part of some activities. Examples of such data include log data generated from online activities or transactions on the web, social media or various web and mobile applications.

It should be noted that often the abovementioned divisions are not rigid, and most importantly, in order to be useful as information each type of data should be meaningful to a user, and thus the context of data is extremely useful and relevant for any data-driven activity. This obviously means that how data is collected, coded, stored or labelled, as well as accessed and interpreted, is important for inferring the intended and accurate meanings of data and the context for its use.

In order to provide context that is essential for inferring meaning, we often add data about data, or metadata, that is usually associated with data to provide meaning or context to data. Metadata can be of different kinds, such as: descriptive metadata – for example author title, descriptors – that is used to describe the record of a book or a journal paper; or administrative metadata that is used to describe how certain types of actions can be performed on a specific data, such as open access data type (defined as CC BY, CC BY NC, etc. – for more details of Creative Commons (CC), see: https://creativecommons.org/about/cclicenses). More details of metadata appear in Chapter 2 and also in other chapters in the context of different SDGs.

Data and information management

Wilson provides a simple, and yet profound, example of the relationship between data – which he terms a 'signal' – and information: 'Information is all around us – we live in an information environment, like fish in water' (Wilson, 2010a). He further explains, 'when we consider the favourite definition of information as "any modulated signal" all we need is the ability to decode and interpret the signal and the information is revealed to us'. The key concepts here are that the recipients – machines or humans – need to 'decode and interpret' the modulated signal or data to transform it to information in a specific context; and if the context is taken away or changed, the interpretation may be different, resulting in a different information, or no information at all.

Figure 1.2 opposite provides an overview of the various stages of creation and access to data and information. As shown in the figure, data and information is generated through a number of processes and activities ranging from: various research and scholarly activities; various government and business activities; various computing and mobile devices that we use in our everyday life for communications and other activities; various devices that we wear or use in our houses, on the streets and public places; to various natural phenomena, and so on. Data generated through myriad events and activities is recorded and stored in different forms and formats, coded and tagged using the appropriate labels (called metadata, discussed in Chapter 2), processed through various data and information management systems, and is accessed by machines and/or humans through various interfaces or as part of communications. Obviously, data generated through various activities and processes needs to be collected, coded, processed, managed and accessed or disseminated in accordance with specific user- (machines or humans) and use-contexts.

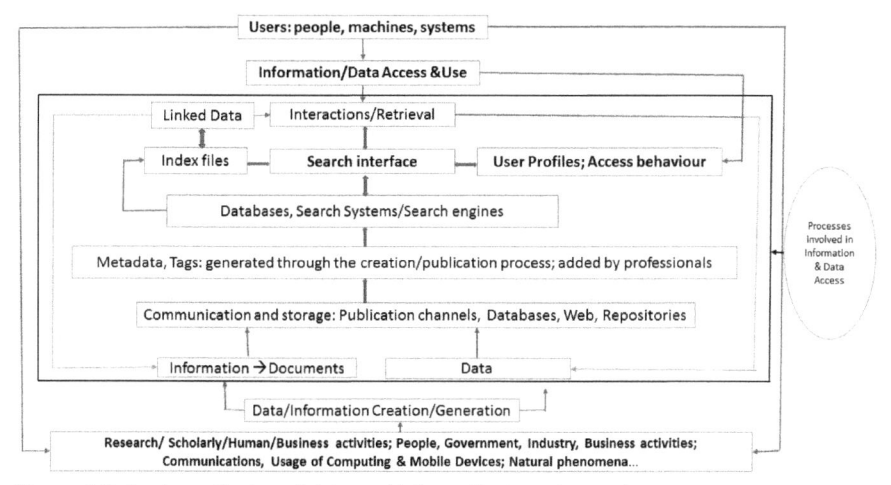

Figure 1.2 *A schematic view of data and information creation and access*

Let's take a couple of examples to understand how data is collected and coded in accordance with some prescribed rules and protocols. Let's think about a bank card – credit or debit card – that contains a lot of primary data which is encoded and can be read and interpreted by machines in order to perform some specific activities. We use a bank card to perform a variety of cash and, mostly, cashless transactions. The data encoded in the card is read by machines and is linked with a number of information systems to perform a cash or cashless transaction. Furthermore, although we finish a particular transaction almost instantly, the processes associated with the transaction do not stop there; and in fact, a chain of activities takes place following a specific transaction, which result in performing financial activities like debiting and crediting to an account, billing the customer, and so on. All bank cards follow a series of standard regulations and protocols which have been created by financial institutions and regulatory bodies, so that the cards can be used virtually anywhere in the world – online or in a shop, restaurant, hotel, etc. However, as an owner or user of the card, we don't need to know about these complex regulations and protocols. All we need to do is to follow some simple steps like entering the password or swiping the card for a cashless transaction, or follow a few steps for online or remote tasks – e.g. over the phone or a computing device – to complete a transaction. Financial institutions and regulators work behind the scenes to ensure that the data is coded with the appropriate standards and various protocols are followed to enable machines to perform specific tasks using the data and the relevant information, such as the persons or institutions to be debited or credited for a specific transaction. A number of measures are also taken to protect us – the customers, who own

and can lawfully use bank cards. A number of technical and regulatory measures are designed to protect the customers from fraud and misuse of our cards; and a huge amount of investment, technological innovation, and constant monitoring and vigilance behind the scenes makes this happen.

Let's take another example where multiple users – machines as well as humans – access and interpret data to gather information needed to make a decision or to accomplish a task. Let's think about a health information context. When a patient is admitted to, or visits, a hospital, a variety of data is collected and stored in the form of a patient record. Such a patient record may store some personal details of the patient which may be useful for humans and/or machines to make certain decisions or perform some specific activities. For example, the patient ID may be used to link the patient's personal data – age, address, medical history, clinical test results, prescribed medications, etc. A doctor can use such an integrated system to check the patient's medical conditions and history, can read and interpret specific clinical and diagnostic test results, can diagnose and prescribe medications or arrange for further tests. If medications are prescribed, the prescription is checked by the pharmacist and matched with the stock, and if the prescribed items are available, they dispense the medicine. At this point, the patient record is updated with the list of prescribed medicines, and the pharmacy stock records are changed accordingly, and if needed, new stocks are ordered. The nurses can check the patient record and can administer the medicines accordingly to the recommended dose, frequency, etc. This is a simple example of how different human users can access the data, and derive the information needed to accomplish a specific task according to the context. However, several machines can also make use of the data, and therefore the relevant information, to accomplish specific tasks. For example, the drugs database can automatically check if one or more prescribed items are in stock, check for side effects, or come up with alternative suggestions. A number of standards and protocols ensure that the data is stored and processed appropriately so that the users – humans or machines – can read and interpret the data in specific contexts. For example, data related to specific drugs are coded in accordance with the SNOMED CT, a structured clinical vocabulary for use in digital health records. 'SNOMED CT gives clinical IT systems a single shared language, which makes exchanging information between systems easier, safer and more accurate. . . . The use of SNOMED CT as a consistent vocabulary for recording patient clinical information across the NHS helps ensure data is recorded consistently and accurately. This simplifies exchanging clinical information between systems' (NHS Digital, 2021).

So, what have we learnt from these examples? We have noted that:

- Information that is considered relevant for one or more specific purposes or functions is recorded in a document ('information as a thing' according to Buckland, 2017).
- Information can be rendered as data in a variety of different ways, some of which can be read and used by humans while others can only be read and interpreted/used by machines.
- Information recorded in a document is read and interpreted within the context of a set of practices, norms, regulations and protocols, etc., associated with one or more specific environment and activities.
- Information recorded in a document has to be interpreted and used in a specific context, and in such cases, the meaning and value of information is determined based on the specific context.
- Information recorded in a document has to be accurate and trustworthy in order for it to be interpreted and used correctly.
- Information recorded in a document needs to be appropriately protected, otherwise it can be misinterpreted, misused or abused.
- A variety of technological, social and regulatory practices govern the use of the information recorded in different types of documents.
- A huge amount of financial, regulatory and technological investment and innovation goes on behind the scenes to ensure that the documents containing valuable information are used appropriately and lawfully.

People

People access and use different types of information, sometimes consciously or purposely and sometimes unconsciously or not through actively seeking it. Users are, or should be, the focal point of any information system or service. However, the concepts of 'user' and 'information need' are not always clear. Information systems and services are designed to meet the information needs of one or more specific groups of users – for example, students, academics, researchers in the case of university information systems; patients, doctors, nurses, pharmacists, carers, etc., in health care settings; the general public for government information systems. However, in today's digital world, virtually anyone from anywhere could be a user of an information system or service, and with the increasing push for open access to data and information (discussed later in this book), it is becoming a key requirement for information systems to ensure that the data and information that they provide are accessible and (re)usable by everyone in society.

As we have seen with the examples of bank cards and health care settings, data and information can be accessed and used by machines as well as humans. Increasingly, information systems are being designed so that

machines can read, interpret and use data and thus generate the relevant information required to take an action or make decisions. However, people, and by extension communities and society at large, should be at the core of the design and operations of any information system or service. As we have established through the example of credit and debit cards discussed earlier in this chapter, data and information is collected, coded, stored and used for the benefit of the people to make financial transactions easy and cashless. Similarly, with the example of data and information in health care settings, it is evident that the systems are designed to enable people to make appropriate decisions, or perform the required actions, for the benefit of people's health. We also have seen that a variety of standards, regulations and protocols are created to ensure that the information systems can operate by accessing and sharing data seamlessly. Such policies, regulations and standards are created for the benefit of people, communities, and society at large.

As discussed earlier in this chapter, people create, access, use and share information for almost everything that they do in their everyday life and living. Research by Du et al. shows how marketing professionals seek, judge, use and share information in the workplace, and how the information obtained is used for information processing, knowledge construction, information production and applying information. This study uncovers five dimensions of information-sharing occurrences, including people, purpose, mode, content, and level of pro-activeness (Du et al., 2013).

Some of the most important questions in developing an information system or service, therefore, relate to the identification of actual and potential users of the proposed information system, the nature of their activities, their information requirements, and so on. This becomes increasingly complex when multiple user groups and communities, multiple data creation and data management agencies, and multiple countries and regulatory agencies are involved. These challenges will be discussed in the context of the central theme of this book, i.e. Sustainable Development Goals (SDGs), but for now here are some basic concepts that are important and have remained key areas of research within the discipline of information science.

Information need

An article in the *Encyclopedia of Library and Information Science* points out that information need is 'one of the most central concepts within library and information science (LIS). If people did not have information needs, then libraries and other information systems would cease to exist, even basic interpersonal human communication would be altered' (Naumer and Fisher, 2017, 2453). Information need is often triggered by some unresolved

problem(s) or questions; it may arise when an individual recognises that their current state of knowledge is insufficient to cope with the task in hand, or to resolve conflicts in a subject area, or to fill a void in some area of knowledge. However, despite being one of the most widely used constructs to explain the reason why people choose to engage in finding information, the concept of information need remains ill-defined (Case and Given, 2016; Derr, 1983; Ford, 2015; Savolainen, 2017).

There are many different definitions or explanations of information need and these are often presented according to the interests and expertise of specific authors. For example, information need has been defined as a recognition of uncertainty (e.g. Atkin, 1973; Krikelas, 1983), as a lack of knowledge (e.g. Miranda and Tarapanoff, 2008), and as gaps which individuals must address to make sense of their environment (e.g. Dervin, 1983) and so on.

An earlier view (Taylor, 1968) proposes that information needs arise from a certain incompleteness in the inquirer's picture of the world – an inadequacy that prompts or triggers the state of readiness to interact purposefully with the world around him in terms of a particular area of interest. There is a general agreement to Wilson's view (1997) that information need is a secondary need which is triggered by a primary need by such as '(1) Physiological needs – need for food, water, shelter, etc. (2) Affective needs – need for attainment, domination, etc. and (3) Cognitive needs – need to plan, learn, etc.' Naumer and Fisher, 2017, 2456). Naumer and Fisher argue that Taylor's (1968) conception of information need advances the idea that people progress through:

four levels of question formulation:

1 Q1 – the actual, but unexpressed need for information (the visceral need).
2 Q2 – the conscious, within brain description of the need (the conscious need).
3 Q3 – the formal statement of the need (the formalized need).
4 Q4 – the question as presented to the information system (the compromised need)

(Naumer and Fisher, 2017, 2456)

However, some researchers have pointed out certain limitations of Taylor's view of information need. For example, Savolainen (2017) points out, Taylor's conception of information need does not specify how 'incompleteness' or 'inadequacy' gives rise to visceral or conscious information needs. Research also points out that information needs can be unrecognised or misunderstood by those who possess them (Derr, 1983; Green, 1990), and so this is an important area for attention if information needs are to be met.

In summary, research on information need and information-seeking models demonstrate that (Case and Given, 2016; Chowdhury, 2010b; Ormandy, 2009; Savolainen, 2017; Wilson, 2008):

1 Information need is a secondary need.
2 Information need is shaped by their cognitive behaviour and attitude.
3 Information need is dependent and shaped by the environment or situation that they are in; for example, the information need of those in an academic and scholarly environment is different from that in a health, business or government/administrative environment in different institutions and countries.
4 Information need varies from person to person, from job to job, subject to subject, organisation to organisation, and so on.
5 Information need changes over time.
6 Information need often remains unexpressed or poorly expressed.
7 Information need often changes upon receipt of some information.
8 Information need depends on several contextual factors, such as information governance and policies of an institution or a country.
9 Information need is difficult to quantify or measure.
10 Measuring how much of an information need has been met depends on how the information received by people helps them meet their primary need or solves the problem that triggered their specific information need.

Most information systems and services that we use today for finding information require the user to express their information need using one or more keywords on a search interface. Needless to say, this is often a challenging task for, many, if not most, users, especially when they look for something unknown, or in a discipline or topic outside their area of education or expertise.

Information seeking and information behaviour

The act of seeking information is seen as one that is fundamental to human behaviour (Shah, 2017). Information seeking is defined as 'a conscious effort to acquire information in response to a need or gap in one's knowledge' (Case and Given, 2016). An explicit information need is often considered to be the motivating force behind a person's action to seek information (Naumer and Fisher, 2017). However, sometimes information can also be obtained through serendipity or by chance, for example when someone shares information that may be useful.

Information seeking is conceptualised with respect to a person and their needs, irrespective of any system or the availability of any information (Shah, 2017). Information seeking or the pattern of engaging with information systems and services to meet specific information need depends on a number of factors. Some of these may be related to the personal characteristics and traits of users, some may be related to the technology or infrastructure, while some may be related to the governance and policies designed for access and use of the information system or service concerned. Hence, 'understanding the motivational factors involved in human information behaviour is critical to understanding other parts of the information seeking and use processes and has raised several important questions. For example, motivation is central to research regarding passive and active approaches to information seeking as well as blunting and avoidance behaviours' (Naumer and Fisher, 2017, 2453). Varying degrees of uncertainty exist among user groups of different age, gender, ICT skills, categories and disciplines in the context of various information-seeking activities and problems, and in relation to specific information channels or sources (Chowdhury, Gibb and Landoni, 2011). Research further shows that uncertainty may also be caused by a number of information-seeking activities and information-seeking problems; uncertainty persists over the course of a series of search sessions, although there may be a shift in uncertainty; and finally, while there are negative aspects associated with uncertainty, there are some positive ones as well (Chowdhury, Gibb and Landoni, 2014).

Information behaviour is viewed as encompassing a wide range of interactions with information in individuals' daily lives, including planned and intentional information-seeking behaviours as well as the unintentional or serendipitous encountering of information (Case and Given, 2016; Wilson, 1999; 2000). The term 'information behaviour' (IB) 'also includes the broader context of how individuals "deal with" information in their lives, so accounts for situation, time, affect, culture, geography, and other contextual elements in understanding people's IB' (Case and Given, 2016, 6).

Wilson's General Model of Information Behaviour (1997; 1999; 2000) attempts to present the complex relationship between contextual and cognitive factors which influence an individual's motivation to address information needs and to select and use information sources, and their overall information-seeking behaviour. It is the most widely cited research in information science (see for example, Bawden, 2006; Campbell, 2005; Case et al., 2005; Case and Given, 2016; Chowdhury, 2010b; Chowdhury and Chowdhury, 2011; Eyinade and Bakare, 2022; Kostagiolas et al., 2021; McKenzie, 2003; Niedzwiedzka, 2003; Ormandy, 2009; Phiri, Chipeta and Chawinga, 2019; Tury, Robinson and Bawden, 2015; Wilson, 2010b; Zimmermann et al., 2021).

People's general education and literacy skills, awareness and, especially, digital and information skills are also important factors influencing information-seeking behaviour. The following are some general points that can affect the information-seeking behaviour of users of information services (Chowdhury, 2010b):

1 user's educational and professional background and livelihood, the environment in which he or she has grown up and is presently living, and so on
2 user's awareness of, and ability to access, other sources of information
3 user's relationship with the information system/service concerned (e.g. free access, membership access, paid access)
4 user's ease of accessibility to the information system
5 user's working conditions or environment
6 time available to the user for consulting an information system(s)/service(s)
7 user's social or organisational status and socio-professional position
8 user's personal and professional connections
9 the challenge presented by a task or job for which information is needed
10 the amount of competition and urgency that exists in the user's field of activities
11 user's past experience with an information system or service
12 how much the user already knows, if at all
13 how easily the user gets on with an information system/service
14 the general attitude of the user towards information systems and services, etc.
15 how well the user can articulate their information need and formulate their queries
16 how the user makes use of the information obtained
17 how friendly the information system is
18 how good the help system, if any, is
19 user's trust of the information system or service
20 user's perceived costs for accessing (or not accessing) the information.

Some research looking at information needs and information seeking in a specific context has noted that:

- source characteristics predicted activating mechanisms, which in turn predicted online health information-seeking behaviour of people (Cao et al., 2016);

- perceived health risk and health self-efficacy significantly influence the health information-seeking behaviour (Deng and Liu, 2017); and
- health literacy and need-oriented communication efforts and information strategies are required to improve gender-specific health information needs (Baumann, Czerwinski and Reifegerste, 2017).

Some of the factors and challenges mentioned above are beyond the control of any given information system or service, and they depend on the general social structure and the general awareness and consciousness of people about the importance of information and communication. However, some are within the control of information systems and services: some are technical in nature, some are dependent on governance and policies, while others are more behavioural or attitudinal. Furthermore, the information behaviour of users is largely dependent on the context – for example, the environment which the user has been brought up in, or the one in which they presently live or work.

Information society, knowledge economy and knowledge society

Some aspects of development referred to by the phrase 'information society' involve wider use of information (Buckland, 2017). Similar views are also held by other researchers. For example, according to Wessels et al. (2017), an information society is one in which information is a central feature in production, innovation and consumption and is organised via digital networks. The United Nation's vision of information society is a society 'where everyone can create, access, utilize and share information and knowledge, enabling individuals, communities and peoples to achieve their full potential in promoting their sustainable development and improving their quality of life' (UN General Assembly, 2016). An information society often has a strong service sector and its economy is driven by knowledge garnered from flows of information; therefore a knowledge economy is the economic structure of an information society, because the economy is driven by knowledge that is created from information (Wessels et al., 2017). So, in an information society access to the relevant information is essential because its economy is driven by knowledge garnered from the use of information; and this leads to what is known as a knowledge society.

Knowledge societies are built on four pillars: freedom of expression, universal access to information and knowledge, respect for cultural and linguistic diversity and quality education for all (UNESCO, 2021a). In a knowledge society:

- data and information must be accessible and usable to humans and machines
- technological, social and regulatory frameworks and policies have to be constantly evolved
- people and society have to continuously learn and adapt to the emerging digital world
- financial and technology infrastructure have to continuously evolve
- governments, businesses and institutions have to change their business practices.

Wessels et al. (2017) argue that the central value of a knowledge society is openness, which means that data, information and knowledge are seen as a 'commons' or a shared asset in society. The essence of a knowledge economy is that data can be accessed and used by everyone, and therefore there is a continuous use and reuse of data and information to develop new knowledge for the economy and society as a whole.

The human elements of a knowledge society and the SDGs

While we are rapidly evolving as an information and a knowledge society, we face some new challenges as well. As more and more services are becoming online (for example, government services or financial services), people and society as a whole have to learn and adapt to the emerging digital technologies. This may prove to be difficult for some people, especially for people who are not well conversant with the digital technologies, or people who cannot access modern technologies because of financial or other constraints, such as disability or lack of affordability or poor or unreliable network connections. This can create what is known as a digital divide, which puts some people in a disadvantageous position in a digital world where all the services are expected to take place online. Digital divide can be caused by a number of factors, especially the lack of access to technologies – accessibility and affordability – and poor digital skills. In addition, information skills can also severely affect people's capabilities of accessing and using information for everyday life and living. These issues are discussed in more recent literature and reports on digital divide, digital skills and information skills – both in the context of accessing digital information systems/services and data and information related to the SDGs – in Chapters 6, 7 and 8.

SDGs are meant for people and society, and the *2030 Agenda* sets out a 'plan of action for people, planet and prosperity. It also seeks to strengthen universal peace in larger freedom' (UN Department of Economic and Social Affairs, n.d.a). The United Nations recognises the fact that 'every human on

earth – even the most indifferent, laziest person among us – is part of the solution' (United Nations, n.d.b). The United Nations Resolution A/RES/70/125 also highlights the contribution of information and communications technology (ICT) to the SDGs. It notes that access to ICT has also become a development indicator and aspiration in and of itself (UN General Assembly, 2016). Furthermore, the 17 SDGs are not independent of each other; for example, 'ending poverty must go hand-in-hand with strategies that build economic growth and address a range of social needs including education, health, social protection, and job opportunities, while tackling climate change and environmental protection' (United Nations, n.d.a).

A closer look at the SDGs, and the associated Targets and Indicators (discussed in detail in Chapter 3) clearly indicate that open access to, and sharing of, data is a prerequisite for measuring achievements in SDGs. In other words, it is imperative that all kinds of data and information related to all the SDGs and the associated Targets and Indicators are made openly accessible, and can be shared by various institutions, agencies and stakeholders at local, national, regional and international level. However, in order to be openly accessible, data and information need to be interoperable, shareable and reusable; and for this appropriate metadata, vocabulary, standards and protocols need to be developed, adopted and followed by everyone.

As discussed later in this book (Chapters 3–5), a variety of tools, standards and technologies have been developed over the past five or so years by the Statistics Division of the UN and other international and national agencies. However, adoption and practical implementation of such tools and standards for data and information gathering, coding, access and use come with a range of issues and challenges. Some of these issues and challenges are technological – calling for an adequate ICT infrastructure; some are technical – calling for appropriate tools and standards; and others are human and social – calling for wider data literacy and awareness, data governance and policies, and so on. Furthermore, co-operation and collaborations amongst various institutions, agencies, experts and policymakers are essential for developing a set of frameworks, policies, tools and technologies for gathering and sharing data on various SDGs. SDG17 specifically sets out the goals for 'the means of implementation and revitalize the global partnership for sustainable development' (UN Department of Economic and Social Affairs, n.d.d).

About this book

Beginning with an overview of the 17 SDGs and the associated Targets and Indicators in Chapters 2 and 3, this book discusses the different measures

taken to develop and implement, as well as challenges facing, different standards and tools for measuring the achievements in specific Targets associated with different SDGs. Chapters 4 and 5 provide an overview of the current state of achievements in different SDGs in some regions and countries around the world, and discuss some key issues and challenges associated with data standards, data quality and availability of data related to different SDGs. Chapter 5 also discusses some recent developments in regional and global co-operation and collaborations relating to data sharing, education and training models for building capacity and awareness of the SDGs. The book demonstrates why an understanding and appreciation of how an integrated system of data and information, technologies, people and society is required to achieve the SDGs at national and global level. Human and social challenges associated with data, information and SDGs are discussed in Chapters 6, 7 and 8 in the context of the digital divide, digital skills and media and information literacy. Needs and challenges associated with education for sustainable development are discussed in Chapter 9. Finally, the last two chapters of the book discuss research trends in the SDGs in general, and especially in the domain of library and information science, arguing how university education and research in information science, and professional research and development in the information services sector, can contribute to all the SDGs.

Information and the Sustainable Development Goals

Introduction

As mentioned in Chapter 1, the 17 Sustainable Development Goals (SDGs) were adopted in the United Nations Resolution (A/RES/70/1) in 2015. However, the terms 'sustainability' and 'sustainable development' have been in existence for quite some time, and have become key issues of discussions around global development. A report published by the World Commission on Environment and Development in 1987, called *Our Common Future*, which is also known as the Brundtland Report, provided the 'classic' definition of sustainable development as:

> development which meets the needs of the present without compromising the ability of future generations to meet their own needs
>
> (United Nations, 1987).

The Environmental Protection Agency (EPA) in the USA argues that sustainability creates and maintains the conditions under which humans and nature can exist in productive harmony, that permit fulfilling the social, economic, and ecological requirements of present and future generations (EPA, 2010).

These definitions of sustainability focus primarily on the environmental sustainability. However, there are two more dimensions, economic sustainability and social sustainability; the three together are often called the three pillars of sustainability. They are interrelated and interdependent. To achieve sustainable development in any area, there is a need for an integrated approach to these three dimensions of sustainable development (DEFRA, 2009). Thus, sustainable development calls for a convergence between the three pillars of economic development, social equity, and environmental protection (Drexhage and Murphy, 2010).

Appropriate integration of economic, environmental, and social development activities to achieve the SDGs has remained a mission for the

United Nations. A number of topics and issues related to sustainable development have been identified by the United Nations Division for Sustainable Development (UN DSD), some of which are social and economic while others are related to environment or natural resource management. The United Nations Conference on Sustainable Development (UNCSD) organised a conference on Sustainable Development – Rio+20 – that took place in Rio de Janeiro, Brazil, on 20–22 June 2012 (United Nations, 2013b). The objective of this conference was to take stock of the 20 years of actions at all levels to promote sustainable development, and to discuss the future and the way forward. For this, UNCSD created a document called *SD21: Sustainable Development in the 21st Century* with an objective 'to construct a coherent vision of sustainable development in the 21st century' (United Nations, 2013a). One of the main outcomes of the Rio+20 Conference was the agreement by the UN member states to launch a process to 'develop a set of Sustainable Development Goals (SDGs), which will build upon the Millennium Development Goals (MDGs)' (United Nations, 2013c). More details of the 17 SDGs and the associated Targets and Indicators are discussed in Chapter 3.

Information and sustainable development

To achieve sustainable development in any sector – government, business, education, health, and so on – there is a need for building systems and services that are economically, environmentally and socially sustainable. Many countries and international bodies have introduced specific mandates that require every organisation, business and institution to comply with the sustainability requirements, which are causing several changes in the business workflow, products, and services.

Researchers argue that in comparison with other businesses, the information services sector has not been early and proactive in research on sustainable development (Chowdhury, 2012a, 2012b, 2013; 2014a, 2014b; Dimireva, 2012; Nathan, 2012; Nolin, 2010), but of late there has been a growing interest in this area (see for example, Chowdhury and Koya, 2017; Connaway et al., 2023; Meschede and Henkel, 2019). So far as sustainable development is concerned, the concept of information should be considered from two different perspectives: sustainable information systems and services and information systems and services for sustainability. Nathan (2012) points out that the work of information professionals is in part informed by, and in part scaffolds, the information practices of society at large. Drawing on the definition provided by Dourish and Anderson (2006), Nathan (2012) defines sustainable information practices as 'the socially negotiated behaviour

through which we create, change, share, and store information'. The phrase 'socially negotiated behaviour' is important here. It means that standards and protocols should be developed and agreed by specific disciplines, communities of practice, industries, and society at large; and these should be learnt and practised for the entire lifecycle of information in a specific sector for achieving sustainable development. Sustainable information practices should therefore use appropriate technologies, tools, standards, methods, policies and practices so that sustainability can be achieved throughout the lifecycle of data and information; and these should be implemented not only within the information services unit in an organisation or business but should be applicable to the entire organisation and all its activities. Sustainable information practices should also influence the development and use of appropriate ICT infrastructure and digital information tools, regulations, and policies, as well as human and social/institutional behaviour in the use of data and information for sustainability in every sphere of life and activity.

Access to, as well as use and sharing of, appropriate data and information are the essential requirements for any sustainable development. Creation of sustainable information systems and services for every sector is therefore an absolute necessity. Several stakeholders are involved in, and many challenges are associated with, today's digital world of information systems and services. Information science, human–computer interactions, and participatory research approaches can help citizens develop practices that reduce negative ecological, economic and social impacts of our information practices (Chowdhury, 2014b; Nathan, 2012).

Sustainable information systems

Information and communication technologies are the key catalysts to sustainable development and rely heavily on collaborations among researchers in different disciplines, and also extensive communication and collaboration with industry, governments and organisations (Wu et al., 2018). Sustainable information systems and services contribute to the strengthening of the processes in which society is transformed according to the ideals of sustainable development. Early research studies have explored and reported how sustainability can be achieved at the levels of:

- ICT infrastructure (see for example Anagnostopoulou, Saadeldeen and Chong, 2010; Baliga et al., 2008; 2011; Gómez and Lorini, 2022; Hilty and Aebischer, 2015; Iano et al., 2022; Ko, Routray and Ahmad, 2019; Pawlish and Varde, 2010; Thierry, Bruno Emmanuel and Protus Biondeh, 2022; Tomlinson, 2010)

- information and data management software (see for example Bales, Sohn and Setlur, 2011; Basirat and Khan, 2010; Langer, 2011; Shih, Tseng and Yang, 2011; Yang, Kamata and Ahrary, 2009)
- system/product design (see for example Carballo-Penela and Domenech, 2010; Chen, Wu and Chen, 2022; Christianson and Aucoin, 2005; Haigh and Griffiths, 2008; Jenkin, Webster and McShane, 2010; Teregowda, Urgaonkar and Giles, 2010; Watson, Boudreau and Chen, 2010; Watson et al., 2008; Williams and Tagami, 2003).

Researchers from the computer science, and especially the HCI, community have been engaged in research on sustainability from different technological perspectives; for example some of the earlier research focused on:

- HCI and interaction design (Dick et al., 2013; Dourish, 2010; Howard and Lubbe, 2012; Knowles et al., 2016; McKinnon, 2016; Møllenbach, Hornbæk and Hoff, 2012; Nystrom and Mustaquim, 2014; Pargman and Raghavan, 2014);
- sustainability frameworks and Indicators (Combemale et al., 2016; Meyers and Nathan, 2016);
- sustainable ICT and user behaviour (Gegenbauer, 2012; Meurer et al., 2016)
- information and knowledge management tools and techniques for achieving sustainability in different fields (Ghahremanloo, Thom and Magee, 2012; Haupt, Scholtz and Calitz, 2015; Houghton, 2015; Kibe, 2016; Lu, 2018; Madlberger et al., 2013).

Achieving the Targets of the SDGs requires a comprehensive roadmap that encloses all dimensions of data infrastructure, social, economic, environmental and governance ecosystems (Rajabifard et al., 2021). Issa et al. (2020) stress that the awareness of environmental sustainability and prioritisation can lead to the responsible use of resources and processes. There is a need for strategic alignment between sustainability and information systems for higher education institutions (Goni et al., 2017). Walsh et al. (2020) recommend that the wider university strategy should embed sustainability knowledge and values in the university curricula. Chowdhury et al. (2021) discuss the importance of an integrated information system for accessing and sharing indigenous information in achieving SDGs in different areas, and especially in education and culture, but they also point out that a significant amount of technology, policy and resources needs to be mobilised and/or developed to achieve this goal. The *Living Lab* approach provides opportunities to help improve an institution's environmental sustainability, to train staff and

students and to foster publications and the dissemination of good practice (Filho, 2020). Molina et al. (2023) discuss several examples of progress in integrating the SDGs into higher education, primarily through courses, workshops and lectures on the topic.

Some researchers argue that, despite the increasing interest and numerous research publications on the SDGs, thus far both the *2030 Agenda* and digitalisation for SDGs remain yet untapped domains (Del Río Castro, González Fernández and Uruburu Colsa, 2021). Overall, there is a need for more global scientific, technological, industrial, and governmental efforts to promote and support the future achievements of SDGs (Wu et al., 2018). Some recent developments in regard to global collaborations and data sharing are discussed in Chapter 5.

Information for sustainability

As discussed in Chapter 1, terms like information society, knowledge economy, etc., have been in common use over the past decade, and they are now used in many high-level discussions and policy documents produced by international agencies like United Nations, UNESCO and the European Union, and various regional and national governments. In the canonical text on sustainable development *Our Common Future* (United Nations, 1987) the importance of information for sustainable development has been directly and indirectly mentioned in various contexts. The importance of information and knowledge sharing has been recognised repeatedly in many UN policy documents. For example, the 'Expert Consultation on Knowledge and Capacity Needs for Sustainable Development in Post Rio+20 Era' organised by the United Nations Office for Sustainable Development (UNOSD) together with its partners, held in Incheon, Republic of Korea on 6–8 March 2013, made the following observation:

> We are of the view that transition towards sustainability requires efforts on several fronts, but knowledge sharing and capacity building should be the fundamental platform for these efforts.
>
> <div align="right">(UN Office for Sustainable Development, 2013, 1)</div>

It further recommended (p. 3) that 'UNOSD should collaborate with other knowledge providers, and both promote and facilitate the linking and sharing of data and knowledge through open networks, avoiding the duplication of existing initiatives'.

The importance of data and information required for measuring success in sustainable development have been recognised in many other high-level

international reports and documents. The UN General Assembly Resolution A/RES/66/288, called *The Future We Want* (UN General Assembly, 2012) which made a series of recommendations for achieving sustainable development in different areas, clearly points out the importance of information for sustainable development; the following are some examples from that document, where some words are in bold for emphasis:

- 'We underscore **that broad public participation and access to information** and judicial and administrative proceedings are essential to the promotion of sustainable development (p. 8);
- 'We further acknowledge efforts and progress made at the local and subnational levels, and recognize the important role that such authorities and communities can play in implementing sustainable development, including by **engaging citizens and stakeholders and providing them with relevant information, as appropriate**, on the three dimensions of sustainable development (p. 8);
- 'We recognize that improved **participation of civil society depends upon**, inter alia, **strengthening access to information** and building civil society capacity and an enabling environment. We **recognize that information and communications technology is facilitating the flow of information between governments and the public**. In this regard, **it is essential to work towards improved access to information and communications technology**, especially broadband networks and services, and bridge the digital divide, recognizing the contribution of international co-operation in this regard (pp 8–9);
- 'We recognize that **integrated social, economic and environmental data and information**, as well as effective analysis and assessment of implementation, **are important in decision-making processes** (p. 20);
- 'We recognize that there is a need for **global, integrated and scientifically based information on sustainable development**' (p. 48).

The need for access to, and sharing of, information has been mentioned more specifically in the context of various sectors of development in the UN report *Realizing the Future We Want For All* (United Nations, 2012), in the context of, for example: sustainable development in agriculture (p. 23), food market (p. 23), sexual and reproductive health of women (p. 28), employment market and job creation (p. 29), conserving coral reef and mangrove ecosystems and marine life protection (p. 34), hazard and risk assessment (p. 39), biodiversity and ecosystem (p. 40), climate and weather management (p. 41), hazardous chemicals (pp 42–43), education and training (p. 44), technology transfer (p. 51), space technology and geospatial development policies (p. 51). The fact

that information plays a key role in today's information society and digital economy has also been recognised in many other national and international policy documents created by the European Commission (EC, 2010), by the OECD (2010; 2016a), and in a study commissioned by the British Government (Hargreaves, 2011).

Chowdhury and Koya (2017) undertook a thematic analysis of four key UN policy documents in order to understand how the importance of terms like data and information have been recognised in various contexts of sustainable development. The analysed reports were:

1 The Brundtland Report, *Our Common Future* (United Nations, 1987)
2 The UN General Assembly Resolution called *The Future We Want* (UN General Assembly, 2012)
3 UN Resolution A/RES/70/1: *Transforming Our World: the 2030 agenda for sustainable development*, which proposed 17 sustainable development goals (SDGs) and the associated Targets (discussed in Chapter 3) (UN General Assembly, 2015a)
4 The *Addis Ababa Action Agenda*, adopted by the UN General Assembly on 27 July 2015 (Resolution 69/313; UN General Assembly, 2015b).

The notion and context in which the word 'information' occurred in those documents varied, and often the terms have not been used consistently by the authors of those documents, but Chowdhury and Koya's thematic analysis of the content of the documents identified a series of themes around data and information. The most significant themes, based on their weighting, were: Information access, Information sharing, Building databases, Information skills, Scientific/research information, Information Technology, Information advocacy, Information analysis, and Environmental information.

The importance of information and knowledge for sustainable development has been recognised and mentioned by several institutions and experts. 'There is not truly sustainable development without access to information', comments Donna Scheeder, former President of IFLA (International Federation of Library Associations and Institutions) (Scheeder, 2019). UNESCO stresses that 'access to information is not only a basic human right, but also an important tool for promoting the rule of law and ensuring other rights as well as goals under the SDGs. It is therefore an enabler for sustainable development in areas such as health, environment, addressing poverty and fighting corruption' (UNESCO, 2019a). Integrated information systems are critical for the successful achievement of the Sustainable Development Goals (SDGs). Machingura et al. (2018) emphasise the need for engaging, inclusive, iterative, interactive and flexible mechanisms of

knowledge exchange among the key players, including climate scientists, resource users and practitioners. They further add that 'more research is needed to understand climate information user needs and decision-making processes in different contexts towards coming up with high quality, accessible and accurate climate information services which will adequately support the activities and targets of Agenda 2030.'

To measure the achievements in different SDGs, it is essential that various reporting and data gathering agencies have access to the relevant data that can be decoded and interpreted in the context of the specific Targets for each SDG. This calls for the creation of, and adherence to, standard metadata sets for each SDG and the associated Targets and Indicators which are discussed in Chapters 3 and 4.

Creation and management of data related to the SDGs

To understand the various Indicators associated with the Targets set for each SDG, it is essential to develop a basic understanding of the concept of the creation, management and use of data related to SDGs, and more specifically the concept of metadata. As shown in Figure 1.2 (Chapter 1), data and information is created as part of the everyday life and living of people – communications, health and wellbeing activities and so on; research and scholarly activities; daily business and operational activities of different agencies and institutions, such as government agencies, educational institutions, business and industries; and through natural phenomena like weather, flora and fauna and so on. Data related to the specific Indicators of SDGs are also created through the myriad activities of people, organisations and even nature. To facilitate the management as well as access to and use of such data need to be tagged by some data, which is called metadata, that characterises the data and it is used for indexing, searching and retrieval, including filtering and ranking, purposes. Metadata plays a key role in finding, retrieving and using data for specific Indicators of the SDGs.

Metadata

The term metadata has become a part of common vocabulary in different disciplines, and in fact it is widely used in various contexts. Research shows that the concept of metadata has been around since the first library catalogues were established over 2000 years ago in the Alexandrian Library in ancient Egypt. However, the term metadata was not used until a very long time afterwards. It became established in the field of database management in the 1970s and began to appear in the library and information science literature in

the mid-1990s (Lange and Winkler, 1997; Vellucci, 1998). However, within a very short period, metadata became an important area of research and gave rise to thousands of publications in different disciplines, including information and library science. Today the term 'metadata' transcends boundaries among various stakeholders in the internet arena and provides a common vocabulary to describe a variety of data and their different attributes (Chiarello et al., 2018; Chowdhury, 2010b; Dublin Core, 2022; Riel et al., 2017; Riley, 2017; Smit et al., 2016).

Simply speaking, metadata is data about data, but this definition does not say much about the diverse contexts in which it is created and used. In the context of information management, 'metadata' is normally understood to mean structured data about digital as well as non-digital resources that can be used to support a wide range of operations, such as resource description and discovery and management (including rights management) of information resources and their long-term preservation. Several definitions of metadata exist in the literature, that describe the role of metadata, but they vary depending upon one's objectives and perspectives, for example Dempsey and Heery, 1997; 1998; Gill, 1998; Gilliand-Swetland, 1998; 2004; Haynes, 2018):

- metadata describes various attributes of a resource
- metadata describes the content, format and/or attributes of an information resource
- metadata provides the users with some useful knowledge about the existence of records and their characteristics
- metadata describes a discrete data object.

From these definitions of metadata, it may be noted that metadata for specific data or an information object is created to add value to facilitate its management, discovery, use, sharing and reuse. The users of metadata are not only human beings; computer programs are increasingly becoming the main users of metadata. Metadata is important for the information systems and service providers as well as the users. Appropriate use of information modelling and metadata helps system designers or service providers develop more effective information systems, and thereby facilitates better access to, and use/reuse and sharing of, data and information in different contexts.

Libraries have long been used to create catalogue records of their collections as metadata, which have been used by library users as well as librarians for a variety of purposes, especially for searching and retrieval of records. Such metadata consists of some item-specific information, as well as headings and so on that have associated rules for further processing, such as the creation

of headings, rules for filing or relationship with other records. Metadata serves many functions: for example to facilitate the identification, location, retrieval, manipulation, and use of digital objects in a networked environment. In course of the Metadata Recordkeeping Project in Australia, Duff and McKemmish (2000) identified nine purposes of metadata:

1 identification of resources
2 authentication of resources
3 persistence of resources' content
4 structure and context of resources
5 administration of terms and conditions for access to, and disposal of, resources
6 tracking and documenting history of use of resources
7 discovery and retrieval
8 delivery of resources to the users
9 facilitating interoperability in a networked environment.

Metadata standards have been created by several communities dealing with information in some form or the other. The library world, for example, developed the MARC formats since the 1960s as a means of encoding metadata defined in cataloguing rules and has also defined descriptive standards in the International Standard Bibliographic Description (ISBD) series; the computing world and more recently the web have developed metadata standards based on implementations of the Standard Generalized Markup Language (SGML) or the Extensible Markup Language (XML), examples being the Encoded Archival Description (EAD) and the Document Type Definition (DTD).

Depending on its role or purpose, metadata can be classed as different types, e.g.

1 descriptive metadata that describes a data or an information resource
2 structural metadata that describes the structure of a data or an information resource
3 administrative metadata that describes how a data or an information resource can be managed – accessed, used, etc.
4 legal or provenance metadata that describes the ownership and terms of access to a data or an information resource
5 reference metadata that describes the quality and content of data
6 statistical or process metadata that describes how data is collected and/or processed or used in a specific context.

However, the boundaries of these metadata types are not always very strict, and they may have to be considered in the context of a specific application. Different types of metadata serve different purposes, and may be used in different contexts in an information management and retrieval system. For example (Haynes, 2018):

1 resource identification and description: metadata used to identify and describe a data element or an information object
2 retrieving data or information: metadata used to find specific data or information objects
3 managing information resources: metadata used to manage and share data or information objects
4 managing intellectual property rights: metadata used to describe/ascertain the provenance and ownership of data and information
5 supporting e-commerce and e-government: interoperable and actionable metadata used to perform different e-commerce or e-government activities
6 information governance: metadata used for governance of data and information, describing, for example, the terms of access and use/reuse of data and information.

Metadata and SDGs

SDGs require data to be collected and reported on a wide range of topics where, in most cases, data was not collected before. High-quality disaggregated data is required for accuracy of measuring progress in each SDG Target; such data is required from various sources, and sometimes new sources of data need to be explored. The *Global Indicator Framework* (UN Statistics Division, 2022a) was developed by the IAEG-SDGs (the Inter-agency and Expert Group on SDG Indicators) comprising 27 representatives of national statistical offices, representing various regions. The *Global Indicator Framework* was adopted by the UN General Assembly on 6 July 2017. The Indicators are reviewed annually; the last revision was reviewed by the UN Statistical Commission in 2020, and a comprehensive review will take place in 2025 (UN Statistics Division, 2021b). To collect, process, use and share data related to different SDG Indicators requires the use of prescribed standards for data labels, definitions, description of methodology, legends, source information and footnotes; these are all examples of metadata and together these metadata enable discovery, access, interoperability, measurement, monitoring, use/reuse and sharing of data and information related to SDGs (UN Statistics Division, 2021b).

Different types of metadata may be required for different SDGs, and Indicators. The following are some broad categories of metadata required for SDGs (UN Statistics Division, 2022b):

1 statistical metadata: data about statistical data
2 structural metadata that acts as identifiers and descriptors of the data
3 reference metadata that describes the contents and quality of the data:

 (a) conceptual metadata describes the concepts used and their practical implementation, allowing users to understand what the statistics are measuring, and thus, their fitness for use
 (b) methodological metadata describes methods used for the generation of the data (e.g. sampling, collection methods, editing processes)
 (c) quality metadata describes different quality dimensions of the resulting statistics (e.g. timeliness, accuracy).

Typically, metadata related to different SDG Indicators appears in different tiers in the form of a pyramid, and information describing the data is more detailed as one moves down from the top of a pyramid in the following order:

- **Top: Structural metadata**, which contains identifiers and descriptors of data; represents essential information for understanding the data; explains the basics of when, where, who and what. Thus, at a minimum, structural metadata includes information about:
 - the Indicator/data being displayed
 - the reference period
 - source of data
 - geographic scope
 - the unit of measurement.
- **Middle: Conceptual metadata**, which describes the key concepts used to compile the data and methodological elements of the data. Thus, conceptual metadata includes description and details about:
 - definition of the data or specific Target in question
 - key concepts
 - standards
 - classifications used.
- **Bottom: Reference metadata**, which is the source of the most detailed methodological information available. It provides descriptions about:
 - process of collecting data
 - calculations
 - quality aspects

- limitations of data
- other detailed information.

In addition to the *Global Indicator Framework* produced by the IAEG-SDGs, many other initiatives provide useful inputs when drafting metadata for the SDGs and other statistics:

- **SDMX (the Statistical Data and Metadata eXchange)** initiatives set technical standards and content-oriented guidelines to facilitate the exchange of statistical data and metadata. SDMX is maintained by a group of seven sponsors: the Bank of International Settlements (BIS), the European Central bank (ECB), Eurostat (Statistical Office of the European Union), the International Monetary Fund (IMF), the Organization for Economic Co-operation and Development (OECD), the United Nations Statistical Division (UNSD) and the World Bank (https://sdmx.org).
- **DDI (the Data Documentation Initiative)**: a standard for technical documentation describing social science data. The current version (3.1) supports description of the full life cycle of a dataset or data collection (www.ddialliance.org).

Examples of metadata for specific SDGs and Targets are discussed in Chapter 3. Description and examples of metadata related to various SDGs and the associated Targets are available online on the UN Statistics Division websites, as well as some national governments' SDG websites, for example:

- E-handbook on SDG Indicators (https://unstats.un.org/wiki/display/SDGeHandbook/Home)
- Metadata for global SDG data (https://unstats.un.org/sdgs/metadata)
- United States SDG metadata (https://sdg.data.gov)
- UK Sustainable Development Goals; use of non-official sources (www.ons.gov.uk/economy/environmentalaccounts/methodologies/uksu stainabledevelopmentgoalsuseofnonofficialsources)
- Philippines SDG Watch (https://psa.gov.ph/sdg).

Metadata terminology

Metadata for the SDGs recommends standard sets of terminology and prescribed guidelines for coding so that it can be used, and interpreted and shared by various agencies. There are several benefits of using standard metadata terminology, such as these:

- Common terminology helps in compiling metadata that is user-friendly and easier to understand.
- Inconsistent terminology complicates the development of reporting and presentation standards.
- Inconsistent labels for the same concept frequently lead to misunderstandings by users – computers and humans – and the risk of inappropriate use of statistics.

Hence, terminology management is an essential element of a metadata management system. It includes the following components:

- formulation of a common set of terminology, names and descriptions of standard metadata elements. It entails development of metadata terminology across all processes in the data lifecycle
- development of required tools such as thesaurus for the storage and retrieval of those terminologies
- formulation of processes and procedures for ongoing maintenance and updating rules.

Some examples of glossaries/tools for common terminology are:

- SDMX glossary (https://sdmx.org/wp-content/uploads/SDMX_Glossary_Version_2_0_October_2018.htm)
- UNData Glossary (http://data.un.org/Glossary.aspx)
- OECD Glossary of Statistical Terms (https://stats.oecd.org/glossary)
- WHO Indicator Measurement Registry (www.who.int/data/gho/indicator-metadata-registry)
- UNICEF briefing notes on SDG Indicators (https://elearning-cms.unstats.un.org/learn/lesson?trackingActivityId=8346&lessonId=95)
- FAO portal on SDG Indicators (www.fao.org/sustainable-development-goals/Indicators/en)
- IMF Dissemination Standards Bulletin Board (DSBB) (www.imf.org/en/About/Factsheets/Sheets/2016/07/27/15/45/Standards-for-Data-Dissemination).

Features of some of these prescribed terminologies are discussed later in Chapter 3.

Metadata template for the SDG Indicators

A standard template has been put together by the Statistics Division of the

UN (UNSD) for countries to report their national metadata for various SDG Indicators. The standard template uses 'the internationally agreed SDMX Metadata Concepts prepared by the SDMX SDGs Working Group of the IAEG-SDGs to provide a standard format for your SDG metadata' (UN Statistics Division, n.d.a). The same template can be used by both international agencies (global reporting) and countries (national reporting), making it easier to compare national metadata with the global ones. The template is available online at: https://github.com/SNStatComp/validatesdmx.

The main elements of the SDG metadata template include the following:

1 Indicator information: stores information about the specific Indicator in six subfields
2 Data reporter: stores information about the person and the organisation that provide the data in seven subfields
3 Definitions, concepts and classifications: stores the definition of the Indicator, units of measurement, etc., in three subfields
4 Data sources and collection methods: stores data related to the sources of data, collection methods, etc. in seven subfields
5 Method of computation and other methodological considerations: stores details of the method of computation of data, validation criteria, etc., in 11 subfields
6 Data availability and disaggregation: stores additional information about data disaggregation
7 Comparability with international standards: stores data related to international standards and compatibility
8 References and documentation: stores links to reference materials.

For each main data element, there is a separate template, with associated guidelines, for entering data on specific (sub-) elements. These are shown in Tables 2.1 to 2.6.

Table 2.1 *Template for entering SDG Indicator information*

0. Indicator Information
0.a. Goal: *Number and name of the relevant SDG*
0.b. Target: *Number and name of the relevant Target*
0.c. Indicator: *Number and name of the relevant Indicator*
0.d. Series: *Description of the SDG data series*
0.e. Metadata update: *Date when the metadata report was last updated*
0.f. Related Indicators: *Linkages to any other goals and Targets*

As shown in Table 2.1, the template, and the data elements, required for an Indicator include the specific Goal and details of the associated Target and Indicator for which data is collected. Similarly, the template for data reporter

is designed to record data related to the organisation and person(s) responsible for reporting the data for the relevant Indicator (Table 2.2). Thus, these two templates (Tables 2.1 and 2.2) provide some general information about an Indicator and the reporting agency and person.

Table 2.2 *Template for entering information on data reporter*

1.	Data reporter
1.a.	Organisation: *Name of the organisation that reports the data to the NSO/national data platform*
1.b.	Contact person(s): *Name of the focal point for this Indicator*
1.c.	Contact organisation unit: *Organisational unit for focal point*
1.d.	Contact person's function: *Role/job title for focal point*
1.e.	Contact phone: *Phone number of focal point*
1.f.	Contact mail: *Mailing address of focal point*
1.g.	Contact e-mail: *e-mail address of focal point*

Tables 2.3 to 2.5 provide actual information relating to the Indicator. For example, the template shown in Table 2.3 provides a concise definition of the Indicator along with the unit of measure and classification. Templates shown in Tables 2.4 and 2.5 provide details of the data source, data collection method and other details of the Indicator. Together these templates provide details of the source of the data, who creates or complies it, who provides it, and how that data related to the Indicator can be computed, and so on. However, all fields are not mandatory. For example, one may choose to fill out only the main concept in the template shown in Table 2.5 (i.e. 4), 'Other methodological considerations', or to fill out all or some of the detailed concepts (4.a – 4.d, 4.h – 4.k) separately (UN Statistics Division, n.d.a).

Table 2.3 *Template for entering definition, concepts and classification of the Indicator*

2	Definition, concepts, and classification
2.a.	Definition and concepts: *Precise definition of the Indicator, preferably relying on internationally agreed definitions*
2.b.	Unit of measure: *Description of the unit of measurement (proportion, dollars, number of people, etc.)*
2.c.	Classifications: *Describe references to both national and international standards and classification being used.* [Information to be provided where applicable.]

Table 2.4 *Template for entering information on data source and data collection method*

3	Data source type and data collection method
3.a.	Data sources: *Description of all actual and recommended sources of data. This description should include, when applicable, any changes of the data source over time, details of denominator (if from a different source) and any other relevant information related to the origin of the source or Indicator. Similar details should be given for administrative sources.*
3.b.	Data collection method: *Description of all methods used for data collection. This description should include, when applicable, the sample frame used, the questions used to collect the data, the type of interview, the dates/duration of fieldwork, the sample size and the response rate. Some additional information on questionnaire design and testing, interviewer training, methods used to monitor nonresponse etc. should be provided here. Questionnaires used should be annexed (if very long: via hyperlink).*
3.c.	Data collection calendar: *Dates when source collection is next planned.*

Table 2.4 *Continued*

3.d. Data release calendar: *Expected dates of release of new data for this Indicator, including the year (or, ideally, the quarter/month when the next data point associated with the Indicator will become available).*
3.e. Data providers: *Identification of national data provider(s), specifying the organisation(s) responsible for producing the data.*
3.f. Data compilers: *Organisation(s) responsible for compilation of this Indicator at the national level.*
3.g. Institutional mandate: *Description of the set of rules or other formal set of instructions assigning responsibility as well as the authority to an organisation for the collection, processing, and dissemination of statistics for this Indicator.*

Table 2.5 *Template for entering information on other methodological considerations*

4 Other methodological considerations
4.a. Rationale: *Description of the purpose and rationale behind the Indicator, as well as examples and guidance on its correct interpretation and meaning.*
4.b. Comment and limitations: *Comments on the feasibility, suitability, relevance and limitations of the Indicator. Also includes data comparability issues, presence of wide confidence intervals (such as for maternal mortality ratios); provides further details on additional non-official Indicators commonly used together with the Indicator.*
4.c. Method of computation: *Explanation of how the Indicator is calculated, including mathematical formulas and descriptive information of computations made on the source data to produce the Indicator (including adjustments and weighting). This explanation should also highlight cases in which mixed sources are used or where the calculation has changed over time (i.e. discontinuities in the series).*
4.d. Validation: *Description of process of monitoring the results of data compilation and ensuring the quality of the statistical results, including consultation process with countries on the national data submitted to the SDGs Indicators Database. Descriptions and links to all relevant reference materials should be provided.*
4.e. Adjustments: *This concept is typically not applicable for national reporting.*
4.f. Treatment of missing values (i) at country level and (ii) at regional level: *This concept is not applicable for national reporting.*
4.g. Regional aggregations: *This concept is not applicable for national reporting.*
4.h. Methods and guidance available to countries for the compilation of the data at the national level: *For national reporting a country may refer to the globally available metadata and explain how it is being used.*
4.i. Quality management: *Description of systems and frameworks in place within an organisation to manage the quality of statistical products and processes.*
4.j Quality assurance: *Description of practices and guidelines focusing on quality in general and dealing with quality of statistical programmes at your agency, including measures for ensuring the efficient use of resources.*
4.k Quality assessment: *Description of overall evaluation of fulfilling quality requirements, based on standard quality criteria.*

In addition to the templates in Tables 2.1–2.5, three other templates are also recommended for additional metadata, as shown in Table 2.6 on the next page.

Additional metadata guidelines

A number of additional guidelines are associated with metadata for the SDG Indicators, for example (UN Statistics Division, n.d.b):

Table 2.6 *Templates for additional metadata*

Template	Description
5. Data availability by sub-national breakdowns and time periods	Describe the specification of the dimensions and levels used for disaggregation of the Indicator (e.g. income, sex, age group, geographic location, disability status, etc.).
6. Comparability/deviation from international standards.	Provide explanation on the differences between country produced and internationally estimated data on this Indicator, highlighting and summarising the main sources of differences.
7. References and documentation.	Provide descriptions and links to all relevant reference materials related to this Indicator.

- ■ **Metadata access and content**
 - – Users: users of metadata are data producers as well as data users
 - – Sharing: one of the most cost-effective solutions is to disseminate metadata on the web
 - – Country-level differences: there are still significant differences between countries in the methodology used to compile statistics in the same domain. Publishing metadata helps users better understand such differences.
- ■ **Metadata structure**
 - – Publishing metadata: metadata should be organised and published in a way that allows users to go as deeply as necessary, without being buried in enormous amounts of text
 - – Associated documentation: metadata is not compilation guidance. It describes data, but it does not replace technical manuals and guidance materials
 - – Usability: tables, charts and maps should contain sufficient metadata so that they can 'stand alone'.

There are also some specific guidelines that emphasise the need for focusing on the users and simplicity of the metadata and the associated terminology, etc.; for example (UN Statistics Division, n.d.b):

- ■ be aware of the target audience
- ■ use clear and simple language
- ■ keep sentences and paragraphs short
- ■ avoid technical terms, jargon and acronyms
- ■ use a standard glossary of terms
- ■ develop style guide for how data/metadata are presented
- ■ ask colleagues to review the data and metadata for feedback.

Some additional recommendations for the SDG metadata include the following (UN Statistics Division, n.d.b):

- Ensure the metadata is disseminated openly via a range of different media, especially the web.
- Metadata should be structured so as to meet the needs of a range of users with different requirements and/or statistical expertise.
- A layered presentation of metadata is recommended, progressing from summary to more details, each layer with clear and precise text.
- Metadata should be linked to the statistical tables and graphs they describe and vice versa; it should be tailored to each statistical domain.
- Rigorous terminology as found in international and national glossaries should be used when drafting metadata.
- There is a need for the senior management to be engaged and supportive to ensure appropriate practices and principles are followed by those compiling metadata.
- Provide appropriate cross reference or links to glossaries and guidelines to make existing standard terms and definitions more readily available.
- Avoid ambiguity, such as using the same label or title for different definitions.
- Disseminate metadata free of charge on the internet, as a public good concept.
- Make metadata available in the national language(s), and in an international one, such as English.
- Provide contact details for further information on concepts, definitions and statistical methodologies.
- Reuse metadata where possible, for statistical integration as well as efficiency reasons.
- Preserve the history of the metadata.
- Ensure process (workflow) is well documented, so that there is clear identification of ownership, approval status, date of operation, etc.
- Ensure that variations from standards are tightly managed, approved, documented and visible.

Summary

As discussed in this chapter, creation of, and adherence to, the prescribed metadata standard and vocabulary is an essential requirement for assessing progress in each Indicator used to measure success in an SDG. Furthermore, accessibility and openness are strongly recommended, so that people can understand, use and interpret the metadata appropriately. However, there

are some challenges associated with capturing, recording and using metadata for monitoring progress in the SDGs, such as:

- large and quite varied number of Indicators for the SDGs, some of which require quantitative measures while others require qualitative
- the need for data disaggregation of all population groups that contribute to the Indicators
- the need to improve quality, timeliness, reliability and accessibility to a range of data held by multiple national and international agencies.

The use of the prescribed metadata for measuring the progress in the SDG Targets is discussed with specific examples later in the book, especially in Chapters 4 and 5. Countries around the world have often reported several challenges related to effective monitoring of progress in SDGs that relate to data and human elements associated with SDGs (some of these are discussed in Chapter 5):

- a lack of co-ordination among entities within the national statistical system/office
- inadequate funding to strengthen statistical capacity
- a lack of meaningful dialogue between policy makers and national statistical offices (calls for better communications)
- the statistical literacy of policy makers (calls for statistical literacy)
- a lack of human capital in some countries
- the lack of availability of high-quality disaggregated data
- technology: old systems hinder progress.

However, support is also available; for example, a free self-learning course on metadata related to SDGs, created by the UN SDG:Learn (n.d.a) provides training on metadata related to all the SDGs. Specific challenges associated with the collection and creation of metadata for some specific Indicators, and some ongoing efforts for data sharing and training, are discussed in Chapters 4 and 5.

Sustainable Development Goals: Targets and Indicators

Introduction

The 17 SDGs proposed by the United Nations and adopted as the UN Resolution A/RES/66/288 (UN General Assembly, 2015a) are:

Goal 1 End poverty in all its forms everywhere.

Goal 2 End hunger, achieve food security and improved nutrition and promote sustainable agriculture.

Goal 3 Ensure healthy lives and promote well-being for all at all ages.

Goal 4 Ensure inclusive and equitable quality education and promote lifelong learning opportunities for all.

Goal 5 Achieve gender equality and empower all women and girls.

Goal 6 Ensure availability and sustainable management of water and sanitation for all.

Goal 7 Ensure access to affordable, reliable, sustainable and modern energy for all.

Goal 8 Promote sustained, inclusive and sustainable economic growth, full and productive employment and decent work for all.

Goal 9 Build resilient infrastructure, promote inclusive and sustainable industrialisation and foster innovation.

Goal 10 Reduce inequality within and among countries.

Goal 11 Make cities and human settlements inclusive, safe, resilient and sustainable.

Goal 12 Ensure sustainable consumption and production patterns.

Goal 13 Take urgent action to combat climate change and its impacts.

Goal 14 Conserve and sustainably use the oceans, seas and marine resources for sustainable development.

Goal 15 Protect, restore and promote sustainable use of terrestrial eco-systems, sustainably manage forests, combat desertification, halt and reverse land degradation and halt biodiversity loss.

Goal 16 Promote peaceful and inclusive societies for sustainable development, provide access to justice for all and build effective, accountable and inclusive institutions at all levels.

Goal 17 Strengthen the means of implementation and revitalize the global partnership for sustainable development.

The SDGs are 'universal goals and targets which involve the entire world, developed and developing countries alike' (UN General Assembly, 2015a, 3). At the centre of the SDGs, there are the human rights, equality and sustainability issues; and together the SDGs are designed to achieve (United Nations, 2012):

- Inclusive economic development by:
 - eradicating income poverty and hunger
 - reducing inequalities
 - ensuring decent work
 - productive employment.
- Inclusive social development by enabling/ensuring:
 - adequate nutrition for all
 - quality education for all
 - reduced mortality and morbidity
 - gender equality
 - universal access to clean water and sanitation.
- Environmental sustainability by:
 - protecting biodiversity
 - stable climate
 - resilience to natural hazards.
- Peace and security by achieving:
 - freedom from violence, conflict and abuse
 - conflict-free access to natural resources.

Descriptions, logos and other details of the 17 Goals are available on the UN website (https://sdgs.un.org/goals) and widely discussed across a range of UN and other websites and research literature. See for example:

- Indicators – Sustainable development Indicators – Eurostat (europa.eu)
- research papers (e.g. Duane et al., 2022; Farisyi et al., 2022; Filho et al., 2021; Helfaya and Bui, 2022; Kuc-Czarnecka, Markowicz and Sompolska-Rzechuła, 2023; Le Sourd et al., 2021; Popescu, 2022; Sondermann and Ulbert, 2021; Stauropoulou et al., 2023; Xiao et al., 2023)
- reports (e.g. UN SDG Data Portal: https://unstats.un.org/sdgs/dataportal; Regional Forum on Sustainable Development to Define a Road Map for Operationalizing Africa's Decade of Action (UN Economic Commission for Africa, 2020).

The 17 SDGs can be categorised under several themes. For example, A/RES/70/1 *Transforming Our World: the 2030 Agenda for Sustainable Development* (un.org); (OECD, 2022) puts forward 5 Ps:

1 **People**, to end poverty and hunger, in all their forms and dimensions, and to ensure that all human beings can fulfil their potential in dignity and equality and in a healthy environment: SDG1, SDG2, SDG3, SDG4 and SDG5
2 **Planet**, to protect the planet from degradation, including through sustainable consumption and production, sustainably managing its natural resources and taking urgent action on climate change: SDG6, SDG12, SDG13, SDG14, SDG15
3 **Prosperity**, to ensure that all human beings can enjoy prosperous and fulfilling lives and that economic, social and technological progress occurs in harmony with nature: SDG7, SDG8, SDG9, SDG10, SDG11
4 **Peace**, to foster peaceful, just and inclusive societies which are free from fear and violence: SDG16
5 **Partnership**, to mobilise the means required to implement this Agenda through a revitalised Global Partnership for Sustainable Development: SDG17

Wu et al. (2018) categorised the SDGs into three dimensions of sustainability – economic, social and environmental, as follows:

1 **Economic SDGs**
 (a) Life: SDG1, SDG2 and SDG3
 (b) Economic and technological development: SDG8 and SDG9
2 **Social SDGs**
 (a) Equity: SDG4, SDG5 and SDG10
 (b) Social Development: SDG11, SDG16 and SDG17
3 **Environmental SDGs**
 (a) Resources: SDG6, SDG7, SDG12 and SDG14
 (b) Environment: SDG13 and SDG15.

Since the adoption of the SDGs in 2015, there have been many positive developments, but in the 2019 UN report on sustainable development, Brundtland points out that without reliable and robust measurements, it will be impossible to judge whether sufficient progress is being made across all the Targets of the 17 SDGs (Brundtland, in United Nations, 2019, xvi) . The report notes that:

despite the initial efforts, the world is not on track for achieving most of the 169 targets that comprise the Goals. The limited success in progress towards the Goals raises strong concerns and sounds the alarm for the international community. Much more needs to happen – and quickly – to bring about the transformative changes that are required: impeding policies should urgently be reversed or modified, and recent advances that holistically promote the Goals should be scaled up in an accelerated fashion.

(Gueterres in United Nations, 2019, xx)

Recent UN and other reports on the SDGs, discussed later in this book, show some progress in achieving the Targets in some SDGs, but the developments have also been affected, and in many cases stalled, due to the COVID-19 pandemic, which significantly affected data collection as well as the availability of resources required for various data-collection and data-sharing activities.

This chapter takes a closer look at the SDGs, various Targets and the associated Indicators, and more importantly the different kinds of metadata that need to be collected, processed and shared to measure the progress/success in the SDGs.

Links among the SDGs

SDGs are linked to one another, and measures taken to achieve progress on one goal may be mutually reinforcing or perhaps hindering the achievement of others. Hák, Janoušková and Moldan (2016) suggest that the SDGs can be seen as different stages of a policy cycle: policy formulation (identifying issues, setting goals and objectives reflecting ideas and visions and formulating issues to facilitate succeeding operationalisation); policy legitimisation; policy implementation; policy evaluation; and policy change. The SDGs are important to unite the global community, but as Kunčič (2019) stresses, the challenges of sustainable development described in the 17 SDGs, and the associated Targets and Indicators, are substantial and they differ depending on a country's context.

Hák, Janoušková and Moldan illustrate how the various SDG Targets and Indicators can be conceptualised. A recent evaluation that tracks some of the SDG Indicators also stresses that the interlinkages and integrated nature of the SDGs are critical to attaining sustainable development. Research also shows that:

■ Quantitative assessment of the 17 SDGs has largely focused on formulating appropriate Targets and Indicators for each goal, designing

new metrics for monitoring overall success, and collecting comprehensive and reliable data (Campagnolo et al., 2018; Colglazier, 2015; Costanza et al., 2016; Le Blanc, 2015; Lu et al., 2015; Reyers et al., 2017).

- The Indicator framework for SDGs needs more conceptual and methodological work (Hák, Janoušková and Moldan, 2016).
- The proliferation of Targets and Indicators does not undermine the aim of the SDGs to provide a coherent framework for co-ordinated action across environmental, economic and social policy domains (Dang and Serajuddin, 2020; Reyers et al., 2017).
- The net gains and losses for achieving one SDG can impact others (Barbier and Burgess, 2019).
- A more flexible approach is needed for managing the trade-offs and synergies between SDGs and Targets across the economic, social and environmental spheres of sustainable development (Biggeri et al., 2019).
- The SDGs need to be integrated, and cross-sectoral interactions can be useful (Liu, 2017; Timko et al., 2018).

Positive interlinkages among the SDGs are referred to as synergies when progress towards one Goal helps to achieve another Goal; and negative interlinkages are described as trade-offs when progress on one Goal hinders the achievement of another Goal (Kostetckaia and Hametner, 2022). Several studies have shown the interlinkages – synergies and trade-offs – between the SDGs and the corresponding Indicators. See for example Dalampira and Nastis, 2020; IAEG-SDGs, 2019; Kroll, Warchold and Pradhan, 2019; Kuc-Czarnecka, Markowicz, and Sompolska-Rzechuła, 2023; Linnerud, Holden and Simonsen, 2021; Miola et al., 2019; Moyer and Bohl, 2019; Tremblay et al., 2020; Zhao, et al., 2021. However, the interlinkages 'strongly depend on the method and data used and on the geographical scope of the report (meaning whether the interlinkages are analysed on a country, region or world level)' (Eurostat, 2022b).

Based on a review of 70 research papers, Bennich, Weitz and Carlsen show four themes in SDG interaction research: (1) policy challenges typically addressed; (2) ways in which SDG interactions have been conceptualised; (3) data sources used; and (4) methods of analysis frequently employed. They also identify some research gaps where perspectives are largely missing, which include: policy innovation and integrated monitoring and evaluation; and few studies consider actor interactions, account for geographic spillovers, analyse SDG Indicator interactions, employ participatory methods or take a whole-systems approach to the 2030 Agenda. They emphasise that 'failing to address these gaps could lead to inefficient SDG implementation and delay goal attainment' (Bennich, Weitz and Carlsen, 2020).

Tremblay et al. show how organisations classify the SDGs according to the five pillars (Table 3.1). The more similar the Targets are in terms of classification, the more positive the interactions would be. It has also been established that synergies are possible between the Targets of different classifications and the same logic applies to negative interactions (Tremblay et al., 2020). Smith (2019) argues that 'research plays an important role in ensuring the wide ranging goals of the SDGs are not forgotten by highlighting barriers to access for this less educated group and maintaining a focus on broader social and personal goals of education'. Research (Kostetckaia and Hametner, 2022) suggests that synergies manifest a slight advancement, while trade-offs among the Goals slow down countries' progress towards achieving the objectives of the 2030 Agenda.

Table 3.1 *How organisations classify the SDGs according to the five pillars (5Ps)* (Source: Tremblay et al., 2020)

SDG	People	Planet	Prosperity	Peace	Partnership
SDG1 – No poverty	90.5%		9.5%	4.8%	
SDG2 – Zero hunger	95.2%	9.5%	14.3%		
SDG3 – Good health and well-being	100%	4.8%			
SDG4 – Quality education	100%				
SDG5 – Gender equality	95.2%	4.8%			
SDG6 – Clean water and sanitation	38.1%	66.7%	4.8%		
SDG7 – Affordable and clean energy	9.5%	28.6%	66.7%		
SDG8 – Decent work and economic growth	4.8%		100%		
SDG9 – Industry, innovation and infrastructure		4.8%	100%		
SDG10 – Reduce inequalities	33.3%	4.8%	66.7%	9.5%	4.8%
SDG11 – Sustainable cities and communities	9.5%	23.8%	61.9%	9.5%	4.8%
SDG12 – Responsible consumption and production	4.8%	76.2%	23.8%		
SDG13 – Climate action	0%	100%			
SDG14 – Life below water		100%			
SDG15 – Life on land		100%			
SDG16 – Peace, justice and strong institutions	4.8%			90.5%	9.5%
SDG17 – Partnership for the goals			5%	5%	100%

The relations amongst the 17 SDGs are shown in the Eurostat (2022b) report:

- among the SDG1 and SDG2 Indicators, 22% of all the Indicator pairs with available data in all countries are positively correlated; 15% are

negatively correlated and 63% of pairs do not show a statistical correlation
- for 145 out of 153 SDG pairs the share of non-correlations among their Indicators is above 50%.

The Eurostat report further points out that there are more positive (24.1%) than negative (13.4%) interlinkages, and 62.4% are not significantly correlated with each other. It may also be noted that:

- SDG9 (Industry, innovation and infrastructure), SDG8 (Work and economic growth) and SDG12 (Consumption and production) show the highest share of synergies with other goals
- SDG5 (Gender equality), SDG2 (Zero hunger) and SDG17 (Partnerships) have the highest share of trade-offs
- the way people live, produce and consume is interconnected with many other areas: SDG12 (Consumption and production) has an impact on SDG7 (Clean energy), which in turn has an impact on SDG13 (Climate change) and SDG9 (Infrastructure)
- SDG13 (Climate change) has a synergetic relationship with SDG3 (Health)
- SDG11 (Cities and human settlements) affect SDG13 (Climate)
- SDG13 (Climate change) has impact on SDG14 and SDG15 (Biodiversity).

SDGs and Targets: measuring the success

Measuring success in SDGs requires a robust international framework of Indicators and mechanisms for collection and processing of statistical data to monitor progress, inform policy and ensure accountability of all the stakeholders. The *Global Indicator Framework* was 'adopted by the [United Nations] General Assembly on 6 July 2017 and is contained in the Resolution adopted by the General Assembly on Work of the Statistical Commission pertaining to the 2030 Agenda for Sustainable Development (A/RES/71/313)' (https://unstats.un.org/sdgs).

The number of Targets and the associated Indicators vary from one SDG to another. Table 3.2 on the next page provides a summary of the 17 SDGs and the number of associated Targets. The complete list of SDGs, Targets and Indicators is available at: https://unstats.un.org/sdgs/Indicators/Indicators-list. As is shown in Table 3.2, the number of Targets and the associated Indicators vary significantly among the various SDGs. Furthermore, as discussed below, the Indicators also vary quite significantly in terms of the nature of data; some Indicators need quantitative while others need

qualitative data. There are also differences in terms of how data related to some Indicators are to be collected and recorded.

Table 3.2 *SDGs, Targets and Indicators*

SDGs	Targets	Indicators
SDG1: End poverty in all its forms everywhere	7	13
SDG2: End hunger, achieve food security and improved nutrition and promote sustainable agriculture	8	14
SDG3: Ensure healthy lives and promote well-being for all at all ages	13	28
SDG4: Ensure inclusive and equitable quality education and promote lifelong learning opportunities for all	10	12
SDG5: Achieve gender equality and empower all women and girls	9	14
SDG6: Ensure availability and sustainable management of water and sanitation for all	8	11
SDG7: Ensure access to affordable, reliable, sustainable and modern energy for all	5	6
SDG8: Promote sustained, inclusive and sustainable economic growth, full and productive employment and decent work for all	12	16
SDG9: Build resilient infrastructure, promote inclusive and sustainable industrialisation and foster innovation	8	14
SDG10: Reduce inequality within and among countries	10	14
SDG11: Make cities and human settlements inclusive, safe, resilient and sustainable	10	14
SDG12: Ensure sustainable consumption and production patterns	11	13
SDG13: Take urgent action to combat climate change and its impacts	5	8
SDG14: Conserve and sustainably use the oceans, seas and marine resources for sustainable development	10	10
SDG15: Protect, restore and promote sustainable use of terrestrial ecosystems, sustainably manage forests, combat desertification and halt and reverse land degradation and halt biodiversity loss	12	14
SDG16: Promote peaceful and inclusive societies for sustainable development, provide access to justice for all and build effective, accountable and inclusive institutions at all levels	12	24
SDG17: Strengthen the means of implementation and revitalise the global partnership for sustainable development	19	24

Table 3.3 opposite provides a summary of the Targets and associated Indicators for SDG1. It may be noted that there are 7 Targets and 12 Indicators for SDG1; and each Target has between 1 and 3 Indicators that can be used to measure the achievement of the Targets. As shown in Table 3.3, while most of the SDGs and Targets have some form of quantitative Indicators, some have

Indicators that require qualitative data. A closer look at Table 3.3 indicates that for some Indicators – for example Indicators 1.3.1 and 1.4.2 – the data collection systems need to be robust to collect disaggregated data on different parameters. However, as discussed in Chapter 5, even for very robust national data collection and reporting services, like the ONS in the UK, getting timely and disaggregated data on some Targets remains a challenge.

Table 3.3 *SDG1: End poverty in all its forms everywhere – Targets and Indicators* (Goal 1, Department of Economic and Social Affairs, un.org)

Targets	Indicators
1.1: By 2030, eradicate extreme poverty for all people everywhere, currently measured as people living on less than $1.25 a day (this has now been changed to $1.90 a day)	**1.1.1:** Proportion of population below the international poverty line, by sex, age, employment status and geographical location (urban/rural)
1.2: By 2030, reduce at least by half the proportion of men, women and children of all ages living in poverty in all its dimensions according to national definitions	**1.2.1:** Proportion of population living below the national poverty line, by sex and age **1.2.2:** Proportion of men, women and children of all ages living in poverty in all its dimensions according to national definitions
1.3: Implement nationally appropriate social protection systems and measures for all, including floors, and by 2030 achieve substantial coverage of the poor and the vulnerable	**1.3.1:** Proportion of population covered by social protection floors/systems, by sex, distinguishing children, unemployed persons, older persons, persons with disabilities, pregnant women, newborns, work-injury victims and the poor and the vulnerable Note that the solution should focus on how people in these categories are supported through the appropriate digital/information skills and thus reduce digital divide
1.4: By 2030, ensure that all men and women, in particular the poor and the vulnerable, have equal rights to economic resources, as well as access to basic services, ownership and control over land and other forms of property, inheritance, natural resources, appropriate new technology and financial services, including microfinance	**1.4.1:** Proportion of population living in households with access to basic services **1.4.2:** Proportion of total adult population with secure tenure rights to land, with legally recognised documentation and who perceive their rights to land as secure, by sex and by type of tenure Note that this calls for up-to-date and disaggregated data, and people's awareness of rights and policies
1.5: By 2030, build the resilience of the poor and those in vulnerable situations and reduce their exposure and vulnerability to climate-related extreme events and other economic, social and environmental shocks and disasters	**1.5.1:** Number of deaths, missing persons and persons affected by disaster per 100,000 people **1.5.2:** Direct disaster economic loss in relation to global gross domestic product (GDP) **1.5.3:** Number of countries with national and local disaster risk reduction strategies Note that this calls for information/data on how to prevent, and deal with, disasters

Continued

Table 3.3 *Continued*

Targets	Indicators
1.a: Ensure significant mobilisation of resources from a variety of sources, including through enhanced development co-operation, in order to provide adequate and predictable means for developing countries, in particular least developed countries, to implement programmes and policies to end poverty in all its dimensions 1.a.1 Proportion of resources allocated by the government directly to poverty reduction programmes	**1.a.2:** Proportion of total government spending on essential services (education, health and social protection)
1.b: Create sound policy frameworks at the national, regional and international levels, based on pro-poor and gender-sensitive development strategies, to support accelerated investment in poverty eradication actions	**1.b.1:** Proportion of government recurrent and capital spending to sectors that disproportionately benefit women, the poor and vulnerable groups Note that this requires up-to-date and disaggregated data

Similarly, some Targets and Indicators depend on how robust the system is at the time of crisis, for example, for the Indicators 1.5.1, 1.5.2 and 1.5.3, significant amounts of data need to be collected during disasters. However, as discussed later in this chapter, and elsewhere in the book, many countries do not have the infrastructure or capacity to properly gather, record and use data related to major disasters.

Qualitative data Indicators

Some Targets and Indicators require qualitative data gathering. Table 3.4 lists examples of some such Targets and the associated Indicators. Some qualitative SDG Indicators, e.g. 3.d.1 (shown in Table 3.4) call for the capacity and infrastructure for preparedness for health emergencies. However, the recent

Table 3.4 *Targets with qualitative Indicators/data* (https://sdgs.un.org/goals)

Targets	Indicators requiring qualitative data
3.d: Strengthen the capacity of all countries, in particular developing countries, for early warning, risk reduction and management of national and global health risks	**3.d.1:** International Health Regulations (IHR) capacity and health emergency preparedness Note that this calls for proper data collection, management and sharing amongst various agencies and stakeholders and the general public

Continued

Table 3.4 *Continued*

Targets	Indicators requiring qualitative data
4.7: By 2030, ensure that all learners acquire the knowledge and skills needed to promote sustainable development, including, among others, through education for sustainable development and sustainable lifestyles, human rights, gender equality, promotion of a culture of peace and non-violence, global citizenship and appreciation of cultural diversity and of culture's contribution to sustainable development	**4.7.1**: Extent to which (i) global citizenship education and (ii) education for sustainable development, including gender equality and human rights, are mainstreamed at all levels in: (a) national education policies, (b) curricula, (c) teacher education and (d) student assessment Note that this is the same as 12.8.1 below, and that this point is discussed more in Chapter 9
6.6: By 2020, protect and restore water-related ecosystems, including mountains, forests, wetlands, rivers, aquifers and lakes	**6.6.1**: Change in the extent of water-related ecosystems over time Note that this calls for people-centred information systems to improve awareness and preparedness
12.8: By 2030, ensure that people everywhere have the relevant information and awareness for sustainable development and lifestyles in harmony with nature	**12.8.1**: Extent to which (i) global citizenship education and (ii) education for sustainable development (including climate change education) are mainstreamed in (a) national education policies; (b) curricula; (c) teacher education; and (d) student assessment Note that as 4.7 above, this will have an impact on almost all the SDGs
13.3: Improve education, awareness-raising and human and institutional capacity on climate change mitigation, adaptation, impact reduction and early warning	**13.3.2**: Number of countries that have communicated the strengthening of institutional, systemic and individual capacity-building to implement adaptation, mitigation and technology transfer, and development actions Note that this calls for people-centred information and education/training systems
15.2: By 2020, promote the implementation of sustainable management of all types of forests, halt deforestation, restore degraded forests and substantially increase afforestation and reforestation globally	**15.2.1**: Progress towards sustainable forest management
15.9: By 2020, integrate ecosystem and biodiversity values into national and local planning, development processes, poverty reduction strategies and accounts	**15.9.1**: Progress towards national Targets established in accordance with Aichi Biodiversity Target 2 of the Strategic Plan for Biodiversity 2011–2020
16.7: Ensure responsive, inclusive, participatory and representative decision making at all levels	**16.7.2**: Proportion of population who believe decision making is inclusive and responsive, by sex, age, disability and population group Note that this calls for people's awareness of rights and privileges; and also development of appropriate information systems at government/institutional level

COVID-19 pandemic has clearly demonstrated that most countries, including the most resourceful ones like the G-7 countries, did not have adequate preparations for dealing a pandemic.

Some other Indicators shown in Table 3.4 – for example, Indicators 4.7.1., 12.8.1 – call for education for sustainable development (ESD) at all levels. This clearly is a long-term goal, and the success or achievements cannot be measured in the short term. Furthermore, use of terms like 'extent to which' (see Table 3.4) make it rather vague and difficult to measure success accurately. The same applies to some other Indicators that require capacity building at national level that takes time. For example, for Indicators 13.3.2 and 16.7.2, the success or achievements cannot be measured in the short term. Also, very generic and descriptive data is required for some Indicators; see for example, the use of terms like 'strengthening of institutional, systematic and individual capacity building' (for Indicator 13.3.2) that are to be used for the purpose of reporting.

Other Indicators, for example, 15.2.1 and 15.2.9, are also described in very general terms such as 'Progress towards . . .' some action. Other Indicators are also somewhat vague and difficult to measure, e,g. Indicator 16.7.2: 'Proportion of population who believe decision making is inclusive and responsive by sex, age, disability and population group.' This Indicator depends on people's awareness of, and access to, the relevant data in order to be able to come up with an accurate answer.

Indicators with indirect measures and assumed outcomes

Some Targets have Indicators that have an indirect measure of success. Examples of such Targets and Indicators are provided in Table 3.5 on the next page. A closer look at Table 3.5 reveals that some Indicators are the measures of:

- existence of, and utilisation, of legal frameworks and/or policies and process in place (e.g. Indicators 5.1.1, 5.6.2, 5.a.2, 5.c.1, 6.b.1, 8.8.2, 10.7.2, 16.10.2)
- people and behavioural issues (e.g. Indicators 12.1.1 and 17.1.1)
- co-operation and support amongst countries (e.g. Indicators 7.a.1 and 17.6.1).

Of particular importance, especially in the context of access to ICT and information, are the Indicators 16.10.12, 17.6.2 and 17.8.1. According to the Indicator 16.10.12, progress in access to information is measured by the number of countries that adopt and implement constitutional, statutory and/or policy guarantees for public access to information.

Table 3.5 *Targets with indirect measures and assumed outcomes* (https://sdgs.un.org/goals)

Targets	Indicators
5.1: End all forms of discrimination against all women and girls everywhere	**5.1.1:** Whether or not legal frameworks are in place to promote, enforce and monitor equality and non-discrimination on the basis of sex Note that this calls for information for, and awareness of, people about their rights and privileges
5.6: Ensure universal access to sexual and reproductive health and reproductive rights as agreed in accordance with the Programme of Action of the International Conference on Population and Development and the Beijing Platform for Action and the outcome documents of their review conferences	**5.6.2:** Number of countries with laws and regulations that guarantee women aged 15–49 years access to sexual and reproductive health care, information and education Note that this as a direct reference to information and education points towards accessible information systems and health information and data literacy – for schoolchildren/adolescents/ young adults and older women
5.a: Undertake reforms to give women equal rights to economic resources, as well as access to ownership and control over land and other forms of property, financial services, inheritance and natural resources, in accordance with national laws	**5.a.2:** Proportion of countries where the legal framework (including customary law) guarantees women's equal rights to land ownership and/or control Note the complementary requirements: information and training in and awareness of rights and privileges
5.c: Adopt and strengthen sound policies and enforceable legislation for the promotion of gender equality and the empowerment of all women and girls at all levels	**5.c.1:** Proportion of countries with systems to track and make public allocations for gender equality and women's empowerment Note the complementary requirements: information and training in and awareness of rights and privileges
6.b Support and strengthen the participation of local communities in improving water and sanitation management	**6.b.1:** Proportion of local administrative units with established and operational policies and procedures for participation of local communities in water and sanitation management Note that this calls for information for and education of communities for participatory management
7.a: By 2030, enhance international co-operation to facilitate access to clean energy research and technology, including renewable energy, energy efficiency and advanced and cleaner fossil-fuel technology, and promote investment in energy infrastructure and clean energy technology	**7.a.1:** International financial flows to developing countries in support of clean energy research and development and renewable energy production, including in hybrid systems

Continued

Table 3.5 *Continued*

Targets	Indicators
8.8: Protect labour rights and promote safe and secure working environments for all workers, including migrant workers, in particular women migrants, and those in precarious employment	**8.8.2:** Increase in national compliance of labour rights (freedom of association and collective bargaining) based on International Labour Organization (ILO) textual sources and national legislation, by sex and migrant status
9.c: Significantly increase access to information and communications technology and strive to provide universal and affordable access to the internet in least developed countries by 2020	**9.c.1:** Proportion of population covered by a mobile network, by technology Note that this also calls for actions for improving digital and information skills (see Chapters 6 and 7)
10.7: Facilitate orderly, safe, regular and responsible migration and mobility of people, including through the implementation of planned and well-managed migration policies	**10.7.2:** Number of countries that have implemented well-managed migration policies
12.1: Implement the 10-year framework of programmes on sustainable consumption and production, all countries taking action, with developed countries taking the lead, taking into account the development and capabilities of developing countries	**12.1.1:** Number of countries with sustainable consumption and production (SCP) national action plans or SCP mainstreamed as a priority or a Target into national policies Note that the success here depends on how people's behaviour is influenced with regard to the SCP, and this calls for supporting information and education and awareness
14.b: Provide access for small-scale artisanal fishers to marine resources and markets	**14.b.1:** Progress by countries in the degree of application of a legal/regulatory/policy/institutional framework which recognises and protects access rights for small-scale fisheries
14.c: Enhance the conservation and sustainable use of oceans and their resources by implementing international law as reflected in UNCLOS, which provides the legal framework for the conservation and sustainable use of oceans and their resources, as recalled in paragraph 158 of The Future We Want	**14.c.1:** Number of countries making progress in ratifying, accepting and implementing through legal, policy and institutional frameworks, ocean-related instruments that implement international law, as reflected in the United Nation Convention on the Law of the Sea, for the conservation and sustainable use of the oceans and their resources
15.6: Promote fair and equitable sharing of the benefits arising from the utilisation of genetic resources and promote appropriate access to such resources, as internationally agreed	**15.6.1:** Number of countries that have adopted legislative, administrative and policy frameworks to ensure fair and equitable sharing of benefits

Continued

Table 3.5 *Continued*

Targets	Indicators
15.8: By 2020, introduce measures to prevent the introduction and significantly reduce the impact of invasive alien species on land and water ecosystems and control or eradicate the priority species	**15.8.1:** Proportion of countries adopting relevant national legislation and adequately resourcing the prevention or control of invasive alien species
16.10: Ensure public access to information and protect fundamental freedoms, in accordance with national legislation and international agreements	**16.10.2:** Number of countries that adopt and implement constitutional, statutory and/or policy guarantees for public access to information Note that the success depends on people's awareness, digital and information skills; and also training of people at workplace for proper managing and making information openly accessible (vis-à-vis information governance)
17.6: Enhance North–South, South–South and triangular regional and international co-operation on and access to science, technology and innovation and enhance knowledge sharing on mutually agreed terms, including through improved co-ordination among existing mechanisms, in particular at the United Nations level, and through a global technology facilitation mechanism	**17.6.1:** Number of science and/or technology co-operation agreements and programmes between countries, by type of co-operation **17.6.2:** Fixed internet broadband subscriptions per 100 inhabitants, by speed Note that the key to success is improving digital and information skills at all levels (see the discussions on digital divide and digital skills in Chapters 6 and 7)
17.8: Fully operationalise the technology bank and science, technology and innovation capacity-building mechanism for least developed countries by 2017 and enhance the use of enabling technology, in particular information and communications technology	**17.8.1:** Proportion of individuals using the internet Note that the complementary requirements are: information and training/awareness of rights and privileges; for further discussions see Chapters 6 and 7

However, having legislation on access to information is just one aspect of guaranteeing access to information. The benefits of the law cannot be utilised if people who hold information, such as employees in different organisations, and people who want to access information do not have the necessary digital and information skills (Chowdhury et al., 2021). These issues are discussed in detail in Chapter 8.

Indicators 17.6.2 and 17.8.1 are designed to measure improvements in people's access to the internet and digital technologies. However, research shows that there are a number of barriers to access to ICT and the internet, that exist in most countries in the world, including the G-7 countries. Barriers to access to the internet and digital technologies, and digital skills are discussed in detail in Chapters 6 and 7.

Some Indicators that require data creation to be initiated by the general public

Table 3.6 shows examples of some Indicators where the measure of achieving the Target depends on how members of the public report on acts of bribery and how these are recorded by government officials.

Table 3.6 *Examples of Targets and Indicators for SDG16* (Goal 16, Department of Economic and Social Affairs, un.org)

Targets	Indicators
16.5: Substantially reduce corruption and bribery in all their forms	**16.5.1:** Proportion of persons who had at least one contact with a public official and who paid a bribe to a public official, or were asked for a bribe by a public official, during the previous 12 months **16.5.2:** Proportion of businesses that had at least one contact with a public official and that paid a bribe to a public official, or were asked for a bribe by a public official during the previous 12 months
16.b: Promote and enforce non-discriminatory laws and policies for sustainable development	**16.b.1:** Proportion of population reporting having personally felt discriminated against or harassed in the previous 12 months on the basis of a ground of discrimination prohibited under international human rights law

Some Indicators that are the measures of success of the data agencies

Table 3.7 shows examples of how some Indicators are measured by the capacity of the data agencies.

Table 3.7 *Examples showing how some Indicators are measured by the capacity of the national statistical agencies* (Goal 17, Department of Economic and Social Affairs, un.org)

Targets	Indicators
17.18: By 2020, enhance capacity-building support to developing countries, including for least developed countries and small island developing states, to increase significantly the availability of high-quality, timely and reliable data disaggregated by income, gender, age, race, ethnicity, migratory status, disability, geographic location and other characteristics relevant in national contexts	**17.18.1:** Statistical capacity indicator for Sustainable Development Goal monitoring **17.18.2:** Number of countries that have national statistical legislation that complies with the *Fundamental Principles of Official Statistics* **17.18.3:** Number of countries with a national statistical plan that is fully funded and under implementation, by source of funding

Metadata and vocabulary for SDGs

The SDGs, their Targets and Indicators are diverse and involve a diverse community of stakeholders for the collection, use and sharing of a variety of

data. Hence, it is important that appropriate terminology is used to represent the concepts related to the various Targets and Indicators. The UN Data Glossary is an example of such a tool that is used. Figure 3.1 shows a definition of the term 'access' in the UN Data Glossary (http://data.un.org/glossary.aspx).

Access 1 definition
UNdata source: SDMX Metadata Common Vocabulary | Statistical Data and Metadata eXchange

The means and conditions under which data can be viewed or used.

Context: Access also refers to terms, copyright issues and confidentiality constraints related to how the data can be used. A particular case is access to microdata, which can be defined as the process of providing users which are external to the data provider with access to unit level data, usually under strictly controlled conditions.

Source: SDMX (2009)

Figure 3.1 *An example of the term 'Access' as it appears in the UN Data Glossary* (http://data.un.org/glossary.aspx)

It may be noted from Figure 3.1 that the term has been taken from the *SDMX Metadata Common Vocabulary*. Since a significant number of Indicators for SDG Targets require the collection, reporting and sharing of statistical data, it is important that standard metadata and vocabulary are used so that data can be accurately accessed, shared and reused across different national and international agencies. For example, SDMX, which stands for Statistical Data and Metadata eXchange, is an international initiative that aims at 'standardising and modernising ('industrialising') the mechanisms and processes for the exchange of statistical data and metadata among international organisations and their member countries' (https://sdmx.org/?page_id=3425).

The SDMX Glossary provides 'definition of terms found in the SDMX Information Model, Data Structure Definitions (DSDs), and Metadata Structure Definitions (MSDs) at the time of the present release' (SDMX Guidelines). The SDMX Glossary uses a prescribed metadata for describing terms. Figure 3.2 on the next page shows the details of the attributes that are required for describing a term in the Glossary, and Figure 3.3 which follows on page 59 shows how a term (e.g. 'Data Provider') appears in the SDMX Glossary.

Certain terms are used frequently across a range of SDGs, Targets and Indicators in different contexts. However, these terminologies can be interpreted by different people in different countries and stakeholder organisations. For example, the term 'access' occurs 31 times in the SDG Global Indicator Framework, e.g. in: SDG1, Target 1.4; SDG2, Targets 2.5 and 2.c; SDG3, Targets 3.7, 3.8 and 3b (for details, see: World Environment

ATTRIBUTES USED FOR DESCRIBING CONCEPTS LISTED IN THE GLOSSARY
*** Denotes mandatory fields**

Term* Name of the Concept. The term should preferably be entered in the singular form and upper cases should be avoided to the largest extent possible (except for Concepts which are part of the SDMX Information Model).

Definition* Short statement explaining the meaning of the Concept. This textual description of the Concept should answer the question 'What is it?' rather than 'How is it done?' or 'Why do we have it?' etc. It is recommended to keep definitions short and add any explanatory text under field 'Context'.

Context Complementary information on the background, history, use, status, etc. of the Concept. This field is used to add information on how and where the term may be used. It describes SDMX use cases for the term and may contain examples of its use. This field is optional, though strongly recommended.

Type Used to explicitly denote Concepts which are cross-domain.

Concept ID* Unique identifier for the Concept that allows it to be unambiguously used for machine-to-machine exchange.

Recommended representation Recommended type of value for the Concept term. Examples are 'primitive' types such as string (i.e. free text), AlphaNumeric or complex types such as Codelist, that is used for those terms that have an associated Codelist in **Codelist ID**. There may be more than one recommended type; in this case, the first type is recommended over the others. For time types, it is possible to use a more precise representation of time than the recommended type (e.g. Reporting Time Period instead of Observational Time Period).

Codelist ID Unique identifier for the Codelist associated with the Concept. Most often it is the term's Concept ID prefixed by 'CL_'. For example, the 'Observation Status' term has the Concept ID of OBS_STATUS, and the Codelist ID of CL_OBS_STATUS. This attribute is used only if the Concept's 'Recommended representation' includes 'Codelist'.

Related terms Entries in the SDMX Glossary that are closely associated with the Concept term. It is possible here to create relationships between Concepts, e.g. between 'Reference metadata' and 'Structural metadata'. No hierarchy is created between the concepts linked, i.e. if a link is established between 'Reference metadata' and 'Metadata', a similar link will be established between 'Metadata' and 'Reference metadata'.

Source Source information from which the definition was extracted. The reference must be as complete as possible. When available, the source is followed by a hyperlink, i.e. a link to the source material for the term.

Other link(s) Link(s) to material that is related, closely or loosely, to, but not directly associated with the Concept source of the term, e.g. link to a general methodological document.

Figure 3.2 *Metadata for the SDMX Glossary* (SDMX Guidelines)

Situation Room, unep.org). However, the context in which the term 'access' is used in different SDGs and Targets are often quite different. For example, the term 'access' appears in different contexts in the following three Targets; the highlighted text below shows the context in which the term has been used, showing how the term 'access' carries different meaning in different contexts:

- Target 1.4: By 2030, ensure that all men and women, in particular the poor and the vulnerable, have equal rights to economic resources, **as well as access to basic services, ownership and control over land and other forms of property, inheritance, natural resources, appropriate new technology and financial services, including microfinance**

> **Data Provider**
> **Definition** Organisation or individual that reports or disseminates data or reference metadata.
> **Context** Data Providers are maintained in a Data Provider Scheme.
> The Data Provider can be linked to the type of data (Dataflow) or reference metadata (Metadataflow) that it reports or disseminates. This link provides the data collection system or data dissemination system.
> **Concept ID** DATA_PROVIDER
> **Type** Cross-domain concept
> **Recommended representation** String; Codelist
> **Codelist ID** CL_ORGANISATION (used in order to use an agency-based Codelist that is also shared by other concepts; however, a different ID and separate Codelist may be suitable if the use-case of this concept is different to that of an agency-based Codelist).
> **Related terms** Data Provider Scheme
> Item Scheme
> **Source** SDMX, 'SDMX Glossary Version 1.0', February 2016 (https://sdmx.org/wp-content/uploads/SDMX_Glossary_Version_1_0_February_2016.docx)

Figure 3.3 *An entry in the SDMX Glossary for the term 'Data Provider'* (SDMX Guidelines)

- Target 2.5: By 2020, maintain the genetic diversity of seeds, cultivated plants and farmed and domesticated animals and their related wild species, including through soundly managed and diversified seed and plant banks at the national, regional and international levels, and **promote access to and fair and equitable sharing of benefits arising from the utilisation of genetic resources and associated traditional knowledge, as internationally agreed**
- Target: 2.c Adopt measures to ensure the proper functioning of food commodity markets and their derivatives and facilitate **timely access to market information, including on food reserves, in order to help limit extreme food price volatility**.

Hence it is important that the various shades of meaning are represented in a coherent way to prevent confusion when handling data and developing policy actions. This will also ensure the discoverability and management of SDG information and data across all the domains of knowledge. With this in mind, IAEG-SDG in its second meeting, held in Bangkok in October 2015, requested UNEP (the United Nations Environment Programme) to develop the Sustainable Development Goals Interface Ontology (SDGIO) (UNEP, n.d.b). The SDGIO is designed to ensure that 'entities relevant to the SDGs can be logically represented, defined, interrelated, and linked to the corresponding terminology in glossaries and resources such as the UN System Data Catalogue and SDG Innovation platform' (UNEP, n.d.a). SDGIO focuses on specifications of terms and their interrelations in the domain of the sustainable development goals, Targets, and Indicators; and it includes

more than 100 terms with draft definitions and relations, as well as links to various external ontologies (UNEP, n.d.b).

As stated earlier, certain terms occur in multiple Targets and Indicators. The interactive visual interface of the UNEP SDG Portal (https://wesr.unep.org) allows people to find out where a particular term occurs in the context of one or more SDGs and Targets. Figure 3.4 shows where a term, e.g. the term 'internet', occurs in SDG9. By clicking on the specific SDG (in this case SDG9), one can see the specific Target where the term 'internet' occurs.

Figure 3.4 *An example of a visual display of Targets on the UNEP SDG Portal* (https://wesr.unep.org, showing where a chosen term 'internet' occurs in SDG9)

Summary

As shown in the tables in this chapter, a variety of data and information – some quantitative and some qualitative – must be collected, processed and shared amongst various organisations/agencies at national, regional and international levels in order to measure the achievements in various SDGs as per the set Targets and Indicators. Given the fact that some terms are used across a number of SDGs, Targets and Indicators, a standard set of metadata and terminologies were developed and used by all stakeholders. In addition, the SDGIO has been developed to show the specifications of various terms and their interrelations across various SDGs and their associated Targets and Indicators. SDGIO aims to represent the various meanings and usages of these terms, either by creating new content or co-ordinating content from other existing and widely used ontologies.

Although none of the 17 SDGs particularly refers to information and communications technologies (ICTs) as such, and only some Targets mention

ICTs, it is widely recognised that the ICTs can substantially accelerate the development progress of human beings, and may greatly bridge the digital gaps, so as to construct knowledge communities (Wu et al., 2018; Chowdhury and Koya, 2017). Examples of some interactive visual portals for getting details of the SDGs, Targets and Indicators, and progress and achievements, demonstrate the role ICTs can play in promoting the 2030 agenda on SDGs. More on the achievements in different SDGs so far, as well as the levels of collaboration and co-operation at international level, are discussed in Chapter 4 onwards.

Data, Information and Progress in SDGs

Introduction

As discussed in Chapter 3, several Indicators have been proposed for the 169 Targets for the 17 SDGs, and consequently different types of metadata, terminologies and guidelines have been developed for gathering and sharing of the relevant data. However, it is evident that given the diversity of the SDGs and their associated Targets, the Indicators are also quite diverse. Given the fact that every country in the world is required to gather data for measuring success in the diverse set of SDG Targets, it is quite evident that the Indicators are based on the established measurement methods and data availability – in particular, time series – and data consistency (Spangenberg, 2019).

This chapter discusses different SDG Indicators, with some examples to demonstrate the diverse sets of data required for measuring success. Achievements of success in different SDGs are also discussed and appropriate sources for full reports on achievements in the SDGs are also provided for the further understanding of the reader. Specific challenges associated with data quality, data completion, data aggregation and so on are also discussed, to demonstrate how data and information form the foundation of the SDGs and their Targets. This chapter also discusses various challenges associated with data collection, data sharing and use for some Indicators. The differences amongst countries and regions in terms of data availability vis-à-vis achievements in specific SDG Targets are also discussed. The discussions in this chapter demonstrate the needs for co-operation and collaboration at international level, and also the need for understanding of various social and human issues that are associated with data collection, data sharing and data use.

Metadata and the FAIR principles

The FAIR (Findable, Accessible, Interoperable, and Reusable) data principles were proposed in 2016 to promote data sharing (Wilkinson et al., 2016). These principles have since been adopted by research institutions worldwide in

order to support knowledge discovery and innovation, as well as data and knowledge integration, and to promote sharing and reuse of data. The FAIR principles help data and metadata to be machine-readable, supporting new discoveries through the harvesting and analysis of multiple datasets (CGIAR, n.d.). A variety of guidelines have been proposed by researchers and institutions on how to make data compliant with the FAIR data principles; and overall, all of those emphasise the use of standard identifiers, metadata and vocabulary (Bagov, Greiner and Garabedian, 2022; Bonino da Silva Santos, 2021; EC, 2018; Kunis et al., 2021; Soiland-Reyes et al., 2022; Van Antwerp and Heun, 2022; Wilkinson et al., 2016).

The FAIR principles and their purpose can be summarised as follows:

- **How to make data Findable**
 - F1: Data and metadata are assigned a globally unique and persistent identifier.
 - F2: Data is described with rich metadata (identified by R1 below).
 - F3: metadata clearly and explicitly includes the identifier of the data it describes.
 - F4: Data and metadata are registered or indexed in a searchable resource.

 These findability requirements call for the creation and use of a globally unique and eternally persistent identifier (like a DOI or Handle that is a unique identifier of a document), describing the data with rich metadata, and making sure that both data and metadata are findable through standard search and retrieval platforms.
- **How to make data Accessible**
 - A1: Data and metadata are retrievable using a standard communication protocol.
 - A1.1: The protocol is open, free, and universally implementable.
 - A1.2: The protocol allows for an authentication and authorisation procedure, where necessary.
 - A2: Metadata is accessible, even when data is no longer available.

 These accessibility requirements call for the development and use of protocols for access to data and metadata by humans and machines.
- **How to make data Interoperable**
 - I1: Data and metadata use a formal, accessible, shared, and broadly applicable language for knowledge representation.
 - I2: Data and metadata use vocabularies that follow the FAIR principles.
 - I3: Data and metadata include qualified references to other data or metadata – the description of metadata elements should follow community guidelines that use an open, and well-defined vocabulary.

These requirements for interoperability of data call for development and use of domain- and community-specific metadata and guidelines, and well-defined vocabulary.

- ■ **How to make data Reusable**
 - R1: Data and metadata are richly described with a plurality of accurate and relevant attributes.
 - R1.1: Data and metadata are released with a clear and accessible data usage licence.
 - R1.2: Data and metadata are associated with detailed provenance.
 - R.3: Data and metadata meet domain-relevant community standards.

SDG Indicators and tiers

As discussed in Chapter 3, many policies, guidelines, vocabulary and data coding frameworks have had to be developed for each of the Indicators of the 169 Targets of the SDGs. The metadata standards and protocols are essential for ensuring data quality, transparency, and reporting. They also play a key role in meeting compliance with the FAIR principles, as well as data interoperability and data sharing among multiple agencies and institutions nationally and internationally.

However, data gathering for the Indicators is often a very time-consuming and resource-intensive task, and they require every country to have one or more appropriate data collection agencies and/or national statistical offices. Based on the methodologies and standards, as well as the availability of data at country level, the SDG Indicators within the *IAEG-SDG Global Indicator Framework* are classified into three different tiers as follows (IAEG-SDGs – SDG Indicators, un.org):

Tier I The Indicator is conceptually clear, has an internationally established methodology, and standards are available, and data is regularly produced by at least 50% of countries and of the population in every region where the Indicator is relevant.

Tier II The Indicator is conceptually clear, has an internationally established methodology, and standards are available, but data are not regularly produced by countries; and

Tier III No internationally established methodology or standards are yet available for the Indicator, but methodology and standards are being (or will be) developed or tested.

It should be noted that all Indicators 'are equally important, and the establishment of the tier system is intended solely to assist in the development of global implementation strategies' (IAEG-SDGs – SDG Indicators, un.org).

Table 4.1 shows the number of Indicators in each Tier for each SDG.

Table 4.1 *SDG Indicator categories* (https://unstats.un.org/sdgs/iaeg-sdgs/tier-classification)

SDGs	Indicators	Tier I	Tier II	Multiple (I and II)
SDG1 End poverty in all its forms everywhere	13	7	6	0
SDG2 End hunger, achieve food security and improved nutrition and promote sustainable agriculture	14	10	4	0
SDG3 Ensure healthy lives and promote well-being for all at all ages	28	25	3	0
SDG4 Ensure inclusive and equitable quality education and promote lifelong learning opportunities for all	12	5	6	1
SDG5 Achieve gender equality and empower all women and girls	14	5	9	0
SDG6 Ensure availability and sustainable management of water and sanitation for all	11	8	3	0
SDG7 Ensure access to affordable, reliable, sustainable and modern energy for all	6	6	0	0
SDG8 Promote sustained, inclusive and sustainable economic growth, full and productive employment and decent work for all	15	8	7	0
SDG9 Build resilient infrastructure, promote inclusive and sustainable industrialisation and foster innovation	12	10	2	0
SDG10 Reduce inequality within and among countries	14	8	6	0
SDG11 Make cities and human settlements inclusive, safe, resilient and sustainable	14	5	9	0
SDG12 Ensure sustainable consumption and production patterns	13	5	8	0
SDG13 Take urgent action to combat climate change and its impacts	8	3	5	0
SDG14 Conserve and sustainably use the oceans, seas and marine resources for sustainable development	10	5	5	0
SDG15 Protect, restore and promote sustainable use of terrestrial ecosystems, sustainably manage forests, combat desertification and halt and reverse land degradation and halt biodiversity loss	14	11	2	1
SDG16 Promote peaceful and inclusive societies for sustainable development, provide access to justice for all and build effective, accountable and inclusive institutions at all levels	24	6	17	1
SDG17 Strengthen the means of implementation and revitalise the global partnership for sustainable development	24	17	6	1
Total	**246**	**144**	**98**	**4**

It may be noted from Table 4.1 that:

- out of the 246 Indicators, 144 are Tier I, i.e. they are conceptually clear and data is regularly produced by at least 50% of all countries, whereas 98 Indicators are Tier II, i.e. although they are conceptually clear, data is not regularly produced by all countries
- all the Indicators for SDG7 are Tier I, i.e. data is available for at least 50% of the countries, whereas only 25% of the Indicators for SDG16 are Tier I, meaning that data related to the various Indicators of SDG16 are still not produced in most countries.

Some Indicators have been revised since they were originally created; Indicators 11.5.3 and 11.c have not yet been defined.

Data collection and reporting

Each Indicator has one or more custodian agencies that are responsible for collection of data related to each Indicator. Custodian agencies are United Nations bodies (and in some cases, other international organisations) responsible for compiling and verifying country data and metadata, and for submitting the data, along with regional and global aggregates, to the United Nations Statistics Division (UNSD). However, countries are the centre and starting point for all data collection, monitoring and validation activities and they oversee these through their national statistical system such as their national statistical office, relevant ministries and other national institutions involved in monitoring. As shown in Figure 4.1 on the next page, several other agencies in a country – such as civil society organisations, academic institutions, and private sector organisations – may also be involved in data collection and monitoring. Custodian agencies responsible for data related to an Indicator send requests for data to the national statistical system or may collect data from a publicly available data source.

The national statistical system sends the data which is validated by the custodian agency, in consultation with the national statistical system. Another major responsibility of the custodian agencies is to strengthen national monitoring and reporting capacity. When country data is missing, or collected using a different methodology or inconsistently reported by different sources, custodian agencies may need to make estimates or adjust the data in consultation with the specific countries. All final data to be submitted to UNSD has first to be validated and approved by the countries. Custodian agencies often publish the country data in their own databases and use it for thematic reporting.

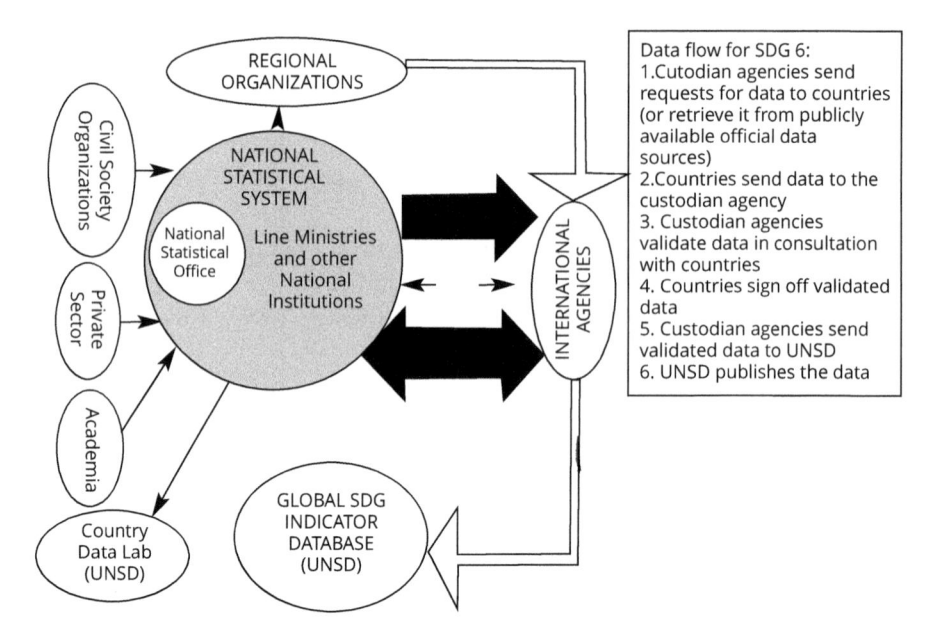

Figure 4.1 *An example of the data collection and validation workflow*
(www.unwater.org/news/roles-and-responsibilities-sdg-monitoring-and-reporting)

Some examples of metadata for Indicators

Data and metadata for the Indicators vary widely in terms of the nature of data to be collected and recorded and the organisations involved in providing and monitoring the data. Some examples are discussed below.

Non-statistical indicators

A number of SDG Indicators are classed as non-statistical, for example Global Compact Network UK (2022b, 132):

- Indicator 5.6.2: Number of countries with laws and regulations that guarantee full and equal access to women and men aged 15 years and older to sexual and reproductive health care, information and education
- Indicator 12.1.1: Number of countries developing, adopting or implementing policy instruments aimed at supporting the shift to sustainable consumption and production
- Indicator 14.6.1: Degree of implementation of international instruments aiming to combat illegal, unreported and unregulated fishing.

Data reported for these Indicators in most cases includes lists of policies, laws and strategy plans which had been identified as relevant. It is suggested that non-statistical Indicators should include (Global Compact Network UK, 2022b):

- more comprehensive lists of relevant policies, legislation, plans, and so on
- sources beyond those provided by the national statistics office to obtain a fuller picture
- access to more timely updated lists, for example, Indicator 13.2.1 makes reference to the 2017 Clean Growth Strategy, but doesn't include the 2021 Net Zero Strategy, a key strategic plan in relation to this Indicator
- the full scope of plans and policies that will enable measurement of impact, e.g. Indicator 12.1.1 includes a limited list of policies relevant to sustainable consumption and production
- data with the appropriate level of focus, i.e. national, regional, or local, e.g. Indicator 8.b.1 makes no reference to how the youth employment strategy would be operationalised at a subnational level.

Some examples of quantitative metadata Indicators and qualitative Indicators are discussed in this section in order to show the diverse nature of data and metadata required for measuring various Targets of the SDGs.

As shown in Table 4.2, Indicator 1.a.1 requires different types of data that need to be computed both from a donor's and a recipient country's

Table 4.2 *Examples of some quantitative data and method of computation for Indicators* (Metadata Repository, https://unstats.un.org/sdgs/metadata)

Indicator	Metadata details (data collection and computation)
Goal 1, Target 1.a, Indicator 1.a.1 **Organisation(s) responsible**: OECD	**Nature of data**: Poverty reduction items can be defined as ODA (official development assistance) to basic social services (basic health, basic education, basic water and sanitation, population programmes and reproductive health) and developmental food aid **Method of computation:** (1) From a donor country's perspective: the sum of bilateral ODA grants by donor that focus on poverty reduction as a share of the donor country's gross national income. (2) From a recipient country's perspective: the sum of total ODA grants from all donors (i.e. DAC (Development Assistance Committee) donors, multilateral organisations and other bilateral providers of development co-operation) that focus on poverty reduction as a share of the developing country's gross national income.

Continued

Table 4.2 *Continued*

Indicator	Metadata details (data collection and computation)
Goal 1, **Target** 1.2, **Indicator** 1.2.2 **Organisation(s) responsible**: The World Bank, United Nations Children's Fund (UNICEF), United Nations Development Programme (UNDP)	**Nature of data:** (1) Official multidimensional poverty headcount, by sex, and age (% of population): The percentage of people who are multidimensionally poor; (2) Average share of weighted deprivations (intensity) for total population: the average share of weighted dimensions in which poor people are deprived among total population; (3) Official multidimensional poverty headcount (% of total households): the percentage of households who are multidimensionally poor; (4) Average share of weighted deprivations (intensity) for total households: the average share of weighted dimensions in which poor people are deprived among total households; (5) Multidimensional deprivation for children (% of population under 18): the percentage of children who are simultaneously deprived in multiple material dimensions **Method of Computation**: The measurement of poverty involves two crucial steps: (1) identification – identifying who is poor; and (2) aggregation – compiling the individual's information into a summary measure.

perspective. Methods for collection and computation of data for Indicator 1.2.2 are equally, if not more, complex. For example, the prescribed method of computation in the prescribed metadata for Indicator 1.2.2 is shown through an example in Figure 4.2 opposite. It is quite evident that a number of complex sets of computation and decision-making skills are required to correctly compute the data for Indicator 1.2.2. As shown in Table 3 within Figure 4.2, some Indicators are given a binary value of 0 or 1 based on a qualitative judgement, perhaps measured over a period of time, e.g. a value of 1 corresponds to having access to an improved sanitation or water source.

Examples of quantitative data collected through surveys

Figure 4.3 opposite shows an example of an Indicator where data is collected through national surveys (Indicator 5.6.1).

Figure 4.4 on page 72 shows an example of an Indicator that requires complex computation. Indicator 5.6.2 measures the legal and regulatory environment across four thematic sections, defined as the key parameters of sexual and reproductive health care, information and education according to these international consensus documents and human rights standards: (1) maternity care; (2) contraception services; (3) sexuality education; and (4) HIV

'Suppose a hypothetical society with five people, where multidimensional poverty is measured based on four indicators: per capita household income, years of schooling, access to sanitation, and access to source of water. The deprivation thresholds for these indicators are, respectively: 400 monetary units (e.g., dollars, pesos, shillings), 5 years of schooling for adults, having access to improved sanitation, and having access to improved sources of water. In this example, the four indicators are weighted equally, and the multidimensional poverty cut-off is two out of the four indicators. That is, the person would be considered poor if she is deprived in at least two out of the four indicators. Table 2 presents the individuals' achievements in each of the four relevant indicators, and the deprivation cut-offs are shown in the bottom row. The achievements falling below the deprivation thresholds are highlighted. Table 3 shows the deprivation status of all individuals in the four indicators. Column (5) shows the sum of deprivations. Comparing this sum with the poverty cut-off (as mentioned above, two out of four) the individuals can be classified as poor and non-poor, as shown in column (6).' (Metadata-01-02-02.pdf (un.org))

Table 2. Individual achievements in the variables to define multidimensional poverty

Individual	Income (in dollars)	Schooling (in years of education)	Improved Sanitation	Improved Water
1	100	3	No	No
2	200	2	No	Yes
3	350	5	Yes	Yes
4	500	4	Yes	No
5	600	6	Yes	Yes
Deprivation cut-offs	400	5	Yes	Yes

Note: Please note that the water and sanitation indicators are binary variables where a value of 1 corresponds to having access to an improved sanitation or water source, and is (0) otherwise.

Table 3. Deprivation status, deprivation score and poverty status

Individual	Deprived in ...				Sum of Deprivations	Poor (at least two out of four)
	Income	Schooling	Sanitation	Water		
	(1)	(2)	(3)	(4)	(5)	(6)
1	1	1	1	1	4	Yes
2	1	1	1	0	3	Yes
3	1	0	0	1	1	No
4	0	1	0	1	2	Yes
5	0	0	0	0	0	No

Figure 4.2 *Tables demonstrating how to compute data for Indicator 1.2.2 (based on a scenario)* (Metadata-01-02-02.pdf, un.org)

Goal 5, Target 5.6, Target 5.6.1: Proportion of women aged 15-49 years who make their own informed decisions regarding sexual relations, contraceptive use and reproductive health care
Data Reporter Organisation: United Nations Population Fund (UNFPA)
A woman is considered to have autonomy in reproductive health decision making and to be empowered to exercise their reproductive rights if they: (1) decide on health care for themselves, either alone or jointly with their husbands or partners, (2) decide on use or non-use of contraception, either alone or jointly with their husbands or partners; and (3) can say no to sex with their husband/partner if they do not want to.
Data for SDG indicator 5.6.1 may be collected through existing county-specific surveys. For existing national household surveys, it must be ascertained that the sampling design does not systematically exclude subgroups of the population that are important to SDG 5.6.1, specifically, women of reproductive age (15-49) that are currently married or in union. Surveys that cover only certain population subgroups, such as women who speak the dominant language or women from the main ethnic group, may exclude the experiences of a large number of women. Data on the ethnicity and religion of the survey participants should be collected whenever available. The survey should have a large sample size (usually between 5,000 and 30,000 households), be nationally-representative, and representative, at least, at one administrative level below the national level.

Figure 4.3 *An example of an Indicator where data is collected through national surveys (Indicator 5.6.1)* (Source: Metadata-05-06-01.pdf, un.org)

(Human Immunodeficiency Virus) and HPV (Human Papilloma Virus). Each of the four thematic areas (sections) is represented by individual components, reflecting topics that are: (1) critical from a substantive perspective; (2) span a broad spectrum of sexual and reproductive health care, information, and education; and (3) the subject of national legal and regulatory frameworks. In total, Indicator 5.6.2 measures 13 components, and for each component information is collected on the existence of: (1) specific legal enablers (positive laws, and regulations) and (2) specific legal barriers. Then a formula is used to determine the value for the Indicator 5.6.2 (see Figure 4.4).

The 13 components are placed on the same scale, with 0% being the lowest value and 100% being the most optimal value. Each component is calculated independently and weighted equally. Each component is calculated as:

$$C_i = \left(\frac{e_i}{E_i} - \frac{b_i}{B_i}\right) \times 100$$

where;
C_i: Data for component i
E_i: Total number of enablers in component i
e_i: Number of enablers that exist in component i
B_i: Total number of barriers in component i
b_i: Number of barriers that exist in component i

As legal barriers are not deemed applicable for C2: life-saving commodities and C9: CSE curriculum, they are calculated as:

$$C_i = \frac{e_i}{E_i} \times 100$$

where;
C_i: Data for component i
E_i: Total number of enablers in component i
e_i: Number of enablers that exist in component i

In addition, as C3: Abortion collects information on four types of legal ground (to save a woman's life, to preserve a woman's health, in cases of rape, and in cases of fetal impairment), and that the legal barriers apply to each type, it is calculated as:

$$C_i = \frac{e_i}{E_i} (1 - \frac{b_i}{B_i}) \times 100$$

where;
C_i: Data for component i
E_i: Total number of enablers in component i
e_i: Number of enablers that exist in component i
B_i: Total number of barriers in component i
b_i: Number of barriers that exist in component i

Value for Indicator 5.6.2 is calculated as *the arithmetic mean of the 13-component data*. Similarly, the value for each section is calculated as the arithmetic mean of its constituent component data.

Figure 4.4 *Example of a complex computation process (for the Indicator 5.6.2)* (Metadata-05-06-02.pdf, un.org).

These examples show the complexities involved in the process of collection and computation of data for some Indicators, and they clearly point out the need for having an established national agency, and trained human resources, for the collection and management of data related to the various SDG Targets and Indicators.

Measures of achievements in SDGs

The UN *Sustainable Development Goals Report 2022* charts progress towards realising the 17 Goals based on millions of data points provided by over 200 countries and areas (UN Statistics Division, 2022a). The report points out that although some progress has been made in some areas, overall achievements in the Targets of various SDGs have been affected by the COVID-19 pandemic. Various other online resources are available from the UN and other agencies that provide details of the progress of SDGs globally, on specific Goals, in specific countries, regions and so on. For example, the SDG Progress Chart 2022 (United Nations, 2022b) presents a snapshot of global and regional progress of selected Targets in the 17 SDGs. The progress chart presents two types of information:

1 a trend assessment using traffic signal colours to measure progress towards the Target (from a baseline year to the most recent data point)
2 a level assessment using a gauge meter to measure the current level of development with respect to the distance from a Target, using the latest data.

Together, this information provides a visual display of progress in each SDG in the world as well as in different parts of the world, i.e. Sub-Saharan Africa, Northern Africa and Western Asia, Central and Southern Asia, Latin America and the Caribbean, Pacific island countries, and the Developed countries. The category 'Pacific island countries' refers to Oceania excluding Australia and New Zealand, and the category 'developed countries' includes Europe, Northern America, Australia and New Zealand.

Progress in SDGs and data challenges

Reports of progress and achievements in the SDGs are published by various agencies at international level, e.g. the UN Sustainable Development Goals Report 2022; at regional level, e.g. the Eurostat report on the SDGs in Europe; and at national level, e.g. the UK SDG Report. Key issues and challenges reported in some of these documents, especially in the context of collection

and management of data for various SDG Targets and Indicators, are discussed in the following sections.

Across the globe

The UN SDG Report 2022 (United Nations, 2022a) highlights some progress, as follows:

- the number of Indicators included in the global SDG database increased from 115 in 2016 to 217 in 2022
- more than 80% of countries have at least one data point since 2015 for Goal 3 (health) and Goal 7 (energy).

However, the report notes that 'the 2030 Agenda for Sustainable Development is in grave jeopardy due to multiple, cascading and intersecting crises. COVID-19, climate change and conflict predominate. Each of them, and their complex interactions, impact all of the Goals, creating spin-off crises in food and nutrition, health, education, the environment, and peace and security' (United Nations, 2022a). The report (United Nations, 2022a) also highlights some key challenges, such as these:

- it is difficult to fully comprehend: (a) the pace of progress towards the realisation of the 2030 Agenda, (b) differences across regions, and (c) who is being left behind
- globally, only 17% of countries felt that their co-ordination within the data ecosystem was satisfactory; and the level of satisfaction varied by income level, averaging 25% in high-income countries, but only 8% in low- and lower-middle income countries
- for 8 of the 17 SDGs, fewer than half of the 193 countries or areas have internationally comparable data from 2015 or later
- only around 20% of countries have data for Goal 13 (climate action)
- significant data gaps still exist in terms of geographic coverage, timeliness and level of disaggregation
- out of the 32 SDG Indicators, only for 21 is disaggregated data available in most countries with a requirement of sex disaggregation; and for 8 Indicators, no sex disaggregated data is available at all
- disaggregated data is available for only 7 out of 21 Indicators that require disaggregation by both sex and age
- disaggregated data is available for only 2 out of 10 SDG Indicators that require disaggregation by disability status

- funding for data specific to the SDGs, such as gender data and climate data, declined more than 18% in 2020.

The report recommends that timely, disaggregated and high-quality data are more important than ever; and significant investment is required in building the data and information infrastructure.

In the European Union

The report on SDGs in Europe (Eurostat, 2022b) builds on around 100 Indicators and is structured along the 17 SDGs; for each SDG, it focuses on aspects that are relevant from an EU perspective. The report 'provides a statistical presentation of trends relating to the SDGs in the EU over the past five years ('short-term') and, when sufficient data are available, over the past 15 years ('long-term')'. Figure 4.5 on the next page provides a visual display of progress in the SDGs in Europe over the past five years. It shows that significant progress has been achieved in six SDGs – SDG1, SDG3, SDG7, SDG8, SDG9 and SDG16 – while moderate progress has been achieved in other SDGs.

It may be noted that there has been a steady progress in household access to the internet in Europe. While in 2016 only 25.2% of EU households had access to very-high-capacity network (VCHN) – fibre connections or other networks offering similar bandwidth – in 2021 this share had risen to 70.2% of households. However, the share of rural households with fixed VCHN connection has not increased that much: between 2016 and 2021 it increased from 7.7% to 37.1% in rural areas across the EU countries (Eurostat, 2022b).

There are some areas of concern as well, e.g. the Eurostat 2022 report (Eurostat, 2022b) points out that 'between 2016 and 2021, the share of people aged 16 to 74 with at least basic digital skills stagnated at 54%, making no progress towards the 80% Target for 2030'. It also notes that fewer women (52%) than men (56%) had at least basic digital skills in 2021; and that age and formal education also affect a person's level of digital skills.

The report shows that older people struggle with the use of digital media. For example, only 35% of people aged 55 to 74 have at least basic digital skills in 2021. As for the education level and digital skills, the report notes that 79% of people with high formal education had at least the basic digital skills, while only 32% of people with no or low formal education had them. The report acknowledges that the basic digital skills for all citizens are a general prerequisite for ensuring they benefit from digital developments.

With regard to the data availability and data disaggregation, Eurostat (2022a) indicates that 'Eurostat is working with other services of the European

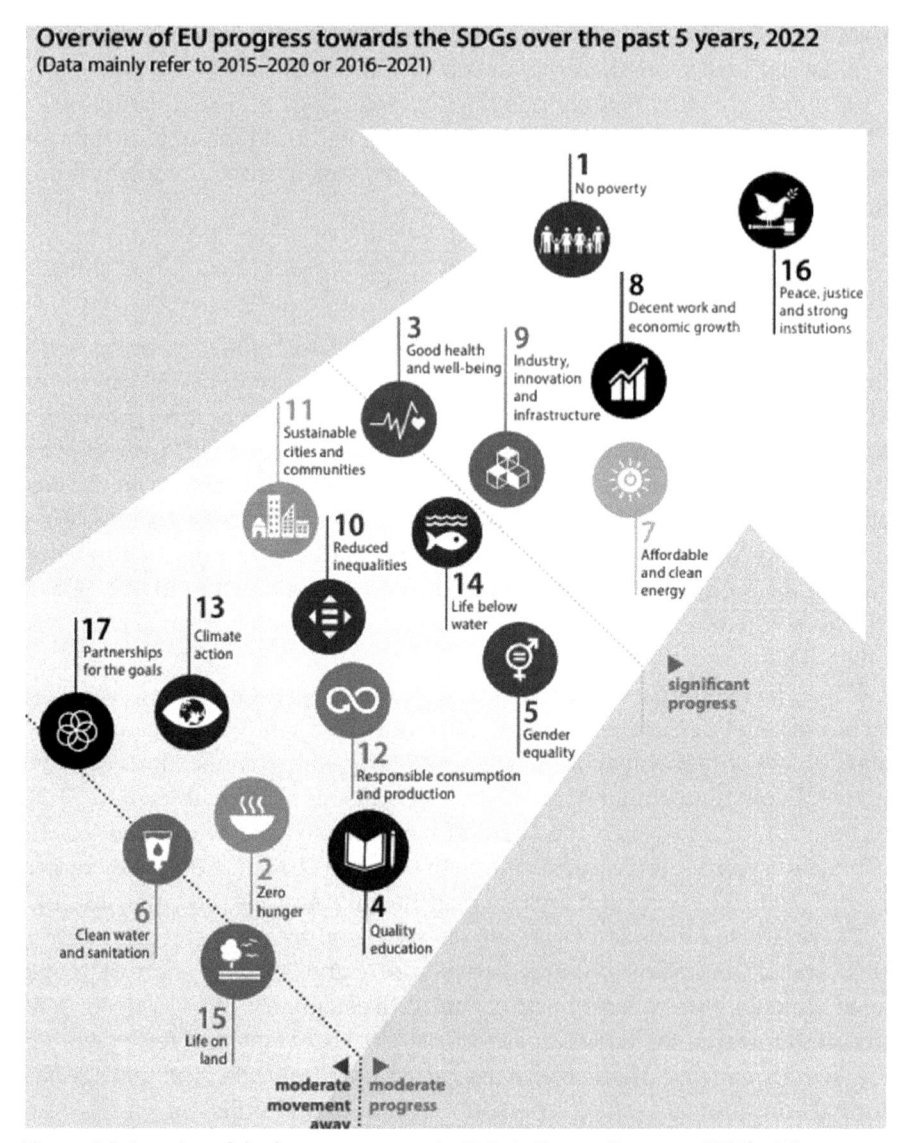

Figure 4.5 *Overview of the five-year progress in SDGs in Europe* (Eurostat, 2022b, 10)

Commission and the EEA [European Economic Area] on the use of new data sources, whenever they contribute to the increased availability, quality, timeliness and disaggregation of data. These are, for example, the integration of earth observation data and information from Copernicus, the European Earth Observation and Monitoring Programme'.

In the USA

The United States US SDG (2022) report provides a visual display of progress in SDGs in the USA, and it shows that only two SDGs – SDG6 and SDG9 – are on track for achievement; nine SDGs – SDG1, SDG3, SDG4, SDG5, SDG7, SDG8, SDG11, SDG16 and SDG17 – are moderately improving; progress in four SDGs – SDG2, SDG13, SDG14 and SDG15 – is stagnant; and progress in SDG10 and SDG12 is decreasing. The report also shows that:

- major challenges remain for seven SDGs – SDG2, SDG10, SDG12, SDG13, SDG15, SDG16 and SDG17
- significant challenges remain for six SDGs – SDG1, SDG3, SDG5, SDG7, SDG8 and SDG14
- challenges remain for four SDGs – SDG4, SDG6, SDG9 and SDG11.

Research shows that even before the pandemic, the USA was not on track to fully achieve a single SDG; and in fact, analysis of 49 SDG Targets using 56 Indicators based on data through to 2019 shows that trends were moving in the wrong direction (Pipa, Rasmussen and Pendrak, 2022). The same research also points out that progress in some areas, e.g. in SDG3, SDG4 and SDG16, has since decreased, while substantial breakthrough is needed in some areas to meet the Targets of 26 Indicators that cover a range of SDGs.

In the UK

The UK SDG index dashboard (UK SDG, 2021) provides a visual display of the current state of progress in the 17 SDGs in the UK. It shows that for the UK, five SDGs – SDG5, SDG6, SDG7, SDG9, and SDG15 – are on track for achievement; nine SDGs – SDG1, SDG3, SDG4, SDG8, SDG12, SDG13, SDG14, SDG16 and SDG17 – are moderately improving; progress in two SDGs – SDG2 and SDG11 – is stagnant; and progress in SDG10 is decreasing. The dashboard also shows that:

- major challenges remain for three SDGs – SDG2, SDG13 and SDG17
- significant challenges remain for six SDGs – SDG3, SDG8, SDG10, SDG12, SDG14 and SDG16
- challenges remain for eight SDGs – SDG1, SD4, SDG5, SDG6, SDG7, SDG9, SDG11 and SGD15.

Data disaggregation has been identified as one of the key stumbling blocks for measuring success in SDG Targets in the UK SDG Report 2021 (ONS,

2021c) points out some significant developments in data gathering and reporting in relation to the SDG Indicators; for example:

- headline data is currently available for 204 (83%) SDG Indicators
- data gaps have been filled for various Targets, for example for:
 - Indicator 1.a.1 on official development assistance grants, which can be found online at https://sdgdata.gov.uk/1-a-1;
 - Indicator 4.1.2 on education completion rate, which can be found online at: https://sdgdata.gov.uk/4-1-2;
 - Indicator 13.2.2 on greenhouse gas emissions, which can be found online at: https://sdgdata.gov.uk/13-2-2; and
 - Indicator 15.1.2 on biodiversity, which can be found online at: https://sdgdata.gov.uk/15-1-2.
- More disaggregated data is currently available, for example:
 - eight main disaggregations can be measured for all Indicators (where applicable) covering income, sex, age, race, ethnicity, migration status, disability and geographic location and other characteristics relevant in national contexts
 - there are also additional disaggregations where needed. For example, new disaggregated data is available for Indicator 4.b.1 on official development assistance by sector and type of study for scholarships, for Indicator 5.4.1 on unpaid domestic and care work by sex, and for Indicator 8.3.1 on informal employment by sector of employment.

The UN Global Compact Network UK, working with hundreds of stakeholders, reviews how the UK is performing against the SDGs, the wider policy context, and the historical trends that affect the achievement of the Goals (Global Compact Network UK, 2022a). Although some progress has been made, overall the progress in the UK has been far from satisfactory, as Network's report notes:

- the UK is performing well only on 17% of the Targets
- there are gaps or inadequate performance on 64% of the Targets
- for 11% of the Targets, there is little to no policy in place to address the Target and where performance is poor or even declining
- there are gaps in available or appropriate data for the remaining 8% of Targets.

The report (p. 13) makes over '120 recommendations to advance the SDGs and almost 50 case studies from business, civil society, and national and local government'. It further finds that:

- Compared to 2018, these results suggest improvements in 23 Targets, regression in 18 Targets, and no change in 65 of the Targets which were rated amber or red four years ago.
- The SDGs have tremendous potential to mobilise action across the whole of society but both government and business are missing an opportunity to use the holistic framing of the SDGs to address systemic challenges.

<div align="right">(Global Compact Network UK, 2022b)</div>

SDG16.10 Access to information

Access to Information (ATI) has been identified as a specific Target within the UN SDGs. UNESCO recommends that 'when countries engage themselves in a self-assessment through the survey, they can identify their own gaps in terms of implementation of ATI laws, and better strategize for future improvements' (UNESCO, 2021c). Target 16.10 and the corresponding Indicator 16.10.2 measures ATI through two principal components for a country: (1) to have a legal framework for ATI; and (2) to have mechanisms for its implementation in practice. In other words, the Indicator 16.10.2 measures success for a country with regard to ATI on the basis of the facts that it:

- Entitles public to request access to information (documents and other information recorded in any format) and to respond to such requests in a timely fashion
- Obliges authorities to ensure that information of public interest is put into the public domain proactively, without the need for requests.

<div align="right">(Metadata-16-10-02.pdf, un.org)</div>

'As countries are trying to emerge from the pandemic, the role of access to information continues to be critical', and the 'world has witnessed a growing public's appetite for information that is accurate, timely and reliable' (UNESCO, 2022c, 3). UNESCO and its Institute for Statistics (UIS) have developed a methodology to help measure and report on Indicator 16.10.2, where data is gathered through a survey that measures the adoption and implementation of:

- legal frameworks that ensure the right of access to information (RTI)
- limited exception or exemptions, which means that withholding of certain categories of information is based on narrow, proportionate, necessary and clearly defined limitations
- oversight mechanisms

- appeals mechanisms
- record keeping and reporting.

Each question has a value between 0 and 2, and upon completion of the survey, a country can get a total score. It may be noted that Indicator 16.10 requires the states not only to have the legal frameworks that entitle people to have the right to have access to information, it also requires the establishment of mechanisms for making information available in the public domain proactively. UNESCO believes that when countries engage themselves in a self-assessment through the survey, 'they can identify their own gaps in terms of implementation of ATI laws, and better strategize for future improvements' (UNESCO, 2022c, 3). UNESCO (2022c) summarised the major findings on ATI:

- a growing interest in reporting on ATI
- national regulation systems are increasingly conducive
- the limited scope of exemption
- dedicated oversight institutions are well established
- record keeping mechanisms exist in most countries.

However, another report (Metadata-16-10-02.pdf, un.org) notes that: 'Out of 100 countries that responded to UNESCO Survey on Public Access to Information (SDG Indicator 16.10.2), 80% have oversight institutions on Access to Information (ATI). However, only 50% of them keep records of appeals with regards RTI requests.' This clearly shows a lack of a good record-keeping system that is vital for evidence-based reporting on progress in Indicator 16.10.2, Access to Information. It also shows the need for the countries to establish appropriate information management systems that have the appropriate tools, technologies and standards for gathering, management of and access to information for everyone. These call for a range of requirements for the nations to ensure data and information management, data quality and standardisation, as well as data and information access facilities. Some of these issues and challenges in association with ATI and SDGs are discussed in Chapters 5, 6 and 7.

Furthermore, making information available is only one aspect of ensuring access to information. Rights to information and access to information depend on a number of human behavioural, literacy, socioeconomic and cultural factors. Some of these issues in association with ATI and SDGs are discussed in Chapters 7 and 8.

Indicator 17.6.1: Access to the internet

Target 17.6 is designed to promote international co-operation to ensure access to science, technology and innovation and knowledge sharing through global technology facilitation mechanisms. Indicator 17.6.1 has been created for measuring success in this Target. Indicator 17.6.1 measures fixed internet broadband subscriptions per 100 inhabitants, by speed in three categories (Metadata-17-06-01.pdf, un.org):

1 **256 kbit/s to less than 2 Mbit/s subscriptions**, which refers to all fixed broadband internet subscriptions with advertised downstream speeds equal to, or greater than 256 kbit/s and less than 2 Mbit/s
2 **2 Mbit/s to less than 10 Mbit/s subscriptions**, which refers to all fixed broadband internet subscriptions with advertised downstream speeds equal to, or greater than, 2 Mbit/s and less than 10 Mbit/s
3 **Equal to or above 10 Mbit/s subscriptions**, which refers to all fixed broadband internet subscriptions with advertised downstream speeds equal to, or greater than, 10 Mbit/s.

The International Telecommunication Union (ITU) collects data for this Indicator through a questionnaire from national regulatory authorities or information and communication technology (ICT) ministries, which collect the data from internet service providers; and since it is collected from the internet operators or service providers, the data cannot be broken down by any individual characteristics.

Summary

All the reports on SDGs demonstrate a general agreement that in order to achieve success, more financial support and co-operation is needed. Discussions in this chapter also show that metadata, data quality and standards, and data collection and management capacity, also need to be improved in order to achieve success in the SDGs. Data availability is also a key challenge. The UN Sustainable Development Goals Report 2022 points out that 'we still lack timely, high-quality and disaggregated data to fully understand where we are and where we are headed. Investment in data and information infrastructure should be a priority of national governments and the international community' (Metadata-17-06-01.pdf, un.org).

As discussed earlier in this chapter, even after about eight years of adoption of the SDGs, there are still about 100 Indicators that are Tier II, which means that appropriate data on those Indicators is not produced by countries. The situation is somewhat better in the developed countries, but as has been

repeatedly pointed out in the 2030 Agenda and other UN and related reports and documents, everyone in the world should benefit from the SDGs, and no one should be left behind.

All the reports and papers discussed in this chapter agree with the point that progress in the achievements of all the SDG Targets has been significantly affected by two major global events: the COVID-19 pandemic and the war in Ukraine. As a UNESCO report emphasises, 'with global challenges becoming more interconnected, access to information should be the thread that binds together diverse actions towards the successful implementation of the 2030 Agenda for Sustainable Development and beyond' (UNESCO, 2022c, 7). An earlier UNESCO report points out that 'new challenges have emerged for law and implementation of ATI in digital times. In future, there could be more tension between the right to access information and right to privacy' (UNESCO, 2019b, 50). Access to information, and its proper use, heavily depends on digital access, digital skills and information skills. These issues are discussed in Chapters 6, 7 and 8.

Capacity, Co-operation and Sharing of Data for SDGs

Introduction

In a 2022 UN report, the Secretary-General of the United Nations commented:

> While considerable progress has been made in building stronger data and statistical systems for Sustainable Development Goal monitoring, significant data gaps still exist. Gaps in terms of geographical coverage, timeliness and the disaggregation levels of global Indicators make it difficult to fully comprehend the pace of progress, differences across regions and who is being left behind. Greater investment in data and strengthened data capabilities will be crucial in getting ahead of crises and triggering earlier responses, anticipating future needs, preventing crises from becoming full-blown conflicts and designing the urgent actions needed to realize the 2030 Agenda for Sustainable Development.
>
> (UN Economic and Social Council, 2022, 3)

Co-operation, capacity building and data sharing have been identified as some of the key requirements for achieving the SDGs, and SDG17 has been specifically created to 'strengthen the means of implementation and revitalize the Global Partnership for Sustainable Development' (UN Statistics Division (n.d.d). However, several reports and research publications point out that although we are more than halfway through the period of achieving the Targets (by 2030) since the SDGs were first adopted by the global community in 2015, several data-related challenges still exist. The Cape Town Global Action Plan for Sustainable Development Data (CTGAP) report (World Bank, 2023) notes that many gaps remain, particularly with regard to national statistical capacity in low- and middle-income countries, and financing of data and statistics. Data gaps, timeliness and availability of data have been identified as some of the key challenges for achieving success in the SDGs. Some of these challenges have been discussed in Chapter 4, and some more are discussed in this chapter in the context of specific SDGs and countries.

Data gaps

Availability of reliable and comparable data on SDGs is often a major challenge. Analysis of the Indicators in the *Global SDG Indicators Database* (United Nations, 2021, 5) reveals that:

- fewer than half of 193 countries, or areas, have internationally comparable data for 5 of the 17 SDGs
- the lack of country-level data is particularly worrisome for SDG13 (climate action), where, on average, only about 1 in 6 countries have data available
- country-level data deficits are also significant in areas related to:
 - sustainable cities and communities (SDG11)
 - peace, justice, and strong institutions (SDG16)
 - sustainable production and consumption (SDG12)
 - gender equality (SDG5).

Similar concerns have been noted in other UN reports. For example, the Executive Summary of the United Nations (2022a) report notes that 'considerable gaps in official statistics remain in terms of country coverage and timeliness for many SDGs; in particular SDG4 (Quality Education), SDG5 (Gender Equality), SDG12 (Responsible Consumption and Production), SDG13 (Climate Action), and SDG14 (Life Below Water)'. The report (p. 6) notes: 'among countries surveyed, 39% had difficulties adequately collecting data on migrants, 27% had difficulties collecting data on older persons, and 27% had difficulties with data on persons with disabilities'.

Information infrastructure and data timeliness

Data timeliness has also been a challenge for SDG monitoring. For instance, the latest data point available for climate change Indicators (SDG13) is around 2015, while so many high-level international meetings in the COP series (https://climateaction.unfccc.int/Events/COP27), and several IPCC (Inter-governmental Panel on Climate Change) reports (www.ipcc.ch) have been published since then. Similarly, the average of the latest available year for data on poverty (SDG1) and education (SDG4) is around 2016 (United Nations, 2021, 5).

The OECD (2022) report on SDGs notes that 'while available data make it possible to cover 136 of the 169 Targets, some of the data do not properly gauge current outcomes nor performance over time.' The OECD report continues to state that 'beyond availability, many other gaps – such as timeliness or granularity – influence our understanding of progress towards

the 2030 Agenda.' A United Nations report notes that despite some progress, serious data gaps persist in SDG data collection, monitoring and dissemination (UN Statistics Division, 2022a). Some of the key challenges are in the areas of:

- **Information and communication technology (ICT) infrastructure:** Many NSOs (National Statistical Offices) lack the ICT infrastructure to carry out their daily work remotely. Compounding these problems was the fact that domestic and external funding for statistical activities has been cut back in many countries, particularly those that need it most (United Nations, 2022a, 4); and 71% of NSOs in Sub-Saharan Africa (SSA) saw a reduction in government funding, and other funding for NSOs dropped by 49% in SSA (United Nations, 2022a, 7).
- **Co-operation:** Globally, only 17% of countries surveyed felt that their co-ordination within the data ecosystem was satisfactory. The satisfaction level also varied by income level: on average 25% of the high-income countries appeared to be satisfied with the data ecosystem, but it was only 8% in low- and lower-middle-income countries (p. 6).
- **Effective communication strategies:** Major gaps exist in the approaches used for effective communications, depending on the income level of a country. Higher-income countries preferred the use of newer, more innovative approaches, such as social media, publication programmes targeted to specific user groups, seminars, eLearning platforms, live chat sessions and podcasts; while low- and lower-middle-income countries favoured more traditional approaches to user engagement such as press conferences, traditional media appearances, general awareness campaigns, presentations, conferences and launch events (p. 7).

Overall, data infrastructure and capacity have been a key challenge for several low- and middle-income industries, and this has been worsened by the COVID-19 pandemic. The 2021 UN SDG Report notes that 'while production of short-term statistics was completely unaffected in two thirds of the responding countries in the high-income group, three out of four countries in the low- and middle-income group saw their production of monthly and quarterly statistics negatively affected by the pandemic' (United Nations, 2021, 5). The report also notes (p. 6) that this disparity highlights the need for smart investments to build the necessary infrastructure and the right skill sets across national statistical systems to support remote work, training, and data collection and storage.

Data availability challenges: some examples

Some examples of data gaps and challenges associated with data availability are discussed below. Table 5.1 shows the percentage of countries where data is available for at least one year since 2015 for all the Indicators for all the SDGs.

Table 5.1 *Countries with data for at least one year since 2015, by SDG and Indicator (average across countries in percentage)*
(https://unstats.un.org/sdgs/dataportal/analytics/DataAvailability)

	0–25%	25–50%	50–75%	75–100%
SDG1	1.2.2 (11.2%); 1.4.2 (10%); 1.b.1 (0.0%) **Total: 3 of 13**	1.a.1 (46.4%) **Total: 1 of 13**	1.1.1 (63.0%); 1.2.1 (61.1%); 1.3.1 (63.6%); 1.5.1 (69.7%); 1.5.2 (55.5%); 1.5.3 (68.4%); 1.5.4 (59.2%) **Total: 7 of 13**	1.4.1 (100%); 1.a.2 (92.2%) **Total: 2 of 13**
SDG2	2.3.1 (22.3%); 2.3.2 (10.6%); 2.4.1 (8.6%); 2.b.1 (10.9%) **Total: 4 of 14**	**Total: 0 of 14**	2.1.1 (69.4%); 2.2.2 (69.7%); 2.5.1 (63.6%); 2.5.2 (74.8%); 2.c.1 (69.2%) **Total: 5 of 14**	2.1.2 (76.6%); 2.2.1 (81.3%); 2.2.3 (98.4%); 2.a.1 (91.7%); 2.a.2 (90.9%) **Total: 5 of 14**
SDG3	3.b.3 (9.8%) **Total: 1 of 28**	3.7.1 (47.7%); 3.d.2 (42.7%) **Total: 2 of 28**	3.3.1 (68.9%); 3.3.3 (73.3%); 3.5.1 (56.2%); 3.8.2 (60.1%) **Total: 4 of 28**	3.1.1 (94.8%); 3.1.2 (85.5%); 3.2.1 (99.5%); 3.2.2 (99.5%); 3.3.2 (99.5%); 3.3.4 (99.5%); 3.3.5 (99.5%); 3.4.1 (94.8%); 3.4.2 (94.8%); 3.5.2 (96.9%); 3.6.1 (94.8%); 3.7.2 (85.0%); 3.8.1 (99.5%); 3.9.1 (94.3%); 3.9.2 (94.8%); 3.9.3 (94.8%); 3.a.1 (84.5%); 3.b.1 (81.0%); 3.b.2 (90.9%); 3.c.1 (86.5%); 3.d.1 (100%) **Total: 21 of 28**
SDG4	4.6.1 (7.8%) **Total: 1 of 12**	4.2.1 (34.7%); 4.4.1 (47.2%); 4.5.1 (47.5%); 4.7.1 (31.2%) **Total: 4 of 12**	4.1.1 (57.5%); 4.3.1 (68.9%); 4.a.1 (64.5%); 4.c.1 (69.4%) **Total: 4 of 12**	4.1.2 (79.8%); 4.2.2 (85.0%); 4.b.1 (90.9%) **Total: 3 of 12**

Continued

Table 5.1 *Continued*

	0–25%	25–50%	50–75%	75–100%
SDG5	5.2.2 (0.0%); 5.4.1 (16.2%); 5.6.1 (23.3%); 5.a.1 (19.4%) **Total: 4 of 14**	5.3.2 (30.6%); 5.a.2 (34.7%); 5.b.1 (46.1%) **Total: 3 of 14**	5.1.1 (61.1%); 5.3.1 (51.8%); 5.5.2 (56.9%); 5.6.2 (74.0%); 5.c.1 (51.8%) **Total: 5 of 14**	5.2.1 (79.8%); 5.5.1 (92.0%) **Total: 2 of 14**
SDG6	**Total: 0 of 11**	6.3.1 (36.5%); 6.3.2 (42.2%); **Total: 2 of 11**	6.1.1 (67.4%); 6.2.1 (73.4%); 6.5.2 (54.6%); 6.6.1 (74.4%); 6.b.1 (72.0%) **Total: 5 of 11**	6.4.1 (93.8%); 6.4.2 (91.2%); 6.5.1 (100%); 6.a.1 (90.9%) **Total: 4 of 11**
SDG7	**Total: 0 of 6**	**Total: 0 of 6**	7.a.1 (73.1%); 7.b.1 (74.1%) **Total: 2 of 6**	7.1.1 (100%); 7.1.2 (97.9%); 7.2.1 (99.0%); 7.3.1 (96.9%) **Total 4 of 6**
SDG8	8.4.1 (0.0%) **Total: 1 of 16**	8.7.1 (37.3%); 8.8.1 (37.0%); 8.9.1 (46.6%); 8.a.1 (43.5%) **Total: 4 of 16**	8.3.1 (51.8%); 8.5.1 (54.4%); 8.5.2 (54.8%); 8.6.1 (61.9%); 8.8.2 (71.0%); 8.10.2 (74.6%); 8.b.1 (74.6%) **Total: 7 of 16**	8.1.1 (100%); 8.2.1 (92.2%); 8.4.2 (100%); 8.10.1 (89.4%) **Total: 4 of 16**
SDG9	9.1.1 (10.4%) **Total: 1 of 12**	9.3.1 (35.2%) **Total: 1 of 12**	9.2.2. (65.3%); 9.3.2 (51.3%); 9.4.1. (74.8%); 9.5.1 (60.1%); 9.5.2 (54.4%) **Total: 5 of 12**	9.1.2 (81.9%); 9.2.1 (100%); 9.a.1 (90.9%); 9.b.1 (77.2%); 9.c.1 (98.8%) **Total: 5 of 12**
SDG10	10.7.1 (1.0%) **Total: 1 of 14**	10.3.1 (25.4%); 10.4.2 (35.2%); 10.b.1 (48.7%); 10.c.1 (31.9%) **Total: 4 of 14**	10.1.1 (52.3%); 10.2.1 (62.7%); 10.5.1 (68.7%); 10.7.2 (71.0%); 10.7.3 (64.8%) **Total: 5 of 14**	10.4.1 (92.2%); 10.6.1 (100%); 10.7.4 (100%); 10.a.1 (99.5%) **Total: 4 of 14**
SDG11	11.3.1 (0.0%); 11.3.2. (0.0%); 11.4.1 (14.4%); 11.6.1. (22.3%); 11.7.2 (3.6%) **Total: 5 of 15**	11.5.3 (44.6%) **Total: 1 of 15**	11.1.1 (50.3%); 11.2.1 (66.8%); 11.5.1 (69.7%); 11.5.2 (55.5%); 11.7.1. (58.0%); 11.b.1 (68.4%); 11.b.2 (59.2%) **Total: 7 of 15**	11.6.2 (100%); 11.a.1 (100%) **Total: 2 of 15**
SDG12	12.2.1 (0.0%); 12.5.1 (21.5%); 12.7.1 (10.7%) **Total: 3 of 13**	12.1.1 (32.1%); 12.4.2 (25.6%); 12.6.1. (38.9%); 12.8.1 (31.2%) **Total: 4 of 13**	12.a.1 (74.1%) **Total: 1 of 13**	12.2.2 (100%); 12.3.1. (100%); 12.4.1 (86.0%); 12.b.1 (79.3%); 12.c.1 (94.1%) **Total: 5 of 13**

Continued

Table 5.1 *Continued*

	0–25%	25–50%	50–75%	75–100%
SDG13	13.2.1 (0.0%); 13.2.2. (14.8%); 13.a.1 (0.0%); 13.b.1 (0.0%) **Total: 4 of 8**	13.3.1 (31.2%) **Total: 1 of 8**	13.1.1 (69.7%); 13.1.2 (68.4%); 13.1.3 (59.2%) **Total: 3 of 8**	**Total: 0 of 8**
SDG14	14.2.1 (16.1%); 14.3.1 (20.2%); 14.a.1 (23.6%) **Total: 3 of 10**	14.4.1 (29.5%); 14.c.1 (27.7%) **Total: 2 of 10**	14.1.1. (64.9%); 14.6.1 (66.3%); 14.7.1 (54.4%) **Total: 3 of 10**	14.5.1 (88.2%); 14.b.1 (76.2%) **Total: 2 of 10**
SDG15	15.7.1 (0.0%); 15.c.1 (0.0%) **Total: 2 of 14**	15.a.1 (43.5%); 15.b.1 (43.5%) **Total: 2 of 14**	15.9.1 (73.6%) **Total: 1 of 14**	15.1.1 (100%); 15.1.2 (89.4%); 15.2.1 (86.2%); 15.3.1 (86.0%); 15.4.1 (83.4%); 15.4.2 (84.2%); 15.5.1 (100%); 15.6.1 (100%); 15.8.1 (90.7%) **Total: 9 of 14**
SDG16	16.1.2 (0.5%); 16.1.3 (13.6%); 16.1.4 (22.8%); 16.3.1 (14.9%); 16.3.3. (2.1%); 16.4.1 (2.3%); 16.4.2. (12.4%); 16.6.2. (2.5%); 16.7.2 (1.6%); 16.10.1 (0.0%) **Total: 10 of 24**	16.2.1. (35.8%); 16.2.2. (45.2%); 16.2.3 (25.4%); 16.7.1 (46.8%); 16.a.1 (29.0%); 16.b.1 (25.4%) **Total: 6 of 24**	16.5.1 (67.9%); 16.5.2 (51.3%); 16.10.2 (69.4%) **Total: 3 of 24**	16.1.1. (75.6%); 16.3.2. (82.9%); 16.6.1 (81.3%); 16.8.1 (100%); 16.9.1 (75.1%) **Total: 5 of 24**
SDG17	17.5.1 (0.1%); 17.14.1 (18.7%); 17.16.1 (21.2%); 17.18.1 (0.0%) **Total: 4 of 24**	17.15.1 (31.3%) **Total 1 of 24**	17.2.1 (57.8%); 17.3.1 (74.2%); 17.4.1 (59.6%); 17.7.1. (53.0%); 17.17.1 (65.8%); 17.18.3 (53.5%); 17.19.2 (72.9%) **Total: 7 of 24**	17.1.1. (82.9%); 17.1.2 (82.9%); 17.3.2. (93.8%); 17.6.1. (98.4%); 17.8.1. (97.9%); 17.9.1 (0.9%); 17.10.1 (80.3%); 17.11.1 (98.6%); 17.1.2.1 (98.6%); 17.13.1 (80.6%); 17.18.2 (83.9%); 17.19.1 (99.3%) **Total: 12 of 24**

Table 5.1 shows that there are still several Indicators where data, even for one year since 2015, is available for less than 25% of the countries; and for some Indicators no data is available at all, e.g. SDG8.4.1, SDG11.3.12, SDG11.3.2, SDG12.2.1, SDG13.2.1, SDG13.a.1, SDG13.b.a, SDG15.7.1, SDG15.c.1, SDG16.10.1 and SDG17.8.1.

Further data from the UNStats site which is summarised in Table 5.2 show that

- in more than one-third of the countries disaggregated data is available for only 88 out of the 248 Indicators
- in more than one-third of the countries only one SDG (i.e. SDG4) has disaggregated data for most (10 out of 12) Indicators available
- no disaggregated data is available for any Indicators for SDG13
- there are some SDGs for which very few Indicators have disaggregated data in more than one-third of the countries: 3 out of 24 for SDG17, 2 out of 14 for SDG15, 2 out of 10 for SDG14, 4 out of 15 for SDG11, 4 out of 14 for SDG5, 4 out of 13 for SDG2, 5 out of 13 for SDG1; and so on.

Table 5.2 *SDG Indicators for which disaggregated data is available for more than one-third of the countries* (https://unstats.un.org/sdgs/dataportal/analytics/DataAvailability)

SDG	Total no. of indicators	No. of indicators for which disaggregated data is available for more than one-third of the countries
1	13	5
2	14	4
3	28	12
4	12	10
5	14	4
6	11	6
7	6	3
8	16	8
9	12	2
10	14	7
11	15	4
12	13	6
13	8	0
14	10	2
15	14	2
16	24	10
17	24	3

Figure 5.1 on the next page shows the country-level data, and average number of years of data available, which is reproduced in Table 5.3 for better clarity and comparison.

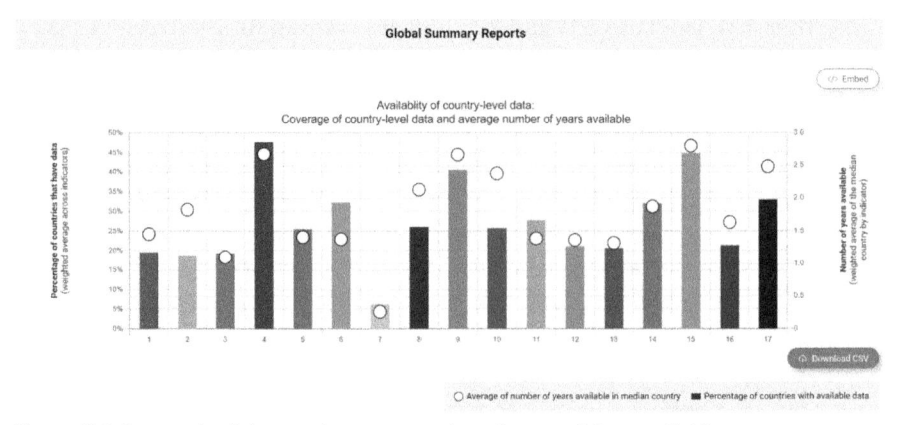

Figure 5.1 *Country-level data and average number of years of data available*
(https://unstats.un.org/sdgs/dataportal/analytics/DataAvailability)

The second column in Table 5.3 shows the average number of years of data available since 2015 for all the Indicators for each SDG. This clearly shows that even after eight years since the adoption of the SDGs, very little data is available. Similarly, data in the third column shows that:

Table 5.3 *Country-level data availability*
(https://unstats.un.org/sdgs/dataportal/analytics/DataAvailability)

SDG	No. of years of data available	Percentage of countries that have data available
1	1.45	19.49%
2	1.83	18.77%
3	1.10	19.28%
4	2.68	47.66%
5	1.41	25.51%
6	1.37	32.26%
7	0.26	6.32%
8	2.13	26.04%
9	2.67	40.56%
10	2.38	25.72%
11	1.38	27.70%
12	1.36	21.08%
13	1.32	20.62%
14	1.88	32.05%
15	2.80	44.84%
16	1.64	21.35%
17	2.49	32.98%

- fewer than 20% of countries have data available for four SDGs (i.e. SDG1, SDG2, SDG3 and SDG7)
- very little data (average 0.26 years' worth) is available for SDG7
- compared to the other SDGs, somewhat better data is available:
 - for SDG15 – data for an average of 2.8 years available in 44.84% countries
 - for SDG4 – data for an average of 2.68 years available in 47.66% countries
 - for SDG9 – data for an average of 2.67 years available in 40.56% countries.

Achievements in the OECD Countries

The 2022 OECD report *Measuring Distance to the SDG Targets* (OECD, 2022) uses a chart to illustrate how the SDGs have been achieved in selected countries. The report provides an assessment of the progress in the SDGs in the OECD countries, and points out that:

- while a few Targets have already been met, mainly those relating to securing basic needs and to the implementation of policy tools and frameworks, in many areas OECD countries still have a long road to travel
- OECD average already exceeds 10 Targets, while 18 additional Targets are considered close to be met; but
- OECD countries still have a long way to go to meet 21 Targets by 2030:
 - lack of progress is visible in the area of inequalities and exclusion, for example, 'on average, around one in eight OECD residents are considered as income poor, based on a relative threshold set at half of the median income of each country (Targets 1.2 and 10.2); over the past decades, most OECD countries did not make any progress toward poverty reduction based on this measure' (OECD, 2022, 9)
 - many population groups including women and young adults are facing additional challenges: for example, with regard to women's rights and opportunities in private and public spheres; inequalities in education owing to numerous factors, such as socio-economic background, gender and place of residence (SDG4.5), basic skills needed to become active, responsible and engaged citizens (SDG4.6); unhealthy behaviours including malnutrition and consumption, such as smoking (SDG3.a), alcohol abuse (SDG3.4) and obesity (SDG2.2) (OECD, 2022, 9).

On a positive note, the OECD report observes that most OECD countries have already adopted or implemented some policy instruments mentioned in the 2030 Agenda, such as promoting public procurement practices (SDG12.7), guaranteeing public access to information (SDG16.10), having national urban policies or regional development plans to support urban planning (SDG11.a) and implementing measures to prevent the introduction of Invasive Alien Species (SDG15.8). However, progress in some of the Targets is affected by the lack of good-quality data and/or the context of data collection and interpretation; for example:

- SDG4.2 refers to the quality of childhood education, but the data only captures the quantity of education by counting the participation rate in organised learning
- the monitoring of SDG9.c on access to ICT is done using data on the number of connections to the mobile network, but relying on this measure may mask significant connectivity gaps, and it needs to reflect the specific conditions prevailing in the OECD countries.

Blind spots in data

As discussed in Chapter 3, several SDGs and their Targets are interlinked. Improvements in one SDG or Target may affect the progress in another SDG or Target. Furthermore, there are some data blind spots arising from missing data. For instance, although for the OECD countries, 'data are currently available for almost 70% of the Targets pertaining to the Planet category, only one in three of these Targets can be monitored over time due to limited availability of robust time-series data' (OECD, 2022, 17).

There are also some significant differences in the wording of the Targets and Indicators which make them difficult to measure globally. For example, 'while some Targets are expressed using strong prescriptive verbs such as 'eradicating' (e.g. SDG1.1. aims at 'eradicating extreme poverty') or 'ending' (e.g. SDG5.1 aims at 'ending all forms of discrimination against all women and girls'), others are more loosely defined (e.g. SDG12.5 aims at 'substantially reducing waste generation')' (OECD, 2022, 17). The wording used for Targets like 'ending all forms' and 'substantially reducing' are quite different, and the latter indicates reductions compared to some previous measures that may be interpreted differently in the context of a specific country or a region.

Furthermore, some Targets may be interpreted very widely depending on the wording, and whether and how the relevant data is collected and used. The OECD report points out that the available data does not allow assessing the trends for several Targets, for example (OECD 2022, 20–21):

- SDG4.a: 'Build and upgrade education facilities that are child, disability and gender sensitive and provide safe, nonviolent, inclusive and effective learning environments for all'
- SDG8.b: 'By 2030, develop and operationalise a global strategy for youth employment and implement the *Global Jobs Pact* of the International Labour Organization'
- SDG11.a: 'Support positive economic, social and environmental links between urban, peri-urban and rural areas by strengthening national and regional development planning'
- SDG12.1: 'Implement the 10-year framework of programmes on sustainable consumption and production, with all countries taking action, and with developed countries taking the lead, taking into account the development and capabilities of developing countries'
- SDG12.7: 'Promote public procurement practices that are sustainable, in accordance with national policies and priorities'
- SDG14.6: 'By 2030, prohibit certain forms of fisheries subsidies that contribute to overcapacity and overfishing, eliminate subsidies that contribute to illegal, unreported and unregulated fishing and refrain from introducing new such subsidies, recognising that appropriate and effective special and differential treatment of developing and least developed countries should be an integral part of the World Trade Organisation negotiations on fisheries subsidies'
- SDG15.8: 'By 2030, introduce measures to prevent the introduction and significantly reduce the impact of invasive alien species on land and water ecosystems and control or eradicate the priority species'
- SDG16.5: 'Substantially reduce corruption and bribery in all their forms'
- SDG16.9: 'By 2030, provide legal identity for all, including birth registration'
- SDG16.10: 'Ensure public access to information and protect fundamental freedoms, in accordance with national legislation and international agreements'
- SDG17.18: 'By 2030, enhance capacity-building support to developing countries, including for least developed countries and small island developing states, to increase significantly the availability of high-quality, timely and reliable data disaggregated by income, gender, age, race, ethnicity, migratory status, disability, geographic location and other characteristics relevant in national contexts'
- SDG17.19: 'By 2030, build on existing initiatives to develop measurements of progress on sustainable development that complement gross domestic product and support statistical capacity-building in developing countries'.

The OECD report points out that 'some SDG Targets are multifaceted, phrased in general terms or open to different interpretations, implying that more than one Indicator is needed to monitor progress. In these cases, relying on a single Indicator can lead to wrong conclusions (OECD, 2022, 19). The report also points out that data availability is one of the most salient challenges standing in the way of a more robust assessment of the progress in SDGs, but other statistical gaps such as timeliness or granularity also weigh heavily on the assessment of progress.

SDG17 – Global partnership

Given the importance of resources, capacity building, technology and data sharing amongst various countries, and multiple agencies and stakeholders, a specific SDG, SDG17, has been proposed for strengthening the means of implementation and revitalising the global partnership for sustainable development. SDG17 has 19 Targets and 24 Indicators that focus on specific areas of global partnership, for example:

- Five Targets, SDG17.1 to SDG17.5, and seven corresponding Indicators for *Finance*
- Three Targets, SDG17.6 to SDG17.8, and three corresponding Indicators for *Technology*
- One Target, SDG17.9 and one corresponding Indicator for Capacity building
- Three Targets, SDG17.10 to SDG17.12, and three corresponding Indicators for *Trade*
- and seven Targets on systemic issues:
 - Targets SDG17.13 to SDG17.15, and three corresponding Indicators for *Policy and Institutional Coherence*
 - Two Targets, SDG17.16 and SDG17.17, and two corresponding Indicators for *Multi-stakeholder Partnerships*
 - Two Targets, SDG17.18 and SDG17.19, and five corresponding Indicators for *Data Monitoring and Accountability*.

Seventeen of these Indicators are Tier I, i.e. data is available or produced in at least 50% of the countries, 6 are Tier II, i.e. data is not available or produced in most countries, and one is mixed, i.e. can be Tier I or Tier II, depending on the available resources. These Targets and the corresponding Indicators have led to the development of some global partnerships, co-operation and capacity building. However, as shown in Table 5.1, disaggregated data is available only for 3 out of 24 Indicators in more than one-third of the

countries. Also as shown in Table 5.2, only a third of the countries have data for some Indicators for SDG17, that is the equivalent of about 2.5 years since 2015.

The UN report highlights the following developments in the area of ICT (UN Economic and Social Council, 2022, 24–5):

- The number of people using the internet surged by 782 million to reach 4.9 billion people in 2021, or 63% of the world's population.
- Globally, in 2020, 62% of men were using the internet compared with 57% of women.
- Fixed broadband subscriptions continue to grow steadily, attaining a level of 17 subscriptions per 100 inhabitants on a global average in 2021.
- In the least developed countries, fixed broadband remains a privilege of the few, with only 1.4 subscriptions per 100 inhabitants.
- Growth in trade of environmentally sound technologies over 2015–2020 was 5%, which represented a drop in the overall growth rate of 8% during 2015–2019.

On a positive note, the report (p. 25) observes: 'while the pandemic has had a negative impact on international trade, those countries with strong economies, large manufacturing and/or financial bases and a focus on innovation are increasing their investment and trade in environmentally sound technologies'.

With regard to the SDG17, the OECD 2022 report points out that 'the total official development assistance (ODA) provided by members of the Development Assistance Committee (DAC) is less than half the Target (0.7% of gross national income (GNI) agreed by the donor community (Target 17.2), and that very few OECD countries are using results frameworks and planning tools owned by recipient countries when deciding how to allocate ODA (Target 17.15)' (OECD, 2022, 23).

Some examples of collaboration and resources

Some specific examples of collaborative efforts, especially in relation to data collection and data sharing, as well as challenges regarding technology, capacity building and data monitoring and accountability are:

- **UN Global Pulse** (www.unglobalpulse.org): UN Global Pulse is the UN Secretary-General's Innovation Lab – a hub for experimentation on how inclusive innovation can contribute to the achievement of the SDGs. It has produced several white papers, innovation guides, project briefs and

other publications around challenges and opportunities in five thematic areas, as follows:

1 Restoring trust: focuses on mitigating risks of technologies and building trustworthy digital ecosystems
2 Digital inclusion: focuses on improving diversity, equity and inclusion in the context of digital transformation
3 A fair digital commons: focuses on growing new digital infrastructure and public goods and services
4 Crisis prevention and response: focuses on running crisis anticipation experiments and providing support for proactive crisis response
5 UN transformation: focuses on contributing to the transformation of the UN system and supporting the Secretary-General's vision.

- The **Open SDG Data Hub** 'promotes the exploration, analysis, and use of authoritative SDG data sources for evidence-based decision-making and advocacy' (https://unstats-undesa.opendata.arcgis.com).
- **SDG API**: The United Nations Statistics Division SDG Application Programming Interface (API) (https://unstats.un.org/sdgapi/swagger) allows people to explore the official SDG data reported by the custodian agencies.
- **The World Bank SDG Dashboards** (https://datatopics.worldbank.org/sdgs) presents data from the World Development Indicators (WDI) that help to monitor progress in SDGs. Users can 'choose Explore to explore all the Goals and Targets, or Selected Indicators to compare two economies side-by-side for a selection of Indicators'.
- **The UN Global Compact Network UK** (Global Compact Network UK, 2022b) is 'working with hundreds of stakeholders to review how the UK is performing against the SDGs, the wider policy context, and the historical trends that affect us achieving the Goals.'
- **The SDG index dashboard** (https://dashboards.sdgindex.org) provides a ranked list as well as interactive maps, visual displays and country profiles showing how each of the 193 UN member states have performed so far in terms of their overall achievements, as well as achievement in each SDG. In this dashboard, 'countries are ranked by their overall score. The overall score measures a country's total progress towards achieving all 17 SDGs. The score can be interpreted as a percentage of SDG achievement. A score of 100 indicates that all SDGs have been achieved.'
- **SDMX (Statistical Data and Metadata eXchange)** is 'an international initiative that aims at standardising and modernising ("industrialising") the mechanisms and processes for the exchange of statistical data and

metadata among international organisations and their member countries' (https://sdmx.org/?page_id=3425).

- **ADAPT (Advanced Data Planning Tool)** (www.paris21.org/advanced-data-planning-tool-adapt) is a free, cloud-hosted, multilingual and consultative data planning tool developed by PARIS21. PARIS21, the Partnership in Statistics for Development in the 21st Century, was founded in November 1999 by the United Nations, the European Commission, OECD (Organization for Economic Co-operation and Development), IMF (International Monetary Fund) and the World Bank to support the goals of the UN Conference on Development. ADAPT helps data producers to: (1) adapt their data production to the priority data needs, (2) promote quality assessment and reuse of data, (3) reinforce data infrastructure in a national or regional context, (4) enable detailed analysis of the demand and supply of data; and (5) support monitoring of data planning activities including costing, budgeting, and reporting (PARIS21, 2022a). The PARIS21 Partner Report on Support to Statistics 2022 shows nearly 16% shortfalls in funding to data and statistics in 2020, which is partly due to the COVID-19 pandemic, but this funding gap makes it more difficult for countries to catch up, with negative consequences for evidence-based policy making at the country level (PARIS21, 2022b). The report further points out that funding for gender data dropped by more than 50% from 2019, and this is going to have an impact on the global ambitions to support gender equality.
- Release of a unique publication on SDG17 that promotes partnership to transform Africa and the world.
- Regional forum on sustainable development to define a roadmap for operationalising Africa's decade of action.

The SDG dashboard (www.sdgindex.org) shows the total progress across all SDGs for each country. One can hover over the world map to see the overall score for a country. The interactive world map shows the score (out of 100) for each country; and here are some of the examples of country scores:

- Finland is 86.51
- Sweden is 85.19
- Germany is 82.18
- UK is 80.55
- New Zealand is 78.30
- Canada is 77.73
- USA is 74.55
- Venezuela is 60.34

- Afghanistan is 52.49
- South Sudan is 39.05.

These discussions around the availability of data on the SDG Indicators, and the overall progress of SDGs in different countries, clearly point out the need for action in several areas for building and boosting co-operation amongst the countries and multiple international and national agencies and stakeholders in different areas for capacity building in the collection, management and sharing of appropriate data and information for various Targets and Indicators of the SDGs. Open SDG is the product of such an international collaboration.

Open SDG

Open SDG is an open-source multilingual platform for reporting SDG Indicator data, and it is designed to deliver 'improved transparency of SDG data, unlocking the power of data through new presentation and dissemination techniques. It enables the implementation and the delivery of the SDGs at a local, national, regional, and global level' (UN Department of Economic and Social Affairs, n.d.g). Open SDG is the result of collaboration between the UK Office for National Statistics (ONS), the US government, the non-profit Center for Open Data Enterprise (CODE) and members of the Open SDG community. ONS also provides direct support to some countries to establish their own national SDG data platforms and so far seven countries have received direct support from the ONS for this; currently, globally Open SDG is being used by 22 countries, regions and cities (UN Department of Economic and Social Affairs, n.d.g). Key features of Open SDG are (open-sdg.readthedocs.io):

- machine-readable data
- data visualisations: graphs, data tables, and maps
- multilingual: already available in the six official UN languages and more, using the SDG Translations resource
- fully customisable, e.g. by default, data uploaded to an Open SDG platform is displayed on a chart and a table, but users can configure their platform and display data on a map.

Open SDG platforms have a search function, that helps users to find information quickly (https://open-sdg.readthedocs.io/en/latest/open-sdg-features):

- the title of an SDG Indicator page
- the content of the Indicator page, which starts with and ends with some words/phrases
- the content of pages such as the About or FAQ page
- the ID number of an Indicator or SDG, e.g. 3 or 3.1.2.

SDG data for the UK is published on the SDG website, which uses the free Open SDG tool. The UK SDG data is available in more formats, such as Statistical Data and Metadata eXchange (SDMX) (discussed above) to enable sharing of data across systems easily by the UN and UK government (ONS, 2021c).

Summary

'A sustainable future for all will not be possible without accurate information and data', comments the Secretary-General of OECD (OECD, 2022). As discussed earlier in this book, and especially in this chapter, data is being widely recognised as a strategic asset in accelerating the achievements in the SDGs. However, significant data gaps exist, even though eight years have passed since the adoption of the UN 2030 Agenda.

As discussed in this chapter, despite having a specific SDG for co-operation and capacity building (SDG17) with 24 specific Targets, many countries are still lacking the appropriate capacity and resources for data collection, management, and monitoring of the SDG Targets. Data gaps and time lags in official statistics from several countries highlight the need for further investment in building national statistical capacity, and new approaches to monitor countries' commitments and progress on key SDG trans-formations.

Progress in the SDGs can be affected by a multitude of external threats and shocks, such as natural disasters like floods, droughts, fire, earthquake; health disasters like the COVID-19 pandemic; armed conflicts like the Ukraine war, and civil war; and technological challenges like data infrastructure and cybersecurity. No country can single-handedly prevent, respond and recover from these global challenges, and consequently the multilateral system must be supported to work effectively for strengthening preparedness, co-ordinated responses and resilience to critical risks (Sachs et al., 2021).

Along the same lines, the 2021 UN report on SDGs points out: 'what is needed now are new investments in data and information infrastructure, as well as human capacity to get ahead of the crisis and trigger earlier responses, anticipate future needs and design the urgent actions needed to realize the

2030 Agenda for Sustainable Development' (United Nations, 2021, 4). It is also recommended that 'more 'forward-looking' policy trackers are also needed to assess implementation efforts on key SDG transformations, and especially to monitor countries' actions on sustainable land use, diets, and responses to the biodiversity crisis' (SDG Index, 2023).

In addition to increased investments in building capacities of national agencies, and boosting collaborations amongst various national and international agencies and stakeholders, the main objectives of the UN 2030 Agenda will remain unmet if people cannot access data and information using the appropriate tools and technologies. Here the term 'people' should be considered in a wider context, to include those who: (1) create and manage data in various government departments, businesses and institutions; (2) need data and information for making decisions (like politicians, managers and executives in multiple countries and organisations); and (3) need data and information for everyday learning and living – education, health, citizenship, and so on. This calls for wider initiatives and measures for improving: (1) digital access, and thus bridging the digital divide, and (2) inclusive access to data and information, and thus bridging the information divide. These issues are discussed in the next two chapters.

People and the SDGs: the Digital Divide

Introduction

People are at the centre of the SDGs, and while some SDGs are directly aimed at improving people's lives and living, such as eradication of poverty (SDG1) and hunger (SDG2), health (SDG3), education (SDG4), clean water and sanitation (SDG5), and work and economic growth (SDG8), others are meant for society as a whole, like gender equality (SDG5), reduced inequality (SDG10), and peace, justice and strong institutions (SDG16). As discussed in Chapter 3, the SDGs can be grouped in different ways, for example, in five categories, called the five Ps:

- People: SDG1, SDG2, SDG3, SDG4 and SDG5
- Planet: SDG6, SDG12, SDG13, SDG14, SDG15
- Prosperity: SDG7, SDG8, SDG9, SDG10, SDG11
- Peace: SDG16
- Partnership: SDG17.

Or they can be grouped in the three categories, as the economic, social and environment SDGs:

1 Economic SDGs
 (a) Life: SDG1, SDG2 and SDG3
 (b) Economic and technological development: SDG8 and SDG9
2 Social SDGs
 (a) Equity: SDG4, SDG5 and SDG10
 (b) Social Development: SDG11, SDG16 and SDG17
3 Environmental SDGs
 (a) Resources: SDG6, SDG7, SDG12 and SDG14
 (b) Environment: SDG13 and SDG15.

Given that data is now considered as the 'oil' for the digital era (Economist, 2017), ICT (information and communication technology) and data form the

foundation of progress in all the SDGs and their Targets. Access to the internet has significantly impacted society – people's lives and living. It is now considered as one of the key requirements for making progress in any area of life and living in the digital era. Therefore, it is the key Indicator to measure the growth of the information society.

The 2030 Agenda for Sustainable Development recognises that 'the spread of information and communications technology and global interconnectedness has great potential to accelerate human progress, to bridge the digital divide and to develop knowledge societies' (ITU, 2020, 1). Therefore, the SDG Indicator 17.8.1 specifically aims to measure how people in different countries access the internet, and can help to measure the digital divide.

Though ICT and data form the foundation of progress in all the SDG Targets, the level of access to, and use of, the internet for access to information is still a far-off goal for many people, and this creates a digital divide in society. It is clear that the gaps in the level of access to the internet or the digital divide create a major challenge for progress in any SDG.

The challenges of the digital divide are discussed in this chapter, and through data on the digital divide in the UK, and in some other countries, it is shown how progress in the SDGs can be affected by the digital divide. If the digital divide is not properly addressed, it will escalate the inequalities in all development domains; hence, some variables, such as, age, sex, education level and so on can help to identify digital divides in individuals using the internet. Strategies and activities designed to identify and bridge the digital divide can also contribute to the design of targeted policies to overcome those divides (UN Statistics Division, 2023).

Access to the internet and the digital divide

Digital divide is defined as 'the problem of some members of society not having the opportunity or knowledge to use computers and the internet that others have' (Cambridge Dictionary, 2022). Digital divide is also used as a term to describe the perceived disadvantages of those who are either unable, or do not choose, to use the appropriate ICTs in their day-to-day activities, decision making, learning and pleasure. The term 'digital exclusion' is also used to mean the same thing. Digital exclusion is measured by the number of adults who have either never used the internet or have not used it in the last three months, described as 'internet non-users'.

Table 6.1 opposite shows that although there have been significant improvements in access to the internet over the past few years, there is still some significant digital divide in different parts of world. For example, while the current global average of access to the internet is 59.1%, only 21.6% of

Table 6.1 *Proportion of people around the world who use the internet (per 100 inhabitants) (SDG 17.8.1)*
(unstats.un.org/sdgs/files/report/2022/E_2022_55_Statistical_Annex_I_and_II.pdf)

Regions	2000	2005	2010	2015	2020
World	5.3	15.8	28.9	40.5	59.1
Sub-Saharan Africa	0.9	2.7	6.1	16.1	28.6
Northern Africa and Western Asia	2.2	9.9	28.0	46.8	68.4
Northern Africa	0.6	9.7	22.8	41.4	64.2
Western Asia	3.5	10.1	32.7	50.8	72.0
Central and Southern Asia	0.6	2.9	7.9	16.5	41.4
Central Asia	1.0	2.8	18.4	43.7	63.3
Southern Asia	0.6	2.9	7.5	15.5	40.5
Eastern and South-Eastern Asia	5.0	14.2	33.9	48.1	68.7
Eastern Asia	5.7	15.8	39.5	54.4	73.1
South-Eastern Asia	2.6	9.6	18.8	31.5	57.8
Latin America and the Caribbean	5.2	17.5	34.7	54.4	73.1
Oceania	33.6	45.3	57.3	65.4	71.0
Australia and New Zealand	46.8	63.0	76.7	84.7	89.9
Oceania (exc. Australia and New Zealand)	1.8	4.7	6.9	16.1	21.6
Europe and Northern America	20.4	50.8	65.7	74.9	87.3
Europe	18.6	41.0	62.5	74.3	85.2
Northern America	51.3	72.5	72.5	76.1	91.5
Landlocked developing countries	0.5	1.9	7.9	19.2	32.3
Least Developed Countries	0.4	0.8	3.1	10.8	24.6
Small island developing states	6.0	14.2	24.6	39.4	60.6

people in Oceania (excluding Australia and New Zealand), 28.6% of people in Sub-Saharan Africa, 24.6% people in the least developed countries and 32.3% of people in the landlocked developing countries access the internet.

The digital divide, or digital exclusion, can be caused by many factors, such as lack of accessibility to, and affordability of, the internet, and also relevance of the internet, i.e. whether people can meaningfully access and use it. The digital divide encompasses differences both in terms of access and use of the internet (and more broadly ICT) between: (1) industrialised and developing countries (global divide), (2) various socio-economic groups within single nation-states (social divide) and (3) different kinds of users with regard to their political engagement on the internet (democratic divide) (Britannica, 2023).

It is important to investigate the factors related to the digital divide – inequality in access to, and use of, ICTs – and more generally, characteristics

of access to technologies and their use by different demographic and social groups (ITU, 2020, 3). 'Internet user uptake is a key indicator tracked by policy-makers and analysts as an indication of a country's progress towards becoming an information society' (p. 106).

The digital divide in the European Union

The EU SDG monitoring report (EC, 2022a) notes that considerable progress has been made in rolling out fixed very-high-capacity network (VHCN) connections reaching 70.2% of EU households in 2021. Between 2016 and 2021, the share of rural households with fixed VHCN connection increased from 7.7% to 37.1% across the EU (Figure 6.1) . However, these figures also point out that a significant digital divide exists among urban and rural populations: while on average 70.2% of EU households have VHCN, this figure is nearly half (37.1%) for the low-settled areas (rural population) in the EU (Figure 6.1).

Significant differences in terms of the digital divide can also be noticed amongst the various EU countries. Data in Figures 6.1 and 6.2 show that there

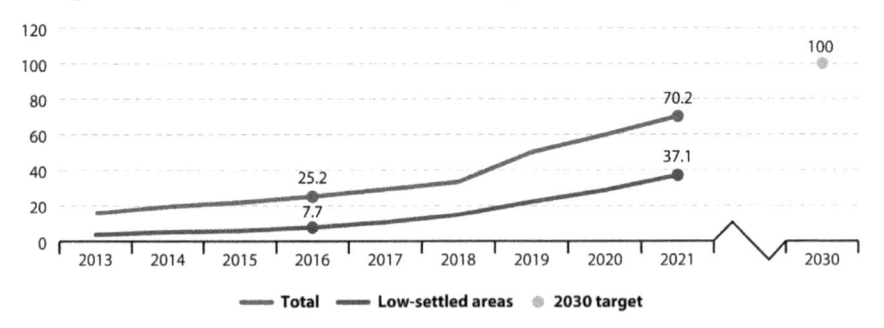

Figure 6.1 *Growth of internet access in the EU countries*
(https://ec.europa.eu/eurostat/documents/15234730/15242025/KS-09-22-019-EN-N.pdf/a2be16e4-b925-f109-563c-f94ae09f5436?t=1667397761499)

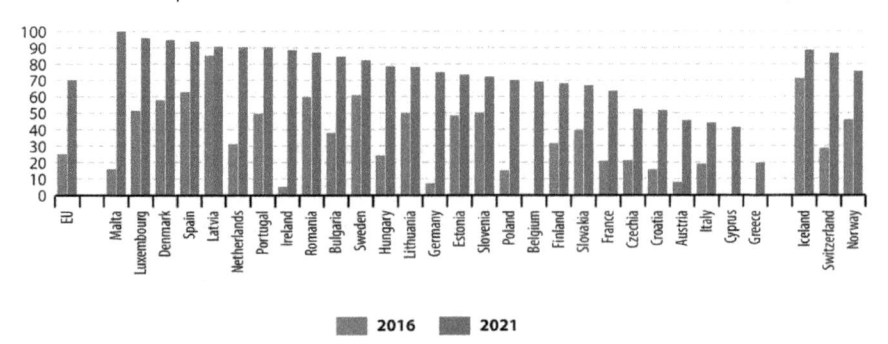

Figure 6.2 *Internet connections in the EU countries*
(https://ec.europa.eu/eurostat/documents/15234730/15242025/KS-09-22-019-EN-N.pdf/a2be16e4-b925-f109-563c-f94ae09f5436?t=1667397761499)

has been a significant improvement in terms of high-speed broadband connections in every EU country over the period 2016–2021. However, some countries in Europe have made much more progress than the others. For example:

- 100% of the households in Malta have high-speed broadband connections.
- Nearly 95% of all households in Denmark, Luxembourg and Spain have high-speed broadband connections.
- Only 19.8% of all households in Greece have high-speed broadband connections.
- All the remaining EU states have over 40% of households with high-speed broadband connections, in comparison with the EU average of about 70%.

It may also be noted that 10 European countries have lower household high-speed internet access than the EU average, and hence 'making Europe fit for the digital age is one of the six Commission priorities for 2019–2024' (Eurostat, 2022b, 7).

The digital divide in the G20 countries

According to the OECD, the term digital divide is used to refer to the gaps in the access and use of ICTs in general, and more specifically, to the gaps in access and use of internet-based digital services (OECD, 2021). The OECD (2021) report points out that the digital divide challenges should be addressed at three layers: (1) the network or connectivity layer, which is related to the access and uptake of communication services; (2) the application interfaces and data layer, which is related to the access and transfer of data, and applications running on networks; and (3) the end-user layer, which is related to diffusion of digital technologies and how these are employed, taking into account the heterogeneity of firms and individuals. The report also points out that compared to the rest of the world, the levels of broadband subscriptions are higher among the G20 countries: on average, 19.6 fixed broadband subscriptions per 100 inhabitants in 2019, which was 2.6 times the rate in the rest of the world, which has 7.5 subscriptions per 100.

The report points out that although the 'connectivity divide' is a common occurrence in areas with low population densities and disadvantaged groups, 'bridging the connectivity divide is by no means an issue solely concerning rural and remote regions'. The report further observes that: 'in addition to the digital divide between countries, a second type of divide exists within countries. Addressing these divides through spatially-sensitive national and

regional policies is necessary to ensure that existing gaps in communication infrastructure and digital human capital are not further magnified, leaving some places with little chance to catch-up with their more advanced peers.'

Digital divide can also be caused by the low speed of broadband services, and such divide is also common in many OECD countries, e.g. (OECD, 2021):

- Compared to 86% of households in all areas overall, only 59% of rural households in Europe had access to fixed broadband with a minimum speed of 30 Mbps (megabits per second).
- Compared to 93% of households in all areas overall, only 67% of rural households in Canada had access to fixed broadband with a minimum speed of 30 Mbps.

The digital divide in the UK

The UK Local Government Association notes that digital access and skills are essential to enabling people to fully participate in the digital society, and tackling the digital divide is crucial to addressing social and economic inequalities (Local Government Association, 2021). Data from the UK Office for National Statistics (ONS) and the Ofcom reports show that (Ofcom, 2022a, 2023; ONS, 2021b):

- While access to the internet at home is widespread, a small group of households remain offline and face the risk of digital exclusion: 93% of UK households have access to the internet at home; 7% of households do not have access via any device, and are at risk of digital exclusion (Ofcom, 2023).
- While most adults in the UK are online, and have access to the internet at home, it is not the case for everyone (Ofcom, 2023).
- Three groups of internet users, 'Narrow', 'Medium' and 'Broad', can be identified based on 13 of the specified online activities (Ofcom, 2023).
- Different devices may be suitable for certain online activities; therefore, how the device is used can affect the user's online experience (Ofcom, 2023).
- Most smartphone users agree it is more difficult to complete forms and work on documents on a smartphone than on a laptop or desktop (66%), and around half (49%) agreed it was more difficult to compare products and services online (Ofcom, 2023).
- Over a quarter of those who access the internet only via a smartphone said they had, at some point, felt disadvantaged by their reliance on the device (Ofcom, 2023).

- The subtlety of digital exclusion is that even those with access to both an internet connection and a suitable device can be at risk of digital exclusion compared to those with greater choice in their means of accessing the internet (Ofcom, 2023).
- 46% of those who didn't use the internet at home had asked someone to do something for them online. Asking someone to buy something was most common (49%), while asking someone to access health services online (24%) and other public services provided by the Government/council (20%) were also cited (Ofcom, 2023).
- The number of disabled adults who were recent internet users in 2020 reached almost 11 million, 81% of disabled adults (ONS, 2021b).
- 21% of internet users were accessing the internet exclusively via a smartphone in 2021, and this was more likely among those (Ofcom, 2022a, 1):
 - aged 25–34
 - in C2 (skilled manual occupations, 20.94% of population in the UK) or DE (semi-skilled and unskilled occupation, unemployed and lowest grade occupations, 20.6% of the population) households
 - the most financially vulnerable, and was more likely among women than men.
- Among all working-age (18–64 years) people in DE households, the incidence of not having internet access at home was 5%; but increased to 30% among those aged 65+ in DE households (Ofcom, 2022a).
- Those of working age in DE households were still more likely to not have internet access at home than those of working age in non-DE households (1%) (Ofcom, 2022a).

Figure 6.3 on the next page shows the differences in internet access by age groups and household income groups. The Ofcom report (2022a) clearly demonstrates that the digital divide exists between the younger and older people, and among the able-bodied and disabled people in the UK. Digital divide also exists amongst different regions of the UK. For example, London continued to be the UK region with the highest recent internet use (95%) in 2020, while Northern Ireland remained the lowest at 88%.

Figure 6.3 shows that 26% of people over the age of 75 do not have access to the internet at home; and 14% of households that have lowest grade occupations do not have access to the internet at home. Similarly, 13% of people who are not working do not have access to the internet at home.

Legend: Households: AB -- Higher & intermediate managerial, administrative, professional occupations (22.17% of population); C1: Supervisory, clerical & junior managerial, administrative, professional occupations (30.84% of population); C2 – Skilled manual occupations (20.94% of population); DE: Semi-skilled & unskilled manual occupations, unemployed and lowest grade occupations (26.05% of population)

Figure 6.3 *People who don't have internet access at home in the UK by age and income groups in 2021* (© Ofcom, 2022a)

Digital carers

A number of people who are digitally excluded often seek or get help from other people who act as the 'digital intermediaries', and some of these intermediaries often become the 'digital carers' for those people who cannot access the internet by themselves. As mentioned earlier in this chapter, the Ofcom report (2022a) shows that nearly half (49%) of those who did not use the internet at home had asked someone else to do something for them online in the past year. The types of help offered by the 'digital intermediaries' or 'digital carers' were:

- to buy something online (63%)
- help with a variety of important government, civic or health activities online:
 - 18% asked someone to access public services provided by the government or council on their behalf
 - 15% to access health services online
 - 9% to apply for or claim some type of benefit.

The same report further points out that:

- 86% of internet users aged 16–24 were most likely to have offered help as the digital carers.
- Those in the AB and C1 households (70%) were more likely than C2 and DEs to have helped someone online (56%).
- Of those who acted as the digital carers, 70% were doing so at least monthly and 37% at least weekly.

- For younger digital carers this was higher: 81% of 16–24s who had helped someone online were doing so monthly, and 46% weekly.

Factors causing the digital divide

The digital divide and digital exclusion are related to wider inequalities in society that the SDGs aim to address. In fact, on the one hand, the digital divide and digital exclusion are caused by social inequalities like low household incomes, but they also contribute to social inequalities, because poor and unemployed people who do not have access to the internet are often disadvantaged in securing jobs or better-paid jobs. Some of these key SDG-related challenges and the digital divide are discussed below.

The discussions below point out that older people and disabled people are less likely to use the internet if they have low incomes, and if they live alone. Data from both the Ofcom report (2022a) and the Local Government Association (2021) support these points.

Age as a factor

Data in Table 6.2 shows that the rate of access to internet in UK households drops with age: it drops for people aged 65–74 (85.5%) and drops sharply for people aged 75 and over (54%), compared to the average of 92.1%.

Table 6.2 *Internet use in the UK by age groups* (ONS, 2021b)

	Used in the last 3 months							
	2013	2014	2015	2016	2017	2018	2019	2020
All adults	83.3	85.0	86.2	87.9	88.9	89.8	90.8	92.1
Age group (years)								
16–24	98.3	98.9	98.8	99.2	99.2	99.3	99.2	99.5
25–34	97.7	98.3	98.6	98.9	99.1	99.2	99.4	99.5
35–44	95.8	96.7	97.3	98.2	98.4	98.6	98.9	99.1
45–54	90.2	92.3	93.6	94.9	96.2	96.8	97.5	97.9
55–64	81.3	84.2	86.7	88.3	90.0	91.8	93.2	94.6
65–74	61.1	65.5	70.6	74.1	77.5	80.2	83.2	85.5
75+	29.1	31.9	33.0	38.7	40.5	43.6	46.8	54.0

When it comes to internet access at home, the number is even lower for older people; for example:

- UK home internet access (2021 figures) (Ofcom, 2022a):
 - 16–24 years: 99%
 - 25–34 years: 99%
 - 35–44 years: 97%
 - 45–54 years: 97%
 - 55–64 years: 96%
 - 65+ years: 73%.
- USA home internet access (2021 figures) (Statista, 2022a):
 - 18–29 years: 70%
 - 30–49 years: 86%
 - 50–54 years: 79%
 - 65+ years: 64%

Similar trends in terms of falling internet access rate with age of people can be seen in other developed countries, e.g.

- the EU-27 home internet access (in the 27 countries in the European Union) (Statista, 2022b):
 - 16–24 years: 95%
 - 25–34 years: 94%
 - 35–44 years: 90%
 - 45–54 years: 82%
 - 55–65 years: 69%
- Daily internet access figures (2021) in the USA shows the following trends (Statista, 2022c):
 - 18–29 years: 99%
 - 30–49 years: 98%
 - 50–54 years: 96%
 - 65+ years: 75%

When these figures of low internet access by older people are compared with the internet access patterns for the overall population in different parts of the world, it is quite evident that older people are more likely to be digitally excluded, and therefore they won't be able to, contribute to, or reap the benefits of the achievement around various SDGs.

Household income as a factor

The Local Government Association (2021) in the UK observes: 'when the pandemic hit in March 2020, only 51 per cent of households earning between £6,000 to £10,000 had home internet access, compared with 99 per cent of households with an income over £40,000.'

Table 6.3 shows the patterns of internet access in different households by income groups defined by the nature of professions/occupations. It shows that fewer people in the lower-income households (C2 and DE) use the internet at home. However, more people from these lower-income groups use only smartphones to go online. This clearly shows that more people from the lower-income groups are likely to be digitally excluded. It is also worth noting that (Ofcom, 2022a):

- population groups that are more likely not to have internet access at home are those aged 75+ (26%), those in DE households (14%), and those who are most financially vulnerable (10%)
- the likelihood of not having internet access at home for DE households was 5% for working age people (18–64 years), but it is 30% among those aged 65 and over.

Table 6.3 *Internet access patterns by household income groups in the UK* (Ofcom, 2022a)

Household income group	Internet use at home	Only use smartphone to go online	Narrow internet users
AB: Higher and intermediate managerial, administrative, professional occupations	97%	15%	23%
C1: Supervisory, clerical and junior managerial, administrative, professional occupations	96%	14%	22%
C2: Skilled manual occupations	91%	28%	32%
DE: Semi-skilled and unskilled manual occupations, unemployed and lowest-grade occupations	82%	31%	40%

Table 6.3 also shows that more people in the lower-income household groups are narrow internet users: 32% in C2 households and 40% in DE households. Ofcom (2022a) classified internet users in three categories based on the number of activities they take part in, out of a list of 13 most commonly used online activities:

1 online banking
2 paying bills
3 paying for council tax or another local council service
4 looking for public services information on government sites
5 finding information for work/business/school/college/university

6 looking or applying for jobs
7 finding information for leisure time
8 completing government processes
9 signing a petition or using a campaigning website
10 using streamed audio services
11 listening to live, catch-up or on-demand radio through a website or app
12 watching TV programmes/films/content
13 watching or posting livestream videos

Based on the number of people's activities online, users are classified by Ofcom as:

1 'Narrow' internet users: those users who had ever undertaken between one and four of the 13 online activities; this accounted for 29% of internet users
2 'Medium' internet users: those users had ever undertaken between five and eight activities; this accounted for 40% of internet users
3 'Broad' internet users: those users had ever undertaken between nine and thirteen of the activities; this accounted for 28% of internet users.

Table 6.4 shows access to the internet by income groups. It shows that only 71.1% of retired people access the internet, as opposed to 99% of the population who are employed.

Table 6.4 *Access to the internet by income groups in the UK* (ONS, 2021b)

	Used in the last 3 months									
	2011	2012	2013	2014	2015	2016	2017	2018	2019	2020
Employed	93.2	94.4	95.6	96.3	96.9	97.7	98.1	98.3	98.7	99.0
Self-employed	89.8	90.9	92.8	93.7	95.0	95.8	96.4	97.1	97.7	98.0
Government employment & training programmes	90.8	91.6	92.2	93.9	92.4	92.5	97.0	98.8	98.4	99.6
Unpaid family worker	83.9	85.9	83.4	86.0	89.5	89.0	90.6	94.6	96.7	93.5
Unemployed	89.8	90.8	92.6	94.6	94.9	96.0	96.9	97.2	97.4	98.5
Student	98.7	98.8	99.0	99.5	99.1	99.2	99.5	99.5	99.3	99.4
Retired	39.8	43.2	48.1	51.8	54.5	58.9	61.4	64.3	66.8	71.1
Inactive[2]	69.9	71.5	75.6	78.7	81.5	83.4	85.8	87.9	88.7	90.3
Total	**79.3**	**80.9**	**83.3**	**85.0**	**86.2**	**87.9**	**88.9**	**89.8**	**90.8**	**92.1**

Note: Inactive refers to looking after family, a disability or other reasons for being economically inactive.

Household income and access to the internet are also closely related in other countries. For example, data on internet access in the USA based on annual household income shows (Statista, 2022d):

- more than US$75,000: 99%
- US$50,000–74,999: 98%
- US$30,000–49,999: 91%
- less than US$30,000: 86%.

Geographical location as a factor

Digital divide is also caused by where people live even within the same country. Table 6.5 shows the internet access in UK by region. It may be noted that London has the highest rate of internet access (nearly 95%) while Northern Ireland has the lowest (88%).

Table 6.5 *Internet access in the UK by region* (ONS, 2021b)

Region	Internet access %
UK	92.1
North East England	88.6
North West England	91.0
Yorkshire and the Humber	90.7
East Midlands	91.3
West Midlands	90.9
East of England	92.2
London	94.9
London South East	94.2
London South West	93.3
Wales	90.2
Scotland	91.3
Northern Ireland	88.0

In addition, there is a difference in the internet access by urban and rural populations in a country or region. As discussed earlier in this chapter, and shown in Figure 6.2, on average 70.2% of EU households have VHCN, but only 37.1% of populations in low-settled (remote or rural) areas. There are also vast regional disparities in the broadband infrastructure in UK; for example (Local Government Association, 2021):

- 70% of premises in London have gigabit coverage.
- On average 50% of premises in large towns and cities in the North and West Midlands have gigabit coverage, but only 21% of premises in county areas.
- 17% of rural residential premises and 30% of rural commercial premises still do not have high-speed broadband (30 Mbit/s or higher).

This clearly shows that digital divide depends on the geographical location of the population, and people living in the remote or rural areas are more likely to be digitally excluded, in one way or another, compared to those who live in the cities.

Ethnicity as a factor

Table 6.6 shows how ethnicity plays a role in digital divide or digital exclusion.

Table 6.6 *Access to the internet by ethnicity of population in the UK* (ONS, 2021b)

	Internet used in the last 3 months							
	2013	**2014**	**2015**	**2016**	**2017**	**2018**	**2019**	**2020**
White	82.9	84.7	85.9	87.4	88.4	89.3	90.5	91.6
Mixed/multiple ethnic background	95.1	95.2	97.0	95.4	96.2	97.9	96.0	99.2
Indian	84.2	85.8	87.8	88.9	90.6	92.7	90.4	96.3
Pakistani	79.5	79.2	85.7	88.1	90.3	92.8	91.1	91.7
Bangladeshi	82.5	86.9	83.1	86.5	87.0	90.7	91.9	87.8
Chinese	93.6	90.8	92.6	96.4	98.3	97.6	98.6	97.6
Other Asian background	91.3	90.4	91.0	92.7	93.1	96.4	95.6	96.8
Black/African/Caribbean/Black British	86.2	87.7	87.7	90.5	92.1	91.2	92.8	95.4
Other ethnic groups	87.9	88.0	90.5	94.2	94.1	95.4	94.5	97.6

As shown in Table 6.6, Bangladeshi communities in the UK are more digitally excluded compared to the people from other ethnicities, and especially from the population from mixed/multiple ethnic background.

Disability as a factor

Table 6.7 opposite shows how people with disability in different age groups access the internet in the UK.

Overall, 25% of people in the UK with a registered disability (about 3.5 million) are unlikely to be online. It may be noted that older people with disability, who need to use the digital services the most, are more likely to be

Table 6.7 *Internet access by people with disability (Equality Act disabled*) in the UK* (ONS, 2021b)

Age group	Used in the last 3 months						
	2014	2015	2016	2017	2018	2019	2020
All	64.9	67.8	71.0	73.4	76.6	78.3	81.4
16-24	95.7	95.2	97.3	97.1	98.0	98.0	98.6
25-34	94.0	95.2	96.2	96.9	98.0	98.1	98.0
35-44	89.9	92.0	94.6	94.8	95.9	96.8	96.4
45-54	80.9	85.0	87.4	89.2	91.6	92.8	94.4
55-64	72.3	76.0	77.6	80.4	83.9	86.4	88.8
65-74	55.4	60.5	65.0	69.4	73.5	75.8	79.4
75+	25.8	27.4	30.8	34.0	38.8	40.7	47.0

*Equality Act disabled refers to those who self-assess that they have a disability in line with the Equality Act definition of disability.

digitally excluded. Use of internet is a yardstick to measure the digital divide; increasing the use of internet is often used as a force to reduce the digital divide, in other words digital exclusion, in society. However, disability is often ignored as a potential reason for the digital divide. Many researchers have shed light on it (see for example, Dobransky and Hargittai, 2021; Johansson, Gulliksen and Gustavsson, 2021; Pettersson et al., 2023; Scholz, Yalcin and Priestley, 2017).

Summary

As discussed in this chapter, access to ICT in general, and the internet in particular, is an essential requirement for living in today's digital world. However, although a separate SDG Target has been set for access to the internet (SDG17.8.1), data available from different countries and international agencies shows that the level of access to the internet varies significantly amongst countries; there are differences among the least developed countries in terms of internet access, and overall the figures on internet access are lower in those countries than in the developed countries. Data and discussions in this chapter also show that there are differences in the level of access to the internet among people from different cross-sections of society, and different population groups even in the developed countries like the UK, USA and the EU and OECD countries. These differences and gaps in internet access cause the digital divide and digital exclusion.

Discussions in this chapter show that the digital divide and digital exclusion can be caused by the age, ethnicity, disability status, country and place of living, and employment status and household income, of population

groups even in the same country. While the reports and data cited in this chapter acknowledge these challenges, some recommendations for bridging the digital divide have also been made. For example, the OECD makes the following recommendations for improving people's access to the internet (OECD, 2021):

- People need access to high-quality communication networks and services at competitive prices, regardless of where they live.
- Providing affordable access to high-quality communication networks is a necessary part of the solution for bridging the gaps and preparing rural places for the future.
- Policies and regulations should be created to foster competition, promote investment in fixed and mobile networks and reduce barriers to infrastructure deployment.
- Where private funding is not sufficient, some initiatives to bridge connectivity divides in rural and remote areas may require government financing, while others may focus on public–private partnerships.

The EU's digital strategy aims to make the digital transformation work for people and businesses, while helping to achieve its target of a climate-neutral Europe by 2050. 'Europe aims to empower businesses and people in a human-centred, sustainable and more prosperous digital future' (EC, 2023a), and the Commission's 'Digital Decade' aims to ensure that '80% of adults have at least basic digital skills and that 20 million ICT specialists are in employment in the EU by 2030' (EC, 2023b).

However, access to the internet alone does not ensure the optimum use of data and information relevant to people's needs for learning, living, development, entertainment and so on that the SDGs aim to achieve. Countries, institutions and society as a whole have important roles in increasing awareness and improving digital skills, literacy and information skills of people of all ages and all walks of life. Chapters 7 and 8 discuss the role of digital skills and information skills in the lives and living of people in general, and especially in the context of achieving success in the SDGs.

People and the SDGs: Access to Data and Digital Skills

Introduction

'The SDGs are meant to improve the lives of individuals, protect the planet and help ensure a prosperous future for all. In summary, the SDGs are meant to protect the interest of the public' (Vargas and Lee, 2023, 25). Many people in today's digital age have access to data; however, all citizens should have access to the relevant data and information for their learning, living, citizenship and so on. Therefore, everyone in society should not only have access to information and communication technologies (ICTs) and the internet, but they should also have the proper skills to navigate, access and use information. It echoes with the United Nation's *2030 Agenda*, which focuses on several communication and information issues: 'SDG5 highlights the importance of Information and Communication Technologies (ICTs) as tools for women's empowerment, while SDG9 promotes universal internet access. ICTs are also mentioned in SDG4 and SDG17. SDG16 calls attention to the importance of access to public information legislation and to the imperative of protecting journalists, trade unionists, and human rights defenders' (Vargas and Lee, 2023, 27).

As discussed in Chapter 6, it is widely recognised that access to adequate ICTs in general, and access to the internet in particular, is a prerequisite for access to data and information. However, access to the ICT or the internet alone cannot ensure that people are able to find and meaningfully use the data and information in the appropriate context of their living, learning, work and myriad other activities and events that take place in today's digital society. To make appropriate use of ICTs and the internet for accessing data and information, people need to acquire a set of digital skills. This chapter discusses what constitutes digital skills, and how they impact people's life, employment, work, health, etc.; and, more importantly, what digital skills mean in the context of the SDGs.

Digital literacy and digital skills

'The concept of digital literacy has been defined in numerous ways over the last two decades to incorporate rapid technological changes, its versatility, and to bridge the global digital divide' (Radovanović et al., 2020, 151). Generally speaking, digital literacy, or digital skills, is the set of skills or competencies required for optimum access to, and use of, ICTs in general, and the internet in particular, for communications, access, management, and use of information. In today's digital world, one needs a range of digital skills or competencies for almost every aspect of life and society, including learning, living, work, health and wellbeing, communications, entertainment and citizenship.

The COVID-19 pandemic, and the associated lockdown measures taken around the world, has been a game changer in our understanding of the importance of digital technologies and more specifically the importance of digital skills in today's world. Research shows that 'failure to understand digital technologies as communication, information and tools for social and behavioural change is a major bane in the attempt to achieve the SDGs' (Servaes and Yusha'u, 2023, 253).

Various governments and international agencies around the world have come up with different Indicators for measuring people's digital skills. SDG17.10 measures access to ICTs based on a simple estimation: whether and how people accessed the internet over the past three months for accomplishing various activities related to everyday living, learning, work, communications, health and wellbeing, entertainment and so on. However, access to ICTs and the internet is not a sufficient Indicator or measure of people's digital skills.

Research shows a number of key manifestations of communications and information poverty which is caused by the digital divide – lack of access to ICT and lack of digital skills, such as (Vargas and Lee, 2023, 29):

- lack of access to platforms meaningfully to raise concerns about issues that affect one's life
- under- or misrepresentation in media content
- low levels of media literacy
- limited access to relevant information, including public information
- exclusion from decision-making processes
- restrictions on freedom of expression, association, and assembly
- absence of a free, independent, inclusive and pluralistic media sector
- prevalence of negative stereotypes about marginalised groups
- social and cultural factors preventing genuine participation (e.g. discrimination because of gender, race, ethnicity, social class, etc.)
- media concentration in the hands of the powerful

- inaccessibility of information and communication (e.g. linguistic barriers)
- breaches of privacy, especially in relation to digital communication
- limited opportunities to participate in decision-making processes related to the regulation and governance of communication ecosystems.

In addition, the growth of information in all its forms, such as data, texts, videos or pictures, is rapid: some 3.2 billion images and 720,000 hours of video are circulated every day on social media (Angus, Dootson and Thomson, 2020). Digital skills play an important role in tackling the information overload/explosion in the digital society. Digital literacy also plays a significant role in providing sustainable development and therefore bridging the digital divide is an absolute necessity. Hence, some countries have come up with policies to build the capacity of teachers in the learning of digital skills. Eleven European countries that brought in such policies are: Germany, France, Portugal, Belgium, Cyprus, Denmark, Greece, Ireland, Italy, Malta and Spain (Zancajo, Verger and Bolea, 2022).

DigComp and DSI in the EU

Since 2014, the European Commission has been using the Digital Skills Indicator (DSI) framework to measure citizens' digital skills. It comprises a composite set of Indicators based on selected activities using the ICTs and the internet (Misheva, 2022). DSI has been revamped to create the new DSI2.0 framework in 2022. The European Commission's first Digital Competence Framework for Citizens, also known as the DigComp framework, introduced in 2013 (Vuorikari et al., 2022), and now DigComp 2.0, underpins the DSI as an underlying theoretical framework for measuring people's digital competence (Misheva, 2022).

DSI 2.0 is the result of work carried out in 2019–2022 within Eurostat's Information Society Working Group to modernise the Indicator by adapting it to the revised DigiComp 2.0 framework (Vuorikari et al., 2022). DSI 2.0 is now used to produce the annual Digital Economy and Society Index (DESI) report published by the European Commission that monitors the progress of EU Member States on their digital development (DESI, 2022a).

The selected activities for measuring people's digital skills/competence in DSI 2.0 are divided in five areas of DigComp 2.0, as follows (Vuorikari et al., 2022):

1 **Information and data literacy**: activities used for calculating the information and data literacy skills are:

 i1: Finding information about goods or services

 i2: Seeking health-related information

 i3: Reading online news sites, newspapers or news magazines

 i4: Activities related to fact-checking online information and its sources.

2 **Communication and collaboration**: activities used for calculating the communication and collaboration skills:

 c1: Sending/receiving e-mails

 c2: Telephoning/video calls over the internet

 c3: Instant messaging

 c4: Participating in social networks

 c5: Expressing opinions on civic or political issues on websites or in social media

 c6: Taking part in online consultations or voting to define civic or political issues.

3 **Digital content creation**: activities used for calculating the digital content creation skills:

 d1: Using word-processing software

 d2: Using spreadsheet software

 d3: Editing photos, video or audio files

 d4: Copying or moving files (such as documents, data, images, video) between folders, devices (via e-mail, instant messaging, USB, cable) or on the cloud

 d5: Creating files (such as documents, image, videos) incorporating several elements such as text, picture, table, chart, animation or sound

 d6: Using advanced features of spreadsheet software (functions, formulas, macros and other developer functions) to organise, analyse, structure or modify data

 d7: Writing code in a programming language.

4 **Safety**: activities used for calculating the safety:

 s1: Managing access to own personal data by checking that the website where the respondent provided personal data was secure

 s2: Managing access to own personal data by reading privacy statements before providing personal data

 s3: Managing access to own personal data by restricting or refusing access to own geographical location

 s4: Managing access to own personal data by limiting access to profile or content on social networking sites or shared online storage

 s5: Managing access to own personal data by refusing use of personal data for advertising purposes

 s6: Changing settings in own internet browser to prevent or limit cookies on any of the respondent devices.

5 **Problem solving**: activities used for calculating the problem-solving skills:
 p1: Downloading or installing software or apps
 p2: Changing settings of software, app or device
 p3: Online purchases (in the last 12 months)
 p4: Selling online
 p5: Used online learning resources
 p6: Internet banking
 p7: Looking for a job or sending a job application.

The Digital Skills framework in the UK

In the UK, the Essential Digital Skills (EDS) framework was created in 2018, and since 2019 the EDS has been measured by the Lloyds Banking Group, on behalf of the Department for Education. Working with the Department for Education and 40 cross-sector partners, the Lloyds Banking Group led the design of the new EDS framework that includes 26 tasks in Life EDS (Essential Digital Skills) and 20 work tasks (Work EDS), split across five skill areas (Lloyds Bank, 2022).

Essential Digital Skills (EDS), in the Lloyds Bank Digital Consumer Index (Lloyds Bank, 2022), measures how people can perform the following activities:

1 **Communicating**, which includes the following skills:
 (a) being able to set up accounts for communicating online, e.g. e-mail, social media, forums
 (b) being able to communicate with others using e-mail or apps like WhatsApp, Instagram, Facebook
 (c) being able to use software like Microsoft Word, Google docs, etc., for creating, writing or editing documents
 (d) being able to share files – such as proof of identity or images – by attaching to an e-mail, or uploading to a website or an app
 (e) being able to make and receive video calls, e.g. Facetime, Zoom, Facebook portal or WhatsApp call
 (f) being able to post messages, photographs, videos and blogs on social media platforms, such as Facebook, Instagram, TikTok, Twitter or Snapchat.
2 **Handling information and content**, which includes the following five skills:
 (a) being able to recognise what information or content online may or may not be trustworthy
 (b) being able to use search engines to find information such as news, weather, train times

(c) being able to store and back up photos, messages, documents, etc. on iCloud, Google Drive, Dropbox, OneDrive and so on

(d) being able to use the cloud to access content from different devices like smartphones, tablets, laptops or desktops

(e) being able to use the internet to stream or download entertainment, e.g. films, TV, music, games, etc., using services like YouTube, Netflix, Spotify, BBC iPlayer.

3 **Transacting**, which includes the following four skills:

(a) being able to set up an account for buying goods and services online e.g. on Amazon, eBay, supermarkets

(b) being able to fill in forms online for specific services like booking doctor's appointments, ordering repeat prescriptions, booking appointments with specific services

(c) being able to buy goods and services online and make payments using debit and credit cards, PayPal, Google Pay

(d) being able to manage money and transactions online, e.g. viewing account balance, transferring funds via internet or mobile banking apps.

4 **Problem solving**, which includes the following two skills:

(a) being able to use the internet to find information for solving specific problems, e.g. by using search engines, FAQs, forums

(b) being able to use the internet to improve skills and ability to do new things, e.g. using online tutorials, learning platforms and how-to-do guides.

5 **Being safe and legal online**, which includes the following nine skills:

(a) being able to act with caution online and understand that there are risks and threats in carrying out activities online and hence use tools such as anti-virus software and share information securely

(b) being able to set privacy settings on e.g. social media

(c) being able to follow data protection guidelines for e.g. data storage and retention

(d) being able to respond to requests for authentication for online accounts, e.g. resetting passwords, multifactor authentication

(e) being able to identify secure websites

(f) being able to recognise suspicious links

(g) being able to update device software and operating systems when necessary

(h) being able to identify secure Wi-Fi networks

(i) being able to be careful with what to share online.

It may be noted that some of the skills, and especially those that are required to be safe and legal online, require some awareness and training, and hence not everyone can possess all these skills without proper training. An individual needs to perform at least one task within each of the five Life and Work skill areas, without assistance, to achieve Life or Work Essential Digital Skills (EDS) (Lloyds Bank, 2022).

In this digital skills framework, the *Foundation Level* digital skills consist of eight most fundamental tasks. An individual needs to perform all the eight tasks without assistance to have the Foundation Level digital skills (Lloyds Bank, 2022):

1 Being able to turn on the device and enter the required account login information;
2 Being able to use the available controls on a device, e.g. mouse, keyboard, touchscreen;
3 Being able to use the different settings on a device to make it easier to use, e.g. adjust the font size, volume, brightness, etc.;
4 Being able to find and open different applications/programmes/ platforms on a device e.g. opening a web browser;
5 Being able to set up a connection to a Wi-Fi network on a device;
6 Being able to set up a connection to find and use websites;
7 Being able to keep login information and passwords for a device and any accounts secure; and
8 Being able to update and change passwords when prompted to do so.

Essential digital skills for work (Work EDS) are the skills required to be digitally proficient in the workplace. In addition to the Life EDS listed above, Work EDS require the following skills:

1 **Communicating**, which includes the following three skills:
 (a) being able to communicate in the workplace digitally using messaging applications like e-mails, Microsoft teams, Zoom, Slack
 (b) being able to use workplace digital tools to create, share and collaborate with colleagues, e.g. OneDrive, Office365
 (c) being able to set up and manage an account on a professional online network, community or job site like LinkedIn.
2 **Handling information and content**, which includes the following two skills:
 (a) being able to follow own organisation's ICT policies when sharing information internally and externally

 (b) being able to securely access, synchronise and share information at work across different devices.

3 **Transacting,** which includes the following two skills:

 (a) being able to complete digital records on behalf of the organisation, or within the organisation

 (b) being able to access salary and tax information digitally.

4 **Problem solving,** which includes the following four skills:

 (a) being able to find information online, e.g. search engines, ICT helpdesk, etc., that helps to solve work-related problems

 (b) being able to use appropriate software that is required for day-to-day jobs

 (c) being able to improve skills and ability to do new things at work using online tutorials, learning platforms and how-to guidelines

 (d) being able to improve own and/or the organisation's productivity using digital tools.

Digital skills in the UK: some facts

Although 99% of the UK is now online, the Lloyds Bank Consumer Digital Index (Lloyds Bank, 2022) points out that:

- Around 80% (42.7 million) of people have the Foundation Level digital skills.
- Around 20% (10.2 million) of people lack the basic digital skills, i.e. they do not have the Foundation Level skills.
- Around 4% (2.4 million) of people cannot do any of the digital basics.
- Around 27% (14 million) of people still have the lowest digital skills, and 11% (5.7 million) have very low digital skills.
- Around 10% (5.0 million) of people cannot use an app.
- Around 8% (4.5 million) of people cannot turn on a device and enter login information by themselves.
- Overall, around 10% (5.3 million) of people lack both the digital basics and the essential digital skills for everyday life.
- Age continues to be the largest correlating factor of basic digital capability; 13% (6.7 million) of people have an ultralow digital engagement score and 80% of them are aged over 60.
- Having an impairment or disability has a bearing on someone's ability to do the basic digital tasks: 32% of people with an impairment or disability lack the Foundation Level skills compared to only 13% with no impairment or disability.

There is also a regional divide in the digital skills of the UK population. Table 7.1 opposite shows the regional differences in terms of digital skills of the

Table 7.1 *Proportion of total and working populations per region who have Foundation Skills and Essential Digital Skills for life or work, 2022* (Lloyds Bank, 2022)

Region	Foundation Level Skills	Life EDS	Work EDS
UK	80%	88%	78%
Scotland	85%	91%	79%
Northern Ireland	83%	90%	78%
Wales	71%	77%	74%
England	80%	88%	78%
Northeast England	79%	82%	77%
Northwest England	78%	85%	80%
Yorkshire & Humberside	76%	90%	77%
East Midlands	82%	91%	79%
West Midlands	76%	83%	66%
Southeast England	82%	91%	81%
Southwest England	78%	88%	78%
London	86%	91%	82%

population in the UK. London has the highest level of digital skills at all levels – Foundation, Life EDS and Work EDS – followed by Scotland and Northern Ireland. The East Midlands, London, Southeast England and Scotland are all ahead of the UK average across all three areas of the EDS framework; while the Northeast, West Midlands and Wales all rank below the UK average. Wales is the region scoring lowest for the Foundation Level (71%) and Life EDS (77%); West Midlands has the lowest Work EDS (66%).

Socio-economic conditions also have an impact on people's digital skills. For example, of the 2.4 million people in the UK who have no digital skills, 75% are those from poor socio-economic backgrounds who are from C2 (people with skilled manual occupations) and DE households (people with semi-skilled or unskilled manual occupations or unemployed) (Lloyds Bank, 2022).

Digital skills in the EU: some facts

According to the Digital Skills Indicator (DSI) 2.0, it is assumed that individuals having performed certain activities over the internet using digital tools and software have the corresponding skills. According to the number of activities performed in each area, two levels of skills are calculated, i.e. 'basic' and 'above basic'. 'For individuals to be considered as having overall "above basic" level of digital skills, they need to have above basic skills in all five areas. If an individual has "basic" in some areas and "above basic" in others, then this individual is considered having overall "basic digital skills" ' (DESI, 2022a).

In addition to the two 'basic' and 'above basic' levels, the DSI 2.0 also divides the population into different levels based on the nature of their digital skills:

1 **Individuals with low digital skills**: this category includes those who have either basic or above basic level in four out of the five areas
2 **Individuals with narrow digital skills**: this category includes those who have either basic or above basic level in three out of five areas
3 **Individuals with limited digital skills**: this category includes those who have either basic or above basic level in only two out of five areas
4 **Individuals with no digital skills**: this category includes those who have no skills in four areas or in all five areas
5 **Digital skills could not be assessed**: this category includes those individuals who have not used the internet in the last three months.

The Digital Skills Indicator is the tool that monitors the EU member states' performances in reaching 'the skills targets of the Digital Decade proposal and provide useful information on citizens' behaviour online and people's skills and competences in different digital domains' (DESI, 2022a). Figure 7.1 shows the percentage of population with at least the basic digital skills in each EU country, and Figure 7.2 shows the percentage of population having the 'basic' and 'above basic' digital skills. It may be noted that while 87% of people (aged 16–74) in the EU used the internet regularly in 2021, only 54% possessed at least the basic digital skills (DESI, 2022a). The DESI report also shows that 17% of individuals had digital skills in four out of the five areas monitored ('low digital skills', which means that they are a step away from reaching basic digital skills level). The report also notes that in 2021, 3% of individuals across the EU have no overall digital skills, 5% have skills in two out of five areas ('limited digital skills') and 9% have 'narrow skills' (three out of five areas).

As shown in Figures 7.1 and 7.2 opposite, the Netherlands and Finland are the frontrunners in the EU, while Romania and Bulgaria are lagging behind both in terms of the basic digital skills and above basic digital skills. Overall, a large part of the EU population still lacks the basic digital skills, even though such skills are essential for living, learning and work. It is worth noting that socio-demographic factors have a major influence on the levels of digital skills; for example:

- 71% of young adults (aged 16–24), 79% of individuals with high formal education and 77% of higher education students have at least the basic digital skills

Figure 7.1 *Percentage of population with at least the basic digital skills in the EU countries* (DESI, 2022a)

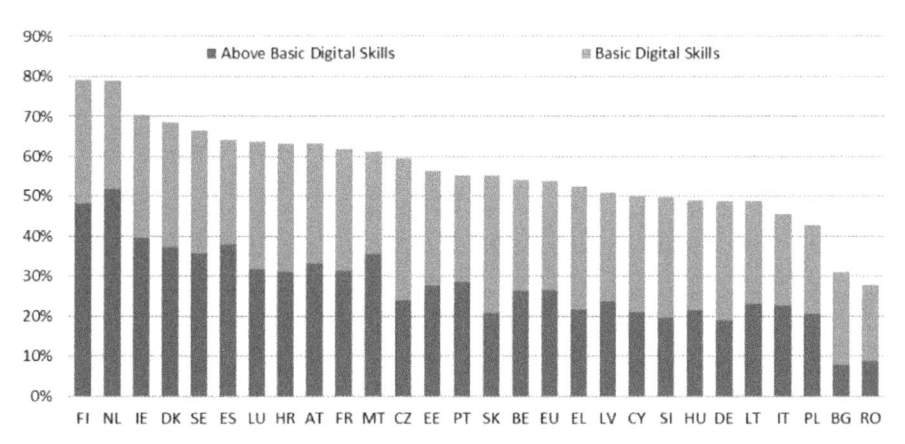

Figure 7.2 *Basic and above-basic digital skills of population in the EU countries (% of population)* (DESI, 2022a)

■ by contrast only 35% of those aged 55–74 and 29% of the retired and the inactive have at least the basic digital skills.

The digital skills gap between rural and urban areas in Europe is also quite substantial: only 46% of individuals living in rural areas have at least the basic digital skills compared to 61% of people living in the predominantly urban areas. Table 7.2 on the next page provides a breakdown of digital skills of the EU population by age, location, education, employment and gender.

Table 7.2 *Basic digital skills of the EU population by age, location, education, employment and gender* (DESI, 2022a)

Factor	Characteristics	At least basic digital skills in 2021 – the EU average (Percentage of population)
Age	16–24 years old	71%
	25–34 years old	69%
	35–44 years old	64%
	45–54 years old	55%
	55–64 years old	42%
	65–74 years old	25%
Location/Density	Living in a predominantly urban area	61%
	Living in an intermediate area	52%
	Living in a predominantly rural area	46%
Education	No formal education	32%
	Medium formal education	50%
	High formal education	79%
Employment	Active labour force (employed or unemployed)	62%
	Retired or inactive	29%
	Employees, self-employed, family workers	63%
	Students	77%
	Unemployed	49%
Gender	Females, 16–74 years old	52%
	Males, 16–74 years old	56%

Digital skills and the SDGs

It is widely recognised amongst various national, international and policymaking institutions that basic digital skills are needed by every citizen to become digitally literate (Local Government Association, 2021), and basic digital skills are a general prerequisite for ensuring that people and society in general benefit from digital developments (Eurostat, 2022b). Digital skills offer a number of benefits for people; for example, the key areas in which individuals who acquire basic digital skills are able to benefit are (Cebr, 2015):

1 **Earnings benefits**: acquiring digital skills contributes to increased earnings of between 3% and 10%

2 **Employability benefits**: digital skills improve the chances of finding work for someone who is unemployed and digital skills offer an increased likelihood that someone who is inactive will look for work
3 **Retail transaction benefits**: digital skills enable people to do online shopping, which has been found to be 13% cheaper on average than shopping in-store
4 **Communication benefits**: basic digital skills have been identified as increasing 14% more chances for people to connect and communicate with family, friends and the community
5 **Time savings**: digital skills save time by enabling people to access government services and banking online rather than in person, and the time saved is estimated to be about 30 minutes per transaction.

However, as discussed in the previous sections, there are significant differences among the population in different countries in terms of their digital skills, which means that some cannot get the benefits that today's digital world can offer. Figure 7.3 shows the gender gaps in basic digital skills in the EU. Figure 7.4 on page 130 shows that in the EU between 2016 and 2021 the share of people aged 16–74 with at least basic digital skills stagnated at 54%, making no progress towards the 80% target for 2030.

Formal education plays an important role in digital skills. In the EU, 79% of people with high formal education had at least the basic digital skills in 2021, while this was only the case for 32% of people with no or low formal education (Eurostat, 2022b). Similarly, overall, 2.4 million people in the UK who have no digital skills and 43% of these people do not have any formal qualifications (Lloyds Bank, 2022).

Age also affects a person's level of digital skills. In the EU 71% of 16–24-year-olds had basic or above-basic overall digital skills in 2021, but this dropped to 62% of 25–54-year-olds (Eurostat, 2022b). In the UK, age continues

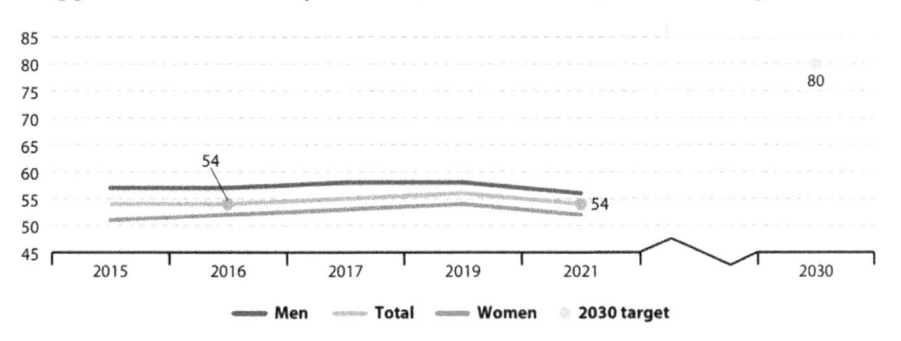

Figure 7.3 *Basic digital skills in the EU by gender and 2030 target (80%)* (Figures 7.3 and 7.4 from EC (2022))

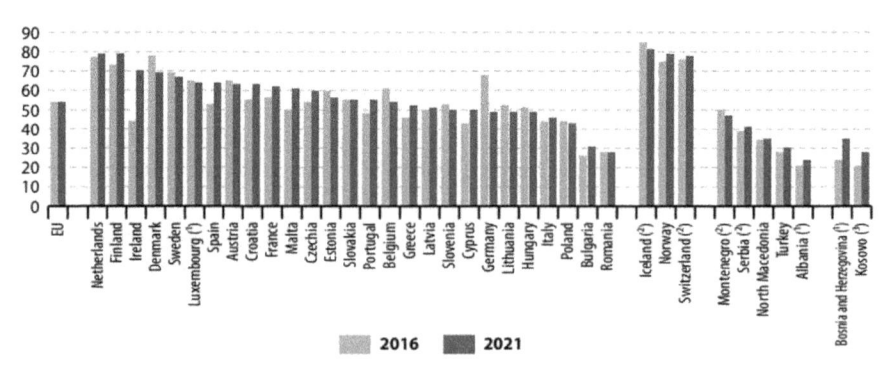

Figure 7.4 *Basic digital skills in the EU* (2016 and 2021)

to be the largest correlating factor of basic digital capability; there are 13% (6.7 million) people with an ultralow digital engagement score and 80% of them are aged over 60 (Lloyds Bank, 2022).

As discussed earlier in this chapter, digital skills also vary amongst urban and rural population. There are gaps in the basic digital skills among the urban and rural population in Europe, and the gaps are quite wide amongst various countries ranging from about 20% to 50% between urban and rural populations. Opportunities to make the most from the digital world in rural areas in the OECD countries are hampered simultaneously by the digital and connectivity divides (OECD, 2021).

Data also shows that disabilities also play a key role in people's digital skills (Lloyds Bank, 2022):

- Amongst those with no impairment or disability, just 13% lack the Foundation Level compared to 32% with an impairment or disability.
- Those with a sensory impairment, compared to those with a mental health impairment, are much less likely to have the fundamental digital skills (55% versus 77%).
- Having more than one impairment or disability also compounds this, as 62% of those with multiple impairments can do the digital basics, compared to 74% who have only one impairment.

Basic digital skills: employment and household economy (SDG8)

The UK Department for Digital, Culture, Media and Sports (DCMS) report notes that 'digital skills have become near-universal requirements for employment' (DCMS, 2019, 7). Digital skills are now an essential entry requirement for two-thirds of occupations in the UK. The report points out

the demand across the country, and shows that at least 82% of advertised job openings require some level of digital skills (DCMS, 2019). The DCMS report further stresses that digital skills are also key to career progression and economic rewards, because job seekers with digital skills command higher salaries, and roles requiring digital skills pay 29% more than those roles that do not. It further adds that specific digital skills are required in 28% of low-skill jobs, 56% of middle-skill jobs, and 68% of high-skill jobs.

The European Digital Economy and Society Index (DESI, 2022a) points out that without a firm command of digital skills, there is no way to propel innovation and remain competitive. It is also noted that the digital skills required in the workplace are more advanced, and as dependence on the internet and digital technology increases, so the workforce must keep up with the evolving skill demand (DESI, 2022b). A European Union report notes that 4 out of 10 adults, and every third person who works, in Europe lacks basic digital skills. The report also notes that over 70% of businesses in Europe have said that the lack of staff with adequate digital skills is an obstacle to investment (EC, 2022a). The European Commission has set targets 'to ensure at least 80% of people with at least basic digital skills and increase the number of ICT specialists to 20 million (around 10% of total employment), with convergence between men and women by 2030' (DESI, 2022a). The European Digital Skills and Jobs Platform is a new initiative launched under the Connecting Europe Facility Programme. It offers information and resources on digital skills, as well as training and funding opportunities (DESI, 2022b).

The Lloyds Bank report points out that poor digital skills affect the employment and financial wellbeing of people in the UK. For example, data shows that (Lloyds Bank, 2022):

- Comparing individuals in a similar job at a similar level, those with high digital capability are making up to £442 more per month.
- People with the highest digital skills check their balance more often, save more money, and save more frequently. This results in greater feelings of confidence – they are almost three times more likely to feel confident when managing their money online.

The Ofcom (2022b) report in the UK that assessed the digital skills of the UK population which was discussed in Chapter 6 (see p. 112) identified three categories of users, 'Narrow', 'Medium' and 'Broad'. The report further noted the following:

1 Narrow internet users: who had ever undertaken between one and four of the 13 online activities we asked about; and this accounted for 29% of internet users;
2 Medium internet users: who had ever undertaken 5–8 activities; and this accounted for 40% of internet users; and
3 Broad internet users: who had ever undertaken 9–13 of the activities; and this accounted for 28% of internet users.

Age and socioeconomic status of people play an important role on the level of access and use. The Ofcom report further noted the following:

- The 'Narrow internet users' were more likely than average to be aged 65+ and in DE households (semi-skilled and unskilled manual occupations, unemployed and lowest grade occupations); while
- the 'Broad internet users' were more likely to be aged 25–44 and in AB (higher and intermediate managerial, administrative, professional occupations) and C1 (supervisory, clerical and junior managerial, administrative, professional occupations) households.

The report noted (p. 14) that: 'that a lack of confidence, and in some cases concerns about the safety and security of the internet, are significant reasons why 6% of UK adults are still digitally excluded'. The report also shows that people who are digitally excluded in one way or another – due to lack of access to the internet, or lack of skills and confidence in using digital services – often resort to seeking help from others. These helpers who help digitally excluded people act as the digital carers, much like the carers who help family members with ill health (Harvey, Hastings and Chowdhury, 2021). A closer look at the Ofcom (2022b) report shows that in their survey, of those who acted as such digital carers, 70% were doing so at least monthly and 37% at least weekly; and for younger digital carers this was higher: 81% of 16–24s who had helped someone online were doing so monthly and 46% weekly. This clearly shows the lack of digital skills for certain categories of users on the one hand, and on the other hand there are some hidden costs of digital services in terms of the time of the digital carers that go unnoticed, and in an environment of rising costs of living, the digital carers lose a lot of their time, and hence money, owing to the poor digital skills of some people.

Summary

While the key aims of all the 17 SDGs are to improve the life and living of people, and improve the quality of life on earth for the present and future

generations, access to digital tools and technologies vis-à-vis data and information is considered to be the key requirement for living in today's digital world. As discussed in the previous chapter and in this chapter, access to the internet as well as the essential digital skills and digital competence are the prerequisites for a digital world and a knowledge society. While international agencies like the European Commission have set a target of 80% essential digital skills for the entire EU population, data discussed in this chapter shows that currently only 54% of the EU population have the digital skills, and this has not progressed much over the past few years. The same applies to other countries in the world: there is a significant digital divide – caused by the lack of access to the internet and lack of digital skills – in the developing and the least-developed countries in the world.

Reports and data discussed in this chapter clearly demonstrate the importance of digital skills/competence for better living in today's world. The UK Digital Consumer Index 2022 report (Lloyds Bank, 2022) shows that people with the highest digital capability are twice as likely to have shown improvements in their financial capability and wellbeing in the last 12 months. On the other hand, the report points out: 'people out of work are four times more likely to lack the digital skills needed for today's UK workplaces and in fact 20% (c.1.6 million) cannot do any of the digital tasks required to be proficient at work' (Lloyds Bank, 2022, 4).

The report recommends: 'with millions of people unable to complete the digital fundamentals to get online, it is important that when they get there, the digital front-door is welcoming. Service providers and system influencers must leverage research and lived-experience to shape their service, products and experience designs to be intuitive and inclusive' (Lloyds Bank, 2022, 5). This very clearly points out that digital services should be welcoming, inclusive and aligned to the life and living of the people for whom they are designed. This is particularly relevant, and yet challenging, for designing data and information services around the SDGs, because of the diversity of users that need access to such services, ranging from government workers, especially in the national statistics agencies, to various non-government organisations and stakeholders in various SDGs, policymakers, educators, researchers, and even the general public.

However, digital access and improved system/service design alone cannot ensure optimum access to, and use and sharing of, information and data amongst people in everyday life and work. It is well recognised (see for example Ofcom, 2022b) that alongside the technical skills, people also need some social skills to interact online, and they also need basic literacy and language skills, as well as some critical thinking skills to understand and navigate the complex landscape of online information. These skills, broadly

defined as the information skills or information literacy, and their implications for digital information access in general, and SDGs in particular, are discussed in the next chapter.

Information Skills and the SDGs in Everyday Life

Introduction

'The Sustainable Development Goals are the blueprint to achieve a better and more sustainable future for all. They address the global challenges we face, including poverty, inequality, climate change, environmental degradation, peace and justice', points out the UN SDG website (United Nations, n.d.a). As discussed earlier in the book, and especially in Chapters 6 and 7, access to digital technologies and digital skills are the essential prerequisites for being part of, and making contributions to, the SDGs. SDG9.c sets a specific Target for access to ICT and the internet as follows:

> SDG9c: Significantly increase access to information and communications technology and strive to provide universal and affordable access to the internet in least developed countries by 2020
> (UN Department of Economic and Social Affairs, n.d.f)

Specific Indicators have also been set for measuring success in improving access to the internet and information. For example, Indicator 17.6.1 is designed to measure 'fixed Internet broadband subscriptions per 100 inhabitants, by speed', and Indicator 17.8.1 is designed to measure the 'proportion of individuals using the Internet' (UN Department of Economic and Social Affairs, n.d.d). Similarly, Indicator 16.10.2 is designed to measure the 'number of countries that adopt and implement constitutional, statutory and/or policy guarantees for public access to information' (UN Department of Economic and Social Affairs, n.d.c).

However, access to digital technologies, or introducing legislation for access to information, do not alone guarantee that everyone will be able to access and use information and data required for their everyday life, work, citizenship and contributions to the SDGs. An important set of literacy and skills set – known as information literacy or information skills – is required for this. Information literacy, or the UNESCO's concept of media and

information literacy (MIL), enables people to discover, access and make optimum use of data and information required in the context of everyday living – learning, work, healthy living, citizenship, and so on.

This chapter discusses the importance of information literacy in general, and in the context of the SDGs in particular. Drawing on the definition and importance of information literacy, and analysis of some of the latest data on the information literacy and information skills of people in different parts of the world, this chapter demonstrates how concerted efforts are needed to improve these skills for achieving success in the SDGs.

Access to information and SDGs

In addition to SDG16.10, which requires every country to 'adopt and implement constitutional, statutory and/or policy guarantees for **public access to information**' (UN Department of Economic and Social Affairs, n.d.c [bold is our emphasis]), the term information occurs across a range of SDGs and Indicators, showing how the importance of access to information is considered to be essential for achieving success in various SDGs. The following are some examples of texts appearing in different SDGs; note that parts of the text have been highlighted below to show in context where the term information occurs (UN Statistics Division, n.d.d):

- access to market information for food commodities: **SDG2.c.** 'Adopt measures to ensure the proper functioning of food commodity markets and their derivatives and facilitate **timely access to market information**, including on food reserves, in order to help limit extreme food price volatility'
- access to health information: **SDG3.7** 'By 2030, ensure universal **access to sexual and reproductive health-care services**, including for family planning, **information and education**, and the integration of reproductive health into national strategies and programmes'
- access to sustainability and environmental information:
 - 12.4.1 Number of parties to international multilateral environmental agreements on **hazardous waste, and other chemicals** that meet their commitments and obligations in transmitting **information** as required by each relevant agreement;
 - 12.6 Encourage **companies, especially large and transnational companies, to adopt sustainable practices and to integrate sustainability information** into their reporting cycle

- 12.8 By 2030, ensure that people everywhere have the relevant **information and awareness for sustainable development and lifestyles** in harmony with nature
- 14.5 By 2020, conserve at least 10 percent of **coastal and marine areas**, consistent with national and international law and based on the best available **scientific information**.
- **information and communications technology (ICT):**
 - 4.b By 2020, substantially expand globally the number of scholarships available to developing countries, in particular least developed countries, small island developing States and African countries, for **enrolment in higher education**, including vocational training and **information and communications technology**, technical, engineering and scientific programmes, in developed countries and other developing countries
 - 5.b Enhance the **use of enabling technology**, in particular **information and communications technology**, to promote the empowerment of women
 - 9.c Significantly increase access to **information and communications technology** and **strive to provide universal and affordable access to the internet** in least developed countries by 2020
 - 17.8 Fully operationalise the technology bank and science, technology and innovation **capacity-building mechanism** for least developed countries by 2017 and enhance the use of enabling technology, in particular **information and communications technology**.

Thus, access to information and ICT have been recognised as essential for achieving the Targets of various SDGs, from eradication of hunger (SDG2) to health (SDG3), education (SDG4), gender equality (SDG5), sustainable infrastructure (SDG9), sustainable consumption (SDG12), sustainable oceans and marine life (SDG14) and global partnership (SDG17). However, digital literacy (discussed in Chapter 7) and information literacy are the essential skills that people should acquire to optimally access and use information that is relevant for the various SDGs.

Information literacy

CILIP: the Library and Information Association in the UK defines information literacy as 'the ability to think critically and make balanced judgements about any information we find and use' (CILIP, 2018). The CILIP definition further emphasises that information literacy 'empowers us as citizens to develop informed views and to engage fully with society'.

The Association of College and Research Libraries (ACRL) in the USA defines information literacy as 'a set of integrated abilities encompassing the reflective discovery of information, the understanding of how information is produced and valued, and the use of information in creating new knowledge and participating ethically in communities of learning' (ACRL, 2016).

A closer look at these two definitions reveals that the context of the ACRL's definition of information literacy is higher education, while the CILIP definition provides a broader and social context, and thus it is more appropriate for the wider context of societal and global development covered by the SDGs. The CILIP (2018) definition points out that information literacy:

- incorporates a set of skills and abilities which everyone needs in order to undertake information-related tasks; for instance, how to discover, access, interpret, analyse, manage, create, communicate, store and share information
- incorporates the skills of critical thinking and awareness, and an understanding of both the ethical and political issues associated with using information
- provides people with the competencies, attributes and confidence needed to make the best use of information and to interpret it judiciously
- helps people to understand the ethical and legal issues associated with the use of information, including privacy, data protection, freedom of information, open access/open data and intellectual property.

Media and information literacy

UNESCO recommends the development of media and information literacy (MIL) for all to enable people's ability to think critically and click wisely. Media and information literacy is defined as:

> an interrelated set of competencies that help people to maximize advantages and minimize harm in the new information, digital and communication landscapes

that offers

> competencies that enable people to critically and effectively engage with information, other forms of content, the institutions that facilitate information and diverse types of content, and the discerning use of digital technologies
>
> (UNESCO, 2022a)

UNESCO's conception of MIL encompasses both traditional and digital media and platforms and addresses all sorts of stakeholders. Milestones in the development of the concept of MIL were the so-called 'Fez Declaration' of 2011, which formalises the extension of media education to include media literacy, and the 'Paris Declaration on Media and Information Literacy in the Digital Era' of 2015, which calls upon all stakeholders to acknowledge MIL in a human rights dimension as part of the digital agenda (Frau-Meigs, Velez and Michel, 2017; Grizzle, 2018; Reineck and Lublinski, 2015; UNESCO, 2013; 2015a).

Researchers argue that MIL is a composite concept, unifying information literacy and media literacy, as well as considering the right to freedom of expression and access to information through ICTs (Grizzle et al., 2013). It brings together three distinct dimensions: information literacy, media literacy, and ICT and digital literacy (Council of Europe, 2023). Reaching more people with MIL and fusing it with other social competences is necessary in today's digital society, given that the environment surrounding literacy has been dynamically changing (Grizzle, 2018).

Researchers also argue that MIL has many interfaces with different sectors of society, and the possibilities that today's digital technologies open up are of great value (Carlsson, 2019, 52); it is embedded in the wider social and political debate, and it calls for critical engagement with media and information (Haider and Sundin, 2022). In a similar way, Balčytienė stresses that 'MIL should not be treated in isolation from human (cognitive and emotional) empowerment. For that purpose, it promotes a "situational" perspective for learning about MIL, which is presented as a qualitative indicator of contextualised societal changes. It also advocates understanding MIL as a "public right"' (Balčytienė, 2020, 295). A boost for MIL towards tackling disinformation and enabling lifelong learning and artificial intelligence approaches would further provide 'an opportunity for UNESCO to remain at the forefront and to keep and expand the intellectual and foresight role it is playing in the area, in particular with a greater focus on gender equality and inclusion' (UNESCO, 2020b, 63).

Information skills or information literacy, or media and information literacy, relate to information in all its forms – print as well as digital content in all formats, including data, images, audio and video; and there is a general agreement that everyone needs to have this in order to be able to access and use information for living, learning and everyday activities. Although digital literacy and information literacy are sometimes used interchangeably in media and literature, they are quite different and complement, rather than replace, each other. Figure 8.1 summarises the basic digital skills and information skills side by side. It may be noted that digital and information

Five Basic Digital Skills	Basic Information Skills
1. **managing information**: using a search engine to look for information, finding a website visited before or downloading or saving a photo found online.	How to **Discover** data and information
	How to **Access** data and information
	How to **Interpret** data and information
	How to **Analyse** data and information
2. **communicating**: sending a personal message via email or online messaging service or carefully making comments and sharing information online.	How to **Manage** data and information
	How to **Create** data and information
	How to **Communicate** data and information
3. **transacting**: buying items or services from a website or buying and installing apps on a device.	How to **Store** data and information and
	How to **Share** data information
4. **problem solving**: verifying sources of information online or solving a problem with a device or digital service using online help.	
5. **creating**: completing online application forms including personal details or creating something new from existing online images, music or video.	

Figure 8.1 *Basic digital skills and basic information skills*

skills are not the same, and in fact, these are complementary sets of skills that everyone needs in order to be able to live properly and benefit from today's digital society.

UNESCO supports and champions MIL initiatives across the globe, that resulted in (UNESCO, 2022d):

- 25 countries taking steps to develop national policies and strategies on MIL
- carrying out training in close to 100 countries based on the UNESCO MIL Curriculum
- expanding the UNESCO MIL Alliance with members in 113 countries
- supporting 300 youth organisations, 100 of which are in Africa, in integrating and strengthening MIL in their policies and operations, reaching hundreds of thousands of young people.

However, significant gaps still exist amongst various countries in terms of people's media and information literacy. Studies show that although about 60% of the global population, and 70% of youth, are using the internet, wide-scale and sustainable MIL training for all is still missing (UNESCO, 2022d).

Table 8.1 shows the ranks and clusters of 41 countries in Europe based on the media literacy scores of their population. The scores are based on the following indicators and weights (Lessenski, 2022):

Table 8.1 *Media literacy in Europe* (Lessenski, 2022)

Rank	Country	Score (100–0)	Cluster	Rank	Country	Score (100–0)	Cluster
1	Finland	76	1	23	Italy	50	3
2	Norway	74		24	Slovakia	49	
3	Denmark	73		25	Croatia	47	
4	Estonia	72		26	Malta	44	
5	Ireland	71		27	Hungary	42	
6	Sweden	71		28	Cyprus	41	
7	Switzerland	68		29	Ukraine	39	4
8	Netherlands	66		30	Greece	38	
9	Germany	62	2	31	Romania	36	
10	Iceland	62		32	Serbia	35	
11	UK	62		33	Bulgaria	33	
12	Austria	61		34	Moldova	32	
13	Belgium	61		35	Montenegro	32	
14	Portugal	61		36	Turkey	31	
15	Spain	59		37	Albania	25	5
16	France	58		38	BiH	24	
17	Lithuania	58		39	Kosovo	23	
18	Czech Republic	57		40	North Macedonia	23	
19	Poland	56		41	Georgia	20	
20	Slovenia	56					
21	Latvia	54					
22	Luxembourg	54					

- media freedom indicators (total weight: 40%):
 - freedom of the press score by Freedom House: 20%
 - press freedom index by Reporters without Borders: 20%
- Education indicators (total weight: 45%):
 - PISA (Programme for International Student Assessment) score in reading literacy (OECD): 30%
 - PISA score in scientific literacy (OECD): 5%
 - PISA score in mathematical literacy (OECD): 5%
 - share of population (%) with university degree (Eurostat): 5%
- trust in others (Eurostat) (Total weight: 10%)
- new forms of participation (e-participation index) (UN): 5%.

It may be noted that the scores and ranks shown in Table 8.1 represent the media literacy of the population which is computed using data at country level, such as media freedom indicators, as well as population levels such as education, trust and e-participation index. Table 8.1 shows data from 41 European countries divided into five clusters based on the scores of media literacy of their population; and it also shows some significant gaps amongst the countries.

Information literacy, or MIL, may be deployed in everyday life without individuals knowing that they are making use of it. For example,

- checking hotel reviews on travel review websites or comparing insurance policy options. It is also about understanding the limitation of these online resources, how they may be subject to manipulation and the need to be discerning about their value
- conducting online transactions, which requires an awareness of internet security measures.

Amongst other things, information literacy enables people to manage their own and personal data more effectively. However, the recent Ofcom (2022c) report shows evidence of significant lack of information literacy amongst UK population; for example:

- Although almost eight in ten internet users (79%) said they were confident in using the internet, a smaller proportion (59%) were confident in managing access to their personal data.
- Often there is a gap between people's confidence in being able to recognise advertising, identify a scam message or judge the veracity of online content.

- A third of internet users were unaware of the potential for inaccurate or biased information online:
 - 6% of internet users believed that all the information they find online is truthful
 - 30% of internet users don't know – or don't think about – whether the information they find is truthful or not.
- Just over a third of internet users did not make any appropriate checks before registering their personal details online.
- While 58% of internet users agreed that the benefits of being online outweigh the risks, 14% disagreed and 28% were unsure.
- The proportion of internet users who thought those online should be protected from inappropriate or offensive content rose from 61% in 2020 to 65% in 2021.
- Although there is an increase in the percentage of people (55% in 2022 as opposed to 47% in 2021) now disagreeing with the idea that people should be able to say whatever they want online, even if hurtful or controversial, a significant proportion of population still don't think so.

Information literacy, everyday life and the SDGs

Given that the United Nations *2030 Agenda* and the 17 SDGs are quite high-level policy documents, apparently it may seem that they do not apply to people at individual and community level. However, this is not quite true. In fact, the UN *2030 Agenda* and the 17 SDGs are 'intended to involve governments, universities, industries and individuals alike because it will take the efforts of all actors working together in partnership to accomplish the urgent global challenges facing the world today' (University of Waterloo, n.d.). Furthermore, the SDGs are not independent goals: they are interlinked, and thus progress in one area, such as employment, health or education, can make significant contributions to other areas like eradication of poverty, improving gender balance or sustainable living. In fact, by recognising the interlinkages 'government, business and civil society can collaborate to develop holistic long-term solutions that benefit multiple groups of people and contribute to several Goals at once' (UK HM Government, 2019).

Improving the MIL at population level can bring long-term benefits for everyone in society, and thus can help in achieving success in all the SDGs. However, MIL should not only target individuals but also converge communities, institutions and organisations to influence life. By doing so, MIL will enhance interactions and communication capacities amongst people, groups and institutions enabling them to engage effectively around critical issues and challenges, influence related policy development and act ethically

and purposefully based on the newly acquired competencies. MIL can also help to develop and propose new values in people's immediate and external social surroundings (inner, intra, and inter groups), and strategically connecting MIL to various social competencies could lead to a more strategic and pragmatic way forward to pursue innovative MIL expansion into the future (Grizzle and Hamada, 2019).

More informed individuals can also make significant contributions to various SDGs, simply by taking a few actions and bringing some changes in everyday habits and living style. The United Nations' *The Lazy Person's Guide to Saving the World* (United Nations, n.d.b) provides a list of some simple everyday life activities that anyone can take part in to make some contributions to the SDGs.

Information literacy and education (SDG4)

Various documents and reports, such as the UNESCO Media and Information Literacy Policy (UNESCO, 2013), the UK HM Government (2019) report on SDGs and the CILIP (2018) *Information Literacy* point out that information literacy, or MIL, can play a major role in several SDGs, for example:

- SDG16.10: promoting access to information
- SDG9c, SDG17.6.1 and SDG17.8.1: promoting access to the internet and thus reducing the digital divide;
- SDG3: promoting health information literacy
- SDG4: promoting education and use of ICT
- SDG8: promoting work and employment
- SDG13: promoting environmental literacy
- SDG4.7 specifically setting a Target for ensuring that everyone acquires the knowledge and skills needed to promote sustainable development.

Achieving gender equality and women's empowerment is integral to each of the 17 goals (UN Women, n.d.) and access to information can significantly improve gender equality and women's empowerment. Therefore, it can be said that information literacy or MIL plays an important role in achieving each of the 17 goals.

SDG Indicator 4.4.1 specifically aims to measure the 'proportion of youth and adults with information and communications technology (ICT) skills, by type of skill' (UN Statistics Division, n.d.c). The importance of digital and information literacy in education at all levels is well documented. Some research works and initiatives of the library and information services sector in the context of green libraries, building initiatives and resources to support

health literacy, environmental literacy/awareness and so on are also discussed in Chapters 9 and 10.

Some examples are given below to show how information literacy plays a significant role in achieving some specific Targets in different SDGs.

Information literacy and health (SDG3)

In order to stay healthy and build a healthy lifestyle, people need access to relevant and reliable health information: but first of all, the question arises as to how and where to find reliable information? Health literacy can answer this question. First proposed in the 1970s, health literacy provides the cognitive and social skills that determine individuals' motivation and ability to gain access to, understand and use information in ways that promote and maintain good health in a variety of settings across the life course (Liu et al., 2021). The Lloyds Bank (2022) Consumer Digital Index report shows that for those who struggle with digital skills, finding digital health services is the most difficult. Lack of health literacy can lead to (NHS, 2021):

- unhealthy lifestyles and poor general health
- low use of preventative services, like vaccinations and screening
- difficulties in taking medicines correctly
- increased attendance at the A&E (accident and emergency) and hospital admissions
- health inequality
- reduced life expectancy.

It is estimated that health literacy-related problems account for up to 5% of the total national health spending in the UK (NHS, 2021). Health literacy has become a major area of research and development both in the health sector as well as in the information sector. A thematic analysis of literature by Liu et al. (2021) identifies three areas of focus in health literacy:

1 knowledge of health, health care and health systems
2 processing and using information in various formats in relation to health and health care
3 ability to maintain health through self-management and working in partnerships with health providers.

Research (Osborn et al., 2011; Sørensen et al., 2015; Sun et al., 2013; Weiss and Paasche-Orlow, 2020) shows that good health literacy helps people to:

- understand and comply with the relevant health policies and guidelines, including self-care instructions
- plan to make changes in their lifestyle
- consent to procedures, make decisions that are informed by different types of information (including quantitative health risk information)
- improve knowledge, self-efficacy, self-care behaviour and health status.

However, a significant number of people have a limited or inadequate health literacy, and it is a challenge for public health in European countries (Sorensen et al., 2015). A social gradient in health literacy is also noticeable (Sørensen et al., 2015). Low health literacy, defined as one where at least one in every three people may not be able to understand essential health-related material, is very common in the EU (Baccolini et al., 2021). Research also confirms that 'financial deprivation is the strongest predictor of low health literacy, followed by social status, education and age; whereas gender has a minor effect' (Sørensen et al., 2015).

Furthermore, the COVID-19 pandemic and the associated misinformation, which is also known as the infodemic (World Health Organization, 2023), demonstrated how misinformation can have a devastating impact on the health of the population in any country. The word 'infodemic' first appeared in the *Washington Post* in 2003, in relation to the Sars epidemic (Rothkopf, 2003). It is defined as 'misleading information in digital and physical environments during a disease outbreak' (World Health Organization, 2023) that:

- causes confusion and risk-taking behaviours that can harm health
- leads to mistrust in health authorities and undermines the public health response.

Infodemic during the COVID-19 pandemic caused rapid spread of misinformation of all kinds, including rumours, gossip and unreliable information about epidemics. People didn't check the authenticity or reliability of information that resulted in harm or bad influence on health. Therefore, health literacy is essential for people's health and wellbeing.

However, recent studies clearly pointed out that health literacy has remained an underestimated challenge. For example, research shows that in 'Europe, nearly half of adults reported having problems with health literacy and not having relevant competencies to take care of their health and that of others' (Paakkari and Okan, 2020). Research (Nielsen et al., 2020; Simon, Howard and Nielsen, 2020) also shows that:

- information inequality around age, gender as well as income and education influence how people engage with information about the coronavirus
- the 'infodemically vulnerable' group had grown from a small minority of 6% early in the pandemic crisis to a significantly larger minority of 15% by late August 2020
- an estimated 8 million people in the UK are more at risk of being at best less informed and at worst un- or misinformed.

Research shows that 'not only can belief in misinformation lead to poor judgements and decision making, it also exerts a lingering influence on people's reasoning after it has been corrected – an effect known as the continued influence effect' (Ecker et al., 2022). Nielsen et al. (2020) point out that there is no silver bullet or 'cure' for misinformation about the new coronavirus. Instead, addressing the spread of misinformation will take a sustained and co-ordinated effort by independent fact-checkers, independent news media, platform companies and public authorities to help the public understand and navigate the pandemic.

Health Education England (HEE) and NHS Education for Scotland (NES) have collaborated to develop a new e-learning resource to help people understand the role health literacy plays and ensure 'people having enough knowledge, understanding, skills and confidence to use health information, to be active partners in their care, and to navigate health and social care systems' (Scottish Government, 2014). Some recent research studies, and professional developments and initiatives, in health literacy are discussed in Chapter 9.

With the mission of making the EU health-literate by 2025 (www.healthparliament.eu/hlsc), the European Parliament Committee on Health Literacy and Self-care recommends that the EU and its member states need to work together to:

- establish best practices for the accessible and reliable online communication of health information
- improve the availability of reliable health information via digital sources; education of health professionals on health literacy, including digital aspects; and meaningful patient involvement in developing health literacy tools and methods.

Information literacy and environment: environmental literacy
In addition to a specific SDG around climate change (**SDG13**), the concept of

environment and sustainability has been a major theme running across a range of SDGs. For example:

- the term 'climate' appears specifically as a separate goal, SDG13, but it also appears in:
 - SDG1.5 in the context of poverty caused by climate-related extreme events and disaster
 - SDG2.4 in the context of food production and strengthening capacity for adaptation to climate change
 - SDG11.b in the context of sustainable cities and mitigation and adaptation to climate change.
- the term 'environment' appears in:
 - SDG1.5 in the context of poverty caused by climate-related extreme events and environmental shocks and disaster
 - SDG8.4 in the context of decoupling economic growth from environmental degradation
 - SDG9.4 in the context of building/upgrading infrastructure to make it sustainable and greater adoption of clean and environmentally sound technologies
 - SDG11.6 in the context of reducing per capita environmental impact of cities
 - SDG11.a in the context of policies for environmental policies and development planning
 - SDG12.4 in the context of environmentally sound management of chemicals and waste
 - SDG12.b in the context of sustainable tourism
 - SDG12.c in the context of policies around the environmental impact of fossil-fuel
 - SDG15.9 in the context of national and local planning and the implementation of environmental-economic accounting
 - SDG17.7 in the context of development, transfer, dissemination and diffusion of environmentally sound technologies.
- the term sustainability appears in:
 - SDG12.6 Encourage companies, especially large and transnational companies, to adopt sustainable practices and to **integrate sustainability information** into their reporting cycle
 - SDG12.b.1 Implementation of standard accounting tools to monitor the economic and **environmental aspects of tourism sustainability**.

Other related terms, like biodiversity and ecosystem, appear in:

- SDG2.4 By 2030, ensure sustainable food production systems and implement resilient agricultural practices that increase productivity and production, that help maintain ecosystems, that strengthen capacity for adaptation to climate change, extreme weather, drought, flooding and other disasters and that progressively improve land and soil quality.
- SDG6.6 By 2020, protect and restore water-related ecosystems, including mountains, forests, wetlands, rivers, aquifers and lakes.
- SDG14.2 By 2020, sustainably **manage and protect marine and coastal ecosystems** to avoid significant adverse impacts, including by strengthening their resilience, and take action for their restoration in order to achieve healthy and productive oceans.
- SDG14.a Increase scientific knowledge, develop research capacity and transfer marine technology, taking into account the Intergovernmental Oceanographic Commission Criteria and Guidelines on the Transfer of Marine Technology, in order to improve ocean health and to enhance the contribution of **marine biodiversity** to the development of developing countries, in particular small island developing States and least developed countries.
- SDG15. Protect, restore and promote sustainable use of **terrestrial ecosystems**, sustainably manage forests, combat desertification, and halt and reverse land degradation and **halt biodiversity loss**; 15.1.2 Proportion of important sites for **terrestrial and freshwater biodiversity** that are covered by protected areas, by ecosystem type.
- SDG15.1 By 2020, ensure the conservation, restoration and sustainable use of **terrestrial and inland freshwater ecosystems** and their services, in particular forests, wetlands, mountains and drylands, in line with obligations under international agreements.
- SDG15.4 By 2030, ensure the conservation of **mountain ecosystems**, including their biodiversity, in order to enhance their capacity to provide benefits that are essential for sustainable development.
- SDG15.5 Take urgent and significant action to reduce the degradation of natural habitats, **halt the loss of biodiversity** and, by 2020, protect and prevent the extinction of threatened species.
- SDG15.8 By 2020, introduce measures to prevent the introduction and significantly reduce the impact of invasive alien species on **land and water ecosystems** and control or eradicate the priority species.
- SDG15.9 By 2020, **integrate ecosystem and biodiversity values** into national and local planning, development processes, poverty reduction strategies and accounts.
- SDG15.a Mobilise and significantly increase financial resources from all sources to conserve and sustainably use biodiversity and ecosystems.

Understanding and use of all of the terms related to environment, and their occurrences in the context of the Targets and Indicators of various SDGs, call for environmental education and a specific type of information literacy, called environmental literacy. The concept of environmental education is not new. For example, Stapp (1969) talked about environment education in the 1960s. However, shaping the definition of environmental literacy and developing different measures started in the 1990s. Roth (1992) created the concept of environmental literacy. The term environmental literacy can be defined as 'the process that shapes or develops a person's environmental values and ability to solve environmental problems' (Fang, Hassan and LePage, 2023). Roth believed that it contains almost all factors related to environmental education.

Quite obviously, 'the most significant factor in environmental literacy is the level of education' (Singleton, 2011, 17). Environmental literacy is also linked with gender, age, geographic location and level of education (Coyle, 2005). It is argued that 'achieving environmental literacy that is inclusive of sustainability values is the first step on the long journey to changing lifestyles and creating ethical, sustainable societies that meet responsibilities to future generations' (Singleton, 2011, 102).

The world's first intergovernmental conference on environmental education was organised by UNESCO in co-operation with the UN Environment Programme (UNEP) and was convened in Tbilisi, Georgia (then in the USSR) on 14–26 October 1977. The *Tbilisi Declaration* of UNESCO (1977) provided the objectives and the guiding principles for international environmental education as follows:

- **awareness** – to help social groups and individuals acquire an awareness and sensitivity to the total environment and its allied problems
- **knowledge** – to help social groups and individuals gain a variety of experience in, and acquire a basic understanding of, the environment and its associated problems
- **attitudes** – to help social groups and individuals acquire a set of values and feelings of concern for the environment and the motivation for actively participating in environmental improvement and protection
- **skills** – to help social groups and individuals acquire the skills for identifying and solving environmental problems
- **participation** – to provide social groups and individuals with an opportunity to be actively involved at all levels in working toward resolution of environmental problems.

SDG13.3 sets a specific goal for education on environment, as follows: 'SDG13.3 Improve education, awareness-raising and human and institutional

capacity on climate change mitigation, adaptation, impact reduction and early warning.' The relevant Indicators are: 13.3.1 Extent to which (i) global citizenship education and (ii) education for sustainable development are mainstreamed in (a) national education policies; (b) curricula; (c) teacher education; and (d) student assessment.

SDG4.7 also sets a goal for education on sustainable development and sustainable lifestyles; and the corresponding Indicators are: 4.7.1 Extent to which (i) global citizenship education and (ii) education for sustainable development are mainstreamed in (a) national education policies; (b) curricula; (c) teacher education; and (d) student assessment.

Consequently, several agencies are now working towards improving environmental literacy, which is also sometimes called climate change literacy (Aytac, 2022). For example, several higher education institutions are signatories to the United Nations Principles for Responsible Management Education initiative (PRME), which leads many initiatives in the sector focused on SDG fulfilment, including a Carbon Literacy Training Programme (www.unprme.org). The Environmental Charity Global Action Plan in the UK is working for improving public understanding and to mobilise actions on tackling air pollution. Similarly, the Climate Coalition Northern Ireland (CCNI) is a network of organisations and individuals, formed in 2020, that works to bring about appropriate action in Northern Ireland to tackle climate change and enhancing policy coherence to ensure sustainable development (Northern Ireland Environment Link, n.d.).

Individual libraries, professional associations such as IFLA, ALA and CILIP and individual researchers in the library and information science field are also working towards improving environmental literacy. The IFLA Environment, Sustainability and Libraries Section (ENSULIB) 'encourage librarians to inspire their communities into more environmentally sustainable ways of action, by providing materials on green librarianship, giving voice to green librarians and library projects worldwide, leading by example, and offering a discussion forum' (IFLA, 2023a). The ALA Special Task Force on Sustainability came up with three core recommendations focusing on (Aytac, 2022):

1 how the Association may provide leadership and serve as a model for sustainability practices more broadly in the profession
2 how the Association may provide leadership in the adoption of sustainability practices in libraries
3 how libraries may provide leadership and serve as a model for sustainability in the communities they serve.

Gray (2018) argues that there are three dimensions of environmental health literacy: (1) awareness and knowledge, (2) skills self-efficacy, and (3) community change. Some researchers argue that environmental literacy programmes should aim to inculcate among people an appreciation for nature, the role nature plays in our way of life, and the knowledge and skills that we need to start taking action to correct some of the environmental issues that we are facing in our everyday life (Fang, Hassan and LePage, 2023).

Information literacy and employment (SDG8)

Information literacy can make significant contributions to people's work, employment and income generation. Information literacy in the workplace depends on the contexts of the workplace, but overall it means knowing when and how to use information and data required to perform and support various activities required to achieve the overall aims of the workplace organisation. Workplace information literacy and skills have been studied in different professional groups and from different perspectives and it is generally agreed that workplace information literacy is the capability to build an understanding of an organisation's changing and complex information environment (Lloyd, 2010); and some of these information skills may not be transferred from one context to another (Bruce, 2011). Research shows that both information and digital literacy are critical for organisations to achieve dynamic capability during their digital transformations (Cetindamar Kozanoglu and Abedin, 2021).

Research during the COVID-19 pandemic found that 34% of small- and medium-sized businesses (SMEs) were not clear on what digital tools were right for their business needs, and 27% hadn't taken any steps to learn new technology (Global Compact Network UK, 2022b). Research by Nikou, De Reuver and Kanafi (2022) also shows that information and digital literacy are antecedents of the Technology Acceptance Model (TAM; Davis, 1989) in the workplace, and they boost the workforce's willingness to adopt digital technologies.

Data shows that information and digital skills have a significant impact on people's income and are related to their financial behaviour. The Lloyds Bank (2022) Consumer Digital Index report identified four categories of people with digital skills (called digital capability in the report) that have influence on annual income, as shown in Table 8.2.

How digital skills have impact on people's financial behaviour with regard to savings, for example compared to the people with the lowest digital skills/capability, are shown in the report:

Table 8.2 *Impact of digital skills/capabilities on financial matters* (Lloyds Bank, 2022)

Level of digital literacy/capability	Population share %/million	Digital skills (confidence in using the internet)	Annual income less than £20,000/year
Very low (least skills)	27% (14 m)	65%	51%
Low	11% (5.7 m)	78%	40%
High	39% (20.2 m)	89%	30%
Very high	24% (12.4 m)	95%	18%

- People with 'low' digital skills/capabilities save 2.1 times more frequently and 4.1 times more money.
- People with 'high' digital skills/capabilities save 2.9 times more frequently and 3.3 times more money.
- People with 'very high' digital skills/capabilities save 3.6 times more frequently and 3.5 times more money.

The report points out that people with foundation level of digital skills have an annual income of between £30,000 and £39,999, close to the average UK income of £31,408, and it further shows that:

- 1% of the UK population have very low digital and financial capability, of whom:
 - 60% earn less than £20,000
 - 54% are male
 - 53% are claiming benefits
 - 25% are aged 50–59.
- Only 3% of the UK population have very high digital and financial capability, of whom:
 - 52% earn over £50,000;
 - 50% are female; and
 - 27% are aged 30–39.

Overall, these datasets clearly demonstrate that digital and information literacy play an important role in people's income and financial capabilities and thereby contribute to achieving the SDG8 (Work and economic growth).

Information literacy and society (SDG16)

In Britain, SDG16.10.2, Access to information, is ensured through the following legislation: (https://sdgdata.gov.uk/16-10-2):

- Freedom of Information Act 2000: This Act ensures public access to information held by public authorities. This Act: (1) obliges public authorities to publish certain information about their activities and (2) entitles members of the public to request information from public authorities.
- The Environmental Information Regulations 2004: This is a statutory right of access to environmental information held by UK public authorities.
- The Data Protection Act 2018: This Act makes provision for the regulation of the processing of information relating to individuals.

These Acts are designed to ensure public access to information, and protection of personal data and privacy. However, achieving the overall aim of the Target SDG16.10 also requires public awareness and means for accessing and using information held by different public and private authorities and service providers. This in turn depends on people's information literacy and digital skills.

As discussed earlier in this chapter, information literacy can help people to:

- use critical thinking skills that are essential for avoiding online and phone scams and guarding against fraudulent transactions
- behave ethically in their online activities, allowing them to be mindful of the information they use and share about themselves and others on all types of online platforms, including social media
- develop an understanding of the concept of a 'digital footprint', the traces that are left behind as individuals consume and create information
- be prepared with strategies for managing their online identity and shaping it in a way they feel comfortable with, taking into account issues of privacy and personal safety of themselves and others.

Thus, in the context of the SDGs, information literacy allows individuals to:

- acquire and develop their understanding of the world around them; to reach informed views; where appropriate, to challenge, credibly and in an informed way assumptions or orthodoxies (including one's own), and even authority (SDG16: Peaceful and inclusive societies)
- recognise bias and misinformation, thereby enabling them to be engaged citizens, able to play a full part in democratic life and society (SDG5: Gender equality and SDG16: Peaceful and inclusive societies)
- address social exclusion, by providing disadvantaged or marginalised groups with the means of making sense of the world around them and participating in society (SDG10: Reduced inequalities).

Summary

In today's information and knowledge society, information literacy should be regarded as a right and as a necessity for all. The UNESCO MIL Strategy document explains how digital solution providers – whether technology companies, NGOs or governments – can follow well-defined steps in order to (UNESCO, 2013):

- offer meaningful services that support the development of digital skills and literacy
- better understand and design solutions for people with low literacy by taking their unique needs and ambitions into account
- create more engaging content and usable interfaces
- ensure that the implementation environments, in addition to technology and content, support inclusive use
- regularly monitor, measure and iteratively improve solutions.

Data from the Ofcom (2022c) report demonstrates some significant gaps in information skills amongst the UK population, and data from the Media and Information Literacy (EC, 2022d) demonstrates some significant gaps in information literacy amongst populations in the EU countries. Discussions in this chapter also show that lack of, or poor, information literacy poses some major challenges to achieving success in, and reaping benefits from, the various SDGs, and therefore hinders the achievements of the SDGs.

Researchers argue that MIL has many interfaces with education and society (Carlsson, 2019); it provides opportunities for dealing with contextual societal challenges (Balčytienė, 2020); and it enables people to critically engage with media and technology, which helps in building trust in information and accountability (Haider and Sundin, 2022). All of these enable people to play their role in behaving responsibly and contributing to an equitable society and a sustainable future; and this is where the link between MIL and SDG can be significant.

Overall, education plays a key role in the success of the SDGs and prosperity of humanity and society. The next chapter discusses some initiatives and frameworks for education for sustainable development in general, and some initiatives and activities for promoting information and media literacy that can indirectly contribute to the achievements in different SDGs.

Information, Education and Sustainable Development

Introduction

Education can play an important role – directly or indirectly – in advancing the achievement of each of the 17 SDGs. UNESCO argues that sustainable development for all countries is only truly possible through comprehensive cross-sector efforts that begin with education. SDG4 (Education) specifically sets a Target, education for sustainable development in all different contexts of life, living and society, in the following terms:

> SDG4.7: By 2030, ensure that all learners acquire the knowledge and skills needed to promote sustainable development, including, among others, through education for sustainable development and sustainable lifestyles, human rights, gender equality, promotion of a culture of peace and non-violence, global citizenship and appreciation of cultural diversity and of culture's contribution to sustainable development.
>
> (UN Department of Economic and Social Affairs, n.d.b)

Education for sustainable development can be divided into two broad categories: (1) education and training of people who are engaged in collecting, processing, managing and making use of data and information related to the SDGs; and (2) education of students, academics, researchers, policymakers and members of the general public about sustainable development in all areas of life and a sustainable world. Several international agencies, such as the United Nations Statistics Division, and national agencies, like the UK Office for National Statistics (ONS), aim to build multinational collaborations to develop training programmes and pathways for the education of people who are engaged in collecting, processing and making use of data and information for measuring achievements in different SDGs, Targets and the relevant Indicators. Similarly, international agencies like UNESCO and national bodies, especially the government departments of education in different countries, are working to develop specific programmes and pathways for

educating students at all levels about the role and importance of the SDGs in different areas of learning and living. Side by side, libraries, being a primary social institution for promoting education and supporting lifelong learning, and various international library associations, like IFLA (International Association of Library Associations and Institutions) and national library associations like CILIP: the Library and Information Association in the UK, ALA (the American Library Association) and so on have introduced different strategies and initiatives for developing awareness and training programmes for promoting education around the SDGs in general, and the sustainability and climate change agenda in particular. This chapter discusses some recent activities and progress related to education for sustainable development at different levels. It also highlights some interesting and novel initiatives, and some challenges, around education for sustainable development.

Education, literacy and media literacy

Data from the World Bank shows that there is a gender gap in the global literacy rate: literacy rate of women aged 15 and above has increased very little in five years – from 82% (in 2015) to 83% (in 2020) and adult male, aged 15 and above, has increased from 89% (in 2015) to 90% (in 2020) (https://data.worldbank.org/ Indicator). Further to that, gender gaps persist in innovation and technology. It is estimated that globally in 2022 more males (69%) in the population have access to the internet than females (63%). This means 259 million more males in the population were using the internet than female in 2022. Gender disparities also persist in access, skills and the quality of education (UNESCO, 2023a).

UNESCO Institute of Statistics (UIS) collects data on literacy rates in countries around the world. It notes that 'there are still 773 million illiterate adults around the world, most of whom are women' (UNESCO Institute of Statistics, 2023). Data presented in Table 9.1 shows the gaps that exist among men and women in terms of basic literacy in different regions of the world. This very clearly indicates that there are still challenges for meeting the Target

Table 9.1 *Male and female literacy rates in some regions of the world*
(https://infogram.com/sdg-4-data-dashboard-1hnq41z1k09p63z?live)

Region	Year of data	Female literacy rate	Male literacy rate
Sub-Saharan Africa	2018	59%	73%
Southern Asia	2018	65%	81%
North Africa/West Asia	2018	74%	86%
Latin America/Caribbean	2018	94%	97%
World	2018	83%	90%

of SDG4.6: 'By 2030, ensure that all youth and a substantial proportion of adults, both men and women, achieve literacy and numeracy.'

Furthermore, so far, no comparable data for countries is available from UIS for the SDG Indicator 4.7.1: 'Extent to which (i) global citizenship education and (ii) education for sustainable development are mainstreamed in (a) national education policies; (b) curricula; (c) teacher education; and (d) student assessment'.

Level of literacy is closely linked to the economy of a country. People can make economic gains if they have better basic skills, i.e. literacy and numeracy (Cherry and Vignoles, 2020). However, in several countries, many still lack good basic skills; and therefore policymakers for those countries need to ensure that both school-leavers and adult workers have higher levels of literacy and numeracy (Cherry and Vignoles, 2020). The cost per student in tertiary education is 93% of GDP per capita in low-income and 41% in lower-middle-income countries, but about 25% in upper-middle- and high-income countries (UNESCO, 2018). Table 9.2 shows some comparisons of the level of literacy and the income band of some countries.

Table 9.2 *Country income band and literacy rate* (World Bank, 2023). Literacy rate: adult total (% of people ages 15 and above)

Country band	Year of data	Literacy rate
Upper middle income	2020	96%
Middle income	2020	87%
Low and middle income	2020	85%
Lower middle income	2020	79%
Low income	2020	61%

Education and training needs of people engaged in activities around the SDGs

As discussed earlier in this book, especially in Chapters 3 and 4, a variety of data needs to be collected, processed, used and shared for measuring success in the 169 Targets of the 17 SDGs. Usually, such data is collected by the national statistical office, or an equivalent organisation, in each country. The required data may be generated, or recorded, by different national or local government and non-government agencies, local government bodies, research institutions, and so on. In consequence, appropriate education and training is required for all those people who are engaged in the collection, recording, processing, using and sharing of data related to the SDG Indicators in each country. The needs for such education and training are also articulated within the SDG Targets and Indicators framework (UN Statistics Division, n.d.c).

Capacity building has been set as a specific Target for various SDGs, for example, in the context of SDG16 – Peaceful Society:

> SDG16.a: Strengthen relevant national institutions, including through international co-operation, for building capacity at all levels, and in particular in developing countries, to prevent violence and combat terrorism and crime
>
> (UN Department of Economic and Social Affairs, n.d.c)

It is also pledged in SDG17 – Co-operation and capacity building:

> SDG17.18: By 2020, enhance capacity building support to developing countries, including for least developed countries and small island developing States, to increase significantly the availability of high-quality, timely and reliable data disaggregated by income, gender, age, race, ethnicity, migratory status, disability, geographic location and other characteristics relevant in national contexts.
>
> (UN Department of Economic and Social Affairs, n.d.d)

Consequently, many national statistical agencies are working to improve education and capacity building of their own staff, as well as staff of the relevant stakeholders. The e-learning platform of the United Nations Statistics Division (https://elearning-cms.unstats.un.org) is a prime example of resources and training of staff on different kinds of statistics and data related to various SDGs (UN Statistics Division, 2021a).

The System of Environmental-Economic Accounting (SEEA) is another example for training in specific areas of SDGs. The SEEA framework contains the internationally agreed standard concepts, definitions, classifications, accounting rules and tables for producing internationally comparable statistics and accounts (https://elearning-cms.unstats.un.org). There are also tools that can be used to search for specific courses and training programmes. For example, the UN SDG:Learn (n.d.b) co-ordinated by GIST (Global Network of Institutes of Statistical Training) provides a platform to search for e-learning resources for use by various countries, international agencies and various stakeholders.

Similar efforts are also being made at individual country level. For example, the GIST report shows that (United Nations, 2021, 6–7):

- Sustainable Statistical Training Programs at NSO (National Statistics Office): Ireland identified 13 key skills with five levels of knowledge under each skill and linked them to the job descriptions of staff.

- The NSO in Morocco identified 65 relevant e-learning courses and those are made available for all staff of the NSO.

SDGs as part of formal education

Inclusion of sustainable development in formal education has been set as an Indicator for several SDGs, for example, Indicator 4.7.1 as part of SDG4 (Education), Indicator 12.8.1 as part of SDG12 (Sustainable consumption and production), and Indicator 13.3.1 as part of SDG13 (Climate change). All these three Indicators (4.7.1, 12.8.1 and 13.3.1) specify the same measures for assessing how sustainable development is embedded in the national education policies, curricula and student assessment:

> 4.7.1/12.8.1/13.3.1: Extent to which (i) global citizenship education and (ii) education for sustainable development are mainstreamed in (a) national education policies; (b) curricula; (c) teacher education; and (d) student assessment
>
> (UN Statistics Division, n.d.c)

Discussions in the following sections show how different SDGs are embedded in the school curricula, as well as in various disciplines and subjects in the higher education courses.

Education for sustainable development (ESD)

ESD is widely recognised as an integral element of the UN *Agenda 2030* for the Sustainable Development Goals. In fact, ESD was born 'from the need for education to address growing sustainability challenges', and it 'employs action-oriented, innovative pedagogy to enable learners to develop knowledge and awareness and take action to transform society into a more sustainable one' (UNESCO, 2020a, iii). Since the United Nations Decade of Education (2005–2014), UNESCO has been the lead UN agency on ESD. Building on the UN Decade on Education for Sustainable Development (ESD) (2005–2014) and the Global Action Programme on ESD (2015–2019), a new framework, *ESD for 2030*, was adopted by the 206th UNESCO Executive Board and the 40th UNESCO General Conference and acknowledged by the 74th UN General Assembly (UNESCO, 2020a). The Council of the European Union also acknowledges that 'ESD is essential for the achievement of a sustainable society and is therefore desirable at all levels of formal education and training, as well as in non-formal and informal learning' (Council of the European Union, 2010).

Both education and training play an essential role for sustainable development and helping to transform the society for the sustainable future. Some researchers argue that if environmental attitude, environmental awareness and environmental knowledge are properly communicated through formal education, it is possible to achieve waste sustainability or environmental sustainability in developing countries (Debrah, Vidal and Dinis, 2021).

ESD for 2030 is the global framework for implementation of education for sustainable development in 2020–2030. How to learn to live differently is the foundation of the *ESD for 2030*. The *ESD2030 Framework* envisions that ESD will enable the achievement of the 17 SDGs through (UNESCO, 2020a):

- raising awareness of the 17 SDGs in education settings: by enhancing the understanding of students and the general public on what the SDGs are and how these goals connect with individual and collective lives
 - promoting critical and contextualised understanding of the SDGs: by raising questions on the inter-linkages and tensions between different SDGs and providing learners with the opportunity to navigate the required balancing acts with its holistic and transformational approaches
- mobilising action towards the achievement of the SDGs: by continuing to mobilise action for sustainable development in education settings, in particular in communities, through whole-institution approaches to ESD.

An excellent visual diagram, produced by UNESCO, shows three interrelated dimensions of ESD: (1) the cognitive learning dimension, (2) the behavioural learning dimension and (3) the social and emotional learning dimension. The diagram, which can be accessed online (at UNESCO, 2020a), shows how ESD can contribute to each of the 17 SDGs. Data is collected by UNESCO to monitor progress, and the following six key Indicators are used to measure progress in ESD for 2030 (UNESCO, 2020a):

1 Policy: It aims to measure to what extent legal frameworks and policies are in place to promote ESD.
2 Learning environment: It aims to measure to what extent the learning environment promotes ESD and its whole-institution approach.
3 Educators: It aims to measure to what extent educators are trained to be able to teach ESD and apply whole-institution approaches to ESD in learning contexts.
4 Youth: It aims to measure to what extent youth are engaged in ESD.
5 Community: It aims to measure to what extent ESD is promoted in local communities.
6 Progress of country initiatives: It aims to measure to what extent ESD for 2030 is implemented in countries around the world.

Thus, the Indicators for measuring success in ESD concern multiple groups of people and stakeholders: learners, including the youth, educators, institutions and learning environment, communities and policies in each country. UNESCO also acknowledges the important role that libraries can play in promoting education and awareness of the SDGs as part of both formal and informal education and lifelong learning. This is discussed later in this chapter.

Learning for the green transition is not yet a systemic feature of education and training policy in the EU; and therefore, it provides a roadmap for the member states for a systemic shift in education by recommending the following:

- make learning for the green transition and sustainable development a priority in education and training policies and programmes
- provide all learners with opportunities to learn about the climate crisis and sustainability in both formal education (for example, schools and higher education) and non-formal education (such as extra-curricular activities and youth work)
- mobilise national and EU funds to invest in green and sustainable equipment, resources and infrastructure
- support educators in developing their knowledge and skills to teach about the climate crisis and sustainability, including dealing with 'eco-anxiety' in their students
- create supportive learning environments for sustainability that span all activities and operations by an educational institution and enable teaching and learning that is hands-on, interdisciplinary and relevant to local contexts
- actively involve students and staff, local authorities, youth organisations and the research and innovation community in learning for sustainability.

(EC, 2022c)

A significant amount of research literature covering different aspects of education and sustainable development has appeared in the recent past. A quick search on the Web of Science database in March 2023 using the search criteria ((Education) and (Sustainab* of SDG*)) produced 55,667 records of which 43,690 are articles and 2,620 are books. Similarly, a number of international agencies, national governments, professional bodies, etc., have produced documents and reports on different aspects of ESD. Some of these are discussed in the following sections.

ESD in school education

ESD promotes the integration of critical sustainability issues – poverty, hunger, health, education, employment, environment, etc. – 'in local and global contexts into the curriculum to prepare learners to understand and respond to the changing world' (UNESCO, 2018). A recent UNESCO report emphasises that ESD 'gives learners of all ages the knowledge, skills, values and agency to address interconnected global challenges including climate change, loss of biodiversity, unsustainable use of resources, and inequality' (UNESCO, 2023b). It also argues that ESD 'empowers learners of all ages to make informed decisions and take individual and collective action to change society and care for the planet'. It further emphasises that ESD is 'a lifelong learning process and an integral part of quality education'. However, the evidence shows that 'problems associated with the general well-being and physical health of children and adolescents are significant barriers to quality education' (UNESCO, 2022b, 2).

Given this, the UNESCO (2022b) report points out that:

- Hunger and malnutrition are among the most significant barriers to education, especially in low- and lower middle-income countries. School-age children and adolescents' nutritional status affects their physical development, health, and cognitive potential, and subsequently their school participation and educational achievement; and hence
- Countries will not be able to achieve Sustainable Development Goal (SDG) 4 on inclusive and equitable education without paying full attention to Target 4.a on providing 'safe, non-violent, inclusive and effective learning environments for all.

(UNESCO, 2022b, 3)

The UNESCO report *Education for Sustainable Development: learning objectives* (UNESCO, 2017) describes the learning objectives of ESD for each SDG in the cognitive, socio-emotional and behavioural domains (UNESCO, 2020a). The report also outlines the indicative topics and pedagogical approaches for each SDG, and recommends that:

To make it possible for everyone around the world to take action in favour of the SDGs, all educational institutions must consider it their responsibility to deal intensively with sustainable development issues, to foster the development of sustainability competencies and to develop the specific learning outcomes related to all SDGs. Therefore, it is vital not only to include SDG-related contents in the curricula, but also to use action-oriented transformative pedagogy.

(UNESCO, 2017)

UNESCO has also developed EC, 2022c a resource bank – designed for educators, education planners and practitioners – that offers 'hundreds of pedagogical ideas for classroom activities and multimedia resources detailing how best to integrate ESD into teaching and learning, from early childhood care through secondary education' (UNESCO, 2021b).

The Council of Europe contributes to SDG4.1 (Universal primary and secondary education) 'through its work on competences for democratic culture and language education' (Council of Europe, n.d.). Activities of the Education Department of the Council of Europe play an essential role in contributing to SDG4.7 (Education for sustainable development) by promoting the core values of the Council: 'democracy, human rights and the rule of law, as well as in the prevention of human rights violations, all of which have a key role to play in ensuring sustainable development' (Council of Europe, n.d.).

In the UK, the Department of Education policy paper provides details of the short-, medium- and longer-term action plans for achieving the strategic aims vision for ESD (Department for Education, 2022). As a country, the UK aims to embed ESD at all levels of education, and especially meet the requirements of Indicator 13.3.1. However, since education in the UK is devolved, there are some variations in the approach to ESD in each of the four UK nations:

- England: Climate change is taught as part of the science programmes of study. More details are available at National Curriculum in England (www.gov.uk/government/collections/national-curriculum).
- Northern Ireland: Climate change is a compulsory part of the GCSE Geography curriculum in Northern Ireland. More details are available at Northern Ireland GCSE Geography Syllabus (https://ccea.org.uk/downloads/docs/Specifications/GCSE/GCSE%20Geography%20%282017%29/GCSE%20Geography%20%282017%29-specification-Standard.pdf).
- Scotland: Climate change is addressed through combining experiences and outcomes across curriculum areas in a variety of contexts as part of the theme of Learning for Sustainability. More details are available at Climate Change and Education in Scotland (https://education.gov.scot/media/oejfidae/climatechangeinscottisheducationbriefing140819new.pdf).
- Wales: The Welsh Assembly Government document *ESDGC – A Strategy for Action* looks at five common areas for ESDGC and suggests action points for each of them. More details are available at Education for Sustainable Development and Global Citizenship

(www.gov.wales/sites/default/files/publications/2018-02/education-for-sustainable-development-and-global-citizenship-a-common-understanding-for-the-adult-and-community-learning-sector.pdf).

ESD in higher education

It is generally agreed that universities can play a major role in educating and preparing the future generations for a sustainable society and economy (Chen, 2019; Coronado et al., 2020; Purcell, Henriksen and Spengler, 2019). The United Nations recognises that students can play a central role in the achievements of the Sustainable Development Goals (SDGs) for the 2030 Agenda (United Nations, 2015). Researchers argue that university education for a sustainable environment can be achieved by:

- building specialised collections and services around sustainability and sustainable development
- developing specialised courses
- designing specific tasks like solving an air pollution problem
- and/or developing specific research projects that would enable students to develop competence for sustainable development (Balog and Siber, 2016; Lambrechts and Van Petegem, 2016; Michel, 2020; Repanovici, Salcă Rotaru and Murzea, 2021; Sulkowski et al., 2020).

It is evident that student organisations at the universities connect people by their beliefs, passions and shared values to achieve several goals and have potential to promote the SDGs (Borges et al., 2017). Universities in different countries have also taken new initiatives to introduce the SDGs as part of their teaching and research programmes. For example, 'over 100 U.S. universities, with total student enrolment of over 2.5 million students, are members of the USA Network of the Sustainable Development Solutions Network (SDSN), a global effort initiated under the auspices of the U.N. Secretary-General to support practical solutions for achieving the SDGs' (Pipa, Rasmussen and Pendrak, 2022, 17). Several universities and colleges around the world have introduced ESD as part of their curricula in different disciplines. For example, the VIP4SD (Vertically Integrated Programme for Sustainable Development) is an excellent example of research-based ESD programme at the University of Strathclyde, UK. The VIP4SD programme comprises a number of multidisciplinary projects working across four of Strathclyde's faculties, bringing together students from different levels of study and disciplines to work in partnership with staff on research projects that address the UN Sustainable Development Goals (SDGs).

The SDG Accord, an international initiative of universities and colleges around the world 'is a commitment learning institutions are making to one another to do more to deliver the goals, to annually report on each signatory's progress, and to do so in ways which share the learning with each other both nationally and internationally' (SDG Accord, 2023).

Advance HE (www.advance-he.ac.uk) is a member-led, sector-owned charity that works with institutions and higher education across the world to improve higher education for staff, students and society, and with the QAA (Quality Assurance Agency, for higher education in the UK) has jointly published guidelines that provide a framework and guidance to help UK higher education institutions incorporate ESD in their curricula (Advance HE, 2021).

It has been recognised by researchers and various international agencies that research and scholarship from multiple disciplines need to be brought together to address the various SDG-related challenges. This has given birth to the new discipline of Sustainability Science, which provides:

> a new approach to deal with complex, long-term global issues, such as human-induced climate and ecosystem changes, from broad perspectives. It also aims to promote solutions that contribute to rebuilding a sound relationship between human society and the environment (i.e. coupled social-ecological systems)
> (https://en.unesco.org/sustainability-science)

Sustainability Science 'draws on all scientific disciplines, including social sciences and humanities in a problem-solving approach, and seeks to shed light on complex, often contentious and value-laden nature–society interactions, while generating usable scientific knowledge for sustainable development' (United Nations, 2019, xxxii).

Business schools at universities around the world are also playing a major role in ESD in higher education. The Principles for Responsible Management Education (PRME), a United Nations-supported initiative founded in 2007, engages business and management schools around the world to introduce ESD in their academic and research programmes (www.unprme.org/about). The Higher Education Sustainability Initiative (HESI) was launched in 2012, providing higher education institutions a unique interface between education, science and policy making by raising the profile of higher education's sector in supporting sustainable development, convening multi-stakeholder discussions and action, and sharing best practices (https://sdgs.un.org/HESI). 'With commitments from over 300 universities from around the world, HESI accounts for more than one-third of all the voluntary commitments that were launched at Rio+20' (UN Department of Economic and Social Affairs, 2017b).

Each year HESI organises a global forum as a special event to the High-level Political Forum on Sustainable Development (HLPF), to highlight the critical role of higher education in achieving sustainable development. The HESI 2023 Global Forum which was held in July focused on understanding the challenges and opportunities to accelerate the recovery from COVID-19 and the full implementation of the 2030 Agenda at all levels, in line with the theme of HLPF in 2023 (https://sdgs.un.org/HESI). The following recommendations were made:

- Urgent action is needed to achieve the SDGs, especially given the challenges posed by the COVID-19 pandemic, climate change, and conflicts.
- Higher education institutions must play a vital role in advancing the understanding and implementation of the 2030 Agenda and the SDGs by drawing on knowledge, technology, and innovation across disciplines.
- Investment from scientific and engineering communities, governments, and funding bodies is necessary to bridge global disparities in scientific capacity and knowledge access.
- Universities should focus on improving access to higher education for all, including efforts to increase science, technology and knowledge transfers from North to South and promote South-South collaborations.
- Quality education with equity and inclusion, including addressing gender disparities, is crucial in higher education institutions to support sustainable development.
- Artificial intelligence has the potential to revolutionize education but requires careful consideration of ethical, legal, and privacy concerns.
- Universities should emphasize cross-institutional partnerships, innovative practices, quality education, academic publications on sustainable development, and the promotion of green jobs to achieve sustainable development.
- Various higher education initiatives and action groups play a vital role in driving the implementation of the SDGs.
- Students and young people must be actively engaged and given opportunities to voice their ideas and contribute to sustainable development efforts within higher education institutions.
- Higher education should prepare students for roles in sustainable development, integrate sustainability into all curricula, and foster interdisciplinary collaboration to address global challenges effectively.
- Education must be viewed as a right for all, regardless of financial status, and a focus on lifelong learning and knowledge exchange should be promoted.

- Higher education needs to evolve rapidly and focus on transformative change, with students at the center of discussions to ensure they receive the education they desire and need.

> (https://sdgs.un.org/sites/default/files/2023-07/
> HESI_2023_GF_summary_0.pdf, 3–4)

Sustainable development for lifelong learning

The lifelong learning issues can be addressed in both local and international contexts. SDG4 and SDG5 are closely intertwined; SDG4 focuses on the value of education and its interrelationships to the other SDGs, and SDG5 emphasises the importance of gender balance in the achievement of all the SDGs by 2030. The Targets for SDG5 are crucial, since all the international assessments show that women and girls are challenged to be equal in lifelong learning pursuits (English and Mayo, 2021, 65).

A number of online courses are available for people to learn about the SDGs as well as specific SDG Targets and Indicators. The UN SDG:Learn is a United Nations initiative that aims to bring relevant and curated learning solutions on sustainable development topics to individuals and organisations (www.unsdglearn.org/courses). This site lists a number of courses (273 as of March 2023) around different SDGs and Targets for people, for example:

- a self-paced eLearning course designed by the FAO (Food and Agricultural Organization) on SDG5.a.2: Ensuring women's legal rights to land ownership and/or control (UN SDG:Learn, n.d.c)
- a self-paced eLearning course *Introduction to Data Governance for Monitoring the SDGs* (UN SDG:Learn, n.d.d), designed by the United Nations Institutes for Training and Research, and the United Nations Statistics Division
- a self-paced eLearning course on *Water: Addressing the Global Crisis* UN (UN SDG:Learn, n.d.e), designed by the SDG Academy
- a self-paced eLearning course on *Compiling National Metadata for Sustainable Development Goals* (UN SDG:Learn, n.d.f), designed by the UN Statistics Division

Similarly, the SDG Academy also offers a number of online courses (50 as of March 2023) on the SDGs. Examples of such courses include (https://sdgacademy.org/courses):

- a self-paced eLearning course on *Using the SDGs for Government Action* designed for public servants and policymakers

- a self-paced eLearning course on *Changing Behaviour for Sustainable Development*, teaching how behavioural science can be applied to building SDG solutions.

ESD and learning institutions

Social and knowledge institutions have always played an important role in promoting education and lifelong learning in different areas, including digital and information literacy, as discussed in Chapters 7 and 8. Donna Scheeder, former President of IFLA, argues that unless measures are taken to bridge the gap that exists in large parts of the world, including advanced economies like the USA, digital divide – between rich and poor, men and women, urban and rural, high- and low-skilled – becomes an information and knowledge divide, and this eventually leads to a development divide (Scheeder, 2019). This would result in the large segments of our communities being unable to benefit from the latest innovations, participate in cultural life or ensure the well-being of themselves and their families.

This is where libraries, and especially public and school libraries, can play a key role and stop the development divide. The role of libraries as a social institution in promoting education and awareness of sustainable development, and SDGs in general, has been highlighted in the *IFLA-UNESCO Public Library Manifesto 2022*, emphasising that public libraries are:

> a living force for education, culture, inclusion and information, as an essential agent for sustainable development, and for individual fulfilment of peace and spiritual welfare through the minds of all individuals.
>
> (IFLA, 2022)

Promoting information literacy, education, inclusivity, civic participation and culture are at the core of public library services. Worldwide, 320,000 public libraries and more than a million parliamentary, national, university, science and research, school, and special libraries ensure that data, information, and information skills are available to everyone, so that the current users develop the capacity to effectively access and use information and ensure ongoing access for future generations (UN Department of Economic and Social Affairs, n.d.e).

The IFLA-UNESCO Public Library Manifesto points out that by promoting access to information, literacy, education, inclusivity, civic participation and culture, public libraries can contribute to the SDGs by a number of activities, for example:

- supporting formal and informal education at all levels as well as lifelong learning
- initiating, supporting and participating in literacy activities and programmes to develop reading and writing skills
- facilitating the development of media and information literacy, and digital literacy, for all people at all ages
- providing their communities with access to scientific knowledge, such as research results and health information that can impact the lives of their users
- providing adequate information services to local enterprises, associations and interest groups
- contributing to the preservation of, and access to, local and indigenous data, knowledge, and heritage (including oral tradition)
- providing an environment in which the local community can take an active role preserving and sharing local and indigenous knowledge
- fostering inter-cultural dialogue and favouring cultural diversity
- promoting preservation of, and meaningful access to, cultural expressions and heritage
- contributing to the development of sustainable behaviour and practices around everyday living, learning, work, entertainment, etc.
- and thus facilitating the construction of more equitable, humane, and sustainable societies.

Academic institutions can play an essential role in achieving the SDGs by helping the next generation with the skills, knowledge and understanding to address sustainability challenges and opportunities and perform research that advances the sustainable development agenda (Bradley, 2016; Cyr and Connaway, 2020; EBLIDA, 2020; Mori, Fien and Horne, 2019). Some experts suggest that libraries can contribute to promoting the SDGs by creating curated collections related to the SDGs and can cultivate literacy around SDGs by developing educational programmes that advance literacy in all key SDG areas (Williams, 2022). Research shows that many academic libraries have contributed to the achievement of the SDGs through:

- providing relevant materials to support students' learning, awareness creation, organising training on information literacy, workshops, seminars, orientation and so on (Dei and Yaba Asante, 2022)
- information literacy and knowledge sharing (Bahrami and Harandi, 2020)
- developing a benchmarking tool for libraries, the 'Library Environment Sustainability Progress Index' (LESPI) (Aytac, 2019).

Some academic and research libraries are playing a key role in ESD by creating awareness of and providing access to relevant data and information for SDGs. For example, in the UK the University of Edinburgh library has made available a number of data sets and information resources across a range of social responsibility and sustainability themes (University of Edinburgh, 2023).

The Council of Australian University Librarians reports (CAUL, 2019) that the Australian university libraries are making contributions to the SDGs by:

- promoting literacy in general and digital, media and information literacy skills
- closing gaps in access to information
- helping individuals in all aspects of their life to better address their information needs
- communicating knowledge created in Australian universities
- serving as the heart of the research and academic community
- building global partnerships and collaborations that provide greater access to digital collections and information capability programmes
- preserving and providing access to the world's culture and heritage
- providing a network of delivery sites for government programmes and services.

Some libraries, or a consortium, have also introduced some specific services that contribute to the SDGs, especially promoting access to information and democratisation of knowledge. SCONUL (Society of College, National and University Libraries) in the UK have introduced a service called Access that allows most of the university library users in the UK and Ireland to borrow or use books and journals at other libraries which belong to the scheme (SCONUL, 2023).

Lack of general awareness of SDGs

Despite the broader themes of sustainability growing in discourse, public engagement with, and awareness of, the SDGs remain low everywhere in the world, including in the developed countries. Researchers argue that the low level of awareness of the SDGs presents a significant threat to the realisation of the SDGs (OECD, 2016b), because effective communication is at the heart of the success of the SDGs and it will be impossible to achieve them without increased awareness (Borg, 2021).

Due to the extensive media coverage, more people are somewhat aware of, and familiar with, the concepts and challenges associated with the

environment and climate change agenda. However, the downside of it is that when the SDGs are mentioned most people think of only the climate change issues. In Britain, while three-quarters of adults appear to be worried about climate change, it is estimated that just over one in ten adults are familiar with the SDGs (ONS, 2021a).

Mention of climate change challenges on news channels, newspapers, social media and so on has significantly increased people's awareness and consciousness of the environmental issues and impact, resulting in some changed behaviour and practices in everyday living, including purchasing behaviour, travel and transportation and energy consumption in everyday life. This demonstrates that advocacy around all the SDGs and their Targets in everyday language and living contexts can significantly improve people's awareness of and commitments to the SDGs; and co-ordinated government, institutional, media and library services can play a key role in addressing the issues.

The EU Development Education and Awareness Raising (DEAR) Programme works with people in the EU and engages them in global issues related to social, economic and environmental development, highlighting the importance of sustainable development, both locally and globally.

LIS education for SDGs

As discussed so far in this chapter, one of the essential ways of moving towards sustainable society is education for sustainable development (ESD), and the main goal of a sustainable university programme is to develop the culture and mindset of its students and staff and society at large towards all areas of sustainable development. Libraries can play a significant role in educating and influencing the public and consequently many researchers argue that sustainability and sustainable development should also find its rightful place in LIS (library and information science) education (Chowdhury and Koya, 2017; Kamińska, Opaliński and Wyciślik, 2022; Meschede and Henkel, 2019; Nolin, 2010). LIS education which lacks a sustainability factor will inevitably take its effect in the future and will inhibit progress towards a sustainable society (Kamińska, Opaliński and Wyciślik, 2022).

Some researchers argue that sustainable development should be translated into an imperative of social and ethical issues, and ought to become a part of university curricula (Kamińska, Opaliński and Wyciślik , 2022). Chowdhury and Koya (2017) argue that sustainability should be embedded in every aspect of data and information management teaching and research in iSchools and other cognate university disciplines, so that the graduates can make appropriate management, research and professional contributions at the workplace in every business and industry towards achieving the SDGs.

Some researchers have proposed what should be included on ESD in the LIS curricula, and where. Turner (2014) suggests that the best place to teach sustainability within the range of LIS curricula is the library management course that would prepare students for developing their own sustainability-informed practices after graduation. Jankowska, Smith and Buehler (2014) recommend that academic libraries should: (a) run regular information literacy classes in collaboration with other units on campus; (b) build collections devoted to sustainability topics; (c) take actions on greening libraries and their surroundings; (d) arrange exhibitions for marketing purposes; and (e) co-operate with academic units in the university for developing courses on sustainable development and organise speeches on that topic. Hayman and Smith (2015) stress the need to focus on the social and economic sustainability of libraries' practices, especially in the context of the technologies in the library environment. Chowdhury and Koya (2017) argue that every LIS programme should focus on four key areas of teaching and conducting research:

1 sustainable information systems and infrastructure
2 sustainable information practices
3 sustainable information policies and governance
4 sustainable user education, training and literacy.

Through these measures, library and information science schools will be able to contribute to the creation of a culture of shared vision, use, access and understanding of data for sustainable development, especially in terms of the means and possibilities of achieving the SDGs. The graduates will then be able to make proper management, research or professional contributions at their future workplaces in every branch of business or industry towards accomplishing the SDGs (Chowdhury and Koya, 2017).

As discussed in Chapters 7 and 8, digital and information skills play an important part in promoting and achieving sustainable development in every area. In addition, environmental literacy also plays an important part in promoting not only the SDG on climate change (SDG13), it also contributes to several other SDGs. Hence, the public have to be more aware of the environmental issues and be ready to act responsibly in their day-to-day life and living (Kurbanoğlu and Boustany, 2014). Green information literacy can be seen as a key to the economic, social and cultural development of communities, institutions, and even nations (Kamińska, Opaliński and Wyciślik, 2022). Repanovici, Salcă Rotaru and Murzea (2021) argue that the sustainable information literacy is situated at the intersection of three core elements of a higher education system: research, curricula and library. Hence

library and information science (LIS) education programmes should develop and offer digital literacy, information literacy and environmental literacy programmes so that every student and future library and information professional could become environmentally literate.

However, a number of challenges needs to be overcome, and some researchers argue that:

- the concept of sustainable development remains a relatively new area of focus in the field of librarianship (Khalid, Malik and Mahmood, 2021)
- there is a need for 'sustainability awareness in academic libraries driven by effective leadership' (Tribelhorn, 2023)
- sustainability could be achieved 'by benchmarking programs and by establishing comparable metrics to assess and understand their contributions to sustainability' (Tribelhorn, 2023)
- there is a need for the libraries and librarians to navigate the cross-pressure between the external and internal incentives of the sustainability agenda (Mathiasson and Jochumsen , 2022)
- a model needs to be developed serving as a foundation for future research and discussions about how libraries and librarians can support the sustainability and sustainable development agenda (Mathiasson and Jochumsen, 2022)
- barriers to the development of the green libraries concept include an ambiguous definition of green libraries, a lack of guidelines for green libraries and a lack of criteria for evaluating green libraries (Fedorowicz-Kruszewska, 2023)
- sustainability leadership is necessary to green a library systematically (Beutelspacher and Meschede, 2020)
- a library's management should 'step outside its comfort zone to create flexible or agile structures and to engage politically' (Keller, 2023)
- there is a need for developing inclusive and sustainable professional development programmes for librarians and library staff that has applicability even beyond the current constraints facing higher education (Carroll and Mallon, 2021).

LIS programmes should also promote and develop the culture of embedding sustainability considerations by undertaking research on sustainable data and information management and use in every scientific discipline and business. Through this measure, LIS schools can contribute to the creation of a culture of shared creation, use, access and understanding of data for sustainable development, especially in terms of the means and possibilities of achieving SDGs, and this can be regarded as a new research direction to be pursued in

more detail in the domain of information science (Kamińska, Opaliński and Wyciślik, 2022).

Summary

The discussions in this chapter highlight the importance of education for sustainable development through formal and informal education routes. Side by side, media and information literacy also plays an important role; it enables people to access, use and share data and information confidently, meaningfully and responsibly. Data presented in this chapter demonstrate that significant gaps still exist among different sections of the population, even in the rich countries, and highlights the needs for more concerted efforts.

As discussed earlier in this chapter, Finland, Denmark and Sweden top the 2022 SDG Index, and all top 10 countries are European countries. However, even these countries face major challenges for achieving success in several SDGs (Sachs et al., 2022). SDGs are global, and hence unless appropriate measures are taken, achievements of rich countries in several SDGs may result in adverse effects on poorer countries. The 2022 International Spillover Index included in the *Sustainable Development 2022* report (Sachs et al., 2022) underlines how rich countries, including many European countries, generate negative socio-economic and environmental spillovers, including through unsustainable trade and supply chains. Governments in individual countries, and by extension the general public, have a key role to play in understanding the Targets and Indicators of the SDGs, and the challenges associated with achieving those. This calls for education, awareness and advocacy.

Despite some gaps and challenges, the discussions in this chapter show a promising picture of improvement through various collaborative efforts around ESD among different countries in the world. Institutions and professional associations are making significant efforts to promote ESD, digital and information literacy and advocacy. The next chapter discusses some recent academic and professional research and development activities around data, information and people in relation to the SDGs.

Research and Development Around the SDGs

Introduction

A significant amount of research literature on different aspects of data, information and sustainable development has appeared in the recent past. A quick search on the Web of Science database in May 2023 using the search string (((SDG*) or (sustainability) or (sustainable development))) and (((data) or (information))) produced:

- 32,919 results in the research area of Computer Science, out of which there were 24,608 articles and 565 books
- 8,632 results within the discipline of Information and Library Science, out of which there were 8,353 articles and 252 books.

Although this is not a comprehensive search on the topic, it gives a sense of the volume of research activities around the SDGs in the computer science and library and information science disciplines.

Some publications date back to the 1990s, but research in this area within the library and information science discipline grew rapidly over the past decade – from 202 publications in 2011 to 1052 in 2021 and 1405 in 2022. In addition, there have also been professional research and development activities within the computer and information sciences area, but most of such research focused on sustainability and climate change in the form of the green ICT, green libraries, etc. This chapter discusses some of the academic as well as professional research, especially around data, information, people and society in the context of the SDGs. It tries to point out some key progress and trends, as well as some gaps in research, and highlights some key challenges. Research and development activities, and some of the associated challenges, within the library and information sector are discussed in Chapter 11.

The overall SDG research landscape

A review, based on the research literature appearing in the Web of Science database (Nakamura et al., 2019) shows the growth of research, in terms of publications, on health, and sustainability in which ecosystems and biodiversity appear top of the list. Bautista-Puig et al. (2021) report on a scientometrics study that aimed to investigate the trend of research related to the SDGs around the world. This study covered research between 2000 and 2017, and the topics included both the SDGs and MDGs (Millennium Development Goals), which were the predecessors of the SDGs. Two sets of the key findings of their research are shown in Tables 10.1 and 10.2. Table 10.1 shows the contributions of each continent to SDG research, whereas results in Table 10.2 show the percentage of research in each SDG by each continent; and it shows the dominance of Europe and North America in terms of research contributions on SDGs. Looking at the data in Tables 10.1 and 10.2 on the nature and volume of research on specific SDGs, and especially the top three areas of research on SDGs, it may be noted that:

Table 10.1 *SDG research and contributions of the five continents (percentage of research on each SDG across the continents)* (Bautista-Puig et al., 2021)

	Africa	North and South America	Asia	Europe	Oceania
SDG1	10.23	33.23	10.17	40.43	5.94
SDG2	9.42	37.60	11.52	35.00	6.46
SDG3	13.32	36.70	11.58	33.15	5.24
SDG4	14.27	34.94	13.33	32.09	5.36
SDG5	15.50	37.43	13.31	28.24	5.52
SDG6	10.80	33.71	10.29	40.87	4.32
SDG7	4.58	32.21	13.07	43.70	6.44
SDG8	10.63	34.98	10.53	37.45	6.41
SDG9	9.43	36.05	10.49	37.60	6.43
SDG10	9.71	36.46	10.42	39.59	5.82
SDG11	13.73	34.79	13.07	33.07	5.35
SDG12	6.03	30.26	11.62	44.85	7.24
SDG13	4.59	32.06	8.65	46.24	8.47
SDG14	8.58	32.83	10.66	42.51	5.41
SDG15	7.49	32.35	9.07	44.28	6.81
SDG16	12.55	35.55	11.47	34.59	5.85
SDG17	10.22	30.40	13.97	38.86	6.55

■ Europe had the largest contribution in SDG13 (Climate action: 46.24%) followed by SDG12 (Responsible production and consumption: 44.85%), and SDG15 (Life on land: 44.28%)

Table 10.2 *Contributions of the continents in terms of the percentage of research output in each continent across all the SDGs* (Bautista-Puig et al., 2021)

	Africa	North and South America	Asia	Europe	Oceania
SDG1	1.82	1.97	1.81	2.33	2.12
SDG2	3.55	4.70	4.32	4.25	4.87
SDG3	23.95	21.93	20.73	19.23	18.86
SDG4	5.30	4.32	4.93	3.85	3.99
SDG5	5.25	4.21	4.49	3.08	3.74
SDG6	2.87	2.98	2.73	3.51	2.30
SDG7	0.55	1.29	1.57	1.70	1.55
SDG8	4.99	5.46	4.92	5.67	6.01
SDG9	2.79	3.55	3.10	3.59	3.81
SDG10	6.69	7.89	7.14	8.80	8.02
SDG11	14.75	12.42	13.99	11.46	11.49
SDG12	0.62	1.03	1.19	1.49	1.49
SDG13	0.88	2.04	1.65	2.86	3.24
SDG14	1.68	2.13	2.07	2.68	2.12
SDG15	1.86	2.67	2.24	3.55	3.38
SDG16	16.48	15.51	15.00	14.65	15.36
SDG17	5.97	5.90	8.13	7.32	7.66

- America (North and South combined) had the largest contribution in SDG2 (Zero hunger: 37.60%), followed by SDG5 (Gender equality: 37.43%) and SDG3 (Good health: 36.70%)
- Highest amount of research on SDGs in Africa has taken place on SDG5 (Gender equality: 15.50%), SDG4 (Education: 14.27%) and SDG11 (Sustainable cities: 13.73%)
- Highest amount of research on SDGs in Asia had taken place on SDG17 (Partnership for the goals: 13.97%), SDG4 (Education: 13.33%), and SDG5 (Gender equality: 13.31%)
- Highest amount of research on SDGs in Oceania had taken place on SDG13 (Climate action: 8.47%), SDG12 (Responsible production and consumption: 7.24%) and SDG15 (Life on land: 6.81%).

Table 10.2 shows the global contributions to research on each SDG, and the contributions of each continent. It shows that the top three areas of research on SDGs across all the continents were as follows:

- Europe has made contributions to: SDG3 (19.23%), SDG16 (14.65%) and SDG11 (11.46%)

- America has made contributions to: SDG3 (21.93%), SDG16 (15.51%) and SDG11 (12.42%)
- Africa has made contributions to: SDG3 (23.95), SDG16 (16.48%) and SDG11 (14.75%)
- Asia has made contributions to: SDG3 (20.73%), SDG16 (15%) and SDG11 (13.99%)
- Oceania has made contributions to: SDG3 (18.86%), SDG16 (15.36%) and SDG11 (11.49%).

Based on a more recent research (Trane et al., 2023), Figure 10.1 shows a visual representation of how selected papers are matching the 2030 Agenda at the specific SDG level.

Figure 10.1 *Occurrences of 2030 Agenda Goals-related keywords in all selected papers* (Trane et al., 2023; authors' elaboration based on the SDG Mapper Tool).

The research productivity, impact and intellectual structure of global SDG research, using Elsevier Scopus and SciVal bibliometric tools for the period 2017–2022, shows that 1511 scientific outputs have been produced in this transdisciplinary field, with 15,588 citations; the USA and the UK are the most productive countries (Alfirević, Perović and Kosor, 2023). Research also shows that the scholarly community plays a significant role in advancing sustainability through SDG-related research and linkage (Sarkis and Ibrahim,

2022), and universities can provide education that supports skills and mindsets that are required to solve complex societal and management decision-making problems associated with the SDGs (Macht, Chapman and Fitzgerald, 2020).

Some researchers argue that the research on the SDGs can be used:

- as a reference for addressing the research impact in management (Flavio, 2021);
- to address the enterprises' strategies (Claro and Esteves, 2021);
- to measure impact and quality of academic research (Chapman et al., 2020);
- to achieve the ambitions of the SDGs (Siri et al., 2022);
- to demonstrate that open-access publications have a unique role to play in serving diverse SDG stakeholders (Alfirević, Perović and Kosor, 2023).

Some researchers argue that:

- studies with well-defined approaches are needed so that the results can be integrated in analysis and evaluation processes that provide a complete view of the state of the SDGs (Alcántara-Rubio et al., 2022)
- sustainable development is an ingrained mindset that is practised in daily actions (Zizka, McGunagle and Clark. 2021), but some sustainability managers do not react in the same way to a firm's greenwashing (Westerman et al., 2022)
- collaborators of different backgrounds should work together and evaluate the suitability of participatory modelling methods for co-creating sustainability pathways (Moallemi et al., 2021) and follow a set of general principles (Norström et al., 2020)
- future research and policy-related studies should focus on resolving the operational challenges that underdeveloped and developing economies face in improving accessibility and affordability (Chaurasia et al., 2022).

Leadership and research funding opportunities are also the requirements for SDG-related research. Lashitew (2021) emphasises that ' the leadership of the European Union – which has committed to a climate-neutral economy by 2050 – in crafting a complex regulatory regime to support a sustainable economy stands out as one of the most important developments'. Many projects focusing on various SDGs were funded during 2016–2021 (some going beyond this period) by the UK government through various Research Councils under the GCRF (Global Challenges Research Fund) scheme. One can search for all the SDG-related projects funded through the GCRF scheme

on an interactive map that shows how many projects have been funded by each UK Research Council, the countries of focus on those research projects, etc.; and by following the link for each specific project one can find more details of it, including the research objectives, research team and institutions, project outcomes and deliverables (see Tableau Public, 2023).

Research on ICTs and SDGs

Broadly speaking, research related to ICT and SDGs can be divided into two groups: (1) sustainable ICT; and (2) ICT for sustainable development and SDGs in general. Wu et al. (2018) comment that the current research on ICT and SDGs primarily focuses on exploring the technological challenges, such as the storage capacity, computing speed, computing capabilities, communications and networking. They argue that some research papers, available in the IEEE and ACM digital libraries, have discussed and recognised the importance of ICT for some specific SDGs, such as SDG3 (Health), SDG11 (Sustainable cities), and SDG13 (Climate action). However, they also point out that some other goals, such as SDG5 (Gender equality), SDG10 (Reduced inequalities), and SDG16 (Peace, justice and strong institutions) have not been addressed by the ICT research communities. Similar views have been expressed by other researchers as well. For example George, Karatu and Edward (2020) comment that the SDGs are still an insufficiently discussed field of application for digital technologies. Reviewing research on ICTs and SDGs, Guandalini (2022) raises a number of questions around digitalisation, digital transformation and sustainable development in the business context that need to be addressed by future research. Some researchers argue that:

- increased investment in ICT infrastructure and research is needed for leveraging ICT to promote holistic, sustainable development by facilitating capacity building, education and training programmes on the linkages between climate change and sustainable development, e.g. in forest management (Empig et al., 2023)
- there are several different ways of assessing ICT's use in SDGs, e.g. in smart and sustainable city initiatives (Daielly Melina Nassif et al., 2021)
- despite ICT policies and infrastructure, the use and impact of ICT on SDGs is not always high, and this calls for improvements at policy, institutional, department and individual levels (Vyas-Doorgapersad, 2022).

SDGS, ICTs and social responsibility: the digital humanism

Technology, and especially ICTs, forms one of the main pillars of SDG17. The rapid developments in ICT, and especially in the development of AI (artificial intelligence) in almost every walk of life, has a huge potential for achieving the Targets of the SDGs. However, there is also a growing concern around the potential effect of misuse and abuse of these technologies on human and society at large. Released in 2019, the *Vienna Manifesto on Digital Humanism* 'describes, analyses, and, most importantly, influences the complex interplay of technology and humankind, for a better society and life, fully respecting universal human rights' (DIGHUM, 2023). The *Manifesto* proposes eight core principles for ensuring the social responsibility of ICT research:

1 Digital technologies should be designed to promote democracy and inclusion.
2 Privacy and freedom of expression are essential values for democracy and should be at the centre of our activities.
3 Effective regulations, rules and laws, based on a broad public discourse, must be established.
4 Regulators need to invoke anti-trust to break tech monopolies.
5 Decisions with consequences that have the potential to affect individual or collective human rights must continue to be made by humans.
6 Academics and industrial researchers must engage openly with wider society and reflect upon their approaches.
7 Practitioners everywhere ought to acknowledge their shared responsibility for the impact of information technologies.
8 A vision is needed for new educational curricula, combining knowledge from the humanities, the social sciences, and engineering studies (DIGHUM, 2023).

Continuing challenges

The COVID-19 pandemic has been one of the major global challenges that the world has seen in the recent past. As in every other area, the pandemic has had a major negative impact on the progress and achievements of the SDGs. In addition, there are a few other challenges that also have an impact on the progress of the SDGs. Some of these recent and continuing challenges are discussed in the following sections.

The COVID-19 pandemic

The UN Sustainable Development Goals Report 2022 points out that

cascading interlinked crises, dominated by the COVID-19 pandemic and other global challenges, such as climate change and conflicts, are creating impacts on all areas of the SDGs, including food and nutrition, health, education, the environment, and peace and security (UN Economic and Social Council, 2022). Furthermore, the COVID-19 pandemic has:

- prompted a massive shift in the demand for data, especially for more timely and higher-quality data (UN Statistics Division, 2021b); and
- rendered much of the pre-pandemic data less useful or outdated (Mahler et al., 2020).

Popescu (2022) provides 'an updated view of the newest trends, novel practices and latest tendencies concerning the manner of supporting and ensuring sustainability and the challenges of Post-COVID-19 Era.' Problems of poverty (SDG1), hunger (SDG2) and good health (SDG3) are significantly affected by the outbreak of the pandemic and therefore these have hugely affected the implementation of the SDGs (Rydz-Żbikowska, 2022). Reviewing the main challenges associated with the implementation of the SDGs in the European countries, including CEECs (Central and Eastern European countries), Rydz-Żbikowska highlights the needs for:

- Stronger and more comprehensive efforts to reach the environmental goals covered under SDG2 (Zero hunger and sustainable agriculture) and SDGs 12–15 (Sustainable consumption and production, and climate and biodiversity goals)
- Reducing inequalities within countries means closing the gaps in access to services and development opportunities across different population groups in EU member states and candidate countries, which is covered under SDG3 (Good health and well-being), SDG4 (Quality education), and SDG5 (Gender equality)
- Strategic and Target-oriented actions to mitigate the negative effects of international spillovers reflected by disruptions in trade and financial flows, which undermines many EU countries' ability to achieve the SDGs
- Minimizing persisting differences in SDG performance across Europe, which requires stronger convergence in Europe and better EU leadership (Southern Europe, the Baltic States, and Central and Eastern European countries all still perform below the average of the EU27 SDG Index score).

(Rydz-Żbikowska, 2022)

The COVID-19 pandemic has also brought some changes in the ways people expect and access data. There is a prediction that the national governments

now have to find new ways to satisfy user demands with reduced budgets and staff resources, while also balancing data timeliness, precision, and quality needs (Sachs et al., 2022). These, along with the scarcity of research funding, especially in the developing and least developed countries, pose a major challenge in education and research on different areas of SDGs, and especially knowledge sharing on multidirectional science and technology through North–South and South–South collaborations. Antoniades, Antonarakis and Kempf (2022) mention a number of social and humanistic challenges for achieving the SDGs that include:

- the current debt wave experienced in developing countries
- the role of inequality
- the significant impact of climate change on livelihoods and on meeting the SDG
- the new challenge presented by the COVID-19 pandemic
- the challenge of sustainable funding for SDGs
- the need for a new eco-social contract.

Consequently, adequate policies and actions are needed in advancing the SDGs in relation to environment and poverty during the current conditions of financial distress (Antoniades, Antonarakis and Kempf, 2022).

General lack of awareness of the SDGs

Although the SDGs, popularly known as *The 2030 Agenda*, were adopted in 2015, there is a lack of awareness of the various Goals and their implications for the everyday life of people and society. A World Economic Forum Survey conducted by Ipsos Group that asked almost 20,000 people aged between 16 and 74 from 28 countries how familiar they were with the SDGs produced some interesting results about people's familiarity (World Economic Forum, 2019). The survey notes that the degree of people's familiarity with the SDGs varies amongst specific countries:, for example, 'Great Britain and Japan rank lowest in terms of familiarity, with 51% having never heard of them; 50% of respondents in the United States have never heard of the SDGs; in comparison, 92% of respondents in Turkey have heard of them'.

Table 10.3 shows familiarity with SDGs of people from different regions of the world, based on another global survey, conducted towards the end of 2019, that resulted in 2198 responses (Rring, 2020). It may be interesting to note, from data shown in Table 10.3, that fewer people in developed countries (Europe and North America) are moderately or extremely familiar with the SDGs than those in the Arab and African countries.

Table 10.3 *Familiarity with the SDGs of people around the world* (Rring, 2020)

Region	Not at all familiar	Slightly familiar	Somewhat familiar	Moderately familiar	Extremely familiar
Arab	19%	14%	14%	29%	24%
African	13%	20%	12%	32%	17%
Latin American and Caribbean	41%	6%	11%	26%	10%
Europe and North America	25%	12%	18%	28%	17%
Asia and the Pacific	19%	14%	23%	29%	15%

The gaps in terms of familiarity with the SDGs apply not only to the general population, but are common also among professionals and researchers, even in the field of library and information services sector. A recent survey conducted by the OCLC amongst its 48 global Council delegates, in which 40 people responded, reveals that only five respondents were 'very familiar' with the SDGs, 18 were 'familiar', 10 were 'somewhat familiar' and seven were 'not familiar' at all (Cyr and Connaway, 2020).

Data availability and gaps

As discussed earlier (Chapter 5), availability of timely, accurate and comparable data for various SDG Indicators has remained a problem not only in the least-developed countries, but in most of the European, and even in the G7, countries. A recent UN report points out that:

- there are gaps in the data compilation where no data has been reported by the ONS against a number of Indicators (e.g. 2.4.1, 3.8.1, 6.3.1, 6.4.1, 11.2.1, 11.3.2)
- the data reported does not always fully reflect the information required by Indicators, e.g. the available data for Indicators that are used across multiple Targets (repeat Indicators) 1.5.1, 11.5.1 and 13.1.1 covers the number of deaths attributed to disasters but not information on missing and directly affected persons, despite the fact that both Indicators make reference to it
- the data reported for Indicator 2.5.1 (number of plant and animal genetic resources for food and agriculture) only partially reflects the required information, something which is acknowledged by the ONS.

(www.unglobalcompact.org.uk/wp-content/uploads/
2022/09/UN-Global-Compact-Network-UK-Measuring-Up-2.0.pdf, 131)

The Statistics Division of the United Nations (UNSD) notes that the production of data and statistics related to the SDGs has faced two main challenges in recent years (UN Statistics Division, 2022c):

1 the need for disaggregated information which is caused by the inequalities amongst countries around the world; more disaggregated information and data is needed to better understand societal challenges around the various SDG Indicators and country-specific challenges
2 the advent of new data sources, which is caused by the digital revolution and growing use of social media that generate large amounts of the so-called 'organic data' – the by-product of an activity, and not a planned outcome aimed at producing information on Indicators for a defined population. Such data can now be obtained, for example, from telecommunication and internet service providers (ISPs), social media companies, mobile and tracking devices and private-sector credit card and bank transactions.

As a result, the 'National statistical systems (NSS) are under increasing pressure to produce timely, high-quality data to monitor the digital economy and implementation of the United Nations 2030 Agenda for Sustainable Development' (UN Statistics Division, 2022c).

Scientific and social gaps

The UN report *The Future is Now* (United Nations, 2019) acknowledges that:

- significant gaps remain for bridging the scientific and technological divide between the developed and developing countries
- over 60% of total scientific literature and most research and development are carried out in the high-income countries
- although the number of women in science and engineering is growing at the global level, men still outnumber women, especially at the upper and management level.

There is also a gap in the way data is gathered for some SDG Targets, e.g. SDG16.10 (Public access to information) which is measured through a binary value of yes or no for whether legislation to the effect exists in a country. Table 10.4 shows data on the number of countries that have legislation supporting public access to information, as of 2022. However, as discussed in Chapters 6, 7 and 8, the preparedness of the population for accessing information depends on digital divide and information divide.

Table 10.4 *Number of countries that adopt and implement constitutional, statutory and/or policy guarantees for public access to information* (UN Economic and Social Council, 2022)

Region	Number of countries (as of February 2022)
World	127
Sub-Saharan Africa	21
Northern Africa and Western Asia	12
Central and Southern Asia	12
Eastern and South-Eastern Asia	9
Latin America and the Caribbean	23
Australia and New Zealand	2
Oceania (excl. Australia and New Zealand)	4
Europe and Northern America	44
Landlocked developing countries	21
Least-developed countries	20
Small island developing states	16

Digital exclusion

Digital exclusion remains a key challenge across the world, even in the developed countries. Digital exclusion in the European countries remains a major challenge, and there are several factors that cause this, for example (EC, 2022a):

- age and formal education affect a person's level of digital skills; while 71% of 16–24-year-olds had basic or above-basic overall digital skills in 2021, this was only the case for 62% of 25–54-year-olds
- older people struggle with the use of digital media, with only 35% of people aged 55–74 having at least basic digital skills in 2021
- while 79% of people with high formal education had at least the basic digital skills in 2021, this was only the case for 32% of people with no or low formal education.

Although the member states of the European Union have been advancing in their efforts to improve ICTs and advanced communications, for example, through the implementation of 5G networks, they still struggle to close the gaps in digital skills and digital transformation of society (EC, 2022d). Similar challenges are faced in other countries as well. The 2022 Ofcom report shows some significant digital exclusion in the UK which is caused by the socio-economic conditions of groups among the population (Ofcom, 2022b):

- the 'Narrow internet users': people who had ever undertaken only between one and four of the 13 online activities asked about (and this accounted for 29% of internet users) were more likely than average to be aged 65+ and in DE households (i.e. semi-skilled and unskilled manual occupations, unemployed and lowest grade occupations)
- age as a factor: among all working-age (18–64 years) people in DE households, the incidence of not having internet access at home was 5%; but increased to 30% among those aged 65+ in DE households
- the 'digital carers' (people who helped others in undertaking digital activities): 70% were doing so at least monthly and 37% at least weekly; and for younger digital carers this was higher: 81% of 16–24s who had helped someone online were doing so monthly and 46% weekly.

Poor digital skills also affect employment and the financial well-being of people. For example, data shows that, in the UK, comparing individuals in a similar job at a similar level, those with high digital capability are making up to £442 more per month (Lloyds Bank, 2022).

Some positive developments

Despite the recent and some ongoing challenges, there are some positive signs of development as well. The rapid growing technology, such as artificial intelligence (AI) can play a huge role in achieving the SDGs. Many researchers have shown the benefits of using the AI technologies on the SDGs (see for example Di Vaio et al., 2020; Sætra, 2021; Truby, 2020; Vinuesa et al., 2020). Similarly, deep learning techniques can also have an impact toward achieving the SDGs. Some researchers show that the student-generated research podcasts may have the utility for deep learning and education for sustainable development (see for example Kadyan, Singh and Ugwu, 2023; Kenna, 2022; Persello et al., 2022). Blockchain technology may also contribute to the SDGs, in particular, to enhance the environmental sustainability (Parmentola et al., 2022), and to transform governance and sustainability in integrated food supply chains (Chandan, John and Potdar, 2023).

As in many other fields, big data can make a significant impact on the SDGs. The 'Big data for sustainable development' site of the United Nations provides one example for each SDG showing how big data can contribute to the SDGs (United Nations, 2023):

- SDG1 (No poverty): Spending patterns on mobile phone services can provide proxy Indicators of income levels.

- SDG2 (Zero hunger): Crowdsourcing or tracking of food prices listed online can help monitor food security in near-real time.
- SDG3 (Good health and well-being): Mapping the movement of mobile phone users can help predict the spread of infectious diseases.
- SDG4 (Quality education): Citizen reporting can reveal reasons for student drop-out rates.
- SDG5 (Gender equality): Analysis of financial transactions can reveal the spending patterns and different impacts of economic shocks on men and women.
- SDG6 (Clean water and sanitation): Sensors connected to water pumps can track access to clean water.
- SDG7 (affordable and clean energy): Smart metering allows utility companies to increase or restrict the flow of electricity, gas or water to reduce waste and ensure adequate supply at peak periods.
- SDG8 (Decent work and economic growth): Patterns in global postal traffic can provide Indicators such as economic growth, remittances, trade and GDP.
- SDG9 (Industry, innovation and infrastructure): Data from GPS devices can be used for traffic control and to improve public transport.
- SDG10 (Reduced inequality): Speech-to-text analytics on local radio content can reveal discrimination concerns and support policy response.
- SDG11 (Sustainable cities and communities): Satellite remote sensing can track encroachment on public land or spaces such as parks and forests.
- SDG12 (Responsible consumption and production): Online search patterns or e-commerce transactions can reveal the pace of transition to energy efficient products.
- SDG13 (Climate action): Combining satellite imagery, crowdsourced witness accounts and open data can help track deforestation.
- SDG14 (Life below water): Maritime vessel tracking data can reveal illegal, unregulated and unreported fishing activities.
- SDG15 (Life on land): Social media monitoring can support disaster management with real-time information on victim location, effects and strength of forest fires or haze.
- SDG16 (Peace, justice and strong institutions): Sentiment analysis of social media can reveal public opinion on effective governance, public service delivery or human rights.
- SDG17 (Partnerships for the Goals): Partnerships to enable the combining of statistics, mobile and internet data can provide a better and real-time understanding of today's hyper-connected world.

A quick search using the search string (SDG* and 'big data') in the Web of

Science database in April 2023 produced 208 results, which include 168 research articles and 26 review articles. A review of 100 publications and datasets on the use of big data in SDGs reveals considerable coverage of the SDGs which corresponded to 15 SDGs, 51 Targets and 69 official Indicators (Allen et al., 2021). Overall, this review observed that there was stronger coverage of the Indicators for several SDGs: SDG3 (Health) (75% of SDG Indicators), SDG15 (Life on land) (64%) and SDG6 (Water and sanitation) (64%), and Indicators for some other SDGs were also covered, such as SDG1 on poverty and SDG11 on sustainable cities (Allen et al., 2021).

It is encouraging to note that several international and national organisations, local governments, private businesses, NGOs and charities are also collaborators in the use of big data for sustainable development in different areas. The review of Allen et al. notes a range of such organisations as collaborators in big data and SDGs research, such as:

- international and regional organisations like the United Nations, Development Banks, Group on Earth Observation and the European Commission
- space agencies like the National Aeronautics and Space Administration (NASA), UK Space Agency, German Aerospace Centre and the European Space Agency
- national government agencies like the National Statistical Offices (NSOs), scientific and geological survey agencies, and specific government ministries and departments
- research institutes like the International Institute of Applied Systems Analysis (IIASA) and European Commission Joint Research Centre (EC-JRC)
- non-government organisations and think tanks like the International Union for the Conservation of Nature, The Nature Conservancy, World Resources Institute, Flowminder Foundation and MindEarth
- private-sector organisations like Google, Orange Telecom, EOMAP
- donor agencies like the Bill and Melinda Gates Foundation, Gordon and Betty Moore Foundation, Global Environment Facility and bilateral donors.

However, it should also be noted that several challenges remain for using big data for measuring the progress and achievements in SDGs. Such challenges may be around skills development, sustainability and cost considerations, as well as potential trade-offs between timeliness and quality of data (Allen et al., 2021). However, lessons can be learnt from international co-operation in data exchange like the GHDx, (Global Health Data Exchange), 'the world's

most comprehensive catalog of surveys, censuses, vital statistics, and other health-related data', which can be can be used, shared, modified, or built upon by non-commercial use.

Reviewing the progress of application of big data on all the 17 SDGs, Hassani et al. (2021) point out that:

- some SDGs , i.e. SDGs 12, 14, 16 and 17, receive relatively less attention despite several practical applications and technological advancement in recent years
- applications of big data in SDGs are hindered by the digital divide of different countries, and although the importance of long-term sustainable development has been realised by some regions or countries and they are willing to embrace advanced technologies, applications of big data-led progress in SDGs are still a far-off goal.

They argue that:

- Big data should not be regarded as a solution in itself, rather it should be used as a contributing element – integrating big data with traditional data sources and 'non-traditional sources', which include, for example, citizen science, where everyone shares and contributes to data collection, integration, monitoring and analyses.
- Big data-empowered technologies should be accompanied by consider-ations of 'privacy, ethics, human rights, and legislation, to find a balance between the common good and individual preferences' (Hassani et al., 2021).

Communications and education

Given the importance of effective communication for achieving success in all the SDGs, some researchers argue that:

- communication for sustainability can be achieved by informing, persuading and enlightening people about the necessity for the change to achieve the SDGs (Chan and Lee, 2023)
- a new SDG like SDG18 – Communication for all – may be useful for empowering people, addressing inequality and reducing misinformation that could harm the public (Servaes and Yusha'u, 2023).

ICTs form the foundation of several SDGs, and especially SDG17 and 'ICT would have great potentials in playing important and key roles to support

global economical, social, and environmental sustainability, which wait for the relevant discovery based on global and multi-disciplinary efforts' (Wu et al., 2018). However, ICTs themselves have long-term sustainability issues that need to be addressed through cross-disciplinary, cross-sector and cross-country research. On the other hand, Hassani et al. (2021) emphasise that 'reducing digital inequality will require a global collective effort – for instance, the sharing of information, knowledge, technologies and essential infrastructure. Moreover, there should be greater focus globally to address dimensions of sustainable development and applications of Big Data that are not necessarily profit or value generating but tackle the consequences of unsustainable activities'.

As discussed in Chapter 9, education is at the core of all the SDGs. Several UNESCO documents and reports emphasise the needs for education for sustainable development; for example:

- 'governments, education policy-makers, academics, and education and environmental stakeholders need to further commit to Education for Sustainable Development' (UNESCO, 2021d)
- 'Education must return to the top of the international community's agenda if we are to meet the Sustainable Development Goals', commented Audrey Azoulay, UNESCO Director-General in September 2022 (UNESCO, 2022e).

UNESCO and various stakeholders of education have put forward some initiatives and action plans for promoting education for sustainable developments; for example:

- 'At the 2023 Education World Forum in London, UNESCO is putting the spotlight on two key initiatives to accelerate the implementation of climate change education and transform education systems: Greening education and digital transformation' (UNESCO, 2023c).
- 'A global initiative, Greening Education Partnership, is recently launched aiming to provide countries with strong, coordinated and comprehensive action to provide learners of all ages with the skills and knowledge needed to cope with climate change and, in turn, to promote sustainable development' (UNESCO, 2023c).
- 'An imbalance among the SDGs was observed, and the main gaps imply more research is needed on reduced inequalities (SDG10), gender equality (SDG5), and peace, justice, and strong institutions (SDG16) as for the social domain; oceans, seas, and marine environment (SDG14) as for the environmental domain; partnership for the goals (SDG17) and

cross-scale governance as a major enabler of the Agenda' (Trane et al., 2023)

- ■ at the Transforming Education Summit, the following key initiatives were put forward to accelerate action:
 - – getting every learner climate-ready
 - – expanding public digital learning
 - – fast-tracking gender equality in education
 - – improving access for crisis-affected children and youth (UNESCO, 2022e).

Summary

Reviewing some of the research literature and reports, this chapter highlights the progress of research around the SDGs while at the same time pointing out some challenges. New and emerging technologies like AI, big data, block chain technologies and deep learning bring in new promises for research and development in the SDGs. Side by side, there are a number of human and social challenges that may be addressed through research and development around education for sustainable development, digital divide, media and information literacy, etc.

Education and research in the information sciences, and the information service sector, can also pave the way for achieving the SDGs in general and making significant improvements in people's life and society as a whole. Most importantly, the information services sector can play a significant role in increasing people's awareness of the SDGs and building a peaceful and sustainable world. The knowledge triangle, i.e. education, research and innovation, needs to be linked with the mission of service to society (D'Adamo and Gastaldi, 2023). Some of the recent developments and challenges associated with education and research in information for sustainable development are discussed in Chapter 11.

Information Education, Research and Professional Developments Around SDGs

Introduction

'There is no truly sustainable development without access to information and no meaningful, inclusive access to information without libraries', remarked Donna Scheeder, the former President of IFLA (Scheeder, 2019). Libraries, and the information services sector in general, can contribute hugely to achieve the UN SDGs by:

- Promoting universal literacy, including media and information literacy, and digital literacy skills
- Closing gaps in access to information and helping government, civil society and business to better understand local information needs
- Providing a network of delivery sites for government programmes and services
- Advancing digital inclusion through access to ICT, and dedicated staff to help people develop new digital skills
- Serving as the heart of the research and academic community
- Preserving and providing access to the world's culture and heritage. 'Programmes for children, women, adults and other marginalized populations' make an important contribution to achieving universal literacy.

(https://sdgs.un.org/partnerships/contribution-libraries-sdgs)

'Literacy is imperative in developing sustainable and inclusive societies', says Arne Carlsen, Director of the UNESCO Institute for Lifelong Learning (UIL) (Carlsen, 2015). SDG4 intends to ensure inclusive and equitable quality education and promote lifelong learning opportunities for all. This implies that all people, 'irrespective of gender, age, race or ethnicity, including persons with disabilities, indigenous peoples, children and youth in vulnerable situations, should have access to learning that helps them acquire the knowledge and skills needed to exploit opportunities and to participate fully in society' (UNESCO, 2015b). As discussed in Chapter 9, education for

sustainable development has been identified by UNESCO as a core requirement for achieving success in the SDGs.

However, education for sustainable development has yet not been fully embedded in information sciences curricula. A few discussions and thoughts have been put forward by some researchers and professional associations, which are discussed in this chapter. Similarly, some research papers have been published in the recent past by researchers and professionals in the information science discipline, and initiatives have been taken by the information services sector in examining the role of information for sustainable development. Some of these research and development activities are discussed in this chapter with a view to showing some key trends, as well as challenges. The chapter concludes that overall, education and research in information science for sustainable development is still emerging, and several gaps still exist, and this calls for a research roadmap for the current and future information science researchers and professionals.

Research on green and sustainable libraries

Research on sustainable libraries, and sustainable information services, began in the late 1990s and much of the early research focused on library buildings and infrastructure. Research focusing particularly on green and sustainable information services began to appear much later. A quick search in October in the Web of Science database using the search string: (((SDG*) or (sustainability) or (sustainable development)) and ((data) or (information))), produced 215,510 results from all databases, out of which 39,758 were in the research area of Computer Science and 10,024 were in 'Information Science Library Science' (the research areas are listed in the Web of Science database). Out of the 10,024 retrieved items within the area of 'Information Science Library Science':

- 681 items were published in 2023; 1,633 in 2022; 1,121 in 2021; 917 in 2020; 886 in 2019; 762 in 2018; 696 in 2017; 489 in 2016; 381 in 2015, 281 in 2014; and so on; and
- 9,038 items were articles; 1,136 were review articles; 398 were theses and dissertations; 252 were books; 226 were editorial materials; and so on;

This clearly shows that researchers in the domain of library and information science have remained active in researching sustainable libraries and/or sustainable information. The number of research publications appearing each year was small before 2010, but increased quite steadily since then.

Some researchers have conducted bibliometric/scientometric analysis of

research on this topic, showing the trends of research (see for example Balogun, 2020; Fedorowicz-Kruszewska, 2022; Kamińska, Opaliński and Wyciślik, 2022; Khalid, Malik and Mahmood, 2021; Li and Yang, 2022; Meschede and Henkel, 2019). Li and Yang's (2022) study points out that the USA and China have published more papers than other countries, and Gobinda Chowdhury (the first author of this book) has the most output, ranking high in both author and paper citations. Different systematic reviews have grouped the research works on green and sustainable libraries under different broad themes. For example,

- Li and Yang's (2022) study shows that green library research has covered areas like library construction, library management, green library awareness training and related policies and regulations
- Kamińska, Opaliński and Wyciślik (2022) have categorised research on green libraries into six major themes: (1) buildings; (2) information; (3) collections; (4) education; (5) culture; and (6) others (research dealing with the overall picture of a library activity, and practices that are aimed at improving the library's performance within the area of SDGs accomplishment)
- Fedorowicz-Kruszewska (2022) identifies eight thematic categories of research on green and sustainable libraries: (1) strategies, plans and management; (2) building and its management; (3) equipment and products; (4) collections; (5) programmes, services, projects; (6) conduct and qualifications of librarians; (7) co-operation with the external environment; and (8) the theory of green libraries.

The review undertaken by Kamińska, Opaliński and Wyciślik (2022) shows the distribution of research on their six thematic areas as follows: (1) information and ICT (33%); (2) education (17%); (3) buildings (11%); (4) collections (7%); and (5) culture (4%); and (6) others (28%). On the contrary, two other reviews, by Li and Yang (2022) and Fedorowicz-Kruszewska (2022), report that green libraries and green library practices are the most discussed topics in this field. Li and Yang also point out that green library research covers such various aspects as library construction, library management, library green awareness training, and related policies and regulations.

Some of the key trends and challenges of research on green and sustainable libraries that have been identified and discussed in different research and review papers can be summarised as follows:

- The role of librarians, their knowledge and environmental awareness has been identified as a key requirement for building green and sustainable

libraries (Binks et al., 2014; Di Domenico, 2020; Hauke, Charney and Sahavirta, 2018; Karioja and Niemitalo, 2013; Sahavirta, 2012).

- There is a need to establish a green information system which is designed in such a way that it reduces the emission of GHG (greenhouse gases) throughout its whole lifecycle – from content creation to distribution, access, use and disposal (Chowdhury, 2010a, 2012a, 2012b, 2016).
- Often measures taken for achieving one form of sustainability can influence or affect the other forms of sustainability, and hence a holistic view and a strategic approach is essential (Chowdhury, 2014b).
- A generic model that can serve as a research framework for sustainable digital libraries of the future should combine all three pillars of sustainability with (i) user, (ii) data and their content and (iii) technical infrastructure (Chowdhury, 2014a).
- Debates and discussions around green library designs visibly intensified in 2007 (Kamińska, Opaliński and Wyciślik, 2022), and consequently researchers and professionals in the USA started paying close attention to green libraries and to formulating relevant green building evaluation standards, such as LEED (Leadership in Energy and Environmental Design, www.usgbc.org/leed) (Li and Yang, 2022), thus the LEED certificates became part of the worldwide green building certification programme.
- Some important areas of evaluation of green libraries were identified as: the indoor environment, energy and prevention of environmental pollution and materials and resources (Noh and Ahn, 2018).
- The key topics that are widely considered as a part of research and development in sustainable library and information services are: access to information, information society, information and communication systems and information science in general (Kamińska, Opaliński and Wyciślik, 2022);
- The relationship between activities undertaken by libraries and the implementation of the SDGs have been discussed in some research (e.g. Cardoso, 2018; Di Domenico, 2020; Sahavirta, 2018).
- International co-operation amongst researchers on green and sustainable libraries is not common (Li and Yang, 2022).
- Collection development, and reducing the carbon footprint of library collections, have been identified as an important area of green and sustainable libraries (Beutelspacher and Meschede, 2020; Huang and Chen, 2018; Jones and Wong, 2016; Ni and Li, 2013).
- The standard terminology and Indicators for green libraries need to be defined (Cardoso and Machado, 2015; Sahavirta, 2017; 2018; 2019; Fedorowicz-Kruszewska, 2020b).

- There is a need for promoting green information behaviour (Chowdhury, 2012a; Fourie, 2012), and green information literacy of users (Binks et al., 2014; Kurbanoglu, and Boustany, 2014; Fedorowicz-Kruszewska, 2020a; Repanovici, Salcă Rotaru, Murzea, 2021);
- Defining a theoretical framework on the issue of green libraries is an important requirement for building sustainable libraries (Fedorowicz-Kruszewska, 2020b; Ghorbani, Babalhavaeji and Nooshinfard, 2016).
- The issue of information behaviour is rarely discussed in the context of green libraries (Balog and Siber, 2016; Chowdhury, 2012a; Fourie, 2012).
- There is a lack of research on the evaluation of green libraries (Sahavirta, 2017; Fedorowicz-Kruszewska, 2020b, 2022).
- While the number of relevant publications has increased during the last 10 years, the research productivity of LIS scholars does not reflect the topic's rising prominence in the general scientific community (Meschede and Henkel, 2019).
- Generally speaking, sustainability and sustainable development concepts seem to interfuse each LIS topic (Kamińska, Opaliński and Wyciślik, 2022).
- Overall, green library research is at a relatively nascent stage, the number of publications continues to be small and the research influence is not strong (Li and Yang, 2022).

Institutional and professional activities and initiatives

'The Green Library movement began in the 1990s, with a strong focus on buildings', but 'libraries are about far more than just buildings', and given that their main business is to educate people by providing access to the relevant data and information, libraries have a major role in all areas of sustainable development, reports the IFLA document *Exemplars, Educators, Enablers: Libraries and Sustainability* (IFLA, 2018). Consequently, IFLA has been actively advocating and providing information on how libraries can connect 4 billion people around the world in contributing to the achievements in the SDGs (Noh, 2021). The IFLA Strategy 2019–2024 highlights IFLA's existing strengths, and its commitment to the SDGs (IFLA, 2019).

Some libraries, professional bodies, international organisations, NGOs, charities, professionals and researchers around the world have taken various initiatives and formed networks aimed at developing policies and guidelines around sustainable library and information systems and services. The Canadian Federation of Library Associations/Fédération canadienne des associations de bibliothèques (CFLA-FCAB) developed its first Strategic Plan spanning from September 2019 to August 2022 for libraries and sustainable

development with the theme of 'Stronger together: advancing the impact of libraries' (McColgan, 2019). Sustainability was adopted as one of the core values of librarianship by the ALA (American Library Association) Council in 2019 (ALA, 2023a). CILIP created the *Green Libraries Manifesto* to build a set of common values and commitments to drive transformational changes for sustainable development (CILIP, 2022). Similar initiatives have also been taken by other national library associations like the ALIA (Australian Library and Information Association) Sustainable Libraries (ALIA Green) in Australia (ALIA, 2023).

Some activities and initiatives of libraries, national and global library and information institutions, and professional bodies towards sustainability are discussed below. Some recently published books discuss why sustainability matters to libraries and their user communities (see for example, Aldrich, 2018; Tanner et al., 2021), and provide accounts of some activities and initiatives incorporating sustainability considerations into the decision making and professional practices undertaken by staff at a range of libraries (see for example, Tanner et al., 2021). Although this is by no means an exhaustive list, it gives an indication of the current state of developments and interests around the concept of sustainability and sustainable development in the sector. While some institutions, associations, groups and individuals have focused on defining terms and developing policies and guidelines (see for example Cardoso and Machado, 2015; Chowdhury, 2012a, 2012b, 2014b; Sahavirta, 2017; 2018; 2019; Fedorowicz-Kruszewska, 2020b), others have conducted specific projects to estimate the carbon footprint of library collections, buildings and infrastructure (see for example, Chowdhury, 2010a; 2014a; 2016) and others have created resources and networks for promoting the concept of sustainability in libraries.

Strategies and policies

An OCLC study that conducted three virtual focus-group interviews with a total of 16 OCLC Global Council delegate participants, and a survey that was completed by 40 OCLC Global Council delegates (Cyr and Connaway, 2020), identified five SDGs where libraries can contribute: SDG4 (Quality education), SDG8 (Decent work and economic growth), SDG10 (Reduced inequalities), SDG16 (Peace, justice and strong institutions) and SDG17 (Partnerships for the Goals). Findings of the OCLC survey indicate that 'library staff who explicitly or implicitly consider the SDGs in their strategic planning also tend to carry out more SDG-related activities', indicating that 'there could be a relationship between SDG-related activities and the explicit or implicit consideration of the SDGs in strategic planning' (Connaway et al., 2023).

International organisations like the United Nations recognise that libraries are providing a wide range of services to support the needs of the community and therefore progress towards the achievements of the SDGs:

- Increasing income for small-scale food producers (SDG2): In Romania, public library staff trained by the Biblionet programme worked with local government to help 100,000 farmers use new ICT services to apply for agricultural subsidies, resulting in US$187 million reaching local communities in 2011–2012.
- Promoting lifelong learning opportunities (SDG4): In Botswana, public libraries have taken large strides toward supporting government objectives under its National Vision 2016, including introducing ICT access, improving the computer skills of library users and enabling users to be successful in business, education, and employment.
- Empowering women and girls (SDG5): The National Library of Uganda has provided ICT training specifically designed for female farmers, ensuring that these women can access weather forecasts, crop prices and support to set up online markets, in their local languages.
- Ensuring productive employment and decent work (SDG8): In one year, 4.1 million adults in the European Union used public library computers to support employment-related activities – 1.5 million used library computers to apply for jobs, and more than a quarter of a million secured jobs this way.
 (https://sdgs.un.org/partnerships/contribution-libraries-sdgs)

The Council of Australian Academic Libraries (CAUL) strategy document notes that academic libraries can contribute to the SDGs by:

- promoting literacy, including digital, media and information literacy skills
- closing gaps in access to information, and helping individuals in all aspects of their life to better understand and address their information needs
- communicating knowledge created in universities, especially around sustainability
- creating community knowledge by serving as the heart of the research and academic community
- building global partnerships and collaborations that provide greater access to digital collections and information capability programmes
- preserving and providing access to the world's culture and heritage
- providing a network of delivery sites for government programmes and services (Missingham, 2019; 2021).

Missingham (2021) comments that while other SDGs, such as SDG10, reduced inequalities, are relevant, four SDGs are highly relevant to the academic library sector, which are quality education (SDG4), gender equality (SDG5), industry innovation and infrastructure (SDG9), and sustainable cities and communities (SDG11). The case study of Australian academic libraries establishes that the SDGs can be used as a reporting framework and demonstrates that academic libraries provide a value to their stakeholders which goes beyond numeric measures of economic and social benefit (Missingham, 2021).

The section on 'Environment, Sustainability and Libraries' (ENSULIB) of the International Federation of Library Associations and Institutions (IFLA) defines a green library as 'a library which takes into account environmental, economic *and* social sustainability' (IFLA, 2023b). The IFLA ENSULIB definition also specifies the characteristics of a green and sustainable library by stating that such a library should have a clear agenda for:

- **green buildings and equipment** that should aim to decrease the emissions, or carbon footprint, of the library
- **green office principles** that incorporate environmentally sustainable operational routines and processes of the library
- **sustainable economy** that promotes the concept of sustainable consumption, and circular and sharing economy practices to the community
- **sustainable library services** that ensure: (a) easy access to relevant and up-to-date information, shared spaces, devices, (b) environmental education is offered, (c) operations are efficient, and (d) the library has a positive carbon handprint (measure of how much greenhouse gas (GHG) emission reductions a library can help its customers to achieve through its products and services)
- **social sustainability** that contributes to good education, literacy, community engagement, cross-cultural diversity, social inclusion, and reducing inequality
- **environmental management** that requires SMART (Specific, Measurable, Achievable, Realistic and Timebound) environmental goals to enable the library to reduce its own negative impact on environment; and the library's environmental policy, its implementation and the results of environmental work are communicated to a wider audience
- **commitment to general environmental goals and** programmes guided by the UN Sustainable Development Goals, the Paris Climate Agreement and related environmental certificates and programmes.

The CILIP *Green Libraries Manifesto* (CILIP, 2022).mandates that libraries should:

1 bring environmental sustainability to the heart of decision making in libraries
2 innovate and evolve environmental practices across core library functions and practices
3 work with communities to learn and support local green initiatives
4 use voice for more impact by using the library's unique reach and position of trust
5 work in partnership with other like-minded organisations in the private, public and voluntary sectors
6 grow and share knowledge by continually expanding environmental understanding, as individuals, teams and organisations
7 support young people to be leaders in a green and just transition, and to take action at home, at school, in communities, and in the workplace.

A closer look at the policies recommended by IFLA ENSULIB and the CILIP *Green Libraries Manifesto* shows that libraries can play a dual role in tackling, and contributing to, the environment and sustainability agenda: (1) by being environmentally sustainable as an institution through its building, facilities, infrastructures and services; and (2) by working with the community to create and support sustainable learning, behaviour and practices.

The ALA *Sustainability in Libraries* briefing guidelines (ALA, 2022) argue that environmental stewardship cannot be the only focus, and we should aim for balancing the realities of ecological limits with humans' right to exist in a fair and just world that is economically feasible for all, by focusing on:

- *Climate mitigation*
 - energy efficient facilities
 - switching to renewable energy sources
 - electric vehicles
 - ethical Carbon Offsets; as well as
- **Climate adaptation/Climate justice**
 - advancing food justice
 - advocating transportation equity
 - upholding civil and human rights in emergency management; and
 - facilitating participatory democracy.

However, although such policies and guidelines are in place, progress in libraries' actions and contributions to sustainability has been slow even in the

developed countries, let alone the developing or the least-developed countries.

Libraries and SDGs: the current state of awareness and initiatives

'In general, the *Agenda 2030* [the SDGs] was still considered an accessory objective, not pivotal in library activities', noted the first report of EBLIDA (European Bureau of Library, Information and Documentation Associations) on libraries and sustainable development (EBLIDA, 2022). However, an interesting shift in the situation was reported in the second EBLIDA report, pointing out that not only had the level of awareness become much higher, but a good number of library associations had convincingly embarked upon the *Agenda 2030* pathway (EBLIDA, 2023a). Two recent transnational surveys – one at the global level conducted by OCLC, and another at the European level undertaken on behalf of EBLIDA, show that the awareness and understanding of the SDGs and their relevance for the sector vary significantly among the information professionals.

Key findings from an OCLC survey

From November 2020 to January 2021, OCLC conducted an online survey of library staff worldwide to identify how their activities are contributing towards five SDGs: SDG4 (Quality education), SDG8 (Decent work and economic growth), SDG10 (Reduced inequalities), SDG16 (Peace, justice and strong institutions), and SDG17 (Partnerships for the Goals) (Connaway et al., 2023). The survey had 1722 respondents in total, with the following distribution:

- Regional coverage
 - Americas: 65% ($n = 1125$)
 - Europe, the Middle East and Africa: 26% ($n = 448$); and from the
 - Asia-Pacific: 9% ($n = 148$)
- Type of libraries
 - Academic (or educational) libraries: 50% ($n = 866$)
 - Public libraries: 31% ($n = 533$)
 - Other library types, such as national, government, corporate, law, museum, and medical libraries, as well as research centres/institutes and consortia: 19% ($n = 323$).
- Level of familiarity with the SDGs: overall, 63% reported that they are at least somewhat familiar with the SDGs, with the following distributions of familiarity in the regions

- – Asia-Pacific region (82%)
- – Europe, the Middle East and Africa region (78%)
- – the Americas (54%)
■ Source of information for awareness/familiarity with the SDGs
 - – 28% from OCLC
 - – 27% from IFLA
 - – 20% from news sources
 - – 18% from the United Nations
 - – 17% at a conference or other event
 - – 16% from a colleague
 - – only 1% from the Association for Information Science and Technology.

Lack of awareness of the SDGs among information professionals is also common in other countries. For example, a survey among the staff of public libraries in South Korea noted a very low level of awareness of the SDGs in the context of library services: only 12.4% of respondents knew about it, whereas 78.1% said they were not aware of the SDGs (Noh, 2021).

Table 11.1 shows how the participating libraries in the OCLC survey ranked their contributions to the five SDGs, in a score out of 5. As shown in Table 11.1, SGD4 (Quality education) has an average ranking score of 4.5 out of 5. SDG10 (Reduced inequalities), SDG16 (Peace, justice and strong institutions), and SDG8 (Decent work and economic growth) were all ranked similarly near the middle, with SDG17 (Partnerships for the Goals) having the lowest average ranking among the five SDGs.

Table 11.1 *Average ranking score for top five SDGs where libraries can contribute* (OCLC survey; Connaway et al., 2023)

SDG	Average ranking (out of 5)
SDG4: Quality education	4.52
SDG10: Reduced inequalities	2.88
SDG16: Peace, justice and strong institutions	2.78
SDG8: Decent work and economic growth	2.69
SDG17: Partnership for the Goals	2.13

The EBLIDA survey in Europe

In June 2021, the EBLIDA Secretariat sent out a survey addressed to library associations in Europe and to the community of EBLIDA experts who are promoting the *2030 Agenda* for sustainable development. The survey received

responses from library associations and other representative institutions from 17 countries. Responses from the EBLIDA survey show that only 10% of the respondents felt that sustainable development is now the core library concept, while 47% felt that the SDGs are being implemented in a convincing and active way. A more positive finding of the EBLIDA survey is that: '84% of national library associations and/or library agencies state that there is a clear promotion of SDG-oriented schemes, with a selection of SDGs that are relevant at national level and the definition of well-established policies', and this confirms that 'awareness, at least at top level, has increased from 2020 to 2021, together with the understanding that SDGs are a central drive for library development' (EBLIDA, 2023a, 10). The EBLIDA survey notes that '15 out of 17 SDGs are recognised as being relevant for ordinary library work', but the priorities varied; for example:

- 95% of the respondents selected SDG4 (Quality education) as the pivotal SDG for libraries
- 68% of the respondents felt that SDG11 (Sustainable cities and communities), and 63% that SDG16 (Peace, justice and strong institutions), are also strongly associated with library work – library heritage is core in SDG11, whereas SDG16.10 deals with access to information
- 57% of the respondents felt that SDG17 (Partnership for the Goals) is strongly associated with library work, although this is understood more in the sense of traditional library co-operation than recognition of the need for international co-operation
- 48% of the respondents felt that SDG10 (Reducing inequality) and 47% felt that SDG3 (Good health and well-being) are also at the core of library activities
- 42% of the respondents felt that SDG5 (Gender equality) is core to library activities
- awareness activities about SDG12 (Responsible consumption and production) and SDG13 (Climate action) also enjoy popularity in SDG-oriented library activities (42%)
- other SDGs, such as SDG1 (No poverty), SDG6 (Clean water and sanitation), SDG7 (Affordable and clean energy), SDG8 (Decent work and economic growth), SDG9 (Industry, innovation and infrastructure), SDG15 (Life on land) – are found to be less popular in libraries (receiving 10% to 30% of the answers)
- SDG2 (Zero hunger) and SDG14 (Life below water) are not perceived to be immediately close to library work.

Challenges

There is still a long way to go before SDGs become the core components of the LIS sector's vision and strategy. A CILIP Green Libraries Partnership survey that collected data from 55 participating public libraries in England reveal that (CILIP Green Libraries Partnership, 2022):

- 85% of public libraries follow local authority environmental policies which are not library-specific, only 15% have their own environmental policies, and 32% are developing their own environmental policies
- Only 36% of people had some environmental roles and responsibilities, and 38% had some environmental training through the local authority but those were non-library specific training.
- Key areas for action include building energy use, materials and waste, plastics, green procurement.
- Key engagement activities include environmentally themed books and collections, environmental services (e.g. e-waste recycling) and environmental learning activities, festivals and events.
- Key opportunities include financial benefits e.g. cost savings, environmental awareness-raising, new engagement opportunities and improved health and well-being for library staff and users.
- Key challenges include dependence on local authorities for bigger changes and investments; access to environmental data; and lack of money, time, knowledge and expertise.
- Key areas where future support is needed include both capital and project funding, environmental training, webinars and events and access to better information on green services, products and solutions.

While the above-mentioned survey reports show evidence of increasing awareness and activities of libraries around the sustainability theme, the progress is not uniform across the board. Some of the key conclusions of the second EBLIDA report of sustainable development are:

- the progress of SDG implementation in European libraries is quite heterogeneous: in some countries, libraries are fully integrated into the national SDG policy; in others, SDG attainment in libraries is done in a practical way, with no involvement of national authorities
- 68% of countries would like to have library indicators for the evaluation of SDG-oriented library projects; as a consequence, there is a strong need for indicators in SDG-oriented library projects and activities

* a great deal of work still has to be done in order to arrange closer and stronger partnership with a diverse range of institutions, whether regional/national and/or international
* professional organisations and librarians' associations have a great role to play in raising librarians' awareness about SDGs
* more active library participation, boosting evaluation tools, raising libraries' awareness of the EU Structural and Investment Funds as well as other EU opportunities, are fundamental tasks for national library associations.

(EBLIDA, 2023a, 24)

Sustainable library infrastructure and facilities

Earlier research has focused on how to reduce the carbon emissions from library and information services, especially comparing the carbon footprint of print versus digital collections (see for example, Chowdhury, 2010a; 2012a; 2012b; 2013; 2014b; 2016). Similarly, several libraries have focused on reducing their carbon footprint through green library buildings and energy-efficient infrastructure and facilities. For example, the British Library has reduced carbon emissions by 26.4% over the last 10 years, and it is working with sustainability consultants to start the journey toward a net zero commitment (British Library, 2023). The Bodleian Libraries and the University of Oxford have taken an approach of working both a top-down green strategy and a more formalised bottom-up movement through a Green Impact scheme (Mackinlay, 2020).

For the first time the carbon footprint of public libraries has been calculated in a study that took place in 2020 in the city of Helsinki in Finland (City of Helsinki, 2021) which noted that:

■ the average carbon footprint of the public libraries involved in the study 'ranged from 30 to 420 tonnes of CO_2 equivalent depending on the size of the library'
■ approximately two thirds of emissions by libraries are caused by heating the premises and electricity consumption, meaning that the larger the library is, the larger the carbon footprint. Libraries do not, however, have a say in what kind of energy they consume.

Networks and resources

Although progress has been slow, there is a growing awareness of sustainability and the role of libraries among the professional associations. For example, the objectives of the EBLIDA 2022–2025 Strategic Plan are:

- to pursue the facilitation of networking and knowledge sharing between members, focusing on the strategic objectives of sustainability, democratic participation and equal access to information, and
- to advocate for libraries and their work at a European level and support advocacy at the national and local level.

<div align="right">(EBLIDA, 2023b)</div>

Also, a number of individual libraries, professional bodies and networks have been engaged in building resources and tools for sustainable libraries. Some examples include the following:

- A greener library: The Bodleian's push for sustainability (CILIP, 2020)
- CILIPS GoGreen Collection (www.cilips.org.uk/cilips-go-green)
- The Green Impact (https://sustainability.admin.ox.ac.uk/green-impact)
- Going Green at Glasgow Women's Library (www.cilips.org.uk/going-greengwl)
- IFLA: Tools for Green Libraries October 2022 (www.ifla.org/wp-content/uploads/GreenLibsTools_v01_202210.pdf)
- Inverclyde and Western Isles Libraries: Scotland's COP26 Climate Beacons (www.creativecarbonscotland.com/project/climate-beacons-for-cop26)
- National Library of Scotland: researching climate change (https://maps.nls.uk/guides/climate)
- The Nature Library: pop-up reading spaces connecting people to land, sky and sea (www.thenaturelibrary.com)
- Scottish Library and Information Council (SLIC), Climate Resources (SLIC, n.d.)
- The Sustainable Libraries Initiative (2023), based in the USA, offers training for 'library leaders to advance environmentally sound, socially equitable, and economically feasible practices to intentionally address climate change and co-create thriving communities' (Sustainable Libraries Initiative, 2023)
- SLIC Lend and Mend Hubs (https://scottishlibraries.org/about-us/news/lend-and-mend-hubs-launch-across-scotland)
- Sir Alex Ferguson Library at Glasgow Caledonian University: the Saltire Garden (www.instagram.com/p/ByXCfa8Avq5).

Information science education for sustainable development

As discussed in Chapter 9, one of the most effective ways of moving towards a sustainable society is education for sustainable development (ESD), and

hence sustainability should also find its rightful place in LIS education (Chowdhury and Koya, 2017; Meschede and Henkel, 2019). As discussed earlier in Chapters 6 and 7, digital and information skills play an important role in promoting and achieving sustainable development in every area. Hence, the concepts of sustainable development in general should be embedded in every aspect of data and information management teaching and research in the information science and the allied disciplines so that the graduates can make appropriate management, research and professional contributions at the workplace in every business and industry towards achieving the SDGs (Chowdhury and Koya, 2017). In addition, environmental literacy also plays an important part in promoting not only the SDG on climate change (SDG13), but it also contributes to several other SDGs. Sustainable information literacy is situated at the intersection of three core elements of a higher education system – research, curricula and library – and this can be regarded as a new direction for teaching and research in the information field (Kamińska, Opaliński and Wyciślik, 2022). In 2023, the American Library Association (ALA), in collaboration with the Sustainable Libraries Initiative, introduced a new course on 'Sustainable Librarianship: core competencies and practices' that aims to provide library staff with access to expert instruction on the subject of sustainable libraries (ALA, 2023b).

The four key dimensions of information poverty that merit collaborative future research: are (i) information as an agent to eradicate poverty; (ii) the causal factors resulting in information poverty; (iii) creation and production activities to combat information poverty; and (iv) better understanding of areas of extreme disadvantage and aspects of information need (Marcella and Chowdhury, 2020).

Literature also shows that libraries are making contributions to several SDGs, such as:

- SDG2, SDG4, SDG5, and SDG8
 (https://sdgs.un.org/partnerships/contribution-libraries-sdgs)
- SDG4, SDG8, SDG10, SDG16, and SDG17 (Connaway et al., 2023)
- SDG4, SDG5, SDG9, and SDG11 (Missingham, 2021)
- 15 out of 17 SDGs (i.e. SDG1, SDG3, SDG4, SDG5, SDG6, SDG7, SDG8, SDG9, SDG10, SDG11, SDG12, SDG13, SDG15, SDG16, SDG17) are recognised as being relevant for ordinary library work, but the priorities vary (EBLIDA, 2023a, 10).

To help countries deliver on SDG14 and implement an inclusive, ecosystem-based approach to managing their coasts and oceans, *Conservation International* and the University of California, Santa Barbara, developed the

Ocean Health Index, which is already being used in 28 countries; it assesses all elements of ocean health – biological, physical, economic, social and cultural – and provides decision makers with the information needed to make sustainable decisions about ocean use, contributing to SDG14, Sustainable oceans, seas and marine resources (UN Department of Economic and Social Affairs, 2017). Research shows contributions to one SDG can positively influence other SDG; for example, achievements in SDG14 (Life under water) can influence other SDGs such as poverty reduction (SDG1); marine training and awareness programmes, improvements in ocean literacy and skilled sustainability professionals on ocean and sea services (SDG4), job creation and economic growth (SDG8);, lower inequalities (SDG10); effective public sectors (SDG16); and partnerships for sustainable development (SDG17) (Horan, 2020).

Towards a roadmap

As discussed earlier in this chapter, much of the research and professional development activities within the information services sector have so far focused primarily on SDG13 (Climate change) with the aim of developing some initiatives and activities around the environment and climate change agenda. However, the progress has been piecemeal, and slow.

A roadmap for sustainable information services

With regard to the sustainability and climate change challenges (SDG13), the information services sector can play a dual role in contributing to the green and sustainability agenda (especially in the SDG13, Climate change) by: (1) reducing their carbon footprint through the buildings and infrastructure, collections and services, and thus being environmentally sustainable institutions; and (2) developing collections and services around environmental literacy, sustainability thinking and community education and advocacy programmes about climate change and sustainability agenda. However, as of now, there are no agreed standards or frameworks, with metrics of targets and indicators, that can be used by different types of libraries to assess their contributions to and achievements in the sustainability agenda.

Figure 11.1 on the next page shows how the information services sector can contribute to different SDGs through:

1 sustainable infrastructure and facilities that can aim to use clean energy (SDG7) and reduce carbon emissions, and thus can directly contribute to SDG13 (Climate change)

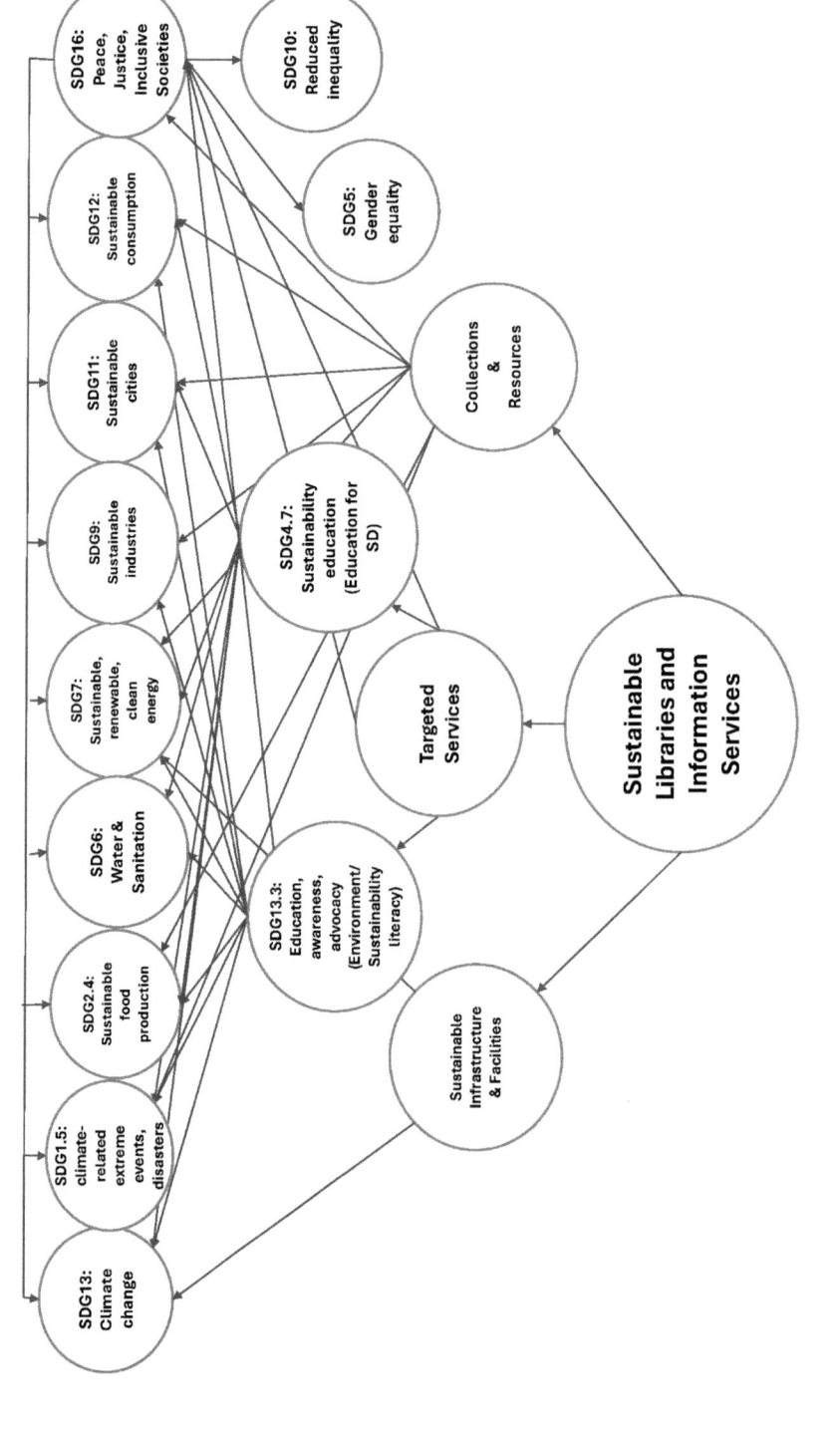

Figure 11.1 A diagram showing how the information services sector can contribute to the sustainability and climate change agenda

2 various targeted services:
(a) developing specific awareness and training programmes around the climate change Targets and Indicators (SDG13.3), e.g. environmental literacy programmes which can contribute to several SDGs, such as SDG13, SDG1.5 (Climate-related extreme events), SDG2.4 (Sustainable food production, maintain ecosystems, adaptation to climate change), SDG6 (sustainable management of water), SDG7 (Clean energy), SDG9 (Sustainable industrialisation), SDG11 (Sustainable cities) and SDG12 (Sustainable consumption)
(b) developing specific programmes for ESD (Education for Sustainable Development) for targeted users which will contribute to several SDGs, e.g. SDG11 (Sustainable cities), SDG12 (Sustainable consumption), SDG16 (Peace and justice), which will in turn contribute to SDG5 (Gender equality) and SDG10 (Reduced inequalities
3. targeted resource development and management: development of thematic collections and resources can contribute to SDG7 (Clean energy), SDG9 (Sustainable industrialisation), SDG11 (Sustainable cities), SDG12 (Sustainable consumption), and SDG16 (Peace and justice).

In addition, by contributing to SDG16 (and especially through SDG16.10: access to information), the information services sector can contribute to all the SDGs: for example by enabling people to engage in effective communications, informed discussions and debates, influencing policies and regulations and so on (as shown in Figure 11.1). Thus, a framework of specific Targets and Indicators developed around the sustainable infrastructure and facilities, collections and services, which can be mapped onto the different SDGs (shown in Figure 11.1), will help the information services sector build research and professional services for contributing to the climate change agenda (SDG13) as well as a number of other SDGs.

A roadmap for education and research in information science for the SDGs

Despite several reports, discussions and advocacy by UNESCO (discussed in Chapter 9), and the academic and research community (see for example, Chowdhury, 2012a, b; 2014a ; 2016; and Chowdhury and Koya, 2017), SDGs have not been fully included or embedded in the academic and research programmes in information science. As a result, the information research and professional communities have not been at the forefront of promoting and contributing to the SDGs. Furthermore, as discussed earlier in this chapter, most people, including the information professionals, relate the words

sustainability or sustainable development to only one SDG, SDG13 (climate change). This may partly be due to the lack of awareness of the information professionals and researchers, partly due to the prominence of the climate change agenda in government and popular media discussions, and partly due to the inactions of information science departments in universities, accreditation bodies and professional associations around the globe. Note that, as discussed earlier in this chapter, only 1% of the OCLC survey participants reported that they had learnt about the SDGs from the Association for Information Science and Technology.

Access to information is a cross-cutting issue that supports all of the SDGs (UN Department of Economic and Social Affairs, n.d.e), and hence the information services sector can make significant contributions to improve the outcomes across all the SDGs. Furthermore, as discussed throughout this book, digital literacy, and media and information literacy, are the key requirements for achieving success in all the SDGs. So by promoting media and information literacy, and closing the gaps in access to information and thus the digital divide, and helping governments, civil societies and businesses to better understand national and local information needs, the information services sector can make a huge contribution to all the SDGs and thus help to build a sustainable society.

Also, the information services sector can play a key role in promoting sustainability thinking (Van Antwerp and Heun, 2022), and together, digital literacy, information literacy and environmental literacy can contribute to achieving sustainability literacy: 'the knowledge, skills and mindsets that allow individuals to become deeply committed to building a sustainable future and assisting in making informed and effective decisions to this end' (https://sustainabledevelopment.un.org/sdinaction/hesi/literacy). However, one of the key challenges facing the information services sector is that there is yet to be an agreed framework and set of Indicators for measuring and reporting the role and contributions that the sector can make in different SDGs. As discussed earlier in this chapter, the disparity of knowledge across the global information services sector is quite wide. Lack of understanding can not only cause delays in the development of a sector-wide strategy towards information for SDGs, it can also lead to 'greenwashing', a term which relates to the act of misleading the public about the extent of an organisation's operational sustainability, or undertaking tiny, almost useless actions to improve sustainability (Elzi, 2022). A common framework for sustainability for the information services sector will help individual libraries develop their own sustainability strategies to identify their potential to do more and establish concrete goals (Davis, Ferriss and Kropp, 2022), changing behaviour around waste management (Kaufman, Cohen and Eller, 2022), or

addressing wider issues, such as racism (Elzi, 2022).

Some encouraging activities have begun that could lead to the development of a strategy and a framework for reporting on the information services sector's contributions to the SDGs. For example, the European Libraries and Sustainable Assessment Working Group called for indicators of library impact to be framed around the SDGs (EBLIDA, 2022), and IFLA (IFLA, n.d.) have created a storytelling manual to help libraries describe their activities in the context of the SDGs.

Figure 11.2 shows how the information services sector, and especially information science education and research, can contribute to the SDGs through:

- building collections and resources (data and information) around the theme, as well as the Targets, of each SDG
- developing EDS (Education for Sustainable Development) and sustainability thinking programmes at all levels – schools, universities, informal and lifelong learning – the information services sector can contribute directly to SDGs 8–17
- developing digital, information and environmental literacy programmes at all levels – schools, universities, informal and lifelong learning – the information services sector can contribute to several SDGs.

The information services sector's contributions to some SDGs will, in turn, contribute to some other SDGs. For example, contributions to SDG16, through access to relevant data and information, sustainability education and sustainability thinking, will enable people to engage in informed discussions and debates, as well as co-operation and resource sharing around a number of other SDGs (see Figure 11.2).

As shown in Figure 11.2, development of a framework of targets and indicators for developing thematic information resources and collections can contribute to all the SDGs. However, in order to achieve this, sustainability and sustainable development goals should become a mainstream topic for education and research within the discipline of information science (Chowdhury, 2013; Chowdhury and Koya, 2017). Future research agendas may include several interrelated facets such as: (a) education and awareness development within the current and future workforce of the information services sector (Chowdhury and Koya, 2017); and (b) frameworks for measuring and evaluating information services for sustainable development (Meschede and Henkel, 2019). Future research on data and information related to all the SDGs, and their Targets and Indicators, should also take into account the huge gaps in capacity and resources, and gender imbalance, in

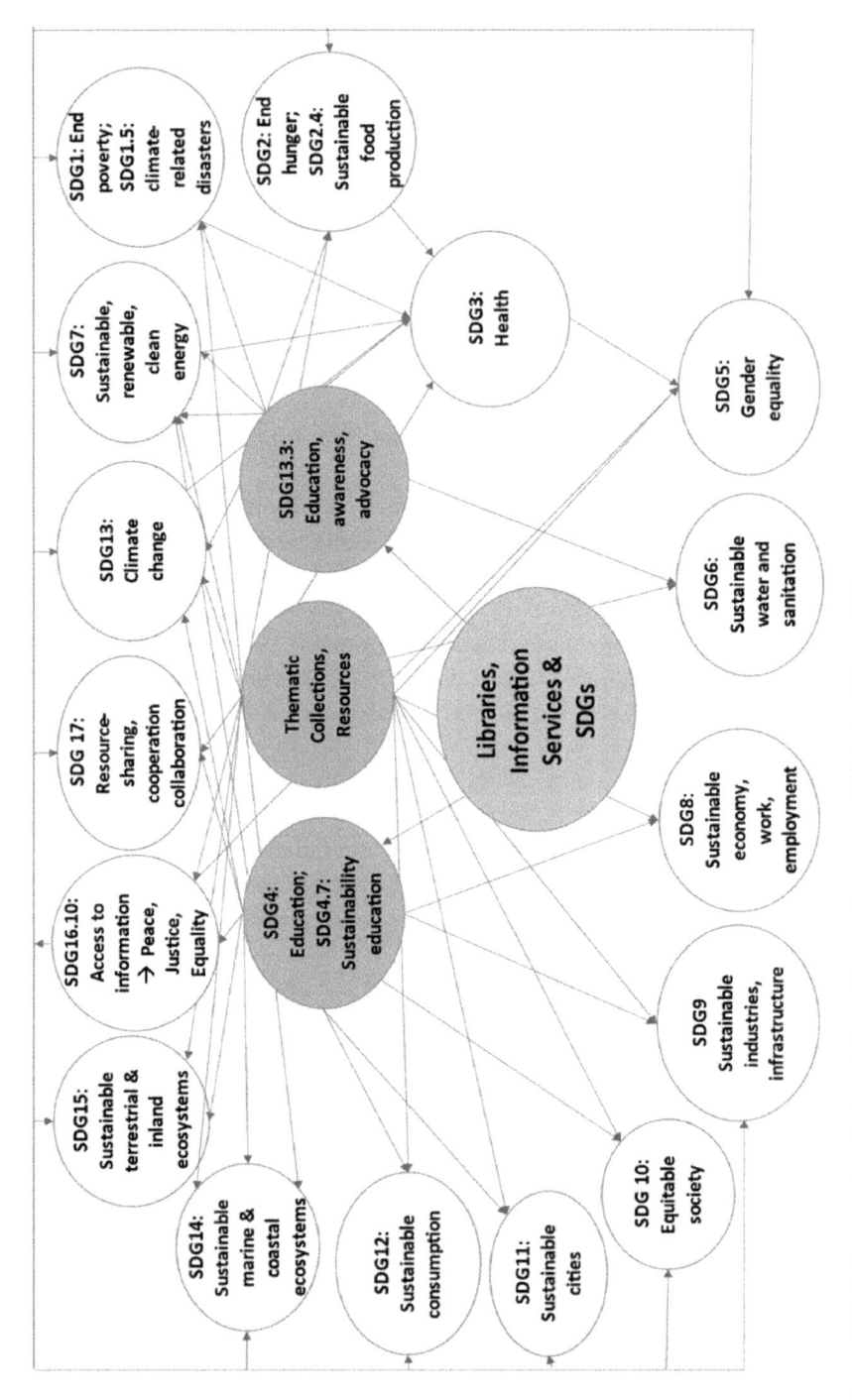

Figure 11.2 *A diagram showing how information services can contribute to different SDGs*

research. Universities, professional associations and major national, public, academic and research libraries around the world should work together to embed the 17 SDGs in information science teaching and research programmes, to create an appropriately trained information systems and services workforce who can contribute to the SDGs through their sustainability thinking and sustainable information practices.

Summary

Libraries, and the information services sector in general, can play a major role in contributing to the SDGs, especially by providing access to the relevant data and information that can not only help the general public but can also help professionals, researchers, decision makers, policy makers, and so on, in playing their roles in promoting the SDGs in their respective professions and areas of activities. Overall, by building collections of thematic resources and targeted services, and especially by adopting open access policies, the LIS sector can contribute in all the three dimensions of sustainable development, economic, social and environmental – for reducing poverty and hunger, improving health, education and employment, and side by side contributing to building sustainable water and sanitation systems, sustainable energy systems, sustainable industries, sustainable cities, and sustainable climate and ecosystems, on land and under water. By improving people's digital skills and media and information literacy, thus bridging the digital divide and, in turn, promoting digital inclusion, the LIS sector can play a significant role in promoting awareness of the SDGs – reducing inequalities in society, improving gender equality, improving sustainability thinking – and thus create habits of sustainable behaviour and sustainable consumption patterns, and overall contribute to building a peaceful sustainable and just society.

References

ACRL (2016) *Framework for Information Literacy for Higher Education*,
www.ala.org/acrl/sites/ala.org.acrl/files/content/issues/infolit/framework1.pdf.

Adriaans, P. (2020) 'Information'. In Zalta, E. N. (ed.) *Intelligence and Lecture Notes in Bioinformatics*, 275–82,
https://plato.stanford.edu/archives/fall2020/entries/information.

Advance HE (2021) Education for Sustainable Development Guidance,
www.advance-he.ac.uk/consultancy-and-enhancement/teaching-learning/education-sustainable-development-higher-education#guidance.

ALA (2022) *Sustainability in Libraries: A Call to Action*,
www.ala.org/aboutala/sites/ala.org.aboutala/files/content/
SustainabilityInLibraries_Briefing_Final_April2022.pdf.

ALA (2023a) Sustainability and Libraries: ALA and Sustainability,
https://libguides.ala.org/sustainablelibraries.

ALA (2023b) News: ALA Continuing Education Launches Sustainability Course in Partnership with Sustainable Libraries Initiative,
www.ala.org/news/press-releases/2023/01/ala-continuing-education-launches-sustainability-course-partnership.

Alcántara-Rubio, L., Valderrama-Hernández, R., Solís-Espallargas, C. and Ruiz-Morales, J. (2022) The Implementation of the SDGs in Universities: A Systematic Review, *Environmental Education Research*, **28** (11), 1585–615,
https://doi.org/10.1080/13504622.2022.2063798.

Aldrich, R. M. (2018) *Sustainable Thinking: Ensuring Your Library's Future in an Uncertain World*, American Library Association.

Alfirević, N., Perović, L. M. and Kosor, M. M. (2023) Productivity and Impact of Sustainable Development Goals (SDGs)-Related Academic Research: A Bibliometric Analysis, *Sustainability*, **15** (9), 1–17,
https://EconPapers.repec.org/RePEc:gam:jsusta:v:15:y:2023:i:9:p:7434-:d:1137294.

ALIA (2023) ALIA Sustainable Libraries (ALIA Green),
www.alia.org.au/Web/Web/Advocacy/Greening-Libraries.aspx.

Allen, C., Smith, M., Rabbie, M. and Dahmm, H. (2021) A Review of Scientific Advancements in Datasets Derived from Big Data for Monitoring the Sustainable Development Goals, *Sustainability Science*, **16** (5), 1706–16. https://doi.org/10.1007/s11625-021-00982-3.

Anagnostopoulou, V., Saadeldeen, H. and Chong, F. T. (2010) Quantifying the Environmental Advantages of Large-scale Computing. In *Green Computing Conference, 2010 International*, IEEE, 269–80.

Angus, D., Dootson, P. and Thomson, T. J. (2020) 3.2 Billion Images and 720,000 Hours of Video are Shared Online Daily: Can You Sort Real From Fake?, *The Conversation*. May 2020, http://theconversation.com/3-2-billion-images-and-720-000-hours-of-video-are-shared-onlinedaily-can-you-sort-real-from-fake-148630.

Antoniades, A., Antonarakis, A. and Kempf, I. (2022) Financial Crises, Poverty and Environmental Sustainability: Challenges in the Context of the SDGs and Covid-19 Recovery, https://doi.org/10.1007/978-3-030-87417-9.

Atkin, C. (1973) Instrumental Qualities and Information-seeking. In Clarke, P. (ed.) *New Models for Mass Communication Research*, Sage, 205–42.

Aytac, S. (2019) Library Environment Sustainability Progress index (LESPI): Benchmarking Libraries' Progress Towards Sustainable Development. In: *IFLA WLIC'19, Athens*, http://library.ifla.org/id/eprint/2443.

Aytac, S. (2022) Libraries as Agents of Climate Change Literacy. In *IFLA WLIC 2002 Satellite Meeting: 'Inspired and Engaged on Sustainability'*, Dublin, 22–23 July 2022, https://repository.ifla.org/bitstream/123456789/2076/1/s5-2022-aytac-en.pdf.

Baccolini, V., Rosso, A., Di Paolo, C., Isonne, C., Salerno, C., Migliara, G., Prencipe, G.P., Massimi, A., Marzuillo, C., De Vito, C., Villari, P. and Romano, F. (2021) What is the Prevalence of Low Health Literacy in European Union Member States? A Systematic Review and Meta-analysis, *Journal of General Internal Medicine*, **36** (3),753–61, https://doi.org/10.1007/s11606-020-06407-8.

Bagov, I., Greiner, C. and Garabedian, N. (2022) Collaborative Metadata Definition Using Controlled Vocabularies, and Ontologies, *Research Ideas and Outcomes*, **8**, 907–28, https://doi.org/10.3897/rio.8.e94931.

Bahrami, S. and Harandi, R. J. (2020) The Relationship Between Information Literacy and Knowledge Sharing in Students of Public University, *SAARJ Journal on Banking and Insurance Research*, **9** (2), 4–10.

Balčytienė, A. (2020) Review of Carlsson, U. (ed.) (2019) Understanding Media and Information Literacy (MIL) in the Digital Age: A Question of Democracy, *Central European Journal of Communication*, **13** (2), 293–5.

Bales, E., Sohn, T. and Setlur, V. (2011) Planning, Apps, and the High-end Smartphone: Exploring the Landscape of Modern Cross-device Reaccess (paper given at the 9th International Conference on Pervasive Computing, Pervasive 2011, San Francisco, CA, 12–15 June 2011), *Lecture Notes in Computer Science*, **6696**, Springer-Verlag, 1–18.

Baliga, J., Ayre, R. W., Hinton, K., Sorin, W. V. and Tucker, R. S. (2008) Energy Consumption in Optical IP Networks, *Journal of Lightwave Technology*, **27** (13), 2391–403.

Baliga, J., Ayre, R. W., Hinton, K. and Tucker, R. S. (2011) Green Cloud Computing: Balancing Energy In Processing, Storage, and Transport, *Proceedings of the IEEE*, **99** (1), 149–67.

Balog, K. P. and Siber, L. (2016) Law Students' Information Literacy Skills and Attitudes Towards Environmental Protection and Environmental Legislation, *Libri*, **6** (3), 201–12, http://doi.org/10.1515/libri-2016-0018.

Balogun, T. (2020) Achievement of the Sustainable Development Goals Through LIS Education in Africa, *Library Philosophy and Practice*, 1–16.

Barbier, E. B. and Burgess, J. C. (2019) Sustainable Development Goal Indicators: Analyzing Trade-offs and Complementarities, *World Development*, **122**, 295–305, https://doi.org/10.1016/j.worlddev.2019.05.026.

Basirat, A. H. and Khan, A. I (2010) Evolution of Information Retrieval in Cloud Computing by Redesigning Data Management Architecture from a Scalable Associative Computing Perspective, *17th International Conference on Neural Information Processing, Sydney, NSW; 22–25 November 2010*, **6444**, 275–82.

Baumann, E., Czerwinski, F. and Reifegerste, D. (2017) Gender-specific Determinants and Patterns of Online Health Information Seeking: Results from a Representative German Health Survey, *Journal of Medical Internet Research*, **19** (4), https://doi.org/10.2196/jmir.6668.

Bautista-Puig, N., Aleixo, A. M., Leal, S., Azeiteiro, U. and Costas, R. (2021) Unveiling the Research Landscape of Sustainable Development Goals and Their Inclusion in Higher Education Institutions and Research Centres: Major Trends in 2000–2017, *Frontiers in Sustainability*, **2**, www.frontiersin.org/articles/10.3389/frsus.2021.620743/full.

Bawden, D. (2006) Users, User Studies and Human Information Behaviour: A Three-Decade Perspective on Tom Wilson's 'On User Studies and Information Needs', *Journal of Documentation*, **62** (6), 671–9, https://doi.org/10.1108/00220410610714903.

Bennich, T., Weitz, N. and Carlsen, H. (2020) Deciphering the Scientific Literature on SDG Interactions: A Review and Reading Guide, *Science of the Total Environment*, **728**, 138405, https://doi.org/10.1016/j.scitotenv.2020.13840.

Beutelspacher, L. and Meschede, C. (2020) Libraries as Promoters of Environmental Sustainability: Collections, Tools and Events, *IFLA Journal*, **46** (4), 347–58, https://doi.org/10.1177/0340035220912513.

Biggeri, M., Clark, D., Ferrannini, A. and Mauro, V. (2019) Tracking the SDGs in an 'Integrated' Manner: A Proposal for a New Index to Capture Synergies and Trade-offs Between and Within Goals, *World Development*, **122**, 628–47.

Binks, L., Braithwaite, E., Hogarth, L., Logan, A. and Wilson, S. (2014) Tomorrow's Green Public Library, *Australian Library Journal*, **63**, 301–12 https://doi.org/10.1080/00049670.2014.969417.

Bonino da Silva Santos, L. O. (2021) FAIR Digital Object Framework Documentation, May 2023, https://fairdigitalobjectframework.org.

Borg, K. (2021) Media and Social Norms: Exploring the Relationship between Media and Plastic Avoidance Social Norms, *Environmental Communication*, **16**, 1–17, https://doi.org/10.1080/17524032.2021.2010783.

Borges, J. C., Cezarino, L. O., Ferreira, T. C., Sala, O. T. M., Unglaub, D. L. and Caldana, A. C. F. (2017) Student Organizations and Communities of Practice: Actions for the 2030 Agenda For Sustainable Development, *International Journal of Management Education*, **15** (2), 172–82.

Borgman, C. L., Wallis, J. C. and Mayernik, M. S. (2012) Who's got the Data? Interdependencies in Science and Technology Collaborations, *Computer Supported Cooperative Work*, **21** (6), 485–523.

Bradley, F. (2016) A World with Universal Literacy: The Role of Libraries and Access to Information in the UN 2030 Agenda, *IFLA Journal*, **42** (2), 118–25.

Britannica (2023) 'Digital divide', www.britannica.com/topic/digital-divide.

British Library (2023) Sustainability, www.bl.uk/about-us/governance/policies/sustainability.

Bruce, C. (2011) Information Literacy Programs and Research: An International Review, *Australian Library Journal*, **60** (4), 326–33.

Buckland, M. (1991) Information as Thing, *Journal of the American Society for Information Science and Technology*, **42** (5), 351–60.

Buckland, M. (2012) What Kind of Science Can Information Science Be?, *Journal of the American Society for Information Science and Technology*, **63** (1), 1–7.

Buckland, M. (2017) *Information and Society*, MIT Press.

Cambridge Dictionary (2022) 'Digital divide', https://dictionary.cambridge.org/dictionary/english/digital-divide.

Campagnolo, L., Eboli, F., Farnia, L. and Carraro, C. (2018) Supporting the UN SDGs Transition: Methodology for Sustainability Assessment and Current Worldwide Ranking, *Economics*, **12** (10), https://doi.org/10.5018/economics-ejournal.ja.2018-10.

Campbell, D. K. (2005) The Context of the Information Behaviour of Prison Inmates, *Progressive Librarian*, **26**, 18–32.

Cao, W., Zhang, X., Xu, K. and Wang, Y. (2016) Modeling Online Health Information-seeking Behavior in China: The Roles of Source Characteristics, Reward Assessment, and Internet Self-Efficacy, *Health Communication*, **31**, 1105–14, https://doi.org/10.1080/10410236.2015.1045236.

Carballo-Penela, A. and Domenech, J. L. (2010) Managing the Carbon Footprint of Products: The Contribution of the Method Composed of Financial Statements (MC3), *International Journal of Lifecycle Assessment*, **15** (9), 962–69.

Cardoso, N. B. (2018) Environmental Responsibility in Brazilian Libraries: Applying Environmental Management, Disseminating Environmental Information and Putting into Practice. In Hauke, P., Charney, M. and Sahavirta, H. (eds), *Going Green: Implementing Sustainable Strategies in Libraries Around the World: Buildings, Management, Programmes and Services*, De Gruyter Saur, 60–74.

Cardoso, N. B. and Machado, E. C. (2015) Sustainable and Green Libraries in Brazil: Guidelines for Local Governments, paper presented at IFLA WLIC, Cape Town, 15–21 August 2015, http://library.ifla.org/1207/1/095-cardoso-en.pdf.

Carlsen, A. (2015) Transforming Our World: Literacy for Sustainable Development, https://uil.unesco.org/literacy/practices-database/transforming-our-world-literacy-sustainable-development.

Carlsson, U. (2019) (ed.) *Understanding Media and Information Literacy (MIL) in the Digital Age: A Question of Democracy*, Department of Journalism, Media and Communication (JMG), University of Gothenburg, https://en.unesco.org/sites/default/files/gmw2019_understanding_mil_ulla_carlsson.pdf.

Carroll, A. J. and Mallon, M. N. (2021) Using Digital Environments to Design Inclusive and Sustainable Communities of Practice in Academic Libraries, *Journal of Academic Librarianship*, **47** (5), 102380, https://doi.org/10.1016/j.acalib.2021.102380.

Case, D. O. and Given, L. (2016) *Looking for Information: A Survey of Research on Information Seeking, Needs, and Behavior*, 4th edn, Emerald Group Publishing.

Case, D. O., Johnson, J. D., Andrews, J. E. and Allard, S. L. (2005) Avoiding Versus Seeking: The Relationship of Information Seeking to Avoidance, Blunting, Coping, Dissonance and Related Concepts, *Journal of the Medical Libraries Association*, **93**, 353–62.

CAUL (2019) 2019 *CAUL report: United Nations Sustainable Development Goals*, Council of Australian University Librarians, www.caul.edu.au/sites/default/files/documents/caul-doc/sdgs2019report.pdf.

Cebr (2015) *The Economic Impact of Basic Digital Skills and Inclusion in the UK: A Report for Tinder Foundation and GO ON UK*, Centre for Economics and Business Research, www.goodthingsfoundation.org/wp-content/uploads/2021/02/the_economic_impact_of_digital_skills_and_inclusion_in_the_uk_final_v2.pdf.

Cetindamar Kozanoglu, D. and Abedin, B. (2021) Understanding the Role of Employees in Digital Transformation: Conceptualization of Digital Literacy of Employees as a Multi-dimensional Organizational Affordance, *Journal of Enterprise Information Management*, **34** (6), 1649–72.

CGIAR (n.d.) Open Access and FAIR Principles, April 30, https://ccafs.cgiar.org/open-access-and-fair-principles.

Chan, C. K. and Lee, P. S. N. (2023) Significance of Communication Studies to SDGs: (Re)setting Global Agendas. In: Servaes, J. and Yusha'u, M. J. (eds) *SDG18 Communication for All, Vol. 1.* Sustainable Development Goals Series, Palgrave Macmillan, https://doi.org/10.1007/978-3-031-19142-8_3.

Chandan, A., John, M. and Potdar, V. (2023) Achieving UN SDGs in Food Supply Chain Using Blockchain Technology, *Sustainability*, **15** (3), 2109, https://doi.org/10.3390/su15032109.

Chapman, G., Cully, A., Kosiol, J., Macht, S., Chapman, R., Fitzgerald, J. and Gertsen, F. (2020) The Wicked Problem of Measuring Real-world Research Impact: Using Sustainable Development Goals (SDGs) and Targets in Academia, *Journal of Management & Organization*, **26** (6), 1030–47, https://doi.org/10.1017/jmo.2020.16.

Chaurasia, S., Pati, R. K., Padhi, S. S., Jensen, J. M. and Gavirneni, N. (2022) Achieving the United Nations Sustainable Development Goals-2030 Through the Nutraceutical Industry: A Review of Managerial Research and the Role of Operations Management, *Decision Sciences*, http://doi.org/10.1111/deci.12515.

Chen, H., Wu, H. and Chen, P. (2022) Innovative Service Model of Information Services Based on the Sustainability Balanced Scorecard: Applied Integration of the Fuzzy Delphi Method, Kano Model, and TRIZ, *Expert Systems with Applications*, **205**, 117601.

Chen, X. (2019) Harmonizing Ecological Sustainability and Higher Education Development: Wisdom from Chinese Ancient Education Philosophy, *Educational Philosophy and Theory*, **51** (11), 1080–90.

Cherry, G. and Vignoles, A. (2020) What is the Economic Value of Literacy and Numeracy?, *IZA World of Labor*, 229, https://doi.org/10.15185/izawol.229.v2.

Chiarello, F., Trivelli, L., Bonaccorsi, A. and Fantoni, G. (2018) Extracting and Mapping Industry 4.0 Technologies Using Wikipedia, *Computers in Industry*, **100**, 244–57, www.sciencedirect.com/science/article/pii/S0166361517306176.

Chowdhury, G. G. (2010a) Carbon F of the Knowledge Sector: What's the Future?, *Journal of Documentation*, **66** (6), 934–46, https://doi.org/10.1108/00220411011087878.

Chowdhury, G. G. (2010b) *Introduction to Modern Information Retrieval*, 3rd edn, Facet Publishing.

Chowdhury, G. G. (2012a) An Agenda for Green Information Retrieval Research, *Information Processing & Management*, **48** (6),1067–77, https://doi.org/10.1016/j.ipm.2012.02.003.

Chowdhury, G. G. (2012b) Building Environmentally Sustainable Information Services: A Green IS Research Agenda, *Journal of the American Society for Information Science and Technology*, **63**, 633–47, https://doi.org/10.1002/asi.21703.

Chowdhury, G. G. (2013) Sustainability of Digital Information Services, *Journal of Documentation*, **69** (5), 602–22, https://doi.org/10.1108/JD-08-2012-0104.

Chowdhury, G. G. (2014a) Sustainability of Digital Libraries: A Conceptual Model and a Research Framework, *International Journal on Digital Libraries*, **14** (3–4), 181–95, https://doi.org/10.1007/s00799-014-0116-0.

Chowdhury, G. G. (2014b) *Sustainability of Scholarly Information*, Facet Publishing.

Chowdhury G. G. (2016) How to Improve the Sustainability of Digital Libraries and Information Services? *Journal of the Association for Information Science and Technology*, **67** (10), 2379–391, https://doi.org/10.1002/asi.23599.

Chowdhury, G. G. and Chowdhury, S. (2011) *Information Users and Usability in the Digital Age*, Facet Publishing.

Chowdhury, G. G. and Koya, K., (2017) Information Practices for Sustainability: Role of iSchools in Achieving the UN Sustainable Development Goals (SDGs), *Journal of the Association for Information Science and Technology*, **68** (9), 2128-38, https://doi.org/10.1002/asi.23825.

Chowdhury, S., Gibb, F. and Landoni, M. (2011) Uncertainty in Information Seeking and Retrieval: A Study in an Academic Environment, *Information Processing & Management*, **47** (2), 157–75, https://doi.org/10.1016/j.ipm.2010.09.006.

Chowdhury, S., Gibb, F. and Landoni, M. (2014) A Model of Uncertainty and its Relation to Information Seeking and Retrieval (IS&R), *Journal of Documentation*, **70** (4), 575–604, https://doi.org/10.1108/JD-05-2013-0060.

Chowdhury, G. G., McLeod, J., Lihoma, P., Teferra Abate, S. and Wato, R. (2021) Promoting Access to Indigenous Information in Africa: Challenges and Requirements, *Information Development*, 10 January, https://doi.org/10.1177/02666669211048488.

Christianson, M. and Aucoin, M. (2005) Electronic or Print Books: Which are Used?, *Library Collections, Acquisitions, & Technical Services*, **29** (1), 71–81.

CILIP (2018) *Information Literacy*, https://infolit.org.uk/ILdefinitionCILIP2018.pdf.

CILIP (2020) A Greener Library: The Bodleian's Push for Sustainability, www.cilip.org.uk/news/493624/A-greener-library-TheBodleians-push-for-sustainability.htm.

CILIP (2022) Green Libraries Manifesto, www.cilip.org.uk/page/GreenLibrariesManifesto.

CILIP Green Libraries Partnership (2022) *Green Libraries Survey: Progress, Challenges, Opportunities and Supporting Future Action*, www.cilip.org.uk/resource/resmgr/cilip/advocacy/green_libraries/frontpage/green_libraries_partnership_.pdf.

City of Helsinki (2021) The Carbon Footprint of Libraries Has Been Calculated for the First Time, www.hel.fi/en/news/the-carbon-footprint-of-libraries-has-been-calculated-for-the-first-time.

Claro, P. B. and Esteves, N. R. (2021) Sustainability-oriented Strategy and Sustainable Development Goals, *Marketing Intelligence & Planning*, **39** (4), https://doi.org/10.1108/MIP-08-2020-0365.

Colglazier, W. (2015) Sustainable Development Agenda: 2030: Building Knowledge-based Societies is Key to Transformative Technologies, *Science*, **349** (6252), 1048–50, https://doi.org/10.1126/science.aad2333.

Combemale, B., Cheng, B. H., Moreira, A., Bruel, J. M. and Gray, J. (2016) Modeling for Sustainability. *In Proceedings of the 8th International Workshop on Modeling in Software Engineering*, 62–6, Association for Computing Machinery.

Connaway, L. S., Doyle, B., Cyr, C., Gallagher, P. and Cantrell, J. (2023) Libraries Model Sustainability: The Results of an OCLC Survey on Library Contributions to the Sustainable Development Goals, *IFLA Journal*, **49** (2), 269–85, https://doi.org/10.1177/03400352221141467.

Coronado, C., Freijomil-Vázquez, C., Fernández-Basanta, S., Andina-Díaz, E. and Movilla-Fernández, M.-J. (2020) Using Photovoice to Explore the Impact on a Student Community after Including Cross-Sectional Content on Environmental Sustainability in a University Subject: A Case Study, https://ruc.udc.es/dspace/bitstream/handle/2183/29979/Coronado_Using.pdf?sequence=3.

Costanza, R., Daly, L., Fioramonti, L., Giovannini, E., Kubiszewski, I., Mortensen, L. F., Pickett, K. E., Ragnarsdottir, K. V., De Vogli, R. and Wilkinson, R. (2016) Modelling and Measuring Sustainable Wellbeing in Connection with the UN Sustainable Development Goals, *Ecological Economics*, **130**, 350–5, https://doi.org/10.1016/j.ecolecon.2016.07.009.

Council of Europe (2023) Media Literacy, www.coe.int/en-GB/web/freedom-expression/media-literacy.

Council of Europe (n.d.) Council of Europe Contribution to the UN Sustainable Development Goals SDG4: Ensure Inclusive and Equitable Quality Education and Promote Lifelong Learning Opportunities for All, https://rm.coe.int/council-of-europe-contribution-to-the-un-sustainable-development-goals/16808e7a34.

Council of the European Union (2010) *Council Conclusions on Education for Sustainable Development*, www.consilium.europa.eu/uedocs/cms_data/docs/pressdata/en/educ/117855.pdf.

Coyle, K. (2005) *Environmental Literacy in America: What Ten Years of NEETF/Roper Research and Related Studies Say About Environmental Literacy in the U.S.*, National Environmental Education and Training Foundation, https://eric.ed.gov/?id=ED522820.

Cyr, C. and Connaway, L.S. (2020) Libraries and the UN Sustainable Development Goals: The Past, Present, and Future, *Proceedings of the Association for Information Science and Technology*, **57** (1), 237, https://doi.org/10.1002/pra2.237.

D'Adamo, I. and Gastaldi, M. (2023) Perspectives and Challenges on Sustainability: Drivers, Opportunities and Policy Implications in Universities, *Sustainability*, **15** (4), 3564, http://dx.doi.org/10.3390/su15043564.

Daielly Melina Nassif, M. R., Flavio, H. J., Cristiana Lara, L. C., Kaetsu, P. T., Dionizio-Leite, P. and Celso, M. J. (2021) Digital Sustainability: How Information and Communication Technologies (ICTs) Support Sustainable Development Goals (SDGs) Assessment in Municipalities, *Digital Policy, Regulation and Governance*, **23** (3), 229–47, https://doi.org/10.1108/DPRG-11-2020-0159.

Dalampira, E. S. and Nastis, S. A. (2020) Mapping Sustainable Development Goals: A Network Analysis Framework, *Sustainable Development*, **28** (1), 46–55, https://doi.org/10.1002/sd.1964.

Dang, H. and Serajuddin, U. (2020) Tracking the Sustainable Development Goals: Emerging Measurement Challenges and Further Reflections, *World Development*, 127. https://doi.org/10.1016/j.worlddev.2019.05.024.

Davis, F. D. (1989) Perceived Usefulness, Perceived Ease of Use, and User Acceptance of Information Technology, *MIS Quarterly*, **13** (3), 319–40.

Davis, J., Ferriss, J. and Kropp, L. (2022) Walking the Path to Sustainable Library Certification. In Tanner, R., Ho, A. K., Antonelli, M. and Smith Aldrich, R. (eds) *Libraries and Sustainability: Programs and Practices for Community Impact*, ALA Editions.

DCMS (2019) *No Longer Optional: Employer Demand for Digital Skills, May 10*, Department for Digital, Culture, Media and Sport, UK, https://assets.publishing.service.gov.uk/government/uploads/system/uploads/attachment_data/file/807830/No_Longer_Optional_Employer_Demand_for_Digital_Skills.pdf.

Debrah, J. K., Vidal, D. G. and Dinis, M. A. P. (2021) Raising Awareness on Solid Waste Management Through Formal Education for Sustainability: A Developing Countries Evidence Review, *Recycling*, **6** (6), https://doi.org/10.3390/recycling6010006.

DEFRA (2009). *Sustainable Development Action Plan: September 2009 – March 2011*. https://www.sd-commission.org.uk/data/files/publications/Defra_SDAP_2009-2011.pdf.

DEFRA (2013) *Sustainable Development Indicators*, Department for Environment, Food and Rural Affairs, UK, www.gov.uk/government/uploads/system/uploads/attachment_data/file/223992/0_SDIs_final__2_.pdf.

Dei, D. J. and Yaba Asante, F. (2022) Role of Academic Libraries in the Achievement of Quality Education as a Sustainable Development Goal, *Library Management*, **43**, https://doi.org/10.1108/LM-02-2022-0013.

Del Río Castro, G., González Fernández, M. C. and Uruburu Colsa, A. (2021) Unleashing the Convergence Amid Digitalization and Sustainability Towards Pursuing the Sustainable Development Goals (SDGs): A Holistic Review, *Journal of Cleaner Production*, **280** (1), https://doi.org/10.1016/j.jclepro.2020.122204 .

Dempsey, L. and Heery, R. (1997) A Review of Metadata: A Survey of the Current Resource Description Formats. Work package 3 of Telematics for Research project DESIRE (RE1004), 15 May 1997, www.ukoln.ac.uk/metadata/desire/overview.

Dempsey, L. and Heery, R. (1998) Metadata: A Current View of Practice and Issues, *Journal of Documentation*, **54** (2), 145–72.

Deng, Z. and Liu, S. (2017) Understanding Consumer Health Information-seeking Behavior from the Perspective of the Risk Perception Attitude Framework and Social Support in Mobile Social Media Websites, *International Journal of Medical Informatics*, **105**, 98–109, https://doi.org/10.1016/j.ijmedinf.2017.05.014.

Department for Education (2022) Sustainability and climate change: A strategy for the education and children's services systems, Policy Paper, Department for Education, UK, www.gov.uk/government/publications/sustainability-and-climate-change-strategy/sustainability-and-climate-change-a-strategy-for-the-education-and-childrens-services-systems.

Derr, R. L. (1983) A Conceptual Analysis of Information Need, *Information Processing & Management*, **19**, 273–8.

Dervin, B. (1983) An Overview of Sense-making Research: Concepts, Methods and Results, paper presented at the annual meeting of the International Communication Association, Dallas, TX, May, https://faculty.washington.edu/wpratt/MEBI598/Methods/An%20Overview%20of%20Sense-Making%20Research%201983a.htm.

DESI (2022a) https://digital-strategy.ec.europa.eu/en/library/digital-economy-and-society-index-desi-2022.

DESI (2022b) https://digital-strategy.ec.europa.eu/en/policies/desi.

Di Domenico, G. (2020) Sustainable: Libraries in the Time of Ecological Crisis (notes in the margin of Going Green), *Italian Journal of Library and Information Science*, **11** (1), 36–55, https://doi.org/10.4403/jlis.it-12604.

Di Vaio, A., Palladino, R., Hassan, R. and Escobar, O. (2020) Artificial Intelligence and Business Models in the Sustainable Development Goals Perspective: A Systematic Literature Review, *Journal of Business Research*, **121**, 283–314.

Dick, M., Drangmeister, J., Kern, E. and Naumann, S. (2013) Green Software Engineering with Agile Methods. In *Green and Sustainable Software (GREENS), 2013 2nd International Workshop*, IEEE, 78–85.

DIGHUM (2023) *Vienna Manifesto on Digital Humanism*, https://dighum.ec.tuwien.ac.at/wp-content/uploads/2019/07/Vienna_Manifesto_on_Digital_Humanism_EN.pdf.

Dimireva, I. (2012) Doing Business in the UK: Sustainability2, *Eubusiness*, 20 February, www.eubusiness.com/europe/uk/sustainable-business.

Dobransky, K. and Hargittai, E. (2021) The Closing Skills Gap: Revisiting the Digital Disability Divide. In Hargittai, E. (ed.) *Handbook of Digital Inequality*, 274–282, https://doi.org/10.4337/9781788116572.00026.

Dourish, P. (2010) HCI and Environmental Sustainability: The Politics of Design and the Design of Politics. In *Proceedings of the 8th ACM Conference on Designing Interactive Systems*, Association for Computing Machinery, 1–10.

Dourish, P. and Anderson, K. (2006) Collective Information Practice: Exploring Privacy and Security as Social and Cultural Phenomena, *Human-Computer Interaction Journal*, **21** (3), 319–42.

Drexhage, J. and Murphy, D. (2010) Sustainable Development: From Brundtland to Rio 2012. In: *United Nations Headquarters, 1st Meeting by the High Level Panel on Global Sustainability*, United Nations.

Du, J. T., Liu, Y. H., Zhu, Q. H. and Chen, Y. J. (2013) Modelling Marketing Professionals' Information Behaviour in the Workplace: Towards a Holistic Understanding, *Information Research*, **18** (1), http://InformationR.net/ir/18-1/paper560.html.

Duane, S., Duane, S., Domegan, C. and Bunting, B. (2022) Partnering for UN SDG#17: A Social Marketing Partnership Model to Scale up and Accelerate Change, *Journal of Social Marketing*, **12** (1), 49–75.

Dublin Core (2022) Metadata Innovation, www.dublincore.org.

Duff, W. and McKemmish, S. (2000) Metadata and ISO 9000 Compliance, *Information Management Journal*, **34** (1), www.sims.monash.edu.au/research/rcrg/publications/smckduff.html.

EBLIDA (2020) *Sustainable Development Goals and Libraries – First European Report*, European Bureau of Library, Information and Documentation Associations, www.eblida.org/Documents/EBLIDA-Report-SDGs-and-their-implementation-in-European-libraries.pdf.

EBLIDA (2022) *Second European Report on Sustainable Development Goals and Libraries*, European Bureau of Library, Information and Documentation Associations, www.eblida.org/Documents/Second-European-Report-on-SDGs-in-Libraries_Full-Report2022.pdf.

EBLIDA (2023a) *Second European Report on Sustainable Development Goals and Libraries: 2023 Update*, European Bureau of Library, Information and Documentation Associations, www.eblida.org/Documents/Second-European-Report-on-SDGs-in-Libraries_Full-Report2022.pdf.

EBLIDA (2023b) *EBLIDA Annual Report 2022–2023*, European Bureau of Library, Information and Documentation Associations, https://eblida.org/publication/eblida-annual-report-2022-2023.

EC (2010) *A Digital Agenda for Europe, Communication from the Commission to the European Parliament, the Council, the European Economic and Social Committee and the Committee of the Regions*, COM, 245, 22 January, European Commission,

http://ec.europa.eu/information_society/digital-agenda/documents/digital-agendacommunicationen.pdf.

EC (2018) Turning FAIR into Reality: Final Report and Action Plan From the European Commission Expert Group on FAIR Data, European Commission, Directorate-General for Research and Innovation, 29 April, https://data.europa.eu/doi/10.2777/1524.

EC (2022a) *Sustainable Development in the European Union – Monitoring Report on Progress Towards the SDGs in an EU Context,* 2022 edn, European Commission, ec.europa.eu/eurostat/documents/15234730/15242025/KS-09-22-019-EN-N.pdf/a2be16e4-b925-f109-563c-f94ae09f5436?t=1667397761499.

EC (2022b) DEAR: Development Education and Awareness Raising Programme, https://international-partnerships.ec.europa.eu/policies/programming/programmes/dear-development-education-and-awareness-raising-programme_en#what-the-dear-programme-does.

EC (2022c) Learning for the Green Transition and Sustainable Development, https://education.ec.europa.eu/news/learning-for-the-green-transition-and-sustainable-development.

EC (2022d) Digital Economy and Society Index 2022: Overall Progress but Digital Skills, SMEs and 5G Networks Lag Behind, https://digital-strategy.ec.europa.eu/en/news/digital-economy-and-society-index-2022-overall-progress-digital-skills-smes-and-5g-networks-lag.

EC (2023a) Europe's Digital Decade: digital targets for 2030, https://commission.europa.eu/strategy-and-policy/priorities-2019-2024/europe-fit-digital-age/europes-digital-decade-digital-targets-2030_en.

EC (2023b) A Europe Fit for the Digital Age, https://commission.europa.eu/strategy-and-policy/priorities-2019-2024/europe-fit-digital-age_en.

Ecker, U., Lewandowsky, S., Cook, J., Schmid, P., Fazio, L., Brashier, N., Kendeou, P., Vraga, E. and Amazeen, M. (2022) The Psychological Drivers of Misinformation Belief and Its Resistance to Correction, *Nature Reviews Psychology,* **1,** 13–29, https://doi.org/10.1038/s44159-021-00006-y.

Economist (2017) The World's Most Valuable Resource is no Longer Oil, but Data, *The Economist,* 6 May, www.economist.com/leaders/2017/05/06/the-worlds-most-valuable-resource-is-no-longer-oil-but-data.

Elzi, E. (2022) Why We Can't Talk About Sustainability in Libraries Without Also Talking About Racism. In Tanner, R., Ho, A. K., Antonelli, M. and Smith Aldrich, R. (eds) *Libraries and Sustainability: Programs and Practices for Community Impact,* ALA Editions.

Empig, E. E., Sivacioğlu, A., Pacaldo, R. S., Suson, P. D., Lavilles, R. Q., Teves, M. R. Y., Ferolin, M. C. M. and Amparado, R. F. (2023) Climate Change, Sustainable Forest Management, ICT Nexus, and the SDG2030: A Systems Thinking Approach, *Sustainability,* **15** (8), NA.

https://link.gale.com/apps/doc/A747540312/AONE?u=ustrath&sid=bookmark-AONE&xid=957d20f9.

English, L. and Mayo, P. (2021) *Lifelong Learning, Global Social Justice, and Sustainability*, 63–73, https://doi.org/10.1007/978-3-030-65778-9_5.

EPA (2010) *Inventory of U.S. Greenhouse Gas Emissions and Sinks: 1990–2008. Executive Summary*, 5 January, US Environment Protection Agency, http://epa.gov/climatechange/emissions/downloads10/US-GHG-Inventory-2010_ExecutiveSummary.pdf.

Eurostat (2022a) Sustainable Development in the European Union, 2022 edn, https://ec.europa.eu/eurostat/en/web/products-flagship-publications/-/ks-09-22-019.

Eurostat (2022b) Sustainable Development in the European Union: Monitoring Report on Progress Towards the SDGs in an EU Context, 2022 edn, https://ec.europa.eu/eurostat/documents/15234730/15242025/KS-09-22-019-EN-N.pdf/a2be16e4-b925-f109-563c-f94ae09f5436?t=1667397761499.

Eyinade, T. and Bakare, O. (2022) Assessing Information-seeking Behaviour of Visually Impaired Students Using Wilson's Model of Information Behaviour in Federal College of Education (special), Oyo, *Library Philosophy and Practice*, 1–19.

Fang, W. T., Hassan, A. and LePage, B. A. (2023) Environmental Literacy. In *The Living Environmental Education* (Sustainable Development Goals series), Springer, https://doi.org/10.1007/978-981-19-4234-1_4.

Farisyi, S., Musadieq, M. A., Utami, H. N. and Damayanti, C. R. (2022) A Systematic Literature Review: Determinants of Sustainability Reporting in Developing Countries, *Sustainability*, 14 (16), 10222, https://doi.org/10.3390/su141610222.

Fedorowicz-Kruszewska, M. (2020a) Environmental Education in Libraries – Theoretical Foundations and Practical Implementation, *Library Management*, 41 (4/5), 279–93, https://doi.org/10.1108/LM-12-2019-0087.

Fedorowicz-Kruszewska, M. (2020b) Green Libraries and Green Librarianship – Towards Conceptualization, *Journal of Librarianship and Information Science*, 53 (4), 645–54, https://doi.org/10.1177/0961000620980830.

Fedorowicz-Kruszewska, M. (2022) Green Library as a Subject of Research – a Quantitative and Qualitative Perspective, *Journal of Documentation*, 78 (4), 912–32.

Fedorowicz-Kruszewska, M. (2023) Green Libraries: Barriers to Concept Development, *Library Management*, 44 (1/2), 111–19, https://doi.org/10.1108/LM-04-2022-0041.

Filho, W. (2020) Living Labs for Sustainable Development: The Role of the European School of Sustainability Sciences and Research. In Filho, W. et al. (eds) *Universities as Living Labs for Sustainable Development* (World Sustainability Series), Springer, https://doi-org.proxy.lib.strath.ac.uk/10.1007/978-3-030-15604-6_1.

Filho, W., Azul, A., Brandli, L., Lange Salvia, A. and Wall, T. (eds) (2021) *Partnerships for the Goals* (Encyclopedia of the UN Sustainable Development Goals), Springer.

Flavio, H. J. (2021) Editorial: The Research Impact in Management Through the UN's Sustainable Development Goals, *RAUSP Management Journal*, **56** (2), 150–5, https://doi.org/https://doi.org/10.1108/RAUSP-04-2021-252.

Floridi, L. (2011) *The Philosophy of Information*, Oxford University Press, https://oxford-universitypressscholarship-com.proxy.lib.strath.ac.uk/view/10.1093/acprof:oso/9780199232383.001.0001/acprof-9780199232383-chapter-1.

Ford, N. (2015) *Introduction to Information Behaviour*, Facet Publishing.

Fourie, I. (2012) A Call for Libraries to Go Green: An Information Behaviour Perspective to Draw Interest from Twenty-first Century Librarians, *Library Hi Tech*, **30** (3), 428–35, , https://doi.org/10.1108/07378831211266573.

Frau-Meigs, D., Velez, I. and Michel, J. F. (eds) (2017) *Public Policies in Media and Information Literacy in Europe: Cross-country Comparisons*, Taylor & Francis.

Gegenbauer, S. and Huang, E.M. (2012) Inspiring the Design of Longer-lived Electronics Through an Understanding of Personal Attachment. In *DIS '12: Proceedings of the Designing Interactive Systems Conference, June 2012*, 635–44, https://doi.org/10.1145/2317956.2318052.

George, T. E., Karatu, K. and Edward, A. (2020) An Evaluation of the Environmental Impact Assessment Practice in Uganda: Challenges and Opportunities for Achieving Sustainable Development, *Heliyon*, **6** (9), https://doi.org/10.1016/j.heliyon.2020.e04758.

Ghahremanloo, L., Thom, J. A. and Magee, L. (2012) An Ontology Derived from Heterogeneous Sustainability Indicator Set Documents. In *Proceedings of the Seventeenth Australasian Document Computing Symposium*, Association for Computing Machinery, 72–9.

Ghorbani, M., Babalhavaeji, F. and Nooshinfard, F. (2016) Sustainable Management Requirements in Libraries of Iran: A Framework on Grounded Theory, *Libri*, **66** (3), 213–22, https://doi.org/10. 1515/libri-2016-0022.

Gill, T. (1998) Metadata and the World Wide Web. In Baca, M. (ed.) *Introduction to Metadata: Pathways to Digital Information*, Getty Information Institute, 9–18.

Gilliand-Swetland, A. (1998) Defining Metadata. In Baca, M. (ed.) *Introduction to Metadata: Pathways to Digital Information*, Getty Information Institute, 1–8.

Gilliand-Swetland, A. (2004) Metadata – Where are We Going? In Gorman, G. E. and Dorner, D. G. (eds), *Metadata Applications and Management. International Yearbook of Library and Information Management 2003/2004*, , Facet Publishing, 17–33.

Global Compact Network UK (2022a) *Annual Activity Report*, April 23, www.unglobalcompact.org.uk/wp-content/uploads/2023/02/UNGC-UK-Annual-report-Final-1.pdf.

Global Compact Network UK (2022b) *Measuring Up 2.0*, www.unglobalcompact.org.uk/wp-content/uploads/2021/11/UKSSD-Measuring-up.pdf.

Go'mez, J. and Lorini, M. (2022) *Digital Transformation for Sustainability: ICT-supported Environmental Socio-economic Development*, Progress in IS, Springer, https://link.springer.com/book/10.1007/978-3-031-15420-1.

Goni, F., Chofreh, A., Mukhtar, M., Sahran, S., Shukor, S. and Klemeš, J. (2017) Strategic Alignment Between Sustainability and Information Systems: A Case Analysis in Malaysian Public Higher Education Institutions, *Journal of Cleaner Production*, **168**, 263–70.

Gray, K. M. (2018) From Content Knowledge to Community Change: A Review of Representations of Environmental Health Literacy, *International Journal of Environmental Research and Public Health*,**15** (3), 466, https://doi.org/10.3390/ijerph15030466.

Green, A. (1990) What Do We Mean by User Needs?, *British Journal of Academic Librarianship*, **5**, 65–78.

Grizzle, A. (2018) Assessing Citizens' Responses to Media and Information Literacy Competencies Through an Online Course: An Empirical Study and Critical Comparative Analysis of Experts' Views, doctoral dissertation, ISBN 9788449084775, Thesis Doctorals en Xarxa (TDX), Autonomous University of Barcelona, Spain, http://hdl.handle.net/10803/666860.

Grizzle, A. and Hamada, M. (2019) Media and Information Literacy Expansion (MILX) Reaching Global Citizens with MIL and Other Social Competencies. In Carlsson, U. (ed.) *Understanding Media and Information Literacy (MIL) in the Digital Age: A Question of Democracy*, Gothenburg: Department of Journalism, Media and Communication (JMG), University of Gothenburg, 241–61.

Grizzle, A., Moore, P., Dezuanni, M.,Asthana, S, Wilson, C., Banda, F. and Onumah, C. (2013) Media and Information Literacy: Policy and Strategy Guidelines, Unesco, https://unesdoc.unesco.org/ark:/48223/pf0000225606.

Guandalini, I. (2022) Sustainability Through Digital Transformation: A Systematic Literature Review for Research Guidance, *Journal of Business Research*, **148**, 456–71, www.sciencedirect.com/science/article/pii/S014829632200426X.

Haider, J. and Sundin, O. (2022) *Paradoxes of Media and Information Literacy*, Vol. 1, 1st edn, Routledge.

Haigh, N. and Griffiths, A. (2008) The Environmental Sustainability of Information Systems: Considering the Impact of Operational Strategies and Practices, *International Journal of Technology Management*, **43** (1/2/3), 48–63.

Hák, T., Janoušková, S. and Moldan, B. (2016) Sustainable Development Goals: A Need for Relevant Indicators, *Ecological Indicators*, **60**, 565–73, https://doi.org/10.1016/j.ecolind.2015.08.003.

Hargreaves, I. (2011) *Digital Opportunity: A Review of Intellectual Property and Growth. An Independent Report*, www.ipo.gov.uk/ipreview-finalreport.pdf.

Harvey, M., Hastings, D. P. and Chowdhury, G. (2021) Understanding the Costs and Challenges of The Digital Divide Through UK Council Services, *Journal of Information Science*, https://doi.org/10.1177/01655515211040664.

Hassani, H., Huang, X., MacFeely, S. and Entezarian, M. R. (2021) Big Data and the United Nations Sustainable Development Goals (UN SDGs) at a Glance, *Big Data and Cognitive Computing*, **5** (3), 28, https://doi.org/10.3390/bdcc5030028.

Hauke, P., Charney, M. and Sahavirta, H. (2018) *Going Green: Implementing Sustainable Strategies in Libraries Around the World: Buildings, Management, Programmes and Services*, IFLA Publications Vol. 177.

Haupt, R., Scholtz, B. and Calitz, A. (2015) Using Business Intelligence to Support Strategic Sustainability Information Management. In *Proceedings of the 2015 Annual Research Conference on South African Institute of Computer Scientists and Information Technologists*, Association for Computing Machinery, 20,.

Hayman, R. and Smith, E. (2015) Sustainable Decision Making for Emerging Educational Technologies in Libraries, *References Services Review*, **43** (1), 7–18, http://dx.doi.org/10.1108/RSR-08-2014-0037.

Haynes, D. (2018*) Metadata for Information Management and Retrieval: Understanding Metadata and its Use*, 2nd edn, Facet Publishing.

Helfaya, A. and Bui, P. (2022) Exploring the Status Quo of Adopting the 17 UN SDGs in a Developing Country – Evidence from Vietnam, *Sustainability*, **14** (22), 15358, https://doi.org/10.3390/su142215358.

Hilty, L. and Aebischer, B. (2015) ICT Innovations for Sustainability. ICT4S conference held 14–16 February 2013 in ETH Zurich, Switzerland, *Advances in Intelligent Systems and Computing*, **310**.

Horan, D. (2020) National Baselines for Integrated Implementation of an Environmental Sustainable Development Goal Assessed in a New Integrated SDG Index, *Sustainability*, **12** (17), 6955, https://doi.org/10.3390/su12176955.

Houghton, J. W. (2015) ICT, The Environment, and Climate Change, *The International Encyclopedia of Digital Communication and Society*, **76**, 39–60.

Howard, G. R. and Lubbe, S. (2012) Synthesis of Green IS Frameworks for Achieving Strong Environmental Sustainability in Organisations. In *Proceedings of the South African Institute for Computer Scientists and Information Technologists Conference*, Association for Computing Machinery, 306–15.

Huang, Q. and Chen, S. (2018) From a Green Library to a Sustainable Library. Case-study of Sun Yat Sen Library of Guangdong Province, China. In Hauke, P., Charney, M. and Sahavirta, H. (eds), *Going Green: Implementing Sustainable Strategies in Libraries Around the World: Buildings, Management, Programmes and Services*, De Gruyter Saur, 110–21.

IAEG-SDGs (2019) *Interlinkages of the 2030 Agenda for Sustainable Development: Background Document*, Inter-agency and Expert Group on Sustainable Development Goals,

https://unstats.un.org/unsd/statcom/50th-session/documents/BG-Item3a-Interlinkages-2030-Agenda-for-Sustainable-Development-E.pdf.

Iano, Y., Saotome, O., Kemper Vásquez, G., Cotrim Pezzuto, C., Arthur, R. and Gomes de Oliveira, G. (2022) ICT Infrastructure Usability Model in the Sustainability of Computational Equipment. In Proceedings of the 7th Brazilian Technology Symposium (BTSym'21), **207**, *Smart Innovation, Systems and Technologies*, 286–93, Springer International Publishing AG.

IFLA (2018) *Exemplars, Educators, Enablers: Libraries and Sustainability*, https://repository.ifla.org/bitstream/123456789/2517/1/libraries_and_sustainability-en.pdf.

IFLA (2019) *IFLA Strategy: 2019–2024*, https://repository.ifla.org/bitstream/123456789/25/1/ifla-strategy-2019-2024-en.pdf.

IFLA (2022) *IFLA-UNESCO Public Library Manifesto 2022*, https://repository.ifla.org/bitstream/123456789/2006/1/IFLA-UNESCO%20Public%20Library%20Manifesto%202022.pdf.

IFLA (2023a) Environment, Sustainability and Libraries Section, 11 May, www.ifla.org/units/environment-sustainability-and-libraries.

IFLA (2023b) The Green Library Website, https://www.ifla.org/the-green-library-website.

IFLA (n.d.) Libraries and the Sustainable Development Goals: A Storytelling Manual, https://librarymap.ifla.org/storytelling-manual.

Issa, T., Issa, T., Issa, T. B. and Isaias, P. (eds) (2020) *Sustainability Awareness and Green Information Technologies*, Springer, https://doi.org/10.1007/978-3-030-47975-6.

ITU (2020) *Manual for Measuring ICT Access and Use by Households and Individuals*, International Telecommunications Union, www.itu.int/en/ITU-D/Statistics/Documents/publications/manual/ITUManualHouseholds2020_E.pdf.

Jankowska, M., Smith, B. and Buehler, M. (2014) Engagement of Academic Libraries and Information Science Schools in Creating Curriculum for Sustainability: An Exploratory Study, *Journal of Academic Librarianship*, **40**, 45–54.

Jenkin, T. A., Webster, J. and McShane, L. (2010) An Agenda for 'Green' Information Technology and Systems Research, *Information and Organization*, **21** (1), 1–24.

Johansson, S., Gulliksen, J. and Gustavsson, C. (2021) Disability Digital Divide: The Use of the Internet, Smartphones, Computers and Tablets among People with Disabilities in Sweden, *Universal Access in the Information Society*, **20** (1), 105–20, https://doi-org.proxy.lib.strath.ac.uk/10.1007/s10209-020-00714-x.

Jones, L. and Wong, W. (2016) More Than Just a Green Building – Developing Green Strategies at the Chinese University of Hong Kong Library, *Library Management*, **37** (6/7), 373–84, https://doi.org/10.1108/LM-05-2016-0041.

Kadyan, V., Singh, T. and Ugwu, C. (2023) Deep Learning Technologies for the Sustainable Development Goals : Issues and Solutions in the Post-COVID Era, https://link.springer.com/book/10.1007/978-981-19-5723-9.

Kamińska, A.M., Opaliński, Ł. and Wyciślik, Ł. (2022) The Landscapes of Sustainability in the Library and Information Science: Systematic Literature Review, *Sustainability*, **14** (1), https://doi.org/10.3390/su14010441.

Karioja, E. and Niemitalo, J. (2013) Sustainable Libraries: A Pilot Survey of International Delegates Attending the IFLA World Library and Information Conference 2012 and Comparison with the Finnish National Survey. In Hauke, P., Latimer, K. and Werner, K.U. (eds), *The Green Library: The Challenge of Environmental Sustainability*, De Gruyter Saur, 137–50.

Kaufman, A. F., Cohen, B. and Eller, J. (2022) Changing Staff Behaviours Around Waste Reduction and Diversion Using a Community-based Social Marketing Approach. In Tanner, R., Ho, A. K., Antonelli, M. and Smith Aldrich, R. (eds) *Libraries and Sustainability: Programs and Practices for Community Impact*, ALA Editions.

Keller, A. (2023) Sustainability 3.0 in Libraries: A Challenge for Management, *Publications*, **11** (6), https://doi.org/10.3390/publications11010006.

Kenna, T. (2022) Podcasting Urban Geographies: Examining the Utility of Student-generated Research Podcasts for Deep Learning and Education for Sustainable Development, *Journal of Geography in Higher Education*, Ahead-of-print, 1–20.

Khalid, A., Malik, G. F. and Mahmood, K. (2021) Sustainable Development Challenges in Libraries: A Systematic Literature Review (2000–2020), *Journal of Academic Librarianship*, **47** (3), 102347, https://doi.org/10.1016/j.acalib.2021.102347.

Kibe, L. (2016) Knowledge Sharing Techniques Amongst 'Jua kali' Artisans in Kenya. In *KMO 2016: Proceedings of The 11th International Knowledge Management in Organizations Conference on The Changing Face of Knowledge Management Impacting Society*, Hagen, 25–8.

Knowles, B., Clear, A., Mann, S., Belvis, E., Hakansson, M. (2016) Design Patterns, Principles, and Strategies for Sustainable HCI. In *CHI EA '16: Proceedings of the 2016 CHI Conference Extended Abstracts on Human Factors in Computing Systems, May 2016*, 3581–8, https://doi.org/10.1145/2851581.2856497.

Ko, G., Routray, J. and Ahmad, M. (2019) ICT Infrastructure for Rural Community Sustainability, *Community Development (Columbus, Ohio)*, **50** (1), 51–72.

Kostagiolas, P., Milkas, A., Kourouthanassis, P., Dimitriadis, K., Tsioufis, K., Tousoulis, D. and Niakas, D. (2021) The Impact of Health Information Needs' Satisfaction of Hypertensive Patients on their Clinical Outcomes, *Aslib Journal of Information Management*, **73** (1), 43–62.

Kostetckaia, M. and Hametner, M. (2022) How Sustainable Development Goals Interlinkages Influence European Union Countries' Progress Towards the 2030 Agenda, *Sustainable Development*, **30** (5), 916–26.

Krikelas, J. (1983) Information-seeking Behaviour: Patterns and Concepts, *Drexel Library Quarterly*, **19**, 5–20.

Kroll, C., Warchold, A. and Pradhan, P. (2019) Sustainable Development Goals (SDGs): Are We Successful in Turning Trade-Offs into Synergies?, *Palgrave Communications*, **5** (1), 140, https://doi.org/10.1057/s41599-019-0335-5.

Kuc-Czarnecka, M., Markowicz, I. and Sompolska-Rzechuła, A. (2023) SDGs Implementation, Their Synergies, and Trade-offs in EU Countries – Sensitivity Analysis-based Approach, *Ecological Indicators*, **146**, 109888, https://doi.org/10.1016/j.ecolind.2023.109888.

Kunčič, A. (2019) Prioritising the Sustainable Development Goals Using a Network Approach: SDG Linkages and Groups, *Teorija in Praksa*, **56** (3), 418–37.

Kunis, S., Hänsch, S., Schmidt, C., Wong, F., Strambio-De-Castillia, C. and Weidtkamp-Peters, S. (2021) MDEmic in a Use Case for Microscopy Metadata Harmonization: Facilitating FAIR Principles in Practical Application with Metadata Annotation Tools, https://doi.org/10.48550/arXiv.2103.02942.

Kurbanoğlu, S. and Boustany, J. (2014) From Green Libraries to Green Information Literacy. In; Kurbanoğlu, S., Špiranec, S., Grassian, E., Mizrachi, D. and Catts, R. (eds), *Communications in Computer and Information Science*, **492**, 47–58.

Lambrechts, W. and Van Petegem, P. (2016) The Interrelations Between Competences for Sustainable Development and Research Competences, *International Journal of Sustainability Higher Education*, **17** (6), 776–95.

Lange, H. R. and Winkler, B. J. (1997) Taming the Internet: Metadata, a Work in Progress. In Godden, I. (ed.) *Advances in Librarianship*, **21**, 47–72.

Langer, S. G. (2011) Challenges for Data Storage in Medical Imaging Research, *Journal of Digital Imaging*, **24** (2), 203–7, https://doi.org/10.1007/s10278-010-9311-8.

Lashitew, A. (2021) Corporate Uptake of the Sustainable Development Goals: Mere Greenwashing or an Advent of Institutional Change?, *Journal of International Business Policy*, **4** (1), 184–200.

Le Sourd, G., Kagawa, A., Alnaji, D., Fabre, P., Gebreselassie, S., de Lotus Ilunga, F., Kato, G., Lee, M., Neme-Lozano, J., Montani, M., Picci, M. and Martín Sánchez, O. (2021) Mapping 17 SDGs: Unlocking the Challenges and Achievements of the World Towards the Sustainable Development Goals Using Cartography, *Abstracts of the ICA*, **3** (172), https://doi.org/10.5194/ica-abs-3-172-2021.

LeBlanc, D. (2015) Towards Integration at Last? The Sustainable Development Goals as a Network of Targets, *Sustainable Development*, **23** (3), 176–87.

Lessenski, M. (2022) *How It Started, How It is Going: Media Literacy Index 2022*, Open Society Institute, Sofia, https://osis.bg/wp-content/uploads/2022/10/HowItStarted_MediaLiteracyIndex2022_ENG_.pdf.

Li, S. and Yang, F. (2022) Green Library Research: A Bibliometric Analysis, *Public Library Quarterly*, https://doi.org/10.1080/01616846.2022.2116886.

Linnerud, K., Holden, E. and Simonsen, M. (2021) Closing the Sustainable Development Gap: A Global Study of Goal Interactions, *Sustainable Development*, **29** (4), 738–53, https://doi.org/10.1002/sd.2171.

Liu, J. (2017) Integration Across a Metacoupled World, *Ecology and Society*, **22** (4), https://doi.org/10.5751/ES-09830-220429.

Liu C, Wang, D., Liu, C., Jiang, J., Wang, X., Chen, H., Ju, X. and Zhang, X. (2021) What is the Meaning of Health Literacy? A Systematic Review and Qualitative Synthesis, *BMJ Family Medicine and Community Health*, **8** (2), https://fmch.bmj.com/content/8/2/e000351.

Lloyd, A. (2010) *Information Literacy Landscapes: Information Literacy in Education, Workplace and Everyday Contexts*, Chandos.

Lloyds Bank (2022) *Consumer Digital Index: The UK's Largest Study of Digital and Financial Lives*, www.lloydsbank.com/assets/media/pdfs/banking_with_us/ whats-happening/221103-lloyds-consumer-digital-index-2022-report.pdf.

Local Government Association (2021) Tackling the Digital Divide: House of Commons, 4 November 2021, www.local.gov.uk/parliament/briefings-and-responses/tackling-digital-divide-house-commons-4-november-2021.

Lu, W. C. (2018) The Impacts of Information and Communication Technology, Energy Consumption, Financial Development, and Economic Growth on Carbon Dioxide Emissions in 12 Asian Countries, *Mitigation and Adaptation Strategies for Global Change*, **23** (1), 1–15, https://doi.org/10.1007/s11027-018-9787-y.

Lu, Y., Nakicenovic, N., Visbeck, M. and Stevance , A. (2015) Policy: Five Priorities for the UN Sustainable Development Goals, *Nature*, **520**, 432–3, https://doi.org/10.1038/520432a.

Machingura, F., Nyamwanza, A., Hulme, D. and Stuart, E. (2018) Climate Information Services, Integrated Knowledge Systems and the 2030 Agenda for Sustainable Development, *Sustain Earth*, **1**, 1–7, https://doi.org/10.1186/s42055-018-0003-4.

Macht, S. A., Chapman, R. L. and Fitzgerald, J. A. (2020) Management Research and the United Nations Sustainable Development Goals, *Journal of Management & Organization*, **26** (6), 917–28, https://doi.org/10.1017/jmo.2020.36.

Mackinlay, R. (2020) A Greener Library: The Bodleian's Push for Sustainability, *Information Professional*, www.cilip.org.uk/news/493624/A-greener-library-The-Bodleians-push-for-sustainability.htm.

Marcella, R. and Chowdhury, G. (2020) Eradicating Information Poverty: An Agenda for Research, *Journal of Librarianship and Information Science*, **52** (2), 366–81, https://doi.org/10.1177/0961000618804589.

Madlberger, L., Thöni, A., Wetz, P., Schatten, A. and Tjoa, A. (2013) Ontology-based Data Integration for Corporate Sustainability Information Systems, *ACM International Conference Proceeding Series*, https://doi.org/10.1145/2539150.2539208.

Mahler, D. G., Lakner, C., Aguilar, A. C. and Wu, H. (2020) Updated Estimates of the Impact of COVID-19 on Global Poverty, World Bank blog, 8 June, https://blogs.worldbank.org/opendata/updated-estimates-impact-covid-19-global-poverty.

Mathiasson, M. H. and Jochumsen, H. (2022) Libraries, Sustainability and Sustainable Development: A Review of the Research Literature, *Journal of Documentation*, **78** (6), 1278–304, https://doi.org/10.1108/JD-11-2021-0226.

McColgan, K. (2019) *Libraries and Sustainability – the Building of a Canadian Federation*, IFLA WLIC 2019, Athens. https://library.ifla.org/id/eprint/2473/1/264-McColgan-en.pdf.

McKenzie, P. J. (2003) A Model of Information Practices in Accounts of Everyday-life Information Seeking, *Journal of Documentation*, **59** (1), 19–40.

McKinnon, H. (2016) The [Everyday] Future by Design: Opportunities for the Design Exploration of Everyday Sustainability, DIS '16 Companion, *Proceedings of the 2016 ACM Conference Companion Publication on Designing Interactive Systems*, Brisbane, 4–8 June.

Meschede, C. and Henkel, M. (2019) Library and Information Science and Sustainable Development: A Structured Literature Review, *Journal of Documentation*, **75** (6), 1356–69, www.emerald.com/insight/content/doi/10.1108/JD-02-2019-0021/full/html.

Meurer, J., Lawo, D., Janßen, L. and Wulf, V. (2016) Designing Mobility Eco-feedback for Elderly Users. In *CHI EA '16: Proceedings of the 2016 CHI Conference Extended Abstracts on Human Factors in Computing Systems, San Jose, CA, May 7–12*, Association for Computing Machinery, 921–6.

Meyers, E. and Nathan, L. (2016) Impoverished Visions of Sustainability: Encouraging Disruption in Digital Learning Environments. In *CSCW '16 Proceedings of the 19th ACM Conference on Computer Supported Cooperative Work & Social Computing, Feb 27– Mar. 02, 2016*, Association for Computing Machinery, 222–32.

Michel, J. O. (2020) Mapping Out Students' Opportunity to Learn about Sustainability across the Higher Education Curriculum, *Innovative Higher Education*, **45**, 355–71, https://doi.org/10.1007/s10755-020-09509-7.

Miola, A., Borchardt, S., Neher, F. and Buscaglia, D. (2019) *Interlinkages and Policy Coherence for the Sustainable Development Goals Implementation: An Operational Method to identify Trade-offs and Co-benefits in a Systemic Way*, Publications Office of the European Union.

Miranda, S. V. and Tarapanoff, K. M. A. (2008) Information Needs and Information Competencies: A Case Study of the Off-site Supervision of Financial Institutions of Brazil, *Information Research*, **13** (2), http://informationr.net/ir/13-2/paper344.html.

Misheva, G. V. (2022) Digital Skills Indicator 2.0: Measuring Digital Skills across the EU, https://digital-skills-jobs.europa.eu/en/inspiration/resources/digital-skills-Indicator-20-measuring-digital-skills-across-eu.

Missingham, R. (2019) *CAUL 2019 Report: United Nations Sustainable Development Goals*, Committee of Australian University Librarians, www.caul.edu.au/sites/default/files/documents/caul-doc/sdgs2019report.pdf.

Missingham, R. (2021) A New Lens for Evaluation – Assessing Academic Libraries Using the UN Sustainable Development Goals, *Journal of Library Administration*, **61** (3), 386–401, https://doi.org/10.1080/01930826.2021.1883376.

Moallemi, E. A., de Haan, F. J., Hadjikakou, M., Khatami, S., Malekpour, S., Smajgl, A., Stafford Smith, M., Voinov, A., Bandari, R., Lamichhane, P., Miller, K. K., Nicholson, E., Novalia, W., Ritchie, E. G., Rojas, A. M., Shaikh, M. A., Szetey, K. and Bryan, B. A. (2021) Evaluating Participatory Modeling Methods for Co-creating Pathways to Sustainability, *Earth's Future*, **9** (3), https://doi.org/10.1029/2020EF001843.

Molina, A. A., Helldén, D., Alfvén, T., Niemi, M., Leander, K., Nordenstedt, H., Rehn, C., Ndejjo,R., Wanyenze, R. and Biermann, O. (2023) Integrating the United Nations Sustainable Development Goals into Higher Education Globally: A Scoping Review, *Global Health Action*, **16** (1), https://doi.org/10.1080/16549716.2023.2190649.

Møllenbach, E., Hornbæk, K. and Hoff, J. V. (2012) HCI and Sustainability: The Role of Macrostructures. In *CHI'12: Extended Abstracts on Human Factors in Computing Systems*, Association for Computing Machinery, www.kasperhornbaek.dk/papers/CHI2012EA_CIDEA.pdf.

Mori, R., Fien, J. and Horne, R. (2019) Implementing the UN SDGs in Universities: Challenges, Opportunities, and Lessons Learned, *Sustainability: The Journal of Record*, **12** (2), 129–33.

Moyer, J. and Bohl, D. (2019) Alternative Pathways to Human Development: Assessing Trade-offs and Synergies in Achieving the Sustainable Development Goals, *Futures*, **105**, https://doi.org/10.1016/j.futures.2018.10.007.

Nakamura, M., Pandlebury, D., Schnell, J. and Szomszor, M. (2019) *Navigating the Structure of Research on Sustainable Development Goals*, Web of Science Group, Navigating-the-Structure-of-Research-on-Sustainable-Development-Goals.pdf.

Nathan, L. P. (2012) Sustainable Information Practice: An Ethnographic Investigation, *Journal of the American Society for Information Science and Technology*, **63** (11), 2254–68.

Naumer, C. M and Fisher, K. E. (2017) Information Needs. In: *Encyclopedia of Library and Information Sciences*, 4th edn, CRC Press, https://doi.org/10.1081/E-ELIS4.

NHS (2021) Digital Services Manual: Health Literacy, National Health Service (UK), https://service-manual.nhs.uk/content/health-literacy.

NHS Digital (2021) SNOMED CT, https://digital.nhs.uk/services/terminology-and-classifications/snomed-ct.

Ni, L. W. and Li, S. L. (2013) My Tree House: World's First Green Library for Kids. In Hauke, P., Latimer, K. and Werner, K. U. (eds), *The Green Library: The Challenge of Environmental Sustainability*, De Gruyter Saur, 295–308.

Niedzwiedzka, B. (2003) A Proposed General Model of Information Behaviour, *Information Research*, **9** (1), 164, http://InformationR.net/ir/9-1/paper164.html.

Nielsen, R. K., Fletcher, R., Kalogeropoulos, A. and Simon, F. (2020) *Communications in the Coronavirus Crisis: Lessons for the Second Wave*, https://reutersinstitute.politics.ox.ac.uk/sites/default/files/2020-10/Nielsen_et_al_Communications_in_the_Coronavirus_Crisis_FINAL_0.pdf.

Nikou, S., De Reuver, M. and Kanafi, M. (2022) Workplace Literacy Skills – How Information and Digital Literacy Affect Adoption of Digital Technology, *Journal of Documentation*, **78** (7), 371–91, https://doi.org/10.1108/JD-12-2021-0241.

Noh, Y. (2021) Study on the Perception of South Korean Librarians of the UN Sustainable Development Goals (SDGs) and the Strategy to Support Libraries, *Profesional de la información*, **30** (4), e300404, https://doi.org/10.3145/epi.2021.jul.04.

Noh, Y. and Ahn, I.-J. (2018) Evaluation Indicators for Green Libraries and Library Eco-friendliness, *International Journal of Knowledge Content Development & Technology*, **8** (1), 51–77, https://doi.org/10.5865/IJKCT.2018.8.1.051.

Nolin, J. (2010) Sustainable Information and Information Science, *Information Research*, **15** (2), http://informationr.net/ir/15-2/paper431.html.

Norström, A.V., Cvitanovic, C., Löf, M., West, S., Wyborn, C., Balvanera, P., Bednarek, A., Bennett, E., Biggs, R., Bremond, A., Campbell, B. , Canadell, J., Carpenter, S. , Folke, C., Fulton, E., Gaffney, O., Gelcich, S., Jouffray, J., Leach, M., Tissier, M., Martín-López, B., Louder, E., Loutre, M., Meadow, A., Nagendra, H., Payne, D., Peterson, G., Reyers, B., Scholes,R., Speranza, C., Spierenburg, M., Stafford-Smith, M., Tengö, M., van der Hel, S., Putten, I. and Österblom, H.(2020) Principles for Knowledge Co-production in Sustainability Research, *Nature Sustainability*, **3**, 182–90, https://doi.org/10.1038/s41893-019-0448-2.

Northern Ireland Environment Link (n.d.), Climate Coalition NI, www.nienvironmentlink.org/working-groups/climate-coalition-ni.

Nystrom, T. and Mustaquim, M. (2014) Sustainable Information System Design and the Role of Sustainable HCI. In *Academic MindTrek '14 Proceedings of the 18th International Academic MindTrek Conference: Media Business, Management, Content & Services*, Association for Computing Machinery, 66–73, https://doi.org/10.1145/2676467.2676486.

OECD (2010) *Committee on Information, Communications and Computer Policy*, https://one.oecd.org/document/C(2010)33/en/pdf.

OECD (2016a) Charts, Tables and Databases, www.oecd.org/dac/stats/data.htm.

OECD (2016b) *GlobeScan. Awareness of SDGs Versus MDGs: How Engaged are Global Citizens?*, OECD DevCom Annual Meeting, https://globescan.com/wp-content/uploads/2017/07/Radar_eBrief_SDGvsMDG.pdf.

OECD (2021) *Bridging Digital Divides in G20 Countries: OECD Report for the G20 Infrastructure Working Group*, www.oecd-ilibrary.org/docserver/35c1d850-en.pdf.

OECD (2022) *The Short and Winding Road to 2030*, www.oecd.org/wise/The-Short-and-Winding_Road-to-2030-Overview-and-key-findings.pdf.

Ofcom (2022a) *Adults' Media Use and Attitudes Report 2022*, www.ofcom.org.uk/__data/assets/pdf_file/0020/234362/adults-media-use-and-attitudes-report-2022.pdf.

Ofcom (2022b) *Digital Exclusion: A Review of Ofcom's Research on Digital Exclusion Among Adults in the UK*, www.ofcom.org.uk/__data/assets/pdf_file/0022/234364/digital-exclusion-review-2022.pdf.

Ofcom (2022c) *Online Nation 2022 Report*, www.ofcom.org.uk/__data/assets/pdf_file/0023/238361/online-nation-2022-report.pdf.

Ofcom (2023) *Adults' Media Use and Attitudes Report 2023*, www.ofcom.org.uk/__data/assets/pdf_file/0028/255844/adults-media-use-and-attitudes-report-2023.pdf.

ONS (2021a) *Three-Quarters of Adults in Great Britain Worry About Climate Change*, Office for National Statistics (UK), www.ons.gov.uk/peoplepopulationandcommunity/wellbeing/articles/threequartersofadultsingreatbritainworryaboutclimatechange/2021-11-05.

ONS (2021b) Dataset: Internet Users, Office for National Statistics (UK), www.ons.gov.uk/businessindustryandtrade/itandinternetindustry/datasets/internetusers.

ONS (2021c) Sustainable Development Goals Data Update, UK, Office for National Statistics (UK), December 2021, www.gov.uk/government/statistics/sustainable-development-goals-data-update-uk-december-2021.

Ormandy, P. (2009) Defining Information Need in Health – Assimilating Complex Theories Derived from Information Science, *Health Expectations*, **14**, 92–104.

Osborn, C. Y., Paasche-Orlow, M. K., Bailey, S. C. and Wolf, M. S. (2011) The Mechanisms Linking Health Literacy to Behavior and Health Status,. *American Journal of Health Behavior.*, **35** (1), 118–28, https://doi.org/10.5993/ajhb.35.1.11.

Paakkari, L. and Okan, O. (2020) COVID-19: Health Literacy is an Underestimated Problem, *The Lancet Public Health*, **5** (5), www.thelancet.com/journals/lanpub/article/PIIS2468-26672030086-4/fulltext.

Pargman, D. and Raghavan, B. (2014) *Rethinking Sustainability in Computing: from Buzzword to Nonnegotiable Limits*, paper presented at NordiCHI '14, October 26–

30, 2014, Helsinki, Finland, https://raghavan.usc.edu/papers/sustainability-nordichi14.pdf.

PARIS21 (2022a) Advanced Data Planning Tool (ADAPT), www.paris21.org/advanced-data-planning-tool-adapt.

PARIS21 (2022b) The PARIS21 Partner Report on Support to Statistics 2022: A Wake-up Call to Finance Better Data, OECD Publishing, https://doi.org/10.1787/c3cfb353-en.

Parmentola, A., Petrillo, A., Tutore, I. and De Felice, F. (2022) Is Blockchain Able to Enhance Environmental Sustainability? A Systematic Review and Research Agenda from the Perspective of Sustainable Development Goals (SDGs), *Business Strategy and the Environment*, **31** (1), 194–217.

Pawlish, M. and Varde, A. S. (2010) Free Cooling: A Paradigm Shift in Data Centers. In *Proceedings of the Fifth International Conference on Information and Automation for Sustainability (ICIAfS 2010)*, IEEE Computer Society, 1–28.

Persello, C., Wegner, J., Hansch, R., Tuia, D., Ghamisi, P., Koeva, M. and Camps-Valls, G. (2022) Deep Learning and Earth Observation to Support the Sustainable Development Goals: Current Approaches, Open Challenges, and Future Opportunities, *IEEE Geoscience and Remote Sensing Magazine*, **10** (2), 172–200.

Pettersson, L., Johansson, S., Demmelmaier, I. and Gustavsson, C. (2023) Disability Digital Divide: Survey of Accessibility of eHealth Services as Perceived by People With and Without Impairment, *BMC Public Health*, **23**, 18, https://doi-org.proxy.lib.strath.ac.uk/10.1186/s12889-023-15094-z.

Phiri, A., Chipeta, G. T. and Chawinga, W. D. (2019) Information Needs and Barriers of Rural Smallholder Farmers in Developing Countries: A Case Study of Rural Smallholder Farmers in Malawi, *Information Development*, **35** (3), 421–34 .

Pipa, T., Rasmussen, K. and Pendrak, K. (2022) The State of Sustainable Development Goals in the United States, United Nations Foundation, Center for Sustainable Development at Brookings, www.brookings.edu/research/the-state-of-the-sustainable-development-goals-in-the-united-states.

Popescu, C. (ed.) (2022) *Handbook of Research on SDGs for Economic Development, Social Development, and Environmental Protection*, IGI Global, https://doi-org.proxy.lib.strath.ac.uk/10.4018/978-1-6684-5113-7.

Purcell, W. M., Henriksen, H. and Spengler, J. D. (2019) Universities as the Engine of Transformational Sustainability Toward Delivering the Sustainable Development Goals: 'Living Labs' for Sustainability, *International Journal of Sustainability in Higher Education*, **20** (8), 1343–57, https://doi.org/10.1108/IJSHE-02-2019-0103.

Radovanović, D., Holst, C., Belur, S., Srivastava, R. Houngbonon, G., Quentrec, E., Miliza, J., Winkler, A. and Noll, J. (2020) Digital Literacy Key Performance Indicators for Sustainable Development, *Social Inclusion*, **8**, 151, https://doi.org/10.17645/si.v8i2.2587.

Rajabifard, A., Kahalimoghadam, M., Lumantarna, E., Herath, N., Peng Hui, F. K. and Assarkhaniki, Z. (2021) Applying SDGs as a Systematic Approach for Incorporating Sustainability in Higher Education, *International Journal of Sustainability in Higher Education*, **22** (6), 1266–84, https://doi.org/10.1108/IJSHE-10-2020-0418.

Reineck , D. and Lublinski, J. (2015) Media and Information Literacy: A Human Rights-based Approach in Developing Countries, DW Akademie, https://issuu.com/dwakademie/docs/151016_dw_akademie_discussion_paper.

Repanovici, A., Salcă Rotaru, C. and Murzea, C. (2021) Development of Sustainable Thinking by Information Literacy, *Sustainability*, **13** (3), 1287, https://doi.org/10.3390/su13031287.

Reyers, B., Stafford-Smith, M., Erb, K.-L., Scholes, R. J. and Selomane, O. (2017) Essential Variables Help to Focus Sustainable Development Goals Monitoring, *Current Opinion in Environmental Sustainability*, **26–27**, 97–105, https://doi.org/10.1016/j.cosust.2017.05.003.

Riel, A., Kreiner, C., Macher, G. and Messnarz, R. (2017) Integrated Design for Tackling Safety and Security Challenges of Smart Products and Digital Manufacturing, *CIRP Annals*, **66** (1), 177–80.

Riley, J. (2017) *Understanding Metadata: What is Metadata and What is it For?*, National Information Standards Organization, January 08, www.niso.org/publications/understanding-metadata-2017.

Roth, C. E. (1992) *Environmental Literacy: Its Roots, Evolution and Directions in the 1990s*, ERIC Clearinghouse for science, mathematics, and environmental education.

Rothkopf, D. J. (2003) When the Buzz Bites Back, *Washington Post*, 11 May, www.washingtonpost.com/archive/opinions/2003/05/11/when-the-buzz-bites-back/bc8cd84f-cab6-4648-bf58-0277261af6cd.

Rring (2020) Global Survey on Familiarity with Sustainable Development Goals, https://rring.eu/survey-familiarity-with-sustainable-development-goals-sdgs.

Rydz-Żbikowska, A. (2022) Implementing Sustainable Development Goals within the COVID–19 Pandemic Future Challenges for the 2030 Agenda, Comparative Economic Research, *Central and Eastern Europe*, **25** (4), 135–60.

Sachs, J., Kroll, C., Lafortune, G., Fuller, G. and Woelm, F. (2021) *Sustainable Development Report 2021*, Cambridge University Press, www.cambridge.org/core/services/aop-cambridge-core/content/view/2843BDD9D08CDD80E6875016110EFDAE/9781009098915AR.pdf.

Sachs, J., Lafortune, G., Kroll, C., Fuller, G. and Woelm, F. (2022) *Sustainable Development Report 2022*, Cambridge University Press, https://s3.amazonaws.com/sustainabledevelopment.report/2022/2022-sustainable-development-report.pdf.

Sætra, H. S. (2021) AI in Context and the Sustainable Development Goals: Factoring in the Unsustainability of the Sociotechnical System, *Sustainability*, **13** (4), 1738, https://doi.org/10.3390/su13041738.

Sahavirta, H. (2012) Showing the Green Way: Advocating Green Values and Image in a Finnish Public Library, *IFLA Journal*, **38** (3), 239–42, https://doi.org/10.1177/0340035212455624.

Sahavirta, H. (2017) From Green to Sustainable Libraries – Widening the Concept of Green Library. In Umlauf, K., Werner, K. U. and Kaufmann, A. (eds), *Strategien fur die Bibliothek als Ort*, De Gruyter Saur, 127–37.

Sahavirta, H. (2018) A Garden on the Roof Doesn't Make a Library Green: A Case for Green Libraries. In Hauke, P., Charney, M. and Sahavirta, H. (eds), *Going Green: Implementing Sustainable Strategies in Libraries Around the World: Buildings, Management, Programmes and Services*, De Gruyter Saur, 5–21.

Sahavirta, H. (2019) *Set the Wheels in Motion – Clarifying 'Green Library' as a Goal for Action*, paper presented at IFLA WLIC, Athens, 24–30 August 2019, http://library.ifla.org/2568/1/166-sahavirta-en.pdf.

Sarkis, J. and Ibrahim, S. (2022) Building Knowledge Beyond Our Experience: Integrating Sustainable Development Goals into IJPR's Research Future, *International Journal of Production Research*, **60** (24), 7301–18, https://doi.org/10.1080/00207543.2022.2028922.

Savolainen, R. (2017) Information Need as a Trigger and Driver of Information Seeking: A Conceptual Analysis, *Aslib Journal of Information Management*, **69** (1), 2–21.

Scheeder, D. (2019) Development and Access to Information: Libraries and the Sustainable Development Goals, *Online Searcher* , **43** (1), 46–7, www.infotoday.com/OnlineSearcher/Articles/The-Searchers-Viewpoint/Development-and-Access-to-Information-Libraries-and-the-Sustainable-Development-Goals-129674.shtml.

Scholz, F., Yalcin, B. and Priestley, M. (2017) Internet Access for Disabled People: Understanding Socio-relational Factors in Europe, *Cyberpsychology: Journal of Psychosocial Research on Cyberspace*, **11** (1), Article 4, https://doi.org/10.5817/CP2017-1-4.

SCONUL (2023) About SCONUL Access, www.sconul.ac.uk/page/about-sconul-access-0.

Scottish Government (2014) Making it Easy, https://www.gov.scot/publications/making-easy.

SDG Accord (2023) The SDG Accord, www.sdgaccord.org.

SDG Index (2023) Sustainable Development Report 2023: Executive Summary, https://dashboards.sdgindex.org/chapters/executive-summary.

Servaes, J. and Yusha'u, M. (2023) Conclusion: SDG18-Communication for All – Neither Too Late, Nor Too Early. In Servaes, J. and Yusha'u, M., *SDG18*

Communication for All, vol. 2, Regional Perspectives and Special Cases (Sustainable Development Goals series), 247–59, https://doi.org/10.1007/978-3-031-19459-7_10.

Shah, C. (2017) Information Seeking. In *Social Information Seeking*, The Information Retrieval series, **38**, Springer, https://doi.org/10.1007/978-3-319-56756-3_2.

Shih, W.-C., Tseng, S.-S. and Yang, C.-T. (2011) Due Time Setting for Peer-to-peer Retrieval of Teaching Material in Cloud Computing Environments. In *2011 International Conference on Information Science and Applications, ICISA 2011; Jeju Island; April 26–29*, https://doi.org/10.1109/ICISA.2011.5772397.

Simon, F., Howard, P. N. and Nielsen, R. K. (2020) Types, Sources, and Claims of COVID-19 Misinformation, https://reutersinstitute.politics.ox.ac.uk/types-sources-and-claims-covid-19-misinformation.

Singleton, J. A. (2011) *Environmental Literacy and Sustainability Values: A Content Analysis of National EE Frameworks and State Standards Through the Lens of the Earth Charter*, Texas A&M University, https://core.ac.uk/download/pdf/147196808.pdf.

Siri, V., Gram-Hanssen I., Maggs, D. and Lynch, A. H. (2022) Can the Sustainable Development Goals Harness the Means and the Manner of Transformation?, *Sustainability Science*, **17** (2), 637–51, https://doi.org/10.1007/s11625-021-01032-8.

SLIC (n.d.) Climate Resources, Scottish Library & Information Council, https://scottishlibraries.org/staff-development/climate-resources.

Smit, J., Kreutzer, S., Moeller, C. and Carlberg, M. (2016) *Industry 4.0: Study for the ITRE Committee*, European Parliament.

Smith, W. (2019) One Indicator to Rule Them All: How SDG4.1.1 Dominates the Conversation and What it Means for the Most Marginalized. In Wiseman, A. (ed.) *Annual Review of Comparative and International Education 2018, International Perspectives on Education and Society*, **37**, Emerald Publishing, 27–34, https://doi.org/10.1108/S1479-367920190000037002.

Soiland-Reyes, S., Castro, L., Garijo, D., Portier, M., Goble, C. and Groth, P. (2022) Updating Linked Data Practices for FAIR Digital Object Principles, *Research Ideas and Outcomes*, **8**, 35–6.

Sondermann, E. and Ulbert, C. (2021) Transformation Through 'Meaningful' Partnership? SDG17 as Metagovernance Norm and its Global Health Implementation, *Politics and Governance*, **9** (1), 152–63.

Sørensen, K., Pelikan, J. M., Röthlin, F., Ganahl, K., Slonska, Z., Doyle, G., Fullam, J., Kondilis, B., Agrafiotis, D., Uiters, E., Falcon, M., Mensing, M., Tchamov, K., van den Broucke, S. and Brand, H. (2015) Health Literacy in Europe: Comparative Results of the European Health Literacy Survey (HLS-EU), *European Journal of Public Health*, **25** (6),1053–8, https://doi.org/10.1093/eurpub/ckv043.

Spangenberg, J. H. (ed.) (2019) Scenarios and Indicators for Sustainable Development: Towards a Critical Assessment of Achievements and Challenges, https://doi.org/10.3390/books978-3-03897-673-8.

Stanford Encyclopedia of Philosophy (2022) Semantic Conceptions of Information, https://plato.stanford.edu/entries/information-semantic.

Stapp, W. B. (1969) The Concept of Environmental Education, *Environmental Education*, **1** (1), 30–1.

Statista (2022a) Adult Home Broadband Penetration in the United States from 2000 to 2021, by Age Group, www.statista.com/statistics/710877/adult-home-broadband-users-in-the-us-by-age.

Statista (2022b) Share of Daily Internet Users in Selected European Countries According to Age 2020, www.statista.com/statistics/1241896/european-countries-internet-users-use-accessed-internet-daily-age._

Statista (2022c) Adult Internet Usage Penetration in the United States from 2000 to 2021, by Age Group, www.statista.com/statistics/184389/adult-internet-users-in-the-us-by-age-since-2000.

Statista (2022d) Share of Adults in the United States who Use the Internet in 2021, by Annual Household Income, www.statista.com/statistics/327146/internet-penetration-usa-income.

Stauropoulou, A., Sardianou, E., Malindretos, G., Evangelinos, K. and Nikolaou, I. (2023) The Effects of Economic, Environmentally and Socially Related SDGs Strategies of Banking Institutions on Their Customers' Behavior, *World Development Sustainability*, **2**, https://doi.org/10.1016/j.wds.2023.100051.

Sulkowski, A. J., Kowalczyk, W., Ahrendsen, B. L., Kowalski, R. and Majewski, E. (2020) Enhancing Sustainability Education Through Experiential Learning of Sustainability Reporting, *International Journal of Sustainability Higher Education*, **21** (6), 1233–47.

Sun, X., Shi, Y., Zeng, Q., Wang, Y., Du, W., Wei, N., Xie, R. and Chang, C. (2013) Determinants of Health Literacy and Health Behavior Regarding Infectious Respiratory Diseases: A Pathway Model, *BMC Public Health*, **13**, 261, https://doi.org/10.1186/1471-2458-13-261. PMID: 23521806; PMCID: PMC3621712.

Sustainable Libraries Initiative (2023) https://sustainablelibrariesinitiative.org.

Tableau Public (2023) RCUK GCRF Awarded Projects by Research Councils UK, https://public.tableau.com/app/profile/research.councils.uk/viz/RCUKGCRFFundedProjects/RCUKGCRFAwardedProjects.

Tanner, R., Ho, A. K., Antonelli, M. and Aldrich, R. M. (2021) *Libraries and Sustainability: Programs and Practices for Community Impact*, ALA Editions.

Taylor, R. S. (1968) Question-negotiation and Information Seeking in Libraries: A Conceptual Analysis, *College and Research Libraries*, **29** (3), 178–94.

Teregowda, P., Urgaonkar, B. and Giles, C. L. (2010) Cloud Computing: A Digital Libraries Perspective. In *Proceedings of the 2010 IEEE Third International Conference on Cloud Computing*, 115–22, IEEE Computer Society.

Thierry, M., Bruno Emmanuel, O. and Protus Biondeh, N. (2022) Environmental Sustainability in Sub-Saharan Africa: Does Information and Communication

technology (ICT) Matter?, *Cogent Economics & Finance*, **10** (1), 2125657, https://doi.org/10.1080/23322039.2022.2125657.

Timko, J., Le Billon, P., Zerriffi, H., Honey-Rosés, J., de la Roche, I., Gaston, C., Sunderland, T. C. H. and Kozak, R. A. (2018) A Policy Nexus Approach to Forests and the SDGs: Tradeoffs and Synergies, *Current Opinion in Environmental Sustainability*, **34**, 7–12. https://doi.org/10.1016/j.cosust.2018.06.004.

Tomlinson, B. (2010) *Greening Through IT: Information Technology for Environmental Sustainability*, MIT Press.

Trane, M., Marelli, L., Siragusa, A., Pollo, R. and Lombardi, P. (2023) Progress by Research to Achieve the Sustainable Development Goals in the EU: A Systematic Literature Review, *Sustainability*, **15** (9), 7055, http://dx.doi.org/10.3390/su15097055.

Tremblay, D., Fortier, F., Boucher, J. F., Riffon, O. and Villeneuve, C. (2020) Sustainable Development Goal Interactions: An Analysis Based on the Five Pillars of the 2030 Agenda, *Sustainable Development*, **28** (6), 1584– 96, https://doi.org/10.1002/sd.2107.

Tribelhorn, S. K. (2023) Preliminary Investigation of Sustainability Awareness and Activities among Academic Libraries in the United States, *Journal of Academic Librarianship*, **49** (3), 102661, https://doi.org/10.1016/j.acalib.2022.102661.

Truby, J. (2020) Governing Artificial Intelligence to Benefit the UN Sustainable Development Goals, *Sustainability Development*, **28**, 946–59.

Turner, D. (2014) Sustainability and Library Management Education, *Journal of Sustainability Education*, **7**, 1–12, www.susted.com/wordpress/content/sustainability-and-library-management-education_2014_12.

Tury, S., Robinson, L. and Bawden, D. (2015) The Information Seeking Behaviour of Distance Learners: A Case Study of the University of London International Programmes, *Journal of Academic Librarianship*, **41** (3), 312–21.

UK HM Government (2019) *Voluntary National Review of Progress Towards the Sustainable Development Goals*, United Kingdom of Great Britain and Northern Ireland, https://sustainabledevelopment.un.org/content/documents/ 23678UK_12072019_UK_Voluntary_National_Review_2019.pdf.

UK SDG (2021) SDG Dashboards and Trends, https://dashboards.sdgindex.org/profiles/united-kingdom.

UN Department of Economic and Social Affairs (2017a) Conservation International, https://sdgs.un.org/statements/conservation-international-15786.

UN Department of Economic and Social Affairs (2017b) Higher Education Institutions - Key Drivers of the Sustainable Development Goals, https://sdgs.un.org/events/higher-education-institutions-key-drivers-sustainable-development-goals-28791.

UN Department of Economic and Social Affairs (n.d.a) Sustainable Development Transforming Our World: The 2030 Agenda for Sustainable Development, https://sdgs.un.org/2030agenda.

UN Department of Economic and Social Affairs (n.d.b), Ensure Inclusive and Equitable Quality Education and Promote Lifelong Learning Opportunities for All, https://sdgs.un.org/goals/goal4.

UN Department of Economic and Social Affairs (n.d.c) Promote Peaceful and Inclusive Societies for Sustainable Development, Provide Access to Justice for All and Build Effective, Accountable and Inclusive Institutions at All Levels, https://sdgs.un.org/goals/goal16.

UN Department of Economic and Social Affairs (n.d.d) Strengthen the Means of Implementation and Revitalize the Global Partnership for Sustainable Development, https://sdgs.un.org/goals/goal17.

UN Department of Economic and Social Affairs (n.d.e) Contribution of Libraries to the SDGs, https://sdgs.un.org/partnerships/contribution-libraries-sdgs.

UN Department of Economic and Social Affairs (n.d.f) Build Resilient Infrastructure, Promote Inclusive and Sustainable Industrialization and Foster Innovation, https://sdgs.un.org/goals/goal9.

UN Department of Economic and Social Affairs (n.d.g) Increasing the Transparency of SDG Data in Developing Countries (Unlocking the Power of Data Through New Presentation and Dissemination Techniques), https://sdgs.un.org/partnerships/increasing-transparency-sdg-data-developing-countries-unlocking-power-data-through-new.

UN Economic and Social Council (2022) *Progress Towards the Sustainable Development Goals: Report of the Secretary-General*, E/2022/55, https://unstats.un.org/sdgs/files/report/2022/secretary-general-sdg-report-2022--EN.pdf.

UN Economic Commission for Africa (2020) Regional Forum on Sustainable Development to Define a Road Map for Operationalizing Africa's Decade of Action, https://archive.uneca.org/stories/regional-forum-sustainable-development-define-road-map-operationalizing-africa%E2%80%99s-decade.

UN General Assembly (2012) Resolution Adopted by the General Assembly. A/RES/66/288. The Future We Want, 11 September 2012, www.un.org/en/development/desa/population/migration/generalassembly/docs/globalcompact/A_RES_66_288.pdf.

UN General Assembly (2015a) Transforming Our World: The 2030 Agenda for Sustainable Development: Resolution A/RES/70/1, 21 October 2015, www.undocs.org/A/RES/70/1.

UN General Assembly (2015b) Resolution Adopted by the General Assembly on 27 July 2015: A/RES/69/313, January 24. https://undocs.org/A/RES/69/313.

UN General Assembly (2016) Resolution Adopted by the General Assembly on 16 December 2015: A/RES/70/125, January 24. https://unctad.org/system/files/official-document/ares70d125_en.pdf.

UN Office for Sustainable Development (2013) *Bridging Knowledge and Capacity Gaps for Sustainability Transition: A Framework for Action*, http://sustainabledevelopment.un.org/content/documents/1681Framework%20for%20Action.pdf.

UN SDG:Learn (n.d.a) Compiling National Metadata for Sustainable Development Goals, www.unsdglearn.org/courses/compiling-national-metadata-for-sustainable-development-goals.

UN SDG:Learn (n.d.b) Learning, www.unsdglearn.org/courses.

UN SDG:Learn (n.d.c) SDG Indicator 5.a.2 - Ensuring Women's Legal Rights to Land Ownership and/or Control, www.unsdglearn.org/courses/sdg-Indicator-5-a-2-ensuring-womens-legal-rights-to-land-ownership-and-or-control-2.

UN SDG:Learn (n.d.d) Introduction to Data Governance for Monitoring the SDGs, www.unsdglearn.org/courses/introduction-to-data-governance-for-monitoring-the-sdgs.

UN SDG:Learn (n.d.e) Water: Addressing the Global Crisis, www.unsdglearn.org/courses/water-addressing-the-global-crisis.

UN SDG:Learn (n.d.f) Compiling National Metadata for Sustainable Development Goals, www.unsdglearn.org/courses/compiling-national-metadata-for-sustainable-development-goals.

UN Statistics Division (2021a) e-Learning Platform of the United Nations Statistics Division, January 17. https://elearning-cms.unstats.un.org/learn.

UN Statistics Division (2021b) SDG Indicator Database, https://unstats.un.org/sdgs/Indicators/Indicators-list.

UN Statistics Division (2022a) SDG Indicators: Global Indicator Framework for the Sustainable Development Goals and Target of the 2030 Agenda for Sustainable Development, https://unstats.un.org/sdgs/indicators/indicators-list.

UN Statistics Division (2022b) Compiling Metadata for Sustainable Development Goals, January 23. https://elearning-cms.unstats.un.org/thematicarea/detail?id=24.

UN Statistics Division (2022c) Methodological Guide on the Use of Mobile Phone Data: Measuring the Information Society (SDG – ICT Indicators), https://unstats.un.org/wiki/pages/viewpage.action?pageId=143098430.

UN Statistics Division (2023) *SDG Indicator Metadata*, https://unstats.un.org/sdgs/metadata/files/Metadata-17-08-01.pdf.

UN Statistics Division (n.d.a) *SDG Metadata Authoring Tool Template Guidance for National Reporting*, https://unstats.un.org/capacity-development/UNSD-FCDO/files/Guidelines-SDG-Metadata-Template-3.2-for-National-Reporting.pdf.

UN Statistics Division (n.d.b) *UN-DFID Project on SDG Monitoring. Module 2: Introduction to Metadata*, https://unstats.un.org/capacity-development/meetings/UNSD-DFID-Metadata/documents/Module_2.1_What-is-metadata.pdf.

UN Statistics Division (n.d.c) *Global Indicator Framework for the Sustainable Development Goals and Targets of the 2030 Agenda for Sustainable Development*, https://unstats.un.org/sdgs/Indicators/Global%20Indicator%20Framework%20aft er%202023%20refinement_Eng.pdf.

UN Statistics Division (n.d.d) E-Handbook on the Sustainable Development Goals Indicators, https://unstats.un.org/wiki/display/SDGeHandbook/Home.

UN Sustainable Development Goals (2018) Raising Awareness and Assessing Sustainability Literacy on SDG7, https://sustainabledevelopment.un.org/sdinaction/hesi/literacy.

UN Women (n.d.) Women and the Sustainable Development Goals (SDGs), www.unwomen.org/en/news/in-focus/women-and-the-sdgs.

UNEP (n.d.a) *Clarifying Terms in the SDGs: Representing the Meaning Behind the Terminology*, United Nations Environment Programme, https://unstats.un.org/sdgs/files/meetings/iaeg-sdgs-meeting-02/Statements/UNEP%20-%20Clarifying%20terms%20in%20the%20SDGs.pdf.

UNEP (n.d.b) SDG Interface Ontology, United Nations Environment Programme, www.unep.org/explore-topics/sustainable-development-goals/what-we-do/monitoring-progress/sdg-interface-ontology.

UNESCO (1977) The Tbilisi Declaration, www.gdrc.org/uem/ee/tbilisi.html.

UNESCO (2013) Media and Information Policy and Strategy, www.unesco.org/en/node/66602?hub=750.

UNESCO (2015a) Media and Information Literacy: for the Sustainable Development Goals, https://unesdoc.unesco.org/ark:/48223/pf0000234657.

UNESCO (2015b) Transforming Our World: Literacy for Sustainable Development, https://unesdoc.unesco.org/ark:/48223/pf0000234253.

UNESCO (2017) Education for Sustainable Development: Learning Objectives, www.sdg4education2030.org/education-sustainable-development-goals-learning-objectives-unesco-2017.

UNESCO (2018) Issues and Trends in Education for Sustainable Development, https://unesdoc.unesco.org/ark:/48223/pf0000261954.

UNESCO (2019a) Access to Information Gets an Upgrade in SDG Indicators Framework, https://en.unesco.org/news/access-information-gets-upgrade-sdg-Indicators-framework.

UNESCO (2019b) Access to Information: A New Promise for Sustainable Development, https://unesdoc.unesco.org/ark:/48223/pf0000371485.

UNESCO (2020a) Education for Sustainable Development: A Roadmap, https://unesdoc.unesco.org/ark:/48223/pf0000374802.

UNESCO (2020b) Evaluation of UNESCO's Work in the Thematic Area of Media and Information Literacy (MIL), https://unesdoc.unesco.org/ark:/48223/pf0000374972.locale=en.

UNESCO (2021a) Building Knowledge Societies, https://en.unesco.org/70years/knowledge_societies_way_forward_better_world.

UNESCO (2021b) Sustainable Development Goals: Resources for Educators, https://en.unesco.org/themes/education/sdgs/material.

UNESCO (2021c) Access to Information and Sustainable Development Goals, www.unesco.org/reports/access-to-information/2021/en/access-infromation-sustaiable-development.

UNESCO (2021d) Learn for Our Planet: A Global Review of how Environmental Issues are Integrated in Education, https://unesdoc.unesco.org/ark:/48223/pf0000377362.

UNESCO (2022a) About Media and Information Literacy, www.unesco.org/en/media-information-literacy/about.

UNESCO (2022b) School Feeding for Inclusion: Brief on Inclusion In Education, https://unesdoc.unesco.org/ark:/48223/pf0000382657.

UNESCO (2022c) To Recovery and Beyond: 2021 UNESCO Report on Public Access to Information (SDG16.10.2), https://www.unesco.org/en/articles/recovery-and-beyond.

UNESCO (2022d) Global Media and Information Literacy Week 2022, www.unesco.org/en/articles/global-media-and-information-literacy-week-2022.

UNESCO (2022e) Transforming Education Summit, www.unesco.org/en/2022-transforming-education-summit.

UNESCO (2023a) Her Education Our Future: Innovation and Technology for Gender Equality; the Latest Facts on Gender Equality in Education, https://unesdoc.unesco.org/ark:/48223/pf0000384678.

UNESCO (2023b) What You Need to Know About Education for Sustainable Development, www.unesco.org/en/education-sustainable-development/need-know.

UNESCO (2023c) Education World Forum 2023: UNESCO Mobilizes Ministers on Greening Education and Digital Transformation, www.unesco.org/en/articles/education-world-forum-2023-unesco-mobilizes-ministers-greening-education-and-digital-transformation?hub=72522.

UNESCO Institute of Statistics (2023) Literacy, https://uis.unesco.org/en/topic/literacy.

United Nations (1987) *Report of the World Commission on Environment and Development: Our Common Future*, www.un-documents.net/our-common-future.pdf.

United Nations (2012) *Realizing the Future We Want for All: Report to the Secretary-General*,

https://sustainabledevelopment.un.org/content/documents/614Post_2015_
UNTTreport.pdf.

United Nations (2013a) Sustainable Development Knowledge Platform: Sustainable
Development in the 21st Century (SD21),
http://sustainabledevelopment.un.org/sd21.html.

United Nations (2013b) Sustainable Development Knowledge Platform, United
Nations Conference on Sustainable Development, Rio+20,
http://sustainabledevelopment.un.org/rio20.html.

United Nations (2013c) We Can End Poverty 2015: Millennium Development Goals,
www.un.org/millenniumgoals.

United Nations (2015) Transforming Our World: The 2030 Agenda for Sustainable
Development, https://sdgs.un.org/2030agenda.

United Nations (2019) *The Future is Now: Science for Achieving Sustainable
Development, Global Sustainable Development Report,*
https://sustainabledevelopment.un.org/content/documents/24797GSDR_report_
2019.pdf.

United Nations (2021) *The Sustainable Development Goals Report 2021,*
https://unstats.un.org/sdgs/report/2021/The-Sustainable-Development-Goals-
Report-2021.pdf.

United Nations (2022a) *The Sustainable Development Goals Report 2022,*
https://unstats.un.org/sdgs/report/2022/The-Sustainable-Development-Goals-
Report-2022.pdf.

United Nations (2022b) *Sustainable Development Goals Progress Chart 2022,*
https://unstats.un.org/sdgs/report/2022/Progress-Chart-2022.pdf.

United Nations (2023) Big Data for Sustainable Development,
www.un.org/en/global-issues/big-data-for-sustainable-development.

United Nations (n.d.a) Sustainable Development Goals: The Sustainable
Development Agenda,
www.un.org/sustainabledevelopment/development-agenda-retired.

United Nations (n.d.b) The Lazy Person's Guide to Saving the World,
www.un.org/sustainabledevelopment/takeaction.

University of Edinburgh (2023) Social Responsibility and Sustainability,
www.ed.ac.uk/sustainability/programmes-and-projects/student-leadership-for-
sustainability/living-lab-projects/sdg-data-library.

University of Waterloo (n.d.) United Nations' Sustainable Development Goals,
https://uwaterloo.ca/associate-provost-co-operative-and-experiential-
education/about/united-nations-sustainable-development-goals.

US SDG (2022) SDG Dashboards and Trends,
https://dashboards.sdgindex.org/profiles/united-states.

Van Antwerp, J. and Heun, M. K. (2022) An Introduction to *A Framework for Sustain-
ability Thinking, Numeracy,* **15** (2), 4, https://doi.org/10.5038/1936-4660.15.2.1423.

Vargas, L. and Lee, P. (2023) Communication and Information Poverty in the Context of the Sustainable Development Goals (SDGs): A Case for SDG18 – Communication for All. In Servaes, J. and Yusha'u, M. (eds) *SDG18 communication for all, Vol. 1, The Missing Link Between SDGs and Global Agendas* (Sustainable Development Goals series), Springer, 25–60, https://doi.org/10.1007/978-3-031-19142-8_2.

Vellucci, S. L. (1998) Metadata, *Annual Review of Information Science and Technology*, **33**, 187–222.

Vinuesa, R., Azizpour, H., Leite, I., Balaam, M., Dignum, V., Domisch, S., Felländer, A., Langhans, S. D., Tegmark, M. and Nerini, F. F. (2020) The Role of Artificial Intelligence in Achieving the Sustainable Development Goals, *Nature Communications*, **11**, 233, https://doi.org/10.1038/s41467-019-14108-y.

Vuorikari, R., Jerzak, N., Karpinski, Z., Pokropek, A. and Tudek, J. (2022) *Measuring Digital Skills Across the EU: Digital Skills Indicator 2.0*, EUR 31193 EN, Publications Office of the European Union, https://doi.org/10.2760/897803, JRC130341

Vyas-Doorgapersad, S. (2022) The Use of Digitalization (ICTs) in Achieving Sustainable Development Goals, *Global Journal of Emerging Market Economies*, **14** (2), 265–78.

Walsh, A., Michalopoulou, E., Tierney, A., Tweddell, H., Preist, C., Willmore, C. (2020) Sustainability in Higher Education: Beyond the Green Mirror. In Filho, W. et al. (eds) *Universities as Living Labs for Sustainable Development*, (World Sustainability series), Springer, https://doi.org/10.1007/978-3-030-15604-6.

Watson, R. T., Boudreau, M. C. and Chen, A. J. (2010) Information Systems and Environmentally Sustainable Development: Energy Informatics and New Directions for the IS Community, *MIS Quarterly*, **34** (1), 23–38.

Watson, R. T., Boudreau, M. C., Chen, A. and Huber, M. H. (2008) *Green IS: Building Sustainable Business Practices in Information Systems*, Global Text project, Athens, GA, http://globaltext.terry.uga.edu/userfiles/pdf/Green.pdf.

Weiss, B. D. and Paasche-Orlow, M. K. (2020) Disparities in Adherence to COVID-19 Public Health Recommendations, *Health Literacy Research and Practice* , **4** (3), e171–e173, https://doi.org/10.3928/24748307-20200723-01.

Wessels, B., Finn, R. L., Wadhwa, K., Sveinsdottir, T., Bigagli, L., Nativi, S. and Noorman, M. (2017) *Open Data and the Knowledge Society*, Amsterdam University Press, http://library.oapen.org/handle/20.500.12657/31743.

Westerman, J., Acikgoz, Y., Nafees, L. and Westerman, J. (2022) When Sustainability Managers' Greenwash: SDG Fit and Effects on Job Performance and Attitudes, *Business and Society Review (1974)*, **127** (2), 371–93.

Wilkinson, M., Dumontier, M., Aalbersberg, I. et al. (2016) The FAIR Guiding Principles for Scientific Data Management and Stewardship. *Scientific Data*, **3**, 160018, https://doi.org/10.1038/sdata.2016.18.

Williams, E. and Tagami, T. (2003) Energy Use in Sales and Distribution via e-Commerce and Conventional Retail: A Case Study of the Japanese Book Sector , *Journal of Industrial Ecology*, **6** (2), 99–114.

Williams, L. (2022) 7 Ways That Libraries Can Support and Promote the UM SDGs at Their Institutions, www.elsevier.com/connect/library-connect/7-ways-that-libraries-can-support-and-promote-the-un-sdgs-at-their-institutions.

Wilson, T. (1997) Information Behaviour: An Interdisciplinary Perspective, *Information Processing & Management*, **33** (4), 551–72.

Wilson, T. (1999) Models in Information Behaviour Research, *Journal of Documentation*, **55** (3), 249–70.

Wilson, T. (2000) Human Information Behaviour, *Informing Science*, **3** (1), 49–56.

Wilson, T. (2008) On User Studies and Information Needs, *Journal of Documentation*, Special issue, 174–86.

Wilson, T. (2010a) Information and Information Science: An Address on the Occasion of Receiving the Award of Doctor Honoris Causa, at the University of Murcia, 30 September 2010., *Information Research*, **15** (4), http://informationr.net/ir/15-4/paper439.html.

Wilson, T. (2010b) Fifty Years of Information Behaviour Research, *Bulletin of the American Society for Information Science and Technology*, **36** (3), 27–34, https://doi.org/10.1002/bult.2010.1720360308.

World Bank (2023) Literacy Rate, Adult Total (% of People Ages 15 and Above), https://data.worldbank.org/indicator/SE.ADT.LITR.ZS?most_recent_year_desc=true.

World Economic Forum (2019) Global Survey Shows 74% are Aware of the Sustainable Development Goals, www.weforum.org/press/2019/09/global-survey-shows-74-are-aware-of-the-sustainable-development-goals.

World Health Organization (2023) Infodemic, www.who.int/health-topics/infodemic#tab=tab_1.

Wu, J., Guo, S., Huang, H., Liu, W. and Xiang, Y. (2018) Information and Communications Technologies for Sustainable Development Goals: State-of-the-Art, Needs and Perspectives, *IEEE Communications Surveys & Tutorials*, **20** (3), 2389–406, https://doi.org/10.1109/COMST.2018.2812301.

Xiao, H., Bao, S., Ren, J. and Xu, Z. (2023) Transboundary Impacts on SDG Progress Across Chinese Cities: A Spatial Econometric Analysis, *Sustainable Cities and Society*, **92,** https://doi.org/10.1016/j.scs.2023.104496.

Yang, Z. , Kamata, S.-I. and Ahrary, A. (2009) NIR: Content Based Image Retrieval on Cloud Computing. In *Proceedings - 2009 IEEE International Conference on Intelligent Computing and Intelligent Systems*, **3**, article number 5358101, 556–9.

Zancajo, A., Verger, A. and Bolea, P. (2022) Digitalization and Beyond: The Effects of Covid-19 on Post-pandemic Educational Policy and Delivery in Europe, *Policy and Society*, **41** (1), 111–28, https://doi.org/10.1093/polsoc/puab016.

Zhao, Z., Cai, M., Wang, F., Winkler, J., Connor, T., Chung, M., Zhang, J., Yang, H., Xu, Z., Tang, Y., Ouyang, Z., Zhang, H. and Liu, J. (2021) Synergies and Tradeoffs Among Sustainable Development Goals Across Boundaries in a Metacoupled World, *The Science of the Total Environment*, **751**, https://doi.org/10.1016/j.scitotenv.2020.141749.

Zimmermann, B., Fanderl, J., Koné, I., Rabaglio, M., Bürki, N., Shaw, D. and Elger, B. (2021) Examining Information-seeking Behavior in Genetic Testing for Cancer Predisposition: A Qualitative Interview Study, *Patient Education and Counseling*, **104** (2), 257–64.

Zizka, L., McGunagle, D. M. and Clark, P. J. (2021) Sustainability in Science, Technology, Engineering and Mathematics (STEM) Programs: Authentic Engagement Through a Community-Based Approach, *Journal of Cleaner Production*, **279**, https://doi.org/10.1016/j.jclepro.2020.123715.

Index